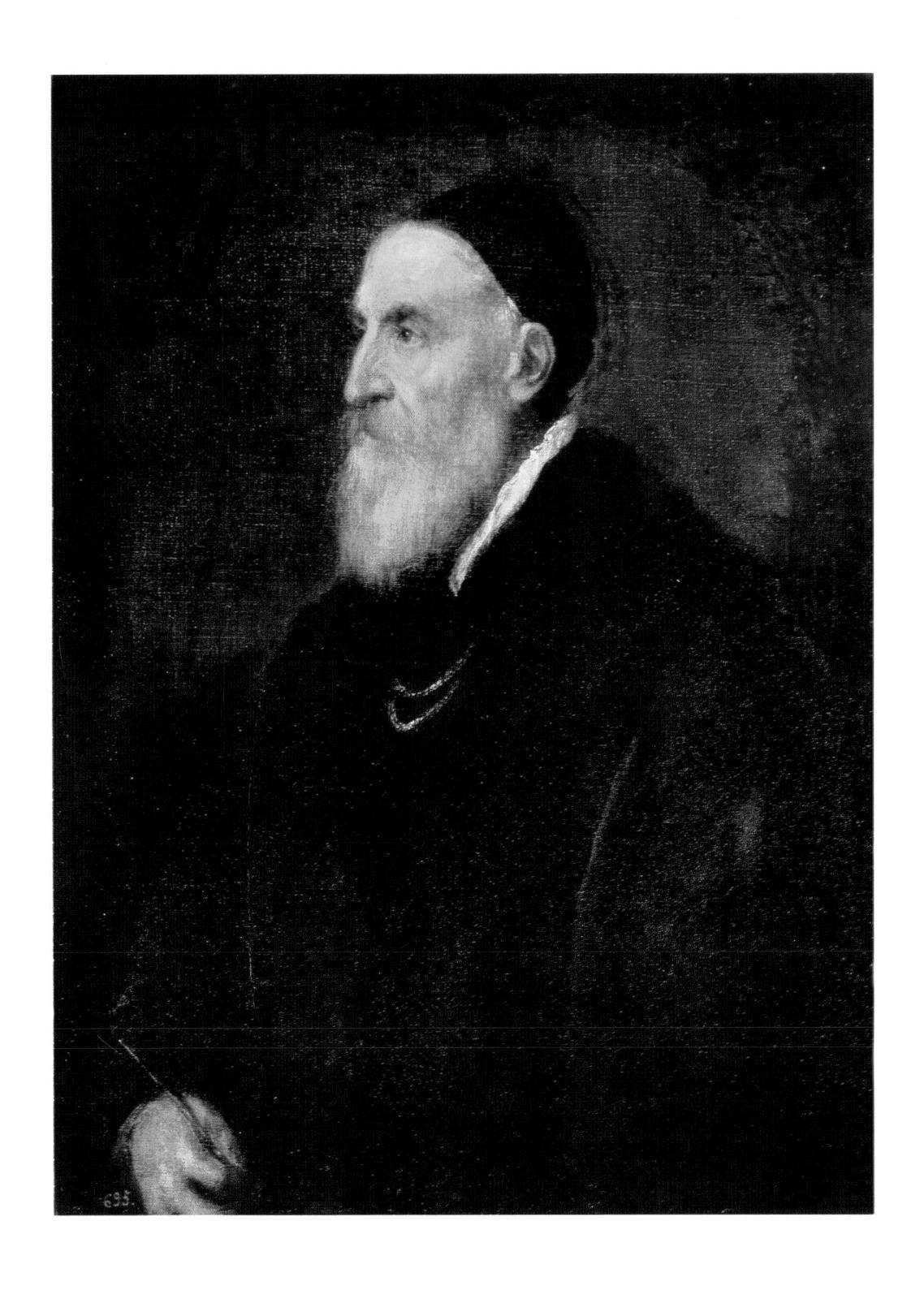

FOR THOMAS

PUBLISHED BY CHAUCER PRESS 20 BLOOMSBURY STREET, LONDON WC1 3QA

© CHAUCER PRESS, 2003

ALL RIGHTS RESERVED. NO PART OF THIS PUBLICATION MAY BE
REPRODUCED, STORED IN A RETRIEVAL SYSTEM OR TRANSMITTED IN ANY
FORM OR BY ANY MEANS, WITHOUT THE PERMISSION OF
THE COPYRIGHT HOLDER

ISBN 1 904449 190

A COPY OF THE CIP DATA IS AVAILABLE FROM THE ${\tt BRITISH\ LIBRARY\ UPON\ REQUEST}$

DESIGNED BY POINTING DESIGN CONSULANCY

REPROGRAPHICS BY GA GRAPHICS

EDITED BY CHRISTOPHER WRIGHT

PICTURE ACKNOWLEDGMENTS: AKG SLONDON, BRIDGEMAN ART LIBRARY, NATIONAL GALLERY, LONDON

OVERLEAF: SELF-PORTRAIT
MADRID, MUSEO DEL PRADO. 1562? OIL ON CANVAS 86 X 65 CM.

CHARLES HOPE

Chaucer Press London

NOTE ON THE CAPTIONS None of the monographs on Titian is reliable regarding the inscriptions on Titian's pictures or their dimensions; even the measurements given in museum catalogues often vary from edition to edition. It is easy enough to check inscriptions, but for dimensions I have had to rely on a variety of published sources; where the evidence is contradictory I have adopted the set of figures whose ratio approximates most closely to the corresponding photograph. Measurements of pictures are given to the nearest centimetre, height before width.

CONTENTS

Preface, page 6
Introduction, page 7
The Early Career, page 9
1516-1530, page 47
1530-1547, page 85
1548-1562, page 125
1562-1576, page 163
Conclusion, page 185

Index, page 190

PREFACE

Titian was one of the longest lived and most prolific of all European painters, and it would require a much larger book than this to give a comprehensive account of his career. I have therefore chosen to concentrate on his larger works, almost all of which are reproduced, at the expense of portraits and other small-scale compositions. At the same time I have tried to examine the basic issues on which there is still disagreement among art historians, those of his stylistic development, his place in the wider context of Venetian painting, his working procedure and the organization of his studio, his relationship with important patrons and the meaning of his pictures. Although my intention has been not only to offer some conclusions, but also to outline the evidence on which these are based, I am very conscious that my text raises many problems which deserve more detailed consideration. I hope to discuss them at greater length in more specialized publications. For this reason the notes, most of which refer to unpublished or little-known material, have been kept to a minimum.

I am particularly grateful to John Shearman, who first suggested that I should work on Titian and who gave me much valuable advice, and to the late Francis Haskell, who supervised the thesis on which this book is based. My research was generously supported first by the Dean and Students of Christ Church, Oxford, and subsequently by the Provost and Fellows of King's College, Cambridge. I am also indebted to many friends and colleagues for information and encouragement, and particularly to the following for their help in connection with material discussed in my text: Jaynie Anderson Pau, Philipp Fehl, David Freedberg, the late Cecil Gould, Michael Hirst, William Hood, Paul Joannides, Lisa Maechling, Elizabeth McGrath, Francis Richardson, Herbert Siebenhüner and the late Harold E. Wethey. Finally, I should like to thank my editors, John Blackett-Ord and Robert Oresko.

INTRODUCTION

Titian has enjoyed excellent health and as much good fortune as any of his peers, and he has received nothing from heaven but favours and happiness. All the princes, writers and celebrities who have gone to Venice or lived there in his lifetime have been in his house, for, quite apart from the excellence of his art, he is extremely courteous, with very good manners and the most pleasant personality and behaviour. In Venice he has had some rivals, but they have not shown much talent, so he has easily surpassed them, thanks both to the quality of his art and to his ability to get on with gentlemen and make himself agreeable to them. Titian, then, who has adorned Venice and indeed all Italy and other parts of the world with outstanding pictures, deserves to be loved and respected by artists, and in many ways to be admired and imitated, as one who has produced and is still producing many works worthy of infinite praise, which will endure as long as the memory of illustrious men survives.

Giorgio Vasari, The Lives of the Most Excellent Painters, Sculptors and Architects, Florence, 1568.

When Vasari wrote these words, four years after the death of Michelangelo, Titian was the most famous living artist not only in Italy but throughout Europe. In a career that had already lasted over sixty years his patrons had included a pope, three successive Holy Roman Emperors and the King of Spain, as well as a cross-section of the Italian ruling élite. In terms of prestige and wordly success, it was an achievement unmatched by any painter before his time and, among later artists, equalled only by Rubens. The extent of this achievement was fully recognized by Vasari, but at the same time he was at pains to indicate that Titian's fame was not due solely to his talent as a painter. Luck and social skill had apparently played an equally important part, even, it would seem, within the restricted milieu of Venice. At first sight there is nothing very surprising in this assessment, since we do not necessarily assume that the patronage of the rich and powerful is in itself any indication of an artist's real merit. But the fact that Vasari should have qualified Titian's achievement in this way, even slightly, seems out of character for the writer. For he was himself a painter, though not a very talented one, and one of his major obsessions, nowhere more clearly expressed than in his collection of artists'

biographies, was to enhance the social status of his profession. To the attainment of this goal no one had made a greater contribution than Titian, so the reasons for Vasari's reservations, and even for the trace of cynicism in this passage, need to be explained.

It is often suggested that his coolness towards Titian was due to chauvinism, but this is not entirely convincing. Although Vasari certainly did show a marked partiality towards his fellow Tuscans, some of the painters whom he most admired, for example Raphael and Parmigianino, came from other parts of Italy. In the case of Titian, then, there was evidently something in his work which Vasari found unsympathetic. This is most clearly indicated by the remark that he 'deserves to be loved and respected by artists, and in many ways to be admired and imitated'. In an earlier passage Vasari had been more explicit about the qualities in Titian's work which did not merit admiration or imitation. In particular, he criticized Titian for his failure to appreciate the importance of drawings, at one point quoting a remark made by Michelangelo about one of Titian's pictures, 'that he greatly liked its colouring and style, but that it was pity that in Venice painters did not learn how to draw well from the start and did not have a better method of study'. It was a criticism that involved more than mere technical competence and reflected a fundamental difference in attitude between Tuscan artists like Michelangelo and Vasari on the one hand and Venetians such as Titian on the other. Put in its simplest terms, for Tuscans the value of a picture lay primarily in the conception, as established in drawings, whereas Venetians were more preoccupied with the actual process of painting.

The shift in emphasis from conception to execution, which first occurred in Venice, is one of the decisive developments in European art. All those painters, from Velázquez and Rubens to the Impressionists and beyond, who exploited the particular characteristics of oil pigment to create a distinctive personal manner were in this respect heirs to the Venetian tradition, however much they may have owed in their figure-style and compositions to central Italian artists like Michelangelo and Raphael. In this development Titian played a crucial rôle, both because of his exceptional fame and because of the wide diffusion of his pictures at an early date. The way in which he achieved his remarkable status and the nature of his contribution to the emergence of the new attitude to painting in Venice form the subject of this book.

THE EARLY CAREER

Apart from short visits to Germany and to other parts of Italy, Titian spent the whole of his working life in Venice. This period coincided with the beginning of the long decline in Venetian political power and commercial prosperity, but until Titian's death in 1576 the effects of the process were scarcely apparent. Venice was still the richest and most stable state in Italy, the only major city of the peninsula which in the sixteenth century experienced neither a violent change of régime nor occupation by foreign troops. The unique conservatism and continuity of its social and political institutions, as well as its exceptional wealth, were not surprisingly reflected in a distinctive local tradition of painting, whose splendour rivalled even that of Florence.

Unfortunately we know much less about artistic life in Renaissance Venice than about the corresponding situation in Florence, mainly because the primary source of information is the work of Vasari, a Florentine, at least by adoption. But certain differences are nonetheless apparent. In the fifteenth century virtually all the major innovations in Italian art and architecture occurred in Tuscany, notably the invention of linear perspective, the mastery of the problems involved in the representation of the human figure, the assimilation of classical motifs and the development of new, non-religious genres. By the end of the century the major technical discoveries of the Florentine school had been adopted by Venetian artists, who had themselves contributed one decisive element to the evolution of Renaissance painting, the Flemish practice of working in oils, which gave their pictures an unprecedented brilliance of colour, luminosity and subtlety of modelling. But despite its technical excellence, Venetian painting was still in many respects less innovative than that of Florence. Pictures served two main functions, as decoration of public buildings and as images for private devotion, and they belonged to a few long-established and familiar genres: small compositions showing the Madonna and Child, altarpieces of sacre conversazioni, with an enthroned principal figure flanked by attendant saints in an architectural setting, and large, anecdotal, narrative scenes, full of picturesque, realistic detail. The production of such paintings was organized on a highly commercial basis, centred on a few important studios, usually family businesses, in particular those of Gentile and Giovanni Bellini, Carpaccio and Alvise Vivarini. But the competitiveness which characterized Florentine artistic life and the desire for innovation which this engendered seem to have been largely absent in Venice. At the same time, even though Venetian artists were treated as

10

TITIAN

gentlemen rather than as artisans, as Dürer was surprised to discover, no one seems to have considered that their work had any particular intellectual interest or importance. There was no Venetian equivalent to Leon Battista Alberti or Leonardo da Vinci, who were interested in theory as well as practice.

In the early years of the sixteenth century we find the first signs of a new attitude to works of art in Venice, with the appearance of a group of private collectors interested in paintings with a secular and seemingly sometimes abstruse subject-matter. Our knowledge of the activities of these collectors comes from a series of notes made in the 1520s and 1530s by a local connoisseur, Marcantonio Michiel. One of the artists most frequently mentioned by Michiel was Giorgione, who was also singled out by Vasari as having been primarily responsible for introducing the modern style of painting in to Venice, the rôle occupied in central Italy by Leonardo da Vinci. According to Vasari, Giorgione had a decisive influence on Titian at the outset of his career, so much so that contemporaries were sometimes unable to distinguish the work of the one from the other, a situation that has persisted to this day. Art historians still disagree about the attribution and dating of many important pictures, and, in more general terms, about the respective contributions of the two artists to the development of Venetian painting in the first years of the sixteenth century. In this chapter I shall not attempt to resolve all these issues, but merely indicate the major problems and suggest a basic outline for Titian's early career. Even for this period the historical sources are much more reliable and informative about him than they are about Giorgione, so it is through the work of Titian that our understanding of their relationship must primarily be determined.

Titian, or Tiziano Vecellio to give him his proper name, was born a Venetian subject in Pieve di Cadore, a small town in the Dolomites not far from Cortina d'Ampezzo. His family, which seems to have been relatively prosperous, played a prominent part in local affairs: both his father Gregorio and his brother Francesco, also a painter, often held administrative office. Titian himself always maintained close ties with his native town, where he owned property and participated in the timber trade in partnership with his brother. Since the name Tiziano had strong Vecellio family associations (their chapel was dedicated to San Tiziano) Titian was presumably the eldest son, and since it is known that he and Francesco went to Venice to train as painters when the latter was twelve, the implication is that he himself was then thirteen or even a little older.² This would have been a normal age at which to begin an apprenticeship. As far as his earlier education is concerned, it probably included little more than reading and writing. Most of his surviving letters, especially those to important patrons, were written for him by other people, and the very few autograph ones known to us reveal no trace of literary skill, even though they show a practised if unpolished hand. Titian certainly did not understand Latin,³ and there is no indication that he ever took much interest in intellectual matters not directly related to the art of painting.

The evidence about the date of his birth is contradictory and inconclusive. The traditional date of 1477 given from the early seventeenth century onwards is probably derived from a statement made in 1584 by a Florentine writer, Raffaello Borghini, who recorded that Titian was ninety-eight or ninety-nine at the time of his death in 1576. This is roughly consistent with the artist's own testimony, in a letter written to Philip II, King of Spain, in 1571, in which he gave his age as ninety-five, and also with various statements of Spanish ambassadors in Venice dating from the 1560s, that he was born sometime between 1474 and 1482. From this evidence, then, it would seem that towards the end of Titian's life there was considerable confusion about the precise date of his birth, but there was a consensus that it was within a few years of 1480. But a rather different conclusion emerges from the two contemporary accounts of Titian's early career, both which were almost certainly based on information provided by the artist himself. The first appeared in a fictional dialogue by his friend Lodovico Dolce called L'Aretino, published in 1557, and the second in Vasari's biography of 1568. According to Dolce, Titian was scarcely twenty when he worked with Giorgione on a series of frescoes on the exterior of the Fondaco dei Tedeschi, the warehouse of the German merchants in Venice. Since we know that Giorgione's contribution dates from 1508 this would mean that Titian was born about 1488. Vasari, for his part, indicated that Titian was about eighteen when he worked at the Fondaco, implying a date of birth around 1490. But to make matters still more complicated Vasari also stated elsewhere that Titian was born in 1480.

In this century most historians have adopted the later birth date of 1488–90 and have used it as a basis for reconstructing the chronology of Titian's early career. They have discounted his own statement to Philip II on the grounds that he was exaggerating his age in order to enlist the sympathy of the king, who had been slow in paying his debts to the artist. The argument seems rather far-fetched and it does not account for the comments of the Spanish ambassadors, who were presumably disinterested. This evidence, in fact, appears quite as worthy of credence as that of Dolce and Vasari, for even if Titian was their informant it is easy enough to see why he might have wanted to exaggerate the difference in age between himself

and Giorgione, who was certainly the principal innovator among Venetian painters during the first decade of the sixteenth century. Indeed, in at least one respect both of Titian's biographers gave a misleading impression of his precocity, since he was evidently older than they claimed when he arrived in Venice. In these circumstances it therefore seems unwarranted and even futile to try to draw any firm conclusions about his development from the available evidence concerning his date of birth.

Fortunately it is not necessary to do so, because there exists much more consistent evidence about the date of his emergence as an independent master. We learn from Dolce and Vasari that Titian was first trained in the studio of Gentile Bellini, but soon tired of his old-fashioned style and went to work with Bellini's more gifted brother Giovanni, then the most famous painter in Venice. Finally he transferred his allegiance to the much younger Giorgione, whose style he rapidly assimilated. According to Vasari this occurred in about 1507. In the following year, when Giorgione was painting the front façade of the Fondaco dei Tedeschi, Titian was allocated the less prominent side façade.4 Although it is often said that he merely acted as Giorgione's assistant on this project Vasari explicitly stated that he obtained the commission independently. In this instance, fortunately, Vasari's account can be corroborated by other evidence. The frescoes themselves have been almost entirely destroyed, but the surviving fragments show that the two artists used quite different techniques, which would be most unexpected if one was still the other's pupil. Moreover, the only surviving records of payment, to Giorgione, concern the front façade alone, whereas one would expect that the value of both façades would have been assessed at the same time had he been responsible for the entire project. By 1508, then, Titian already seems to have acquired a reputation sufficient to win him an important public commission. It is also significant that every writer who saw and discussed these frescoes stated that his contribution was better than that of Giorgione. In the words of an eighteenth-century critic, Zanetti, Titian gave his figures 'a greater liveliness'.

The most prominent feature of the frescoes was a series of life-size figures (Plate 1). Some represented young Venetian aristocrats, while one was apparently a portrait of a celebrated criminal and others were male and female nudes. The meaning of the decorative programme as a whole has never been adequately explained. On only one point is there a wide measure of agreement, namely that Titian's *Judith* (Plate 2) is actually a figure of Justice. This interpretation is most implausible. In fifteenth-century Venice, Justice was often shown with a sword and a decapitated head, but she was generally crowned, she sat decorously on a throne rather than on

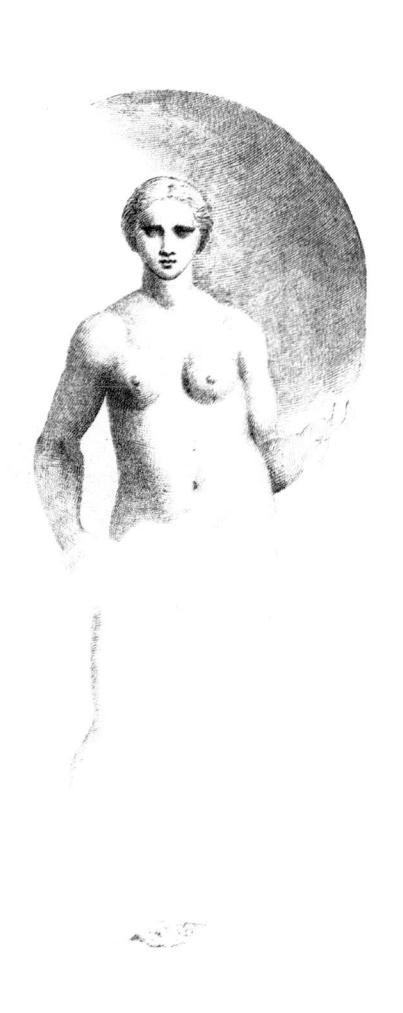

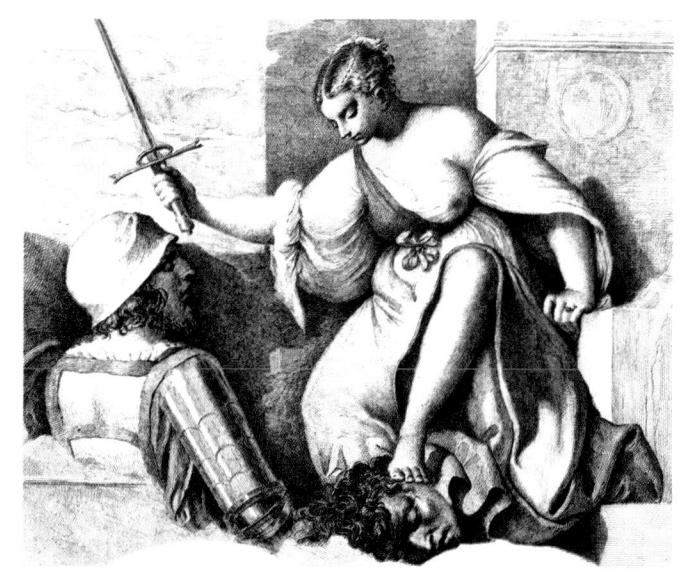

1 STANDING FEMALE NUDE (left)
Anton Maria Zanetti, after Giorgione
Engraving 25 x12 cm.
This engraving published in 1760, is a copy of a fresco painted in 1508 on the facade of the Fondaco dei Tedeschi, now in the Gallerie dell'Accademia in Venice.
The figure is approximately life-size.

2 Judith Anton Maria Zanetti, after Titian Engraving 26 x 21 cm. This engraving is after the fresco, now in the Gallerie dell'Accademia in Venice, which was formerly on the Fondaco dei Tedischi. The fresco was almost certainly painted in 1508; its dimensions are 212 x 345 cm.

a plain ledge and, most important of all, her clothing was never in disarray. In fact, as Dolce and Vasari recognized, Titian's figure has all the attributes of Judith. It is true that Vasari then discounted his identification, suggesting that since her companion was a German the woman must be Germania. His intuition that this fresco, painted above the main door, was a political allegory is sensible enough, but his interpretation is not, since the woman looks no more like Germania than Justice. Fortunately, with the premise that she is indeed Judith, it is possible to suggest an interpretation that would have been easily understood at the time the painting was executed. During the Renaissance Judith was not regarded as an embodiment of Justice; on the contrary, her special virtue was Fortitude.⁵ In Titian's fresco she is faced by a soldier, apparently a German, who was shown, according to an early engraving, holding a concealed weapon, which presumably characterized him as treacherous. In the Venice of 1508 such a composition would have had a precise political significance. Early in that year the Emperor Maximilian I, though proclaiming his

peaceful intentions, had invaded Venetian territory, only to be defeated at the Battle of Cadore. He then withdrew, but continued to pose a military threat. In this context a fresco showing an armed and treacherous German confronted by the formidable figure of Judith, who through her fortitude had saved her people from bondage, could scarcely be more obvious in its meaning or more appropriate to a Venetian government building used by German merchants.

Just because this composition had an allegorical content it does not follow that the same was true of the other frescoes on the Fondaco. As we have seen, Vasari recognized the need to provide an apposite interpretation for the *Judith*, but as far as the rest of the decoration was concerned he suggested that Giorgione, and by implication Titian too, 'had no thought except to paint figures according to his fancy, in order to display his art'. This comment has often been discounted, since historians of art are reluctant to believe that Renaissance painters would have been permitted such initiative in a public commission of this kind. But it is difficult to believe that in devising a programme a government official or literary adviser would have produced a scheme for which, so far as we know, there was no obvious precedent or one whose meaning was obscure. So there may be some truth in Vasari's remark. In particular, it seems likely that Giorgione and Titian would have been responsible for the prominence given to the nudes, the most novel element in the frescoes. To judge from engravings and written descriptions these figures were startlingly realistic, painted with an overt sensuality and a confident classicism unprecedented in Venetian art. They have often been compared, with some justification, to the slightly later *Ignudi* by Michelangelo on the ceiling of the Sistine Chapel.

Another work by Titian which Vasari dated to 1508 is the design for the woodcut of *The Triumph of Christ* (Plate 3). This shows a long procession, with patriarchs, prophets and sibyls preceding a triumphal car on which Christ sits enthroned, followed by a crowd of martyrs and other saints. Compared with earlier Venetian representations of such subjects, Titian's composition is much more vigorous and skilfully organized, with a greater sense of movement as well as a richer and more elegant repertoire of poses. It is an astonishingly ambitious and assured work. Perhaps the most surprising feature, and one particularly indicative of Titian's interests at this period, is the use of motifs taken from Michelangelo's cartoon for *The Battle of Cascina* (Plate 4), dating from 1504–06, of which the most prominent is the figure of the Good Thief carrying the Cross. Such an appreciation of the latest Florentine art was unparalleled in Venice at this time.

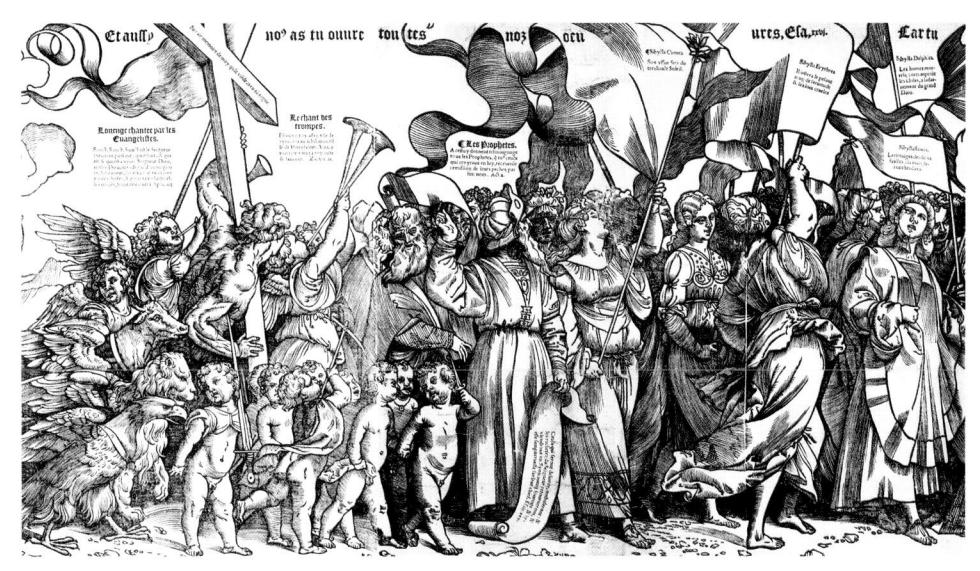

3 THE TRIUMPH OF CHRIST, detail Woodcut. Designed 1508. Height 38.5 cm.

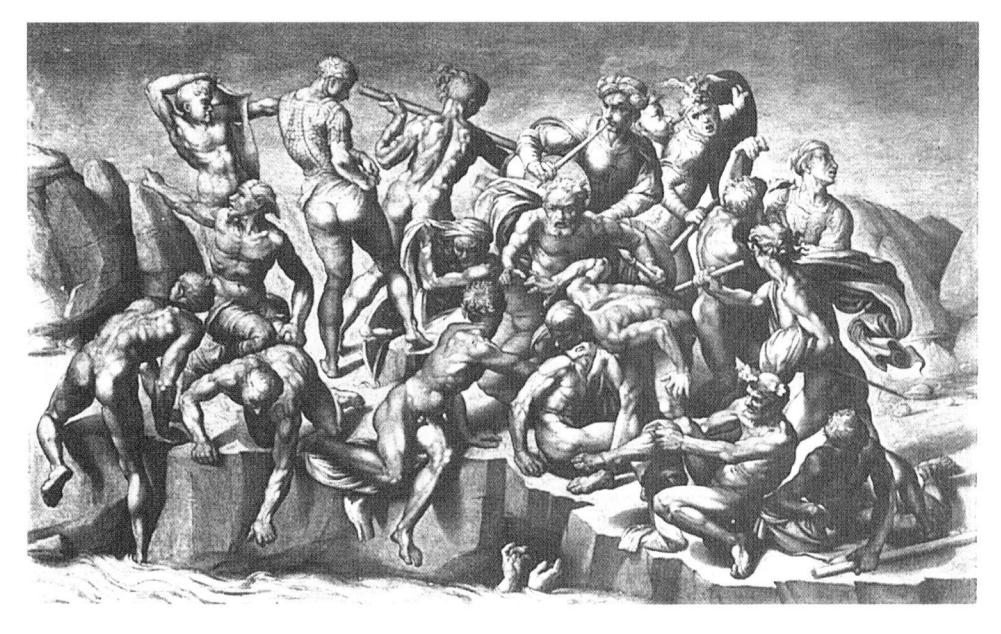

4 THE BATTLE OF CASCINA
Aristotile da Sangallo, after Michelangelo
Norfolk, Holkham Hall, collection of the Earl of Leicester.
Grisaille. This is a grisaille copy of the lost cartoon for the Palazzo Vecchio in Florence, which is datable to 1504-06.
The dimensions of the cartoon are not known.

The Fondaco frescoes and *The Triumph of Christ* established Titian, with Giorgione, at the forefront of the Italian painters of his day. But these works do not provide much evidence about his early pictures painted in oils. The obvious way of discovering what these looked like is to examine the works in this technique by Giorgione, which were apparently very similar in style to those of Titian. Unfortunately, Giorgione is one of the most mysterious figures in European art, and almost nothing is known about his life or personality. He died in the autumn of 1510 and he was born, according to Vasari, in 1477 or 1478. Apart from his frescoes on the Fondaco, none of his surviving work is securely documented, but three of his paintings can be identified from descriptions made by Marcantonio Michiel within a few years of Giorgione's death. These are the *Tempesta* (Venice, Gallerie dell' Accademia), *The Three Philosophers* (Plate 5)

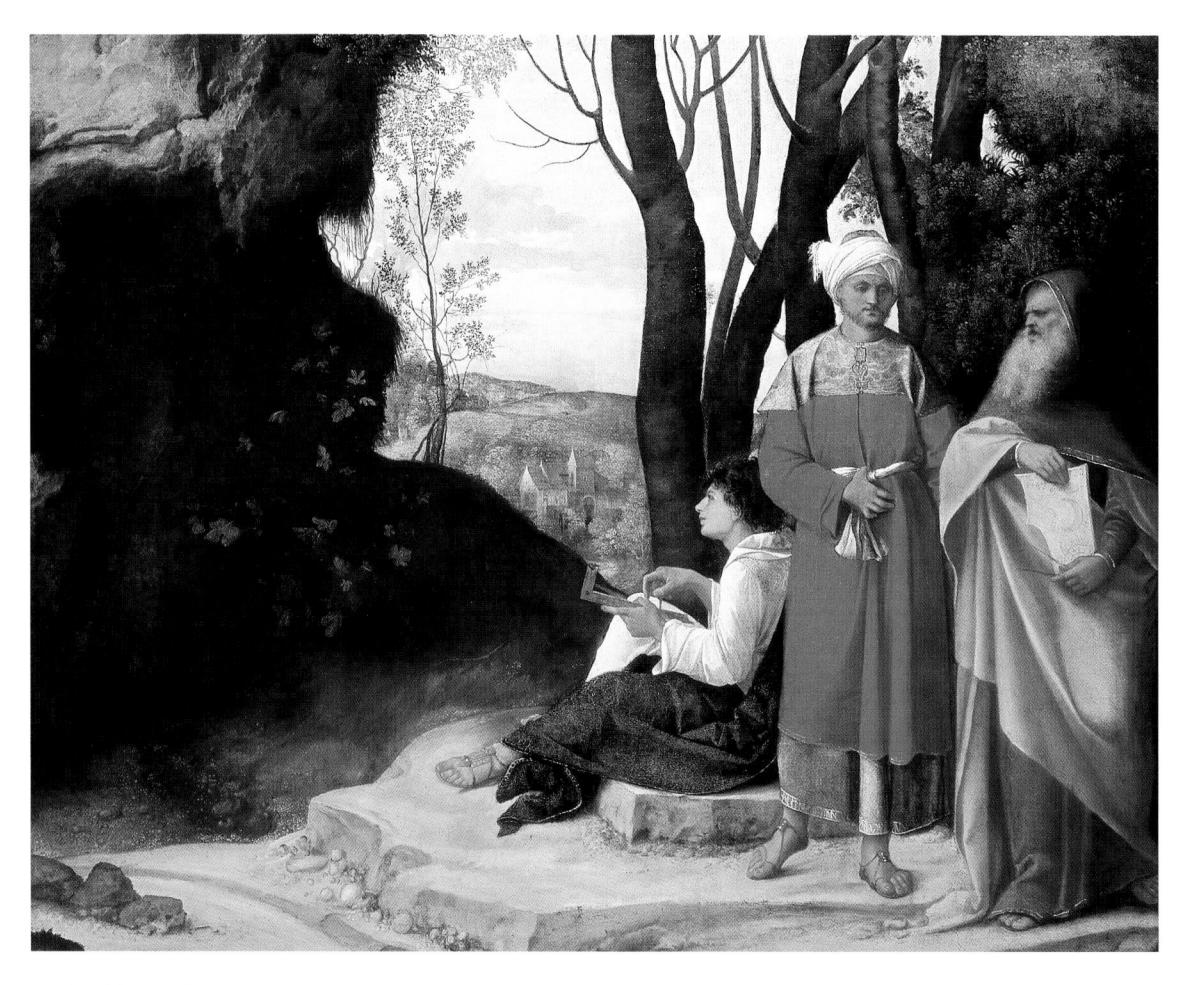

5 The Three Philosophers Giorgione, with assistance from Sebastiano del Piombo Vienna, Kunsthistorisches Museum. ε . 1508. Oil on canvas 123 x 144 cm.

THE EARLY CAREER

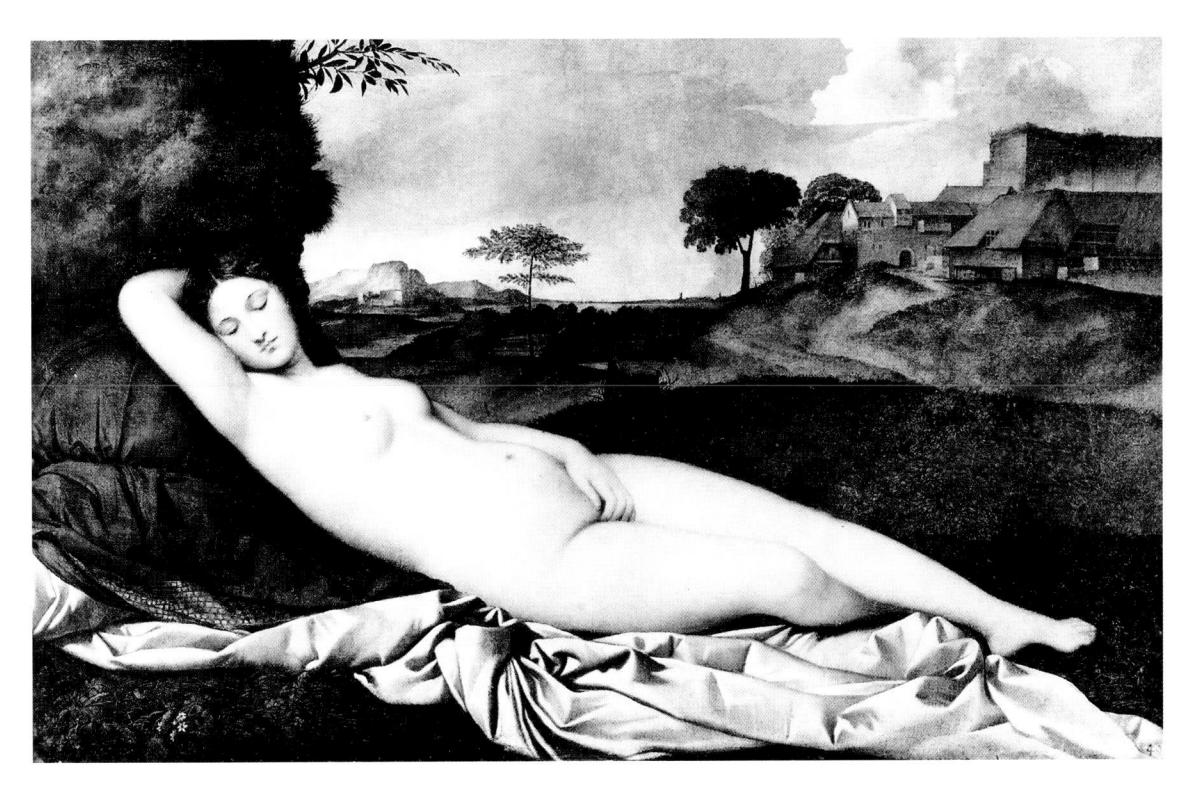

6 VENUS Giorgione, completed by Titian Dresden, Staatliche Gemäldegalerie. *c.*1510. Oil on canvas 108 x 175 cm.

and *Venus* (Plate 6). According to Michiel *Venus* was completed by Titian, who was responsible for part of the landscape and a figure of Cupid later painted out by a restorer. Since it is most unlikely that the two artists would have collaborated extensively on a small picture of this kind, the implication is that *Venus* was unfinished at Giorgione's death. To judge from the scale of the figures and the competence of the draughtsmanship *The Three Philosophers* would seem to be a slightly earlier work, probably of about 1508, and the *Tempesta* earlier still.

These three pictures are all painted in Giorgione's late style, which Vasari said had emerged around 1507. This involved the abandonment of the traditional Venetian practice of working out compositions fully in advance on paper and in very detailed underdrawings on the canvas or panel itself. Instead, Giorgione was prepared to modify his designs as he painted, and he relied on gradations of tone rather than on line as the principal means of describing form. As a result his later pictures have a new kind of spontaneity, softness of contour and subtlety of atmosphere. At the same time they reveal a novel preoccupation with landscape and secular subject-matter. Even in *The Three Philosophers*, which almost certainly shows the Magi awaiting

the appearance of the star, the religious content, conveyed principally by the fig tree and the ivy in front of the rock, both plants with symbolic associations, seems of only marginal significance. These paintings were intended for visually sophisticated private collectors, the kind of men who might also own Antique statues and imported works by Flemish artists: they were first and foremost works of art rather than devotional objects, and in this respect reflect an innovation no less momentous than Giorgione's new method of working.

There are many pictures which share these characteristics and which are usually attributed to either Giorgione or Titian, largely for want of an alternative candidate. Considering how little information survives concerning Venetian painting in general at this period, such an assumption seems unjustified. The question of authorship and date, in fact, can only be settled once a plausible chronology has been established for the undisputed works of the two artists. In the case of Titian, at least, this is a relatively straightforward matter, and it is the only one that need concern us here. Among his securely attributed works those that have most in common with the three pictures by Giorgione just discussed, both in technique and in the emphasis on landscape, are The Baptism of Christ (Plate 7), Noli Me Tangere (Plate 8) and The Three Ages of Man (Plate 9). The first is mentioned by Michiel, the last by Vasari, while the second is so similar to them both that its attribution is now universally accepted. Significantly, in the background of Noli Me Tangere there is a group of buildings which reappears almost unchanged in Giorgione's Venus, but in the section apparently executed by Titian. A clear development can be seen in this group of pictures, suggesting that they were produced over a period of at least a year, probably longer. The Three Ages of Man is surely the latest of the three: it is substantially larger than the others, more ambitious and more assured in the draughtsmanship and modelling. The earliest appears to be *The Baptism of Christ*, in which the recession of the landscape is awkwardly handled and the poses of the figures are insecure and timid. This picture also includes a portrait of the patron, Giovanni Ram, executed in a relatively tight, pedantic technique which still seems to recall Titian's apprenticeship with Giovanni Bellini.

Although it is generally recognized that these three paintings show the influence of Giorgione they are conventionally dated around 1512–13, that is to say substantially after Giorgione's death. There are three main reasons for this dating: first, the assumption that Titian was born about 1490 and achieved little of note on his own account before 1510; secondly, Vasari's reference to *The Three Ages of Man*, which he said had been painted after a supposed visit by Titian to Ferrara in or soon after 1514; thirdly, the fact that the works in question do not

THE EARLY CAREER

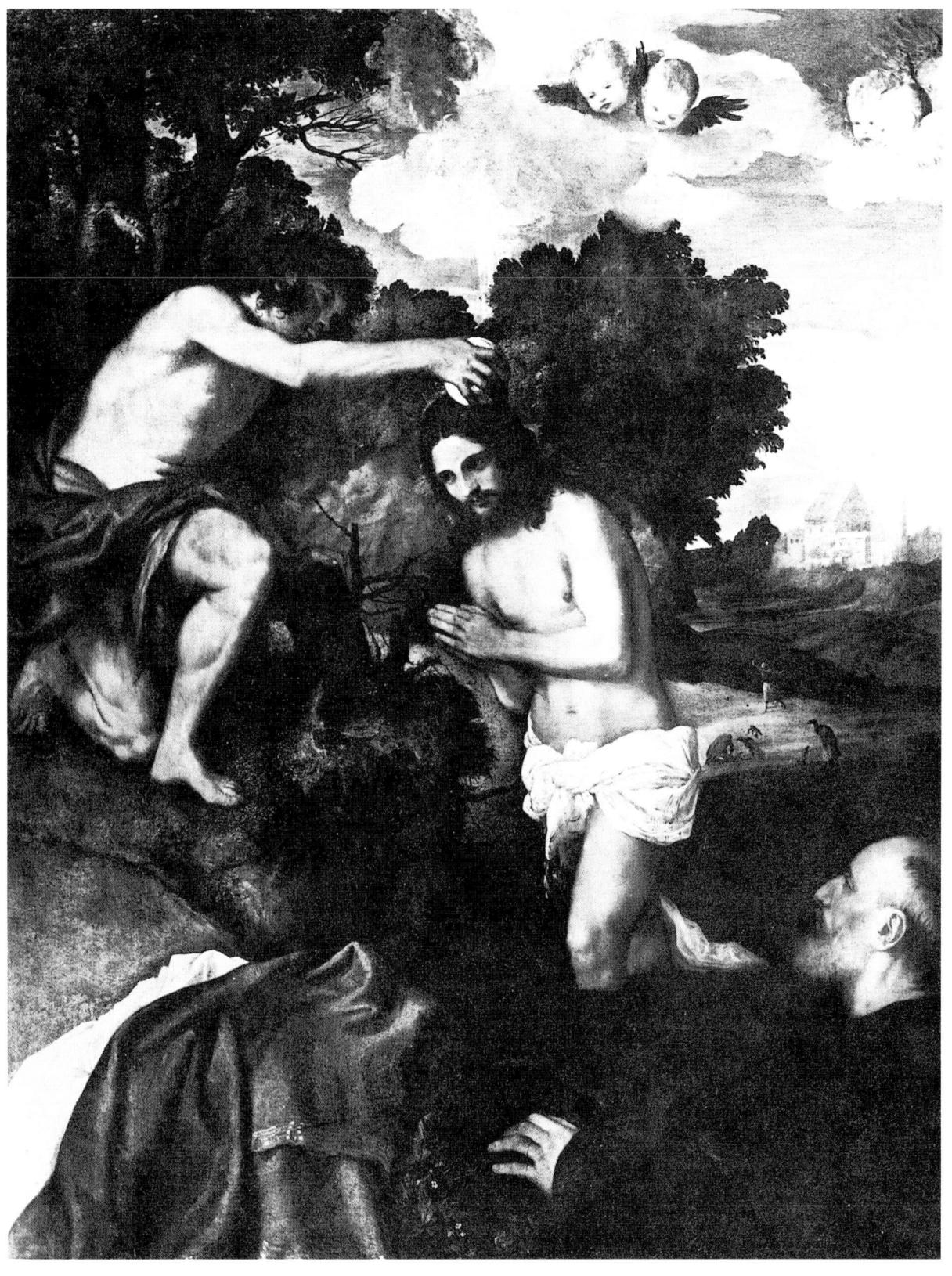

7 THE BAPTISM OF CHRIST Rome, Pinacoteca Capitolina. $\varepsilon.1507.$ Oil on canvas 115 x 89 cm.

have much in common with a group of the artist's pictures which are securely datable around 1511. As we have seen, the first of these arguments is not valid. In this instance Vasari's evidence, too, can be discounted. A close examination of his biography indicates that Titian had given him information mainly about the period up to 1510. His account of the artist's work in Ferrara, which is misleading in the extreme, is manifestly not derived from Titian himself, and the same is presumably true of his remarks about The Three Ages of Man. Here Vasari was simply recalling a picture he had seen twenty years before and remembering that it looked like a relatively early work. He was scrupulous enough as a historian to attach specific dates to works of art or events only when he had some evidence for his statements, a case in point being his reference to Titian's visit to Ferrara, which is based on a sensible, but mistaken deduction from the date on a painting there by Bellini. But otherwise, as in the case of *The Three Ages of Man*, he tended to mention pictures where they most readily fitted into his narrative, without any strict regard for accurate chronology. Nor do the stylistic considerations mentioned above necessarily indicate that the three paintings under discussion are later than 1511. Indeed, such a dating is open to one obvious objection, namely that it would imply that Titian had worked in Giorgione's idiom at two distinct periods, first in Giorgione's own lifetime and again some two years after his death. There is no evidence for this assumption, and it would suggest that Titian was surprisingly and quite uncharacteristically indecisive in this phase of his career. It seems more reasonable to suppose that the pictures in question were all painted while Giorgione was still alive, when Titian is known to have been strongly influenced by him. On this basis one might date The Baptism of Christ to 1507, on account of the reminiscences of Bellini, Noli Me Tangere about a year later and The Three Ages of Man around 1509. In terms of the increasing scale of the figures and the growing assurance of the draughtsmanship this chronology would parallel Giorgione's own development, apparently at the same period, from the Tempesta to Venus, exactly as one would expect in the case of two very gifted artists working in close contact with one another.

Noli Me Tangere was a very rare theme in Venetian art at this period and virtually unprecedented in a work of private devotion. But the Florentine artist Fra Bartolommeo, who visited Venice in the early summer of 1508, had painted just this subject about two years before, so it is tempting to suppose that it was he who gave Titian the idea. Although Fra Bartolommeo's earlier composition does not look much like Titian's, fresco of the subject which he painted in 1517 does, especially in the pose of the Magdalen. This would suggest that

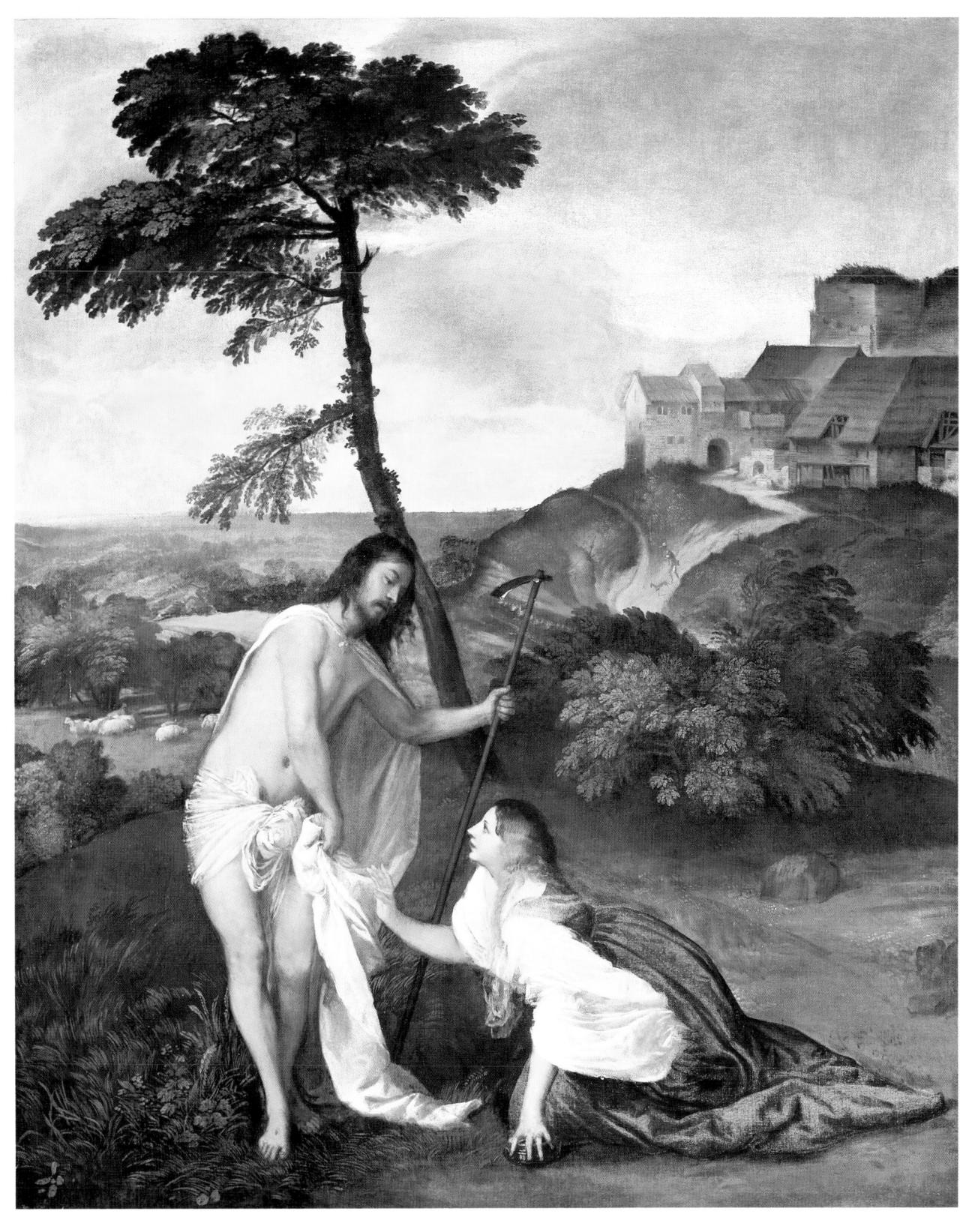

8 NOLI ME TANGERE London, National Gallery. c.1508. Oil on canvas 109 x 91 cm.

Titian's picture, at least in conception, may reflect some kind of collaboration between the two artists and that Fra Bartolommeo kept a sketch of it. As we shall see, there is good evidence of another collaboration of just this kind between Titian and Fra Bartolommeo a few years later. Moreover, quite apart from its subject Titian's Noli Me Tangere shows some distinctively Florentine features which can most easily be explained as reflecting Fra Bartolommeo's influence. The two figures form an unusually coherent group, as if they were designed as a single entity, the poses flowing together in a continuous movement which beautifully expresses the narrative content. This deceptively simple and marvellously eloquent invention was not achieved without effort. X-ray photographs show that Titian drastically modified his original design, developing his final solution directly on the canvas. In dispensing with elaborate preparatory drawings he was of course following the lead of Giorgione, but the changes which he made, the *pentimenti*, are more extensive than can be seen in any work of his teacher, though it must be remembered that X-rays only indicate patches of pigment left on the canvas, not those which the artist removed with a palette knife as he worked, so any oil painting could have been much more extensively revised than one might now suppose. Somewhat unexpectedly the closest parallel to Titian's method of developing a figure group by means of numerous pentimenti is to be found in the similar procedure, invented by Leonardo da Vinci, which Florentine artists had recently begun to use in drawings. From the available evidence Noli Me Tangere therefore seems to show a highly intelligent and original synthesis of the Florentine method of working out compositions and the Giorgionesque method of painting.

The masterpiece of this period in Titian's career, *The Three Ages of Man*, also reveals the influence of Florentine art. In its classical proportions and easy elegance of pose the depiction of the male nude was unprecedented in Venice, even, so far as one can tell, in the Fondaco frescoes. At first sight the subtlety of Titian's modelling and the skill with which he reproduced the texture of living flesh suggest that this figure was studied from life, but as it happens a very similar male nude appears in the right foreground of *The Battle of Cascina*. Since he had already used motifs from Michelangelo's cartoon in *The Triumph of Christ* the resemblance is unlikely to be merely fortuitous. Significantly, the one area in which Titian's draughtsmanship seems insecure, the left shoulder, corresponds precisely to the section of the figure which is obscured in the cartoon. That he should have used such a motif is not in itself very surprising; what is remarkable is that he should have incorporated it so successfully into an entirely different context. The figure is transformed with complete plausibility by Titian from Michelangelo.

THE EARLY CAREER

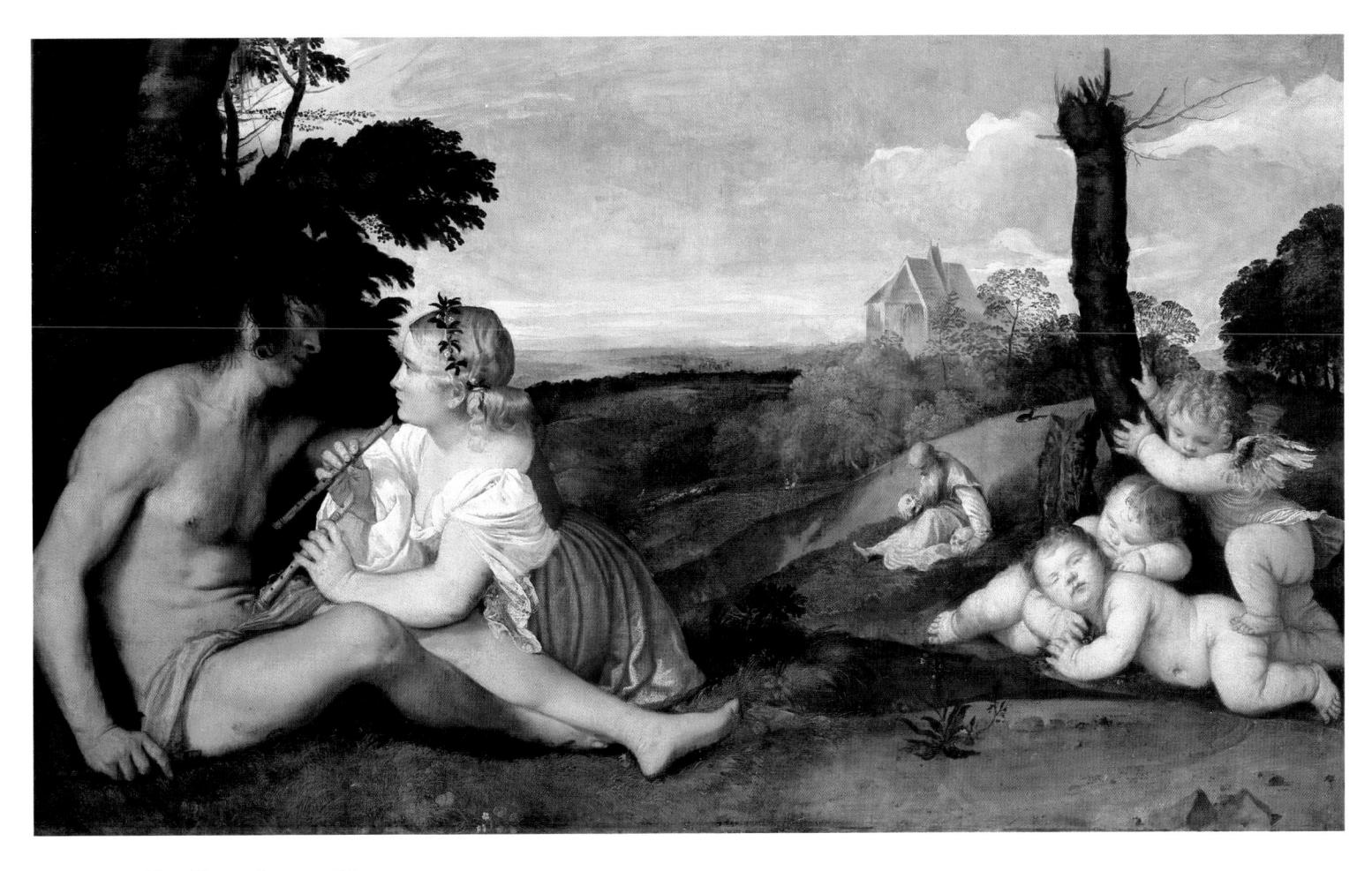

9 THE THREE AGES OF MAN Edinburgh, collection of the Duke of Sutherland, on loan to the National Gallery of Scotland. c.1509.Oil on canvas 90 x 151 cm.

Of all the paintings of this general type by Giorgione and his followers *The Three Ages of Man* is the least problematical in its iconography. Its theme is the transience not just of human life, but of physical love: the implication of the careful placing of the flute in the girl's left hand is unmistakable, as is that of the church in the background, clearly identified by its lancet windows. Such simplicity and clarity is characteristic of Titian throughout his career. Unlike many of his contemporaries, Vasari for example, he did not feel the need to fill his work with learned allusions to literary and philosophical texts, and as a result he is one of the Renaissance artists whose paintings are least in need of abstruse iconographical interpretation.

Probably slightly later than *The Three Ages of Man* is the so-called *Gipsy Madonna* (Plate 10) in Vienna. The attribution, which is now universally accepted, is confirmed by the fact that the distant

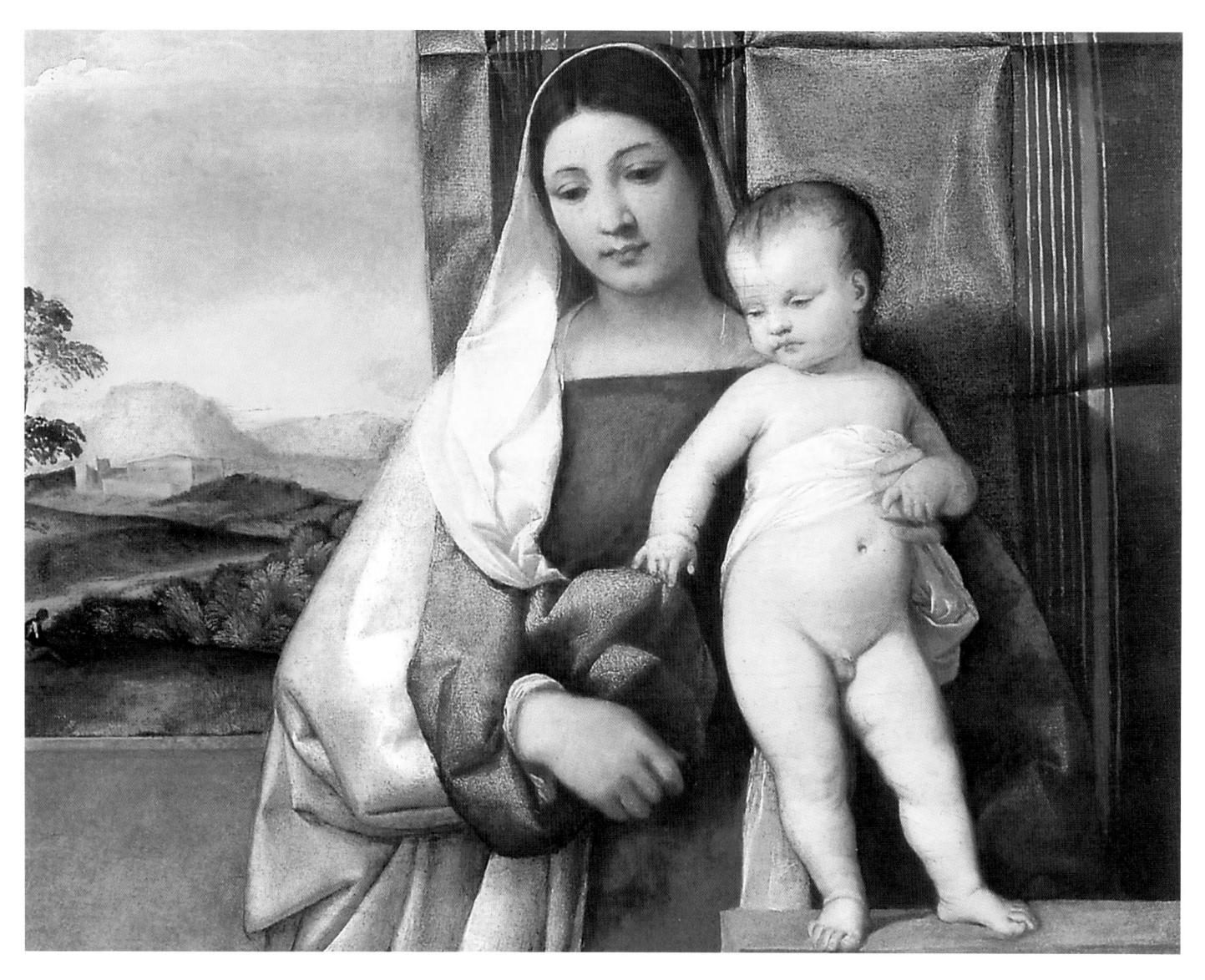

10 THE GIPSY MADONNA (MADONNA AND CHILD) Vienna, Kunsthistorisches Museum, c.1510. Oil on panel 66 x 84 cm.

landscape, like the group of buildings in *Noli Me Tangere*, was used again in the *Venus* which Titian completed after Giorgione's death. The composition is based on a *Madonna* (Detroit, Institute of Arts) by Giovanni Bellini, dated 1509, suggesting that the Vienna picture was painted soon afterwards. At first sight it might seem surprising that Titian should have used such a source, especially as his technique is entirely Giorgionesque. But Bellini was still the foremost painter in Venice, and he had made the theme of the Madonna and Child very much his own, so it was almost inevitable that Titian's treatment of this subject should have reflected his influence.

In terms of its style *The Gipsy Madonna* fits very well into Titian's development around 1509–10. As in the case of *Noli Me Tangere*, X-ray photographs show that during work on the panel he made considerable changes to his initial design. At first the drapery of both figures was more elaborate and fussy; the Madonna's facial features were smaller, as was her veil, which left her head silhouetted against the cloth of honour with a few locks of hair falling loosely at her neck, much like the girl in *The Three Ages of Man*; the child was looking in the opposite direction and his pose was more vigorous. In these respects the first version of the composition was thus closer in style to the three pictures which we have just examined. In the final design the individual forms are larger, the figures more idealized in type, more closely related in mood and their outline is greatly simplified. The effect of these changes is to create an impression of greater monumentality and calm. This is entirely appropriate, since much the same kind of stylistic characteristics appear in the work of other Venetian artists at just this period, notably in Giorgione's *Venus* and in the *Salome* by Giorgione's pupil Sebastiano del Piombo (Plate 11), both of which are datable to 1510. Even Bellini seems to have been developing in the same direction at this moment.

So far we have considered the pictures which Titian produced under the direct influence of Giorgione, since these can be identified and dated without undue difficulty. They provide a clear pattern of development from about 1507 to 1510. But before examining his career after this date we must briefly try to establish what he painted before he came into contact with Giorgione. His early biographers are not very informative on the subject, merely indicating that he was trained first by Gentile and then by Giovanni Bellini. In these circumstances one would not necessarily expect to be able to identify Titian's work of this earlier period, since apprentices were taught to work entirely in the idiom of their teacher, and they did not receive independent commissions. However, there is one painting which Titian appears to have produced after leaving Giovanni Bellini's studio, but which is still in no way Giorgionesque. This is Jacopo Pesaro Presented to St Peter by Pope Alexander VI (Plate 12); the attribution to Titian is confirmed by an old inscription.

Jacopo Pesaro, a Venetian aristocrat, was Bishop of Paphos in Cyprus. In 1502 Pope Alexander VI appointed him admiral of the papal fleet and shortly afterwards he won an important victory against the Turks. Titian's picture, which shows Pesaro accompanied by the pope offering his standard to St Peter, commemorates this victory. The classical relief beneath St Peter's throne presumably alludes to the triumph of Christianity over paganism and

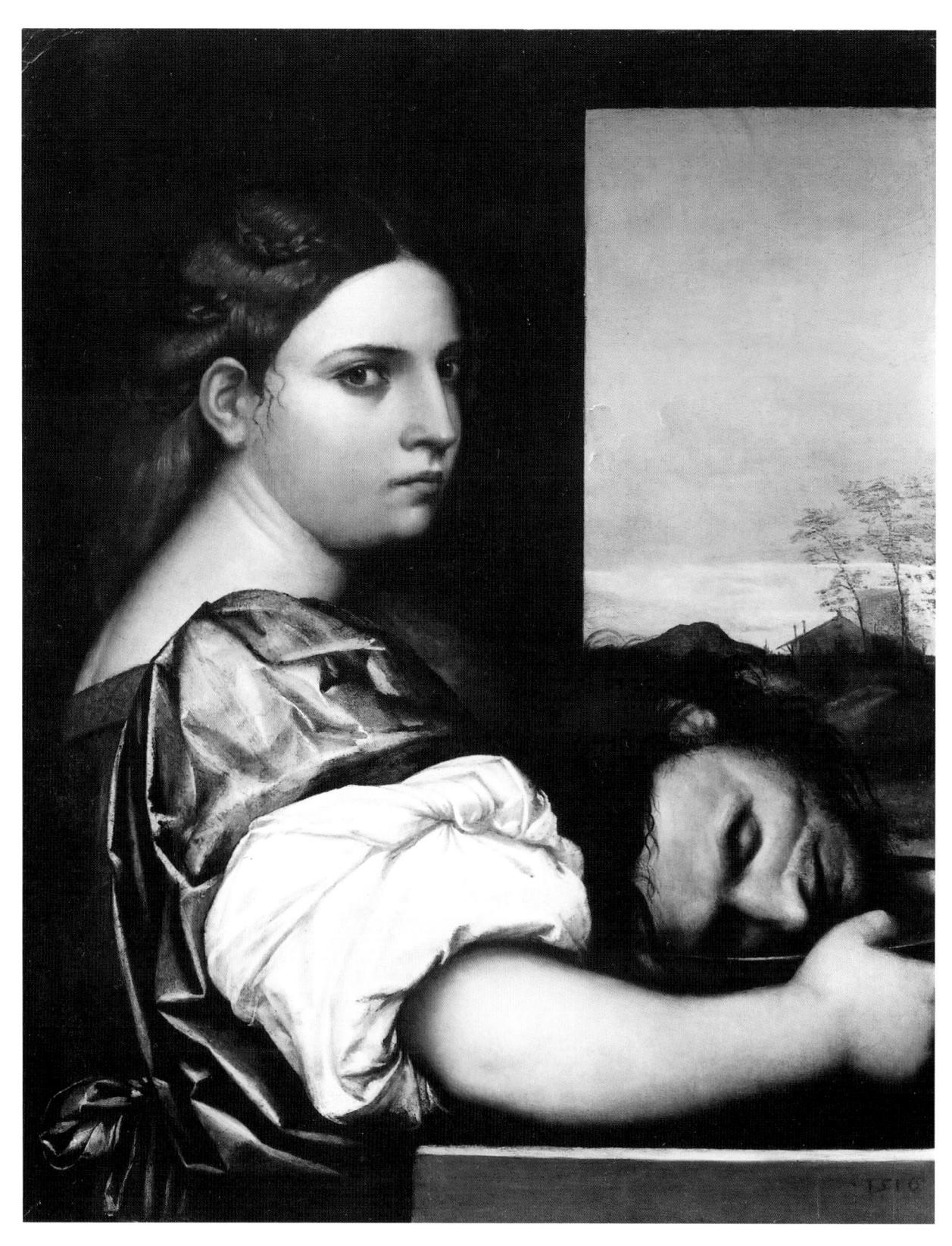

11 SALOME Sebastiano del Piombo London, National Gallery. Dated 1510. Oil on panel 55 x 44 cm.

THE EARLY CAREER

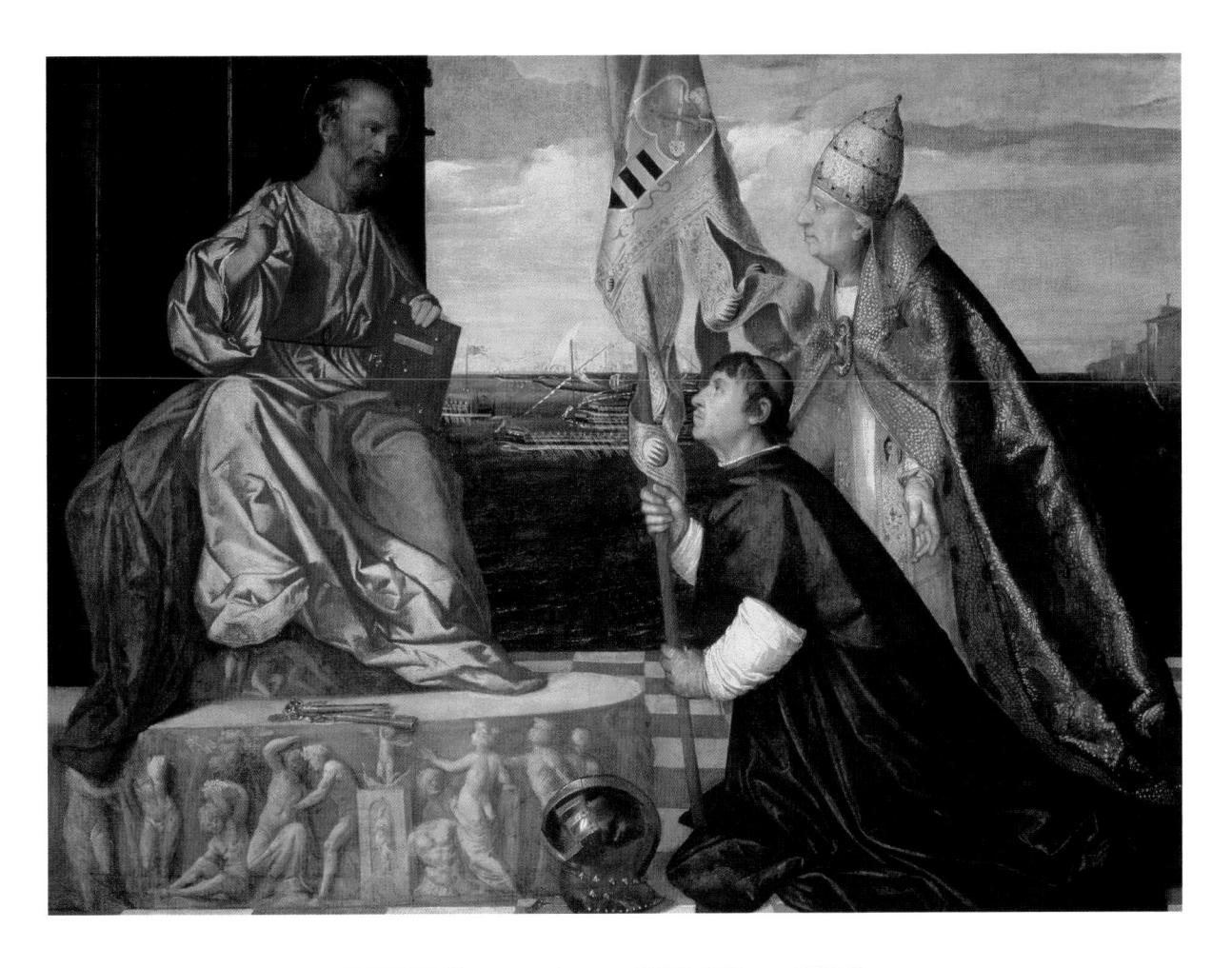

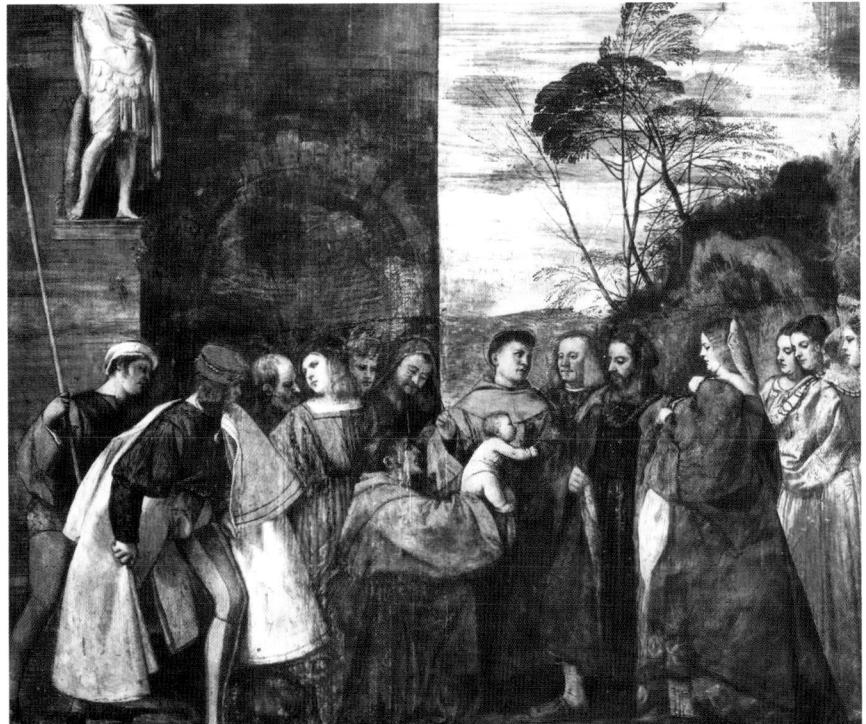

12 JACOPO PESARO PRESENTED TO ST PETER (above)

Antwerp, Koninklijk Museum voor Schone Kunsten.1506.

Oil on canvas 145 x 184 cm.

Inscribed: RITRATTO DI VNO DI CA" PESARO
IN VENETLA CHE FV FATTO GENERALE
DI S" CHIESA, TITLANO F.

13 THE MIRACLE OF THE NEW-BORN CHILD Padua, Scuola di Sant'Antonio. 1511. Fresco 320 x 315 cm.

probably also to Pesaro's bishopric in Cyprus, the island of Venus. Since Alexander is shown standing in the presence of St Peter it is likely that the picture postdates his death in 1503; but one would not expect that a commission of this kind would have been given very long after the event with which it was associated. After his departure at the beginning of 1503 Pesaro is not known to have been in Venice again until 1506,⁸ a plausible date for the picture, especially as the head of St Peter is similar in its modelling and in the rendering of the hair to the portrait of Giovanni Ram in *The Baptism of Christ*. This picture in Antwerp, in fact, appears to be the earliest identifiable work by Titian, suggesting that unless he was exceptionally precocious he was born in the mid-1480s. How he came to receive a commission of such importance apparently at the outset of his career is not known, but it was possibly through the mediation of a minor humanist, Jacopo di Porcia, who was acquainted both with Pesaro and with one of the artist's cousins.⁹

The composition follows the standard Venetian formula for subjects of this kind, but Titian's lack of experience is evident in various ways. The perspective of the pavement is not quite correct and Jacopo Pesaro and the pope both seem curiously flat. Indeed, the whole treatment of space here is tentative. There is also a certain pedantry in the rendering of detail, notably in Alexander's cope. One of the most remarkable features of the picture is the relief, which is a brilliant evocation of the style of classical sculpture even though it is entirely Titian's own invention. It is often suggested that the freedom of handling in this section reflects the work of Giorgione, but this is not necessarily so. On occasion even Bellini used an unusually open type of brushwork in such sculptural details, so Titian may have evolved his solution to this particular problem of representation quite independently. Despite its shortcomings, the picture as a whole is an outstanding achievement for a young and inexperienced painter. In the competence with which he handled a composition of this scale and in his use of chiaroscuro Titian already showed himself in this work to be the equal of any artist then active in Venice apart from Giovanni Bellini.

We must now consider the pictures which he produced after the death of Giorgione. Following the Fondaco frescoes, his first known large-scale works are three frescoes in the Scuola di Sant'Antonio in Padua, painted in twenty-seven working days in the early summer of 1511. These are his earliest documented paintings. They were commissioned by a lay

confraternity and illustrate miracles of St Anthony of Padua. Titian was probably assisted here by his brother, but Francesco, whose commitment to his career never seems to have been very strong and who shortly afterwards became a soldier, and have had little if anything to do with the actual execution of the frescoes. The handling is absolutely consistent, and it shows a fluency and sureness of touch characteristic of Titian himself.

The largest and, as the list of payments indicates, earliest of these frescoes is The Miracle of the New-born Child (Plate 13), which shows St Anthony giving a baby the power of speech so that it could testify to its legitimacy. It marks a turning point in Venetian narrative painting. Compared with the works of the Bellini brothers or their follower Carpaccio, or even with Jacopo Pesaro Presented to St Peter, the composition is unprecedented in its monumentality, economy of detail and sense of movement; the figures are larger in proportion to the picture space, the poses more varied and lifelike, the drapery, as in The Gipsy Madonna, heavier and simpler, forming a pattern of bold areas of unbroken colour, and space is defined not by the use of perspective but by a subtle play of light and shade. Although this fresco must have seemed astonishingly realistic to Titian's contemporaries it would be a mistake to see his new style merely in terms of increased naturalism. The composition is based on one of Giotto's frescoes in the Arena Chapel in Padua, while the arrangement of the figures, with soldiers at the left and women at the right, and the frieze-like format owe something to two earlier versions of the same subject in the nearby Basilica del Santo, namely the bronze relief by Donatello and the marble relief by Antonio Lombardo. Here, as so often before, Titian's innovations depended on a synthesis of the achievements of other artists. Similarly the beautiful group of three women at the right reflects an earlier work of art, but in this case the borrowing was probably meant to be recognized. This detail is a free adaptation, treated in a livelier and more informal way, of the group of three female saints in a sacra conversazione by Sebastiano del Piombo in the Church of San Giovanni Cristostomo in Venice, which had been painted at the earliest only months before. It looks as if Titian was deliberately trying to improve on Sebastiano's invention, just as Sebastiano in turn had based his composition on a rather stiff group in an altarpiece (Venice, Gallerie dell' Accademia) completed by Carpaccio in 1510. This kind of artistic rivalry, probably never before so intense or overt in Venice, must have been a major factor in the rapid development of Venetian painting at this period.

One of Titian's two smaller frescoes in Padua, *The Miracle of the Jealous Husband* (Plate 14), includes a more unexpected borrowing. The dying woman on the ground, who was later restored to life by St Anthony, is based on the figure of Eve in Michelangelo's fresco of *The Fall of Man* on the ceiling of the Sistine Chapel. How Titian could have known about this

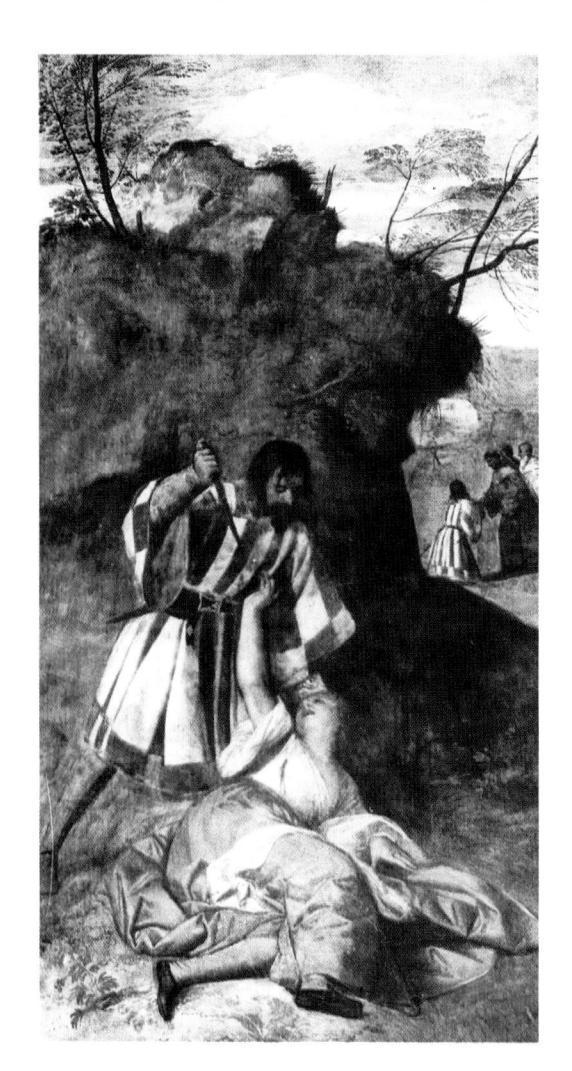

composition is something of a mystery, since it was not as yet generally accessible to the public; presumably he had somehow managed to see a drawing. It must be admitted that the combination of this motif and the more stiffly posed husband is slightly awkward, but it indicates yet again that Titian's primary concern at this moment was not to achieve a greater degree of realism, but to modernize his style inaccordance with the latest developments in central Italian art.

Probably soon after his return from Padua Titian began an altarpiece for the Monastery of Santo Spirito in Isola, showing *St Mark Enthroned with St Cosmas, St Damian, St Roch and St Sebastian* (Plate 15). Mark is the patron saint of Venice, and it has long been recognized that the commission must have been connected with an outbreak of plague in the city, since the protection of Sebastian and Roch was commonly invoked against the disease, while Cosmas and Damian are the patron saints of physicians. This provides an indication of the date of the altarpiece. Venice was seldom entirely free of the plague for long, but it generally manifested itself in few isolated cases, only occasionally developing into a genuine epidemic. After a lull of

three years the disease claimed a handful of victims in the second half of 1509 and then a slightly larger number, among them Giorgione, in the autumn of 1510. In 1511 a few cases were reported in the spring, but in the late summer and autumn the plague made serious headway, this time accompanied by a fever which was even more deadly. On this occasion, for the first time, there was scarcely any respite in the winter, the epidemic persisting almost continuously throughout 1512 and recurring, with diminishing intensity, during the summer months of the following two years. This implies that Titian's altarpiece does not commemorate the end of the epidemic, as is usually supposed, since it was certainly not painted as late as 1515. Rather, it

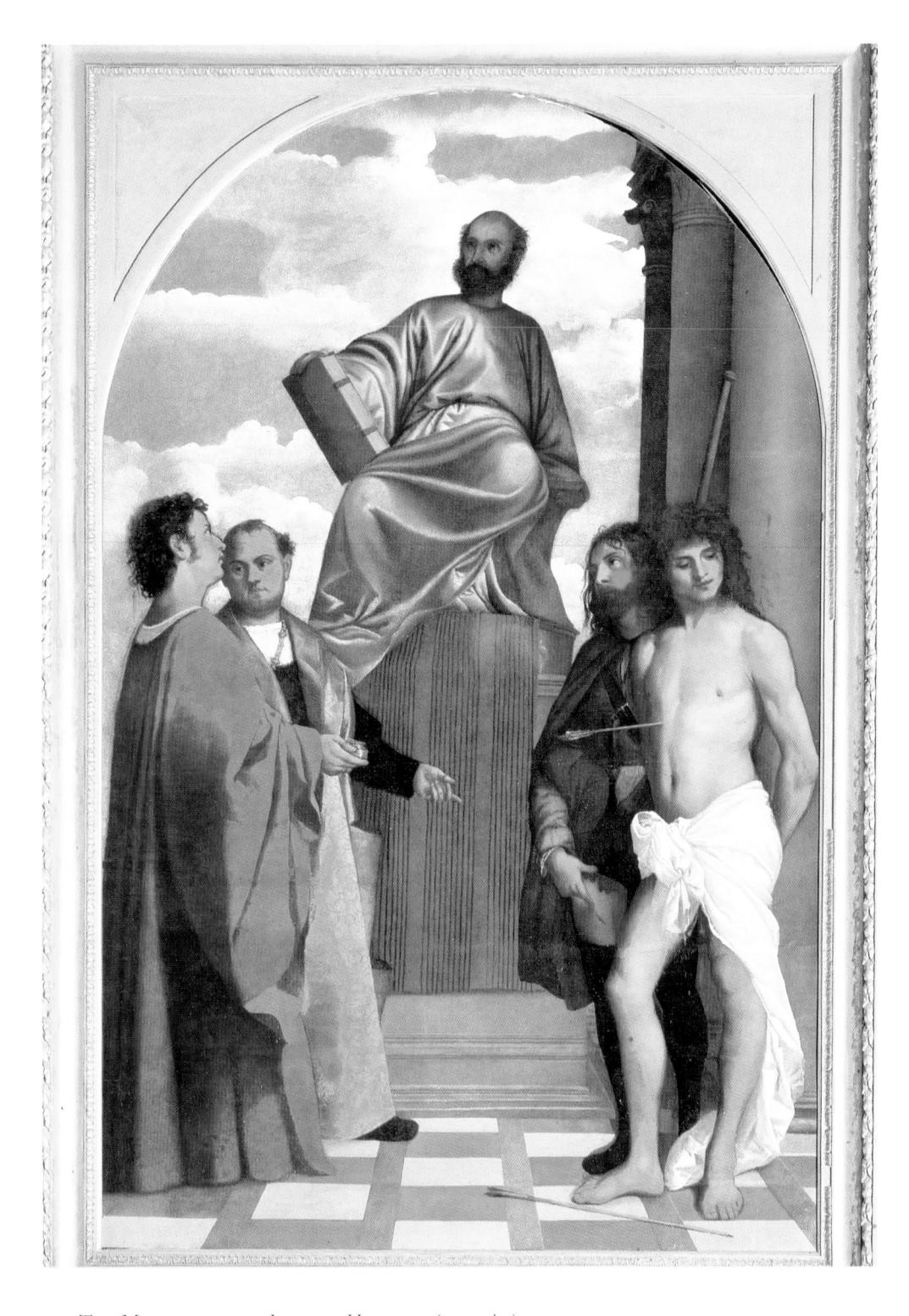

14 THE MIRACLE OF THE JEALOUS HUSBAND (opposite) Padua, Scuola di Sant'Antonio. 1511. Fresco 327 x 183 cm.

15 ST MARK ENTHRONED WITH ST COSMAS, ST DAMIAN, ST ROCH AND ST SEBASTIAN (above) Venice, Church of Santa Maria della Salute (formerly in Venice, Monastery of Santo Spirito in Isola). α 1512. Oil on panel 230 x 149 cm.

certainly not painted as late as 1515. Rather, it painted as late as 1515. Rather, it would seem to date from a period when the plague was at its height, and when there seemed no prospect of relief, which would explain why St Mark's head is in deep shadow.¹⁴ This implies that the commission was probably given to Titian in the second half of 1511 or in 1512, a plausible enough dating given the obvious parallels in drapery and figure style to the Padua frescoes.

This dating would also be appropriate in the context of other Venetian alter-pieces. Sebastiano had just introduced an asymmetrical architectural background and a similar type of dramatic lighting in the picture in San Giovanni Cristostomo, which must have been completed before his departure for Rome in the summer of 1511. His innovations seem to be reflected in Titian's picture, and the extreme simplicity of the setting in which landscape is, almost for the first time, totally eliminated, as well as the obvious virtuosity of the representation of St Sebastian, a virtuosity which is more marked than in the male nude in Sebastiano's altar-piece, confirm that Titian's *St Mark Enthroned* is the later of the two. As a recent restoration has revealed, it is also very different in technique, with a more brilliant range of colour and a much livelier type of handling. At the same time, the exceptional scale of the figures in relation to the area of the picture, the clarity of the spatial organization and the marvellously lifelike depiction of the nude figure make this altarpiece the most fully realized example of High Renaissance painting that had so far been seen in Venice.

Another aspect of Titian's activity in the period from about 1510 to 1512 is illustrated in two paintings in London, *Portrait of a Woman* (Plate 16) and the *The Man with a Blue Sleeve* (Plate 17). According to Vasari, Titian had already produced at least one notable portrait before he worked at the Fondaco, but none of his pictures of this type from the first decade of the century can be securely identified. *The Man with a Blue Sleeve* was certainly executed no later than 1512, since the composition was used in that year by another, much less accomplished, artist in a portrait now in St Petersburg. Equally, it can hardly date earlier than about 1510: although it follows the standard Venetian portrait formula of a parapet and a plain background, used by both Giovanni Bellini and Giorgione, few portraits produced in Venice in the first decade of the century had shown so much of the sitter's body and none had achieved the combination of monumentality and repose so beautifully conveyed by Titian's simple pyramidal composition. A dating in or about 1511 would also fit well into the pattern of his development, since the plain outline of the figure recalls the innovations of the final design of *The Gipsy Madonna*, while the use of strong chiaroscuro can be paralleled in *St Mark Enthroned*.

16 PORTRAIT OF A WOMAN (LA SCHIAVONA) London, National Gallery. c.1511. Oil on canvas 118 x 97 cm.

But there is nothing in Titian's work up to this time that can be compared with the most conspicuous feature of the picture, the blue sleeve itself. This is a *tour de force* of illusionistic painting, and the effect of *trompe l'oeil* is enhanced by the fact that the sleeve projects beyond the parapet which normally defines the picture plane. Titian's display of virtuosity brings to mind a whole series of famous anecdotes recounted by Pliny about the great artists of Antiquity, who are said to have delighted in just this kind of illusionism. If he was trying to emulate their achievements, as may well have been the case, this would be entirely consistent with the recent suggestion that *The Man with a Blue Sleeve* is a self-portrait. In painting himself Titian would thus have been proclaiming his artistic credentials, as well as his aspirations.

The *Portrait of a Woman* appears to be of about the same date: the sitter probably served as the model for the mother in *The Miracle of the New-born Child*. She is portrayed here with the same intimacy and directness as *The Man with a Blue Sleeve*, and in both pictures equal prominence is given to colourful and ostentatious costume. Fashions in portraiture are particularly responsive to the tastes of patrons, and such characteristics do not appear in Venetian portraits much before this date. To judge from these and other early portraits by Titian, his clientele was predominantly young; their clothes were of a fashion which the older generation is known to have found objectionable. The new art, in fact, had a special appeal for a new and unconventional young public. But this does not mean that Titian's clients were unsophisticated. Indeed, the interpretation just proposed for *The Man with a Blue Sleeve* suggests exactly the opposite. In the same way, the curious feature of the head in profile on the parapet in the *Portrait of a Woman*, which was added as an afterthought, is probably an allusion to the controversy about the relative merits, or *paragone*, of painting and sculpture, one of the commonest themes of Renaissance criticism. The implication here, of course, is that painting is more the lifelike art.

Another work which Titian must have produced soon after the death of Giorgione is the marvellous *Salome* (Plate 18). It is obviously based on Sebastiano del Piombo's version of the same subject, dated 1510 (Plate 11). But Titian's design is more complex, without Sebastiano's rather rigid framework of horizontal and vertical axes, once again demonstrating the rivalry that existed between the two artists. In technique it is close to the two portraits just discussed, especially in the head of the Baptist, which is painted in much the same way as that of *The Man with a Blue Sleeve*. Another indication of the dating is provided by Titian's choice of model for
THE EARLY CAREER

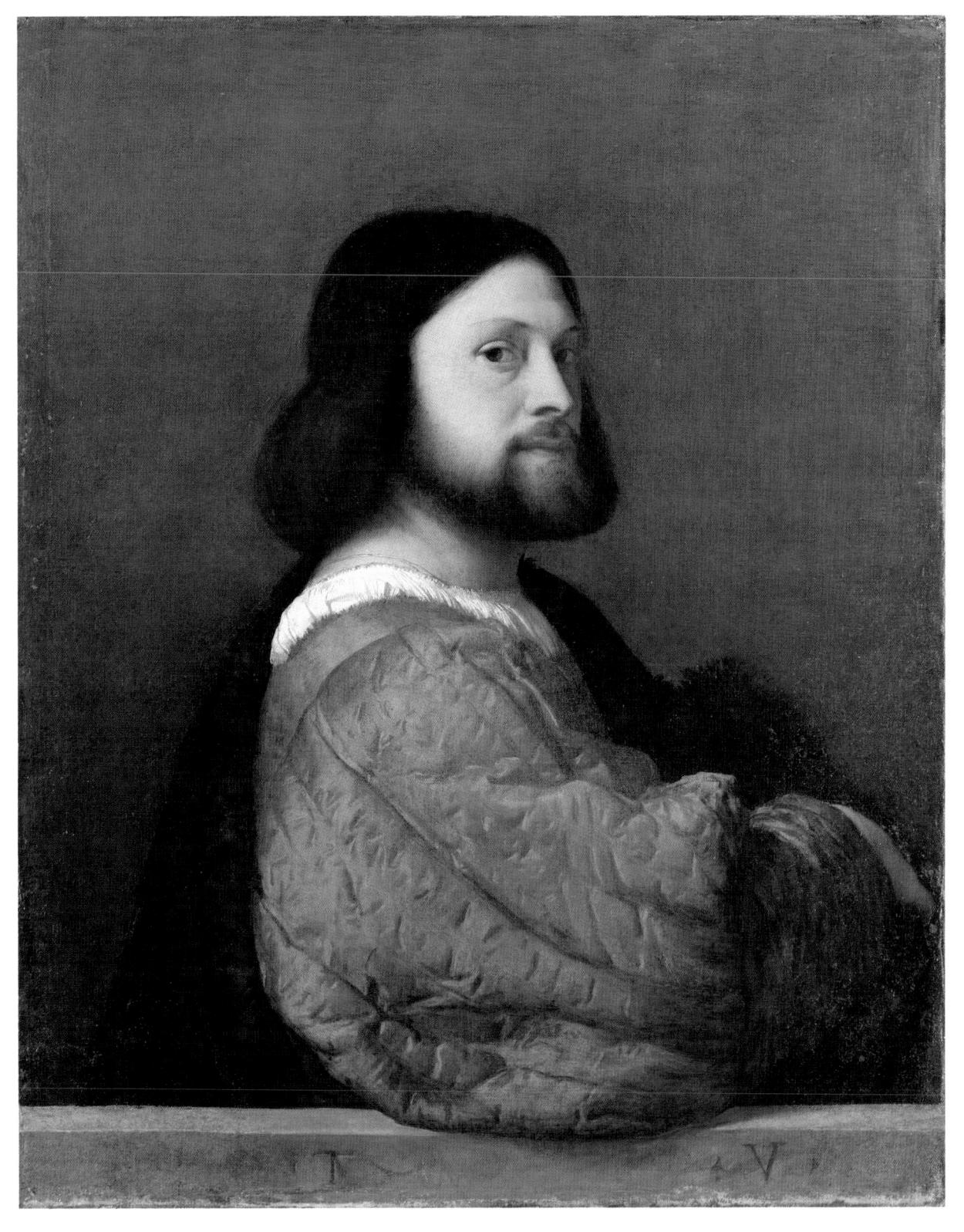

17 THE MAN WITH A BLUE SLEEVE London, National Gallery. & 1511. Oil on canvas 81 x 66 cm. *Inscribed: T.V.*

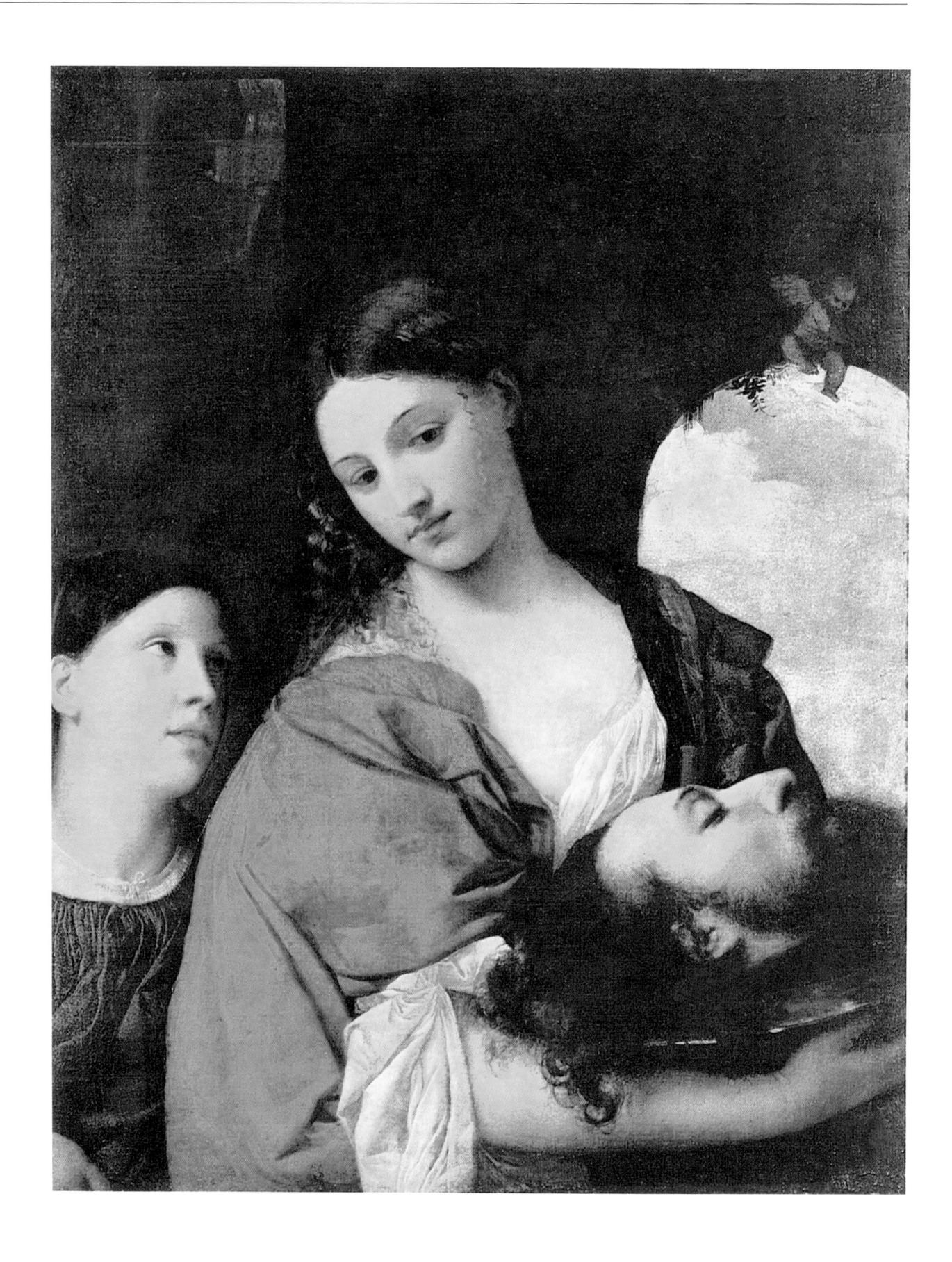

THE EARLY CAREER

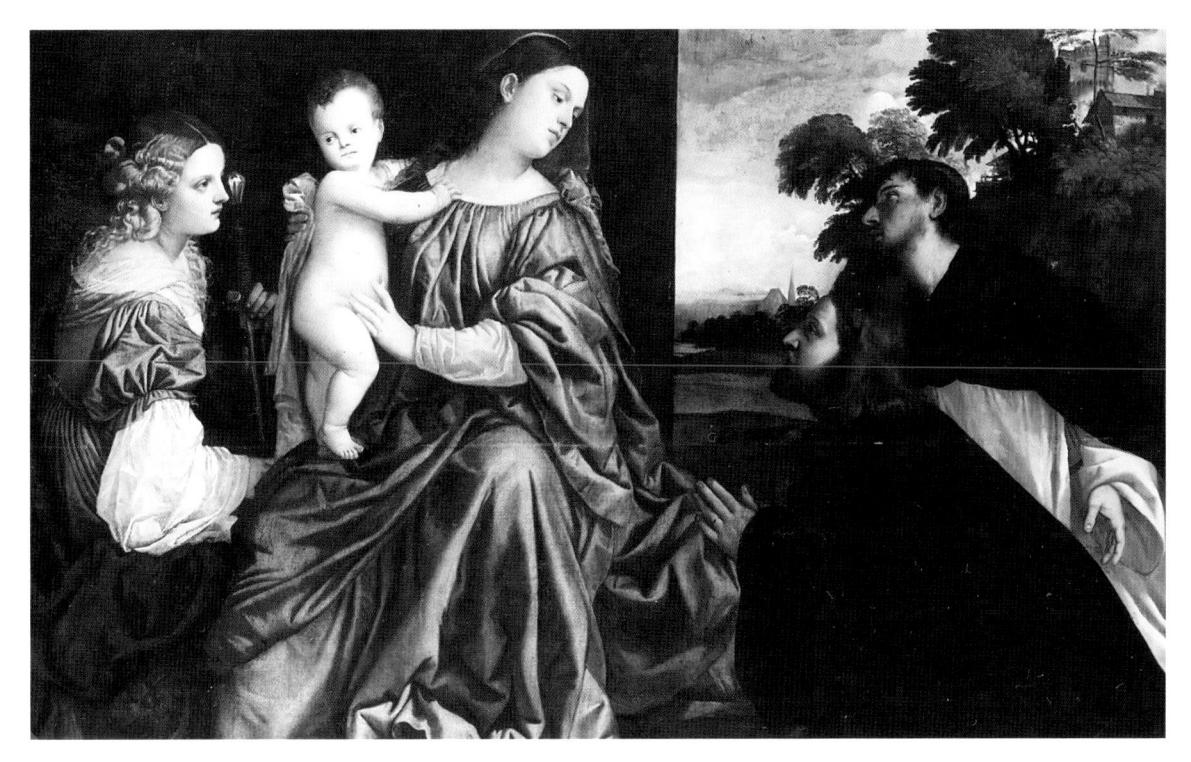

18 SALOME (opposite) Rome, Galleria Doria-Pamphili. £1511. Oil on canvas 90 x 72 cm.

19 MADONNA AND CHILD WITH ST CATHERINE OF ALEXANDRIA, ST DOMINIC AND A DONOR (above) La Gaida (Reggio Emilia), private collection. £1513. Oil on canvas 138 x 185 cm.

the figure of Salome: she is of a type which does not occur elsewhere in his work and seems to be the girl whom Giorgione used for his *Venus*. This is in a sense appropriate, because the theme of Titian's picture is also erotic. As Erwin Panofsky was the first to observe, the legend that Salome was in love with John the Baptist was already current well before Titian's time. Its relevance in this instance is confirmed not only by the unobtrusive presence of Cupid in the background, but also by a detail such as the hair of St John brushing against Salome's naked arm. As we have seen, this kind of secularization of an ostensibly religious subject probably first occurred in Venetian painting in the work of Giorgione.

By about 1512 Titian had created a personal style in which the diverse influences of Giovanni Bellini, Giorgione and the Florentine High Renaissance had been fully assimilated. There was no longer any trace of insecurity in his draughtsmanship; his compositions, notably that of the *Salome*, had a masterly fluency and coherence; and his skill in the use of oil paint was unsurpassed by any artist in Italy. All these qualities are evident in the *Madonna and Child with St*

Catherine of Alexandria, St Dominic and a Donor (Plate 19), which probably dates from about 1513. The basic form of the composition is that of Jacopo Pesaro Presented to St Peter, but handled here with much greater assurance: the figures are larger and less static, the mood more elevated, the modelling more continuous and the pedantic concentration on detail entirely eliminated (Plate 16). The same kind of stylistic evolution can be seen if one compares a passage such as the head of St Catherine with that of the girl in The Three Ages of Man, or the Madonna and Child with The Gipsy Madonna. But in one respect Titian diverged here from the pattern of development that had led to St Mark Enthroned, namely in the drapery, which is no longer simplified but is disposed in a complex display of sumptuous folds. This change, however, had already been anticipated in his smaller pictures such as Salome. Having learnt to combine richness of surface with strength of form on a small scale, he was now able to do the same thing in a much larger and more elaborate composition.

The secular counterpart of the Reggio *Madonna* is the so-called *Sacred and Profane Love* (Plate 20). As we shall see, it was almost certainly commissioned in 1514. The patron was Niccolò Aurelio, whose escutcheons can be seen in the frieze on the fountain; as secretary to the Council of Ten he was one of the most important civil servants in Venice. *Sacred and Profane Love* is Titian's last painting in a specifically Giorgionesque idiom, and it is one of the most memorable combinations of figures and landscape in European art, all the more remarkable because the design, which seems so grandiose and so perfectly balanced, is not based on any of the standard compositional formulae commonly used by Venetian artists, in the way that the Reggio *Madonna* and *St Mark Enthroned* had been. As far as the subject is concerned, the picture has always been considered one of Titian's most enigmatic works. The various interpretations that have been proposed fall into two main categories: the composition has been seen either as an illustration of a literary text or as an allegory, apparently of a rather abstruse kind. But none of the existing explanations is convincing.

The most plausible literary interpretation, indeed the only one to gain a wide measure of support, is that *Sacred and Profane Love* shows an episode from the *Hypnerotomachia Poliphili*, an esoteric romance written in a bizarre mixture of Latin and Italian, which was published in Venice in 1499. According to this theory, the clothed woman is the heroine Polia, who is seen recounting her adventures to Venus. But there are many discrepancies between the painting and the text, not least that both women have their lips closed and that the one at the left appears totally oblivious of the presence of the other figures. Nor is there any very obvious reason why

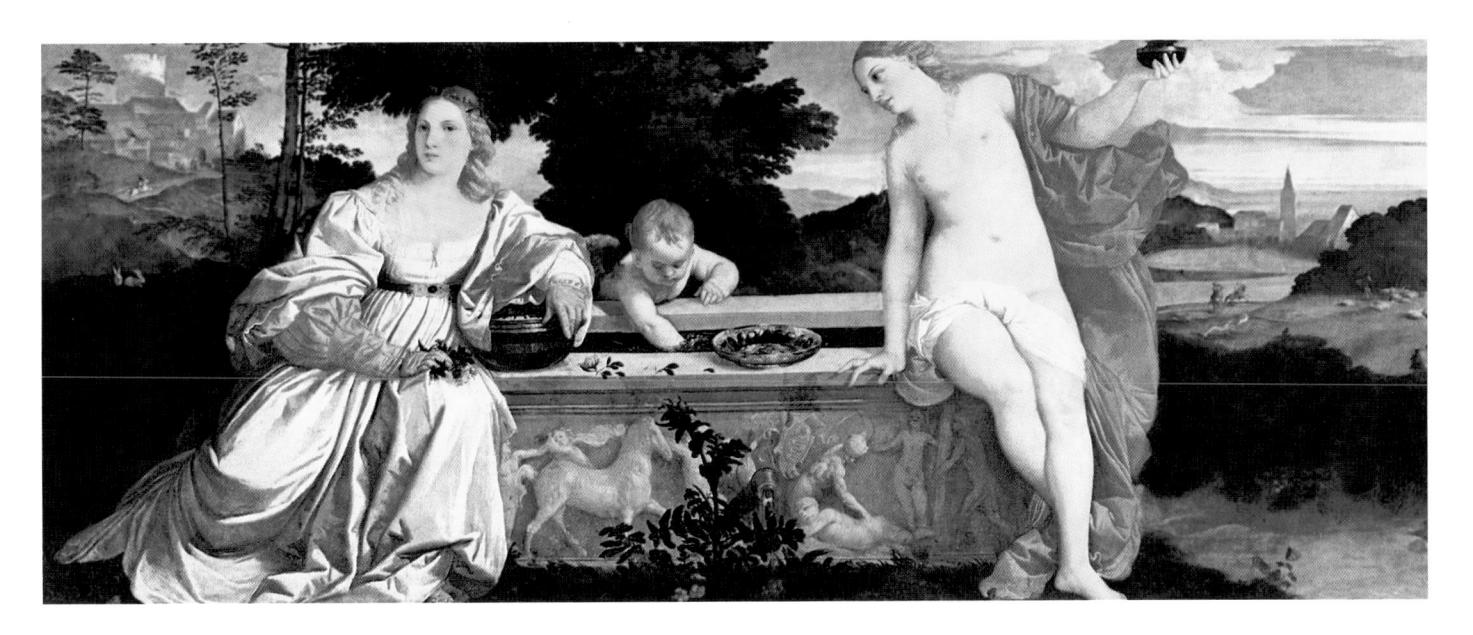

20 SACRED AND PROFANE LOVE (THE BRIDE OF NICCOLÒ AURELIO AT THE FOUNTAIN OF VENUS) Rome, Galleria Borghese. £1514. Oil on canvas 118 x 279 cm.

Aurelio should have chosen to commission a picture illustrating this text: so far as is known, there was no fashion in Venice for paintings based on the *Hypnerotomachia* in this way.

Most historians now believe that *Sacred and Profane Love* is a Neoplatonic allegory, the two women personifying the different aspects of love. Thus the clothed woman would be an embodiment of earthly or sensual love, and the other, who needs no adornment, of platonic or spiritual love. This reading neatly inverts and secularizes the interpretation reflected in the traditional title of the picture, which is certainly anachronistic but which at least has the merit of recognizing the sensuality of the nude. To argue that this figure is associated with the rejection of physical love seems a wilful misreading of the visual evidence. Another problem connected with the Neoplatonic interpretation is that once again there is no clear precedent in Venice for an allegory of this type, nor is there any evidence that Titian himself had the least interest in the ideas which his picture supposedly illustrates. To resolve this difficulty it has been suggested that he simply followed detailed instructions supplied by his patron. But it is hard to believe that such a procedure could have led to the creation of a composition so coherent and original; the stipulation of a precise iconographic programme by patrons frequently led other artists to produce works which were clumsy and pedantic.

The recent discovery of a second escutcheon, that of Aurelio's wife, in the centre of the silver dish suggests a much more straightforward interpretation. Aurelio was married in May

1514, and this has always been regarded as the approximate date of the picture. Given this fact and the presence of the two escutcheons it seems reasonable to assume that Sacred and Profane Love commemorates the marriage. If this is so, the woman wearing sumptuous contemporary dress and crowned with myrtle, which is sacred to Venus and specifically associated with marriage, is surely the bride, whose presence is not surprising given the apparent circumstances of the commission. The identification is confirmed by the unusual colour of her dress; according to a sixteenth-century source, Francesco Sansovino, Venetian brides traditionally wore white. The other figure, naked and accompanied by Cupid, is of course Venus. A vase similar to the one she holds appears as an attribute of the goddess in at least one other work of art produced in the Veneto at this period. Her approving glance suggests that she is giving the bride her blessing. Since she is seated on the ledge of the fountain and Cupid is stirring the water it must be the fountain of Venus, a common enough image. The bride is holding roses, the flowers of love; these are a regular feature of later Venetian marriage pictures. In this case, to make their significance all the clearer, they have been picked from a bush watered by the fountain. The most appropriate title for the picture would therefore seem to be The Bride of Niccolò Aurelio at the Fountain of Venus. There is, however, probably one strand of meaning that is no longer immediately obvious. In at least one other Venetian picture of this period showing both gods and mortals, the former are apparently meant to be understood to be invisible to the latter.¹⁷ This convention fits Titian's picture perfectly, and it would explain why the bride seems to be unaware of Venus and Cupid. The fact that she resembles the goddess so closely is in no way inconsistent with the proposed interpretation. On the contrary, it can be seen as a graceful compliment on Titian's part.

The only feature of the composition that remains mysterious is the relief on the fountain. Judging from its context it presumably has some erotic significance, especially as it includes an unbridled horse, a familiar Renaissance symbol of passion. But it may never be fully explained: like the similar relief in *Jacopo Pesaro Presented to St Peter*; this section could well include personal allusions to the patron, the relevance of which have been lost. In the Antwerp picture, however, the basic theme of the composition is conveyed by the figures and their setting; the relief, rather than providing a hidden key to the meaning, merely elaborates it, as do some similar reliefs in a much later painting by Titian, *The Entombment of Christ* (Plate 88). The frieze of figures presumably plays the same rôle in *Sacred and Profane Love*, so that even with this detail unexplained the subject-matter of the picture, which would have been readily

comprehensible to anyone who saw it at the time, seems simple enough and is perfectly complemented by the simplicity of Titian's composition.

Niccolò Aurelio must have been a valuable patron, for just at this period Titian was in the process of trying to obtain a commission for some paintings in the Doge's Palace. This is the first well-documented incident in his career, and it is very revealing about his personality. The original decoration of the Hall of the Great Council consisted of a series of frescoes illustrating the conflict between the Emperor Frederick I Barbarossa and Pope Alexander III, an important episode in Venetian history. By the 1470s these frescoes were in poor condition, and first Gentile Bellini and then his brother Giovanni were commissioned by the government to replace them with paintings on canvas. As their reward each was promised a *senseria*, a sinecure worth the considerable sum of about 120 ducts a year. In 1488 another painter, Alvise Vivarini, also offered to provide some pictures but he chose to be paid in cash for each canvas as it was completed, presumably because he preferred this arrangement to waiting until a *senseria* fell vacant. Subsequently Carpaccio, who had acted as Giovanni Bellini's assistant, was also promised a *senseria*.

By 1513 all the pictures in the room had been commissioned apart from the seven on the long wall nearest the lagoon, where the lighting was less satisfactory. In May of that year Titian offered to begin work on this wall, starting with a painting of The Battle of Spoleto. The attraction of this particular subject is easy to understand: it gave him the chance of competing with Leonardo and Michelangelo, both of whom had begun, but never finished, famous battle compositions in the Hall of the Great Council in Florence less than ten years before. That Titian had no doubts of his own competence is shown by the language of his petition to the doge, in which he proudly declared that 'although I have been in the past, and also am now urgently requested both by His Holiness the Pope and by other rulers to go and serve them; yet desiring, as the faithful servant of Your Sublimity that I am, to leave some memorial in this famous city, I have decided, if it meets with your approval, to take on the task of coming to paint in the Hall of the Great Council.' Even if one allows for a certain degree of exaggeration, Titian's assessment of his reputation at that time was probably a fair one. There is evidence from Dolce and Vasari that at about this moment he had been invited to Rome by the Medici Pope Leo X, at the suggestion of his secretary Pietro Bembo, and was dissuaded from going by Andrea Navagero, who like Bembo was one of the most prominent Venetian intellectuals of the period. But in making his offer to the doge Titian was certainly not prompted merely by

patriotism or artistic ambition. His request for the next *senseria* to fall vacant and for payment of the salaries of two assistants shows that he was well aware of the material benefits of working in the palace, benefits that were all the greater since in practice the artists involved in the redecoration were under very little pressure to produce finished results.

His petition was duly granted, but nine months later the Council of Ten decided that instead of receiving the next senseria he would have to wait his turn like everyone else. In a second petition Titian blamed this reversal on 'the skill and cunning of some who do not want to see me as their rival'. This remark presumably does not refer to Giovanni Bellini, as is usually supposed, since he was already secure in the possession of his senseria, but to Carpaccio, who apparently was not. It was just at this period that Carpaccio, who was quite unable to come to terms with the new pictorial style of Titian and other younger artists, was ceasing to obtain commissions in Venice. The prospect of the commission for the seven pictures on the lagoon wall offered him the chance of many years of steady and lucrative employment, a prospect now threatened by Titian's initiative. As it turned out Carpaccio's manoeuvre was only temporarily successful. In November 1514 Titian was given an undertaking that he would inherit Bellini's senseria if he had not already obtained another in the normal course of events. But even this arrangement did not last long. At the end of 1515 all the artists employed in the palace were dismissed, following reports that they had been paid large sums of money without producing anything to show for it. After an enquiry only Titian was re-employed, on rather more favourable terms than before, whereas the unfortunate Carpaccio never again received an important commission in Venice.

One can hardly doubt that a major reason for Titian's success in these negotiations was his skill in handling his patrons and especially his ability to acquire and make use of influential friends. In Venice such qualities were no less important to a painter than to anyone engaged in other kinds of commercial activity, and in this instance, despite his protestations to the contrary, there is little doubt that financial considerations were uppermost in Titian's mind. Having obtained the promise of a regular income he consistently evaded his responsibilities in the Doge's Palace. It was not until 1538 that he finally completed *The Battle of Spoleto*, which was destroyed in 1577, and even then he did so only after being threatened with the loss of his *senseria* and with the necessity of repaying everything that he had received during the years in which he had not worked on the picture.

But just because Titian received his re-appointment in 1516 after considerable difficulty, this

does not mean that it was undeserved. If we exclude Bellini, who was to die within the year, by this date Titian was clearly the outstanding painter in Venice. From the outset of his career, some ten years before, his great technical skill and his confidence in handling large-scale compositions had been evident, as had been his commitment to the modernization of Venetian painting. We have it on the authority of Dolce and Vasari that the first crucial step had been taken by Giorgione, with his invention of the new technique of painting in pure colour without preliminary drawings. Titian must have been among the first to follow his lead; but he never seems to have been content merely to imitate the work of another artist. The paintings which we have examined show a strength of form and clarity of expression very different from the dreaminess and romantic nostalgia of Giorgione's undisputed works. These qualities explain why he responded to contemporary developments in central Italy so soon and with such intelligence. Sebastiano needed to go to Rome, but Titian was equally successful in assimilating the new style while remaining in Venice. The early portraits, St Mark Enthroned, the Reggio Madonna and Sacred and Profane Love all have a monumentality, balance and idealization comparable to the finest recent paintings in Florence and Rome. But they also reveal something more, a masterly variety and fluency of touch, a fascination with the actual process of painting in oils that reflects the legacy of Giorgione.¹⁹

FOOTNOTES

- 1 On the Vecellio family and Cadore see Giuseppe Ciani, *Storia del popolo cadorino*, second edition, Treviso, 1940; and Celso Fabbro, 'Documenti editi ed inediti su Tiziano e sulla famiglia Vecellio conservati nella Casa di Tiziano a Pieve di Cadore', *Archivio Storico di Belluno, Feltre e Cadore*, XXIV–XXXII, 1953–61.
- 2 Francesco's age at the time of his arrival with Titian in Venice is given in his funeral oration: see Stefano Ticozzi, *Vite dei pittori Vecelli di Cadore*, Milan, 1817, pp. 320ff. This oration includes the sentence: 'Matrem habuit Luciam foeminam laectantissimam, hoc nomine fato quodam honestam, quod Titianum et Franciscum . . . peperisset'; the fact that Titian was mentioned first in this passage again suggests that he was older than Francesco.
- 3 See the dedicatory epistle in Lodovico Dolce, *Paraphrasi nella sesta satira di Giuvenale*, Venice, 1538. Several of Titian's contemporaries also named Tiziano Vecellio did understand Latin.
- 4 Titian's contribution, unlike Giorgione's, is not documented, but he presumably began his frescoes as soon as the builders vacated the scaffolding used for the construction, in 1508.
- 5 Thus when Pope Leo X visited Florence in 1515 one of the subjects represented on a triumphal arch dedicated to Fortitude was *Judith and Holofernes* (John Shearman, 'The Florentine *Entrata* of Leo X, 1515', *Journal of the Warburg and Courtauld Institutes*, XXXVIII, 1975, p. 145, n. 29).
- 6 Fra Bartolommeo's fresco is at Le Caldine, near Florence. It is closer to Titian's initial design as revealed by X-rays than to his finished picture. I have not found a common source for these compositions either in paintings or in prints.

- 7 Titian's borrowing was noticed by Muraro and Rosand, Tiziano e la silografia veneziana del cinquecento, p. 82.
- 8 Pesaro left Venice soon after 26 January 1503; he was next mentioned as being there on 20 May 1506 (Marin Sanuto, *I Diarii*, ed. R. Fulin and others, Venice, 1879–1903, IV, 659; VI, 340).
- 9 In a collection of Latin letters by Porcia (*Opus Jacobi Comitis Purliliarum Epistolarum Familiarium*, Venice?, 1505?) there is one addressed to "Titianus Cadubriensis", datable 1494–95, concerning a gift of some Latin verses; the recipient of this letter was presumably the painter's namesake who was the schoolmaster in Cadore from 1495 to 1500. Another of Porcia's correspondents was Jacopo Pesaro.
- 10 For the number of *giornate* in the Padua frescocs see Valcanover, 1969, p. 93. The first and last payments for these frescoes, dated 1 December 1510 and 2 December 1511, were made to Titian in Venice; the others, from 23 April to 19 July 1511, were evidently made in Padua.
- 11 According to his funeral oration (see note 2 above) Francesco fought at Vicenza and Verona and was under the command of Seraphino da Cai and Macone. The former, first mentioned by Sanuto in 1509, was killed at Padua in 1513; the latter, first mentioned in 1513, was an infantry officer at Verona in 1516 (Sanuto, *Diarii*, IX, 49; XVII, 170, 199; XXIII, 463).
- 12 Johannes Wilde, Venetian Art from Bellini to Titian, Oxford, 1974, p. 123.
- 13 The information about the plague is taken from Sanuto, *Diarii*; all recent publications are seriously misleading on the subject.
- 14 David Rosand, 'Titian's Light as Form and Symbol', Art Bulletin, LVII, 1975, pp. 58f.
- 15 For the date of Sebastiano's departure, see C. L. Frommel, *Die Farnesina und Peruzzis Architektonisches Frühwerk*, Berlin, 1961, p. 6.
- 16 This was pointed out by Professor Gaetano Cozzi at the conference on 'Tiziano e Venezia' held in Venice in September 1976.
- 17 Philipp Fehl, 'The Hidden Genre: a Study of Giorgione's *Concert Champêtre* in the Louvre', *Journal of Aesthetics and Art Criticism*, XVI, 1957–58, pp. 153ff.
- 18 I discuss Titian's relationship with the Venetian government in detail in the forthcoming publication of the proceedings of the 1976 conference on 'Tiziano e Venezia'.
- 19 Several other pictures obviously can be readily fitted into Titian's chronology as outlined in this chapter, for example *The Holy Family with St John the Baptist* (Edinburgh, collection of the Duke of Sutherland, on loan to the National Gallery of Scotland) of c.1507–08, *The Holy Family with a Shepherd* (London, National Gallery) of c.1510 and Christ Carrying the Cross (Venice, Scuola di San Rocco), for which there exists documentary evidence strongly suggesting a dating between April 1508 and the end of 1509 (Jaynie Anderson, "Christ Carrying the Cross" in San Rocco: its Commission and Miraculous History", Arte Veneta, XXXI, 1977, pp. 186–88). But others such as *The Circumcision* (New Haven, Yale University Art Gallery), *The Madonna and Child* (Bergamo, Galleria dell' Accademia Carrara), *The Madonna and Child with St Anthony of Padua and St Roch* (Madrid, Museo del Prado), Christ and the Adulteress (Glasgow, City Art Gallery and Museum) and the Concert Champétre (Paris, Musée du Louvre) equally obviously cannot. Just because they must be excluded from Titian's oeuvre, however, does not in itself seem an adequate reason for attributing any of them to Giorgione.

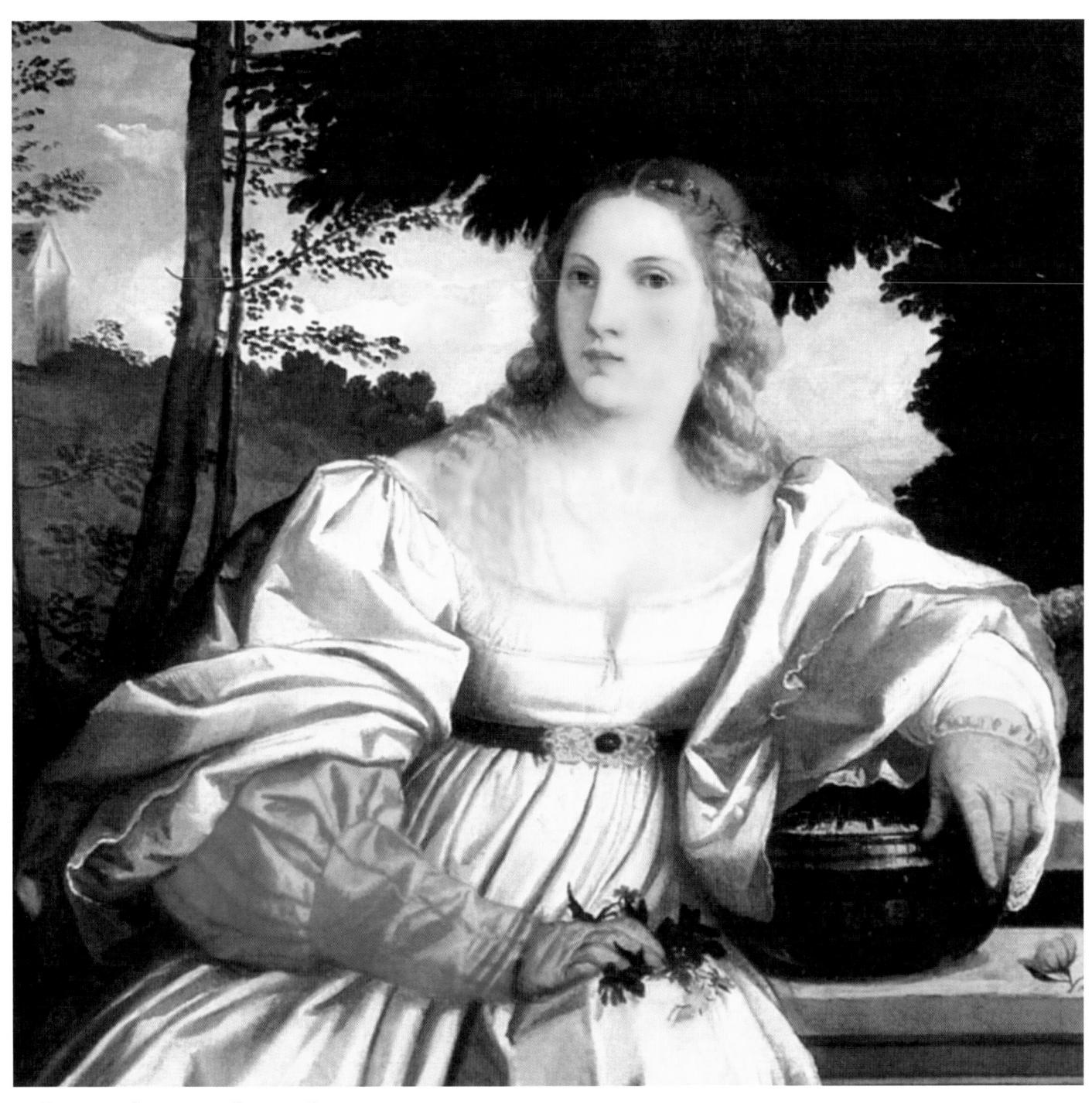

21 Detail of Sacred and Profane Love

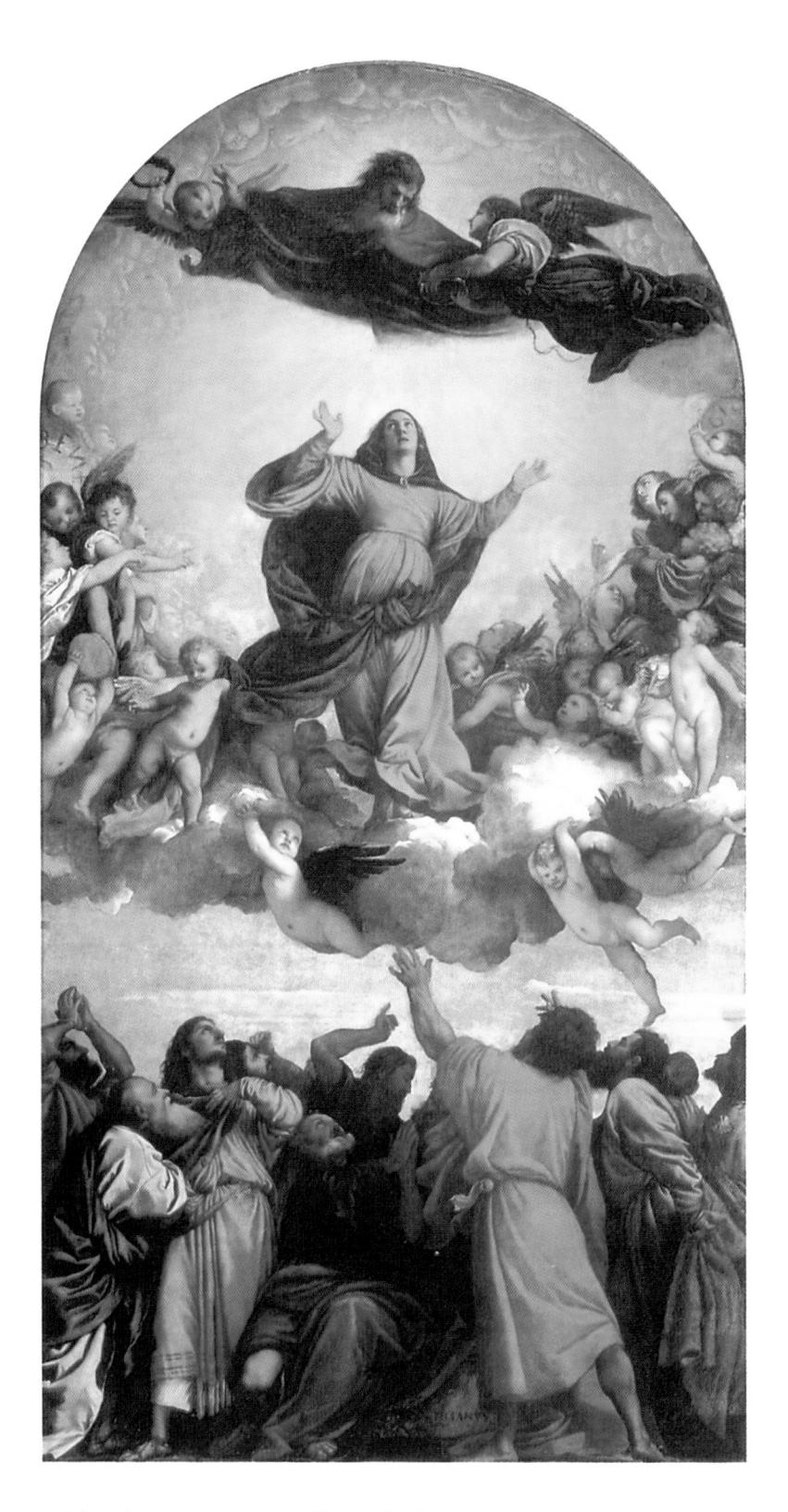

22 THE ASSUMPTION OF THE VIRGIN, before restoration Venice, Church of Santa Maria Gloriosa dei Frari. 1516–18. Oil on panel 690 x 360 cm. Inscribed: TICIANVS

1516-1530

THE CONFIRMATION IN January 1516 of Titian's appointment in the Doge's Palace marked a turning-point in his career. It was very soon followed by the first of a series of commissions for pictures much larger than almost any that he had previously produced. In general his practice was to be at work on several such pictures at any one time, and each of them occupied him for a period of years, so after this point it is no longer possible to consider his *oeuvre* in a simple chronological sequence. The other important event of 1516 was an invitation from Alfonso I d'Este, Duke of Ferrara, with whom Titian was to be associated for more than ten years. Through Alfonso he came into contact with other Italian rulers, and as his reputation spread his work for Venetian patrons came to account for less and less of his total output. But this development was not of real significance before 1530.

The crucial commission of 1516 was for an enormous painting of The Assumption of the Virgin (Plate 22) for the high altar of Santa Maria Gloriosa dei Frari, one of the major churches of Venice. This was the largest altarpiece that had ever been painted in the city, and the most important single work undertaken by any Venetian artist for almost a century. Given the coincidence of dates, it is possible that the task was entrusted to Titian as a direct consequence of the special recognition just accorded him by the government. In this altarpiece, completed in the unusually short span of only two years, he was faced with an entirely new problem, that of devising a composition that would be effective primarily from a distance, even from the other end of the nave almost a hundred yards away. His solution was startlingly original and brilliantly effective. Instead of relating the setting and the scale of the figures to the real space of the church, in the conventional Venetian manner, Titian set out to depict a supernatural event in a wholly non-realistic, highly rhetorical way. He aimed at, and achieved, an immediate dramatic impact. Set against a glowing disc of golden light the Virgin is swept up to Heaven to join God the Father, while the astonished Apostles remain in confusion below. Every figure is in movement, caught up in the miraculous event, the drama of which is heightened by the dazzling colour. It is the colour scheme, in fact, which establishes the structure of the picture, particularly the tall triangle formed by the patches of crimson in the robes of God the Father, the Virgin and the two most prominent Apostles. This triangle, by its

shape, has the effect of creating a strong upward emphasis and thus reinforcing the narrative content.

The Assumption is unprecedented among Venetian altarpieces in the energy and movement of the figures, in the vocabulary of gesture used to reveal their emotions, in their subordination to the total design and in the brilliance and artificiality of the colour. It is one of those rare masterpieces that transcend conventional stylistic categories, having less in common with the art of Titian's own time than with that of the Baroque. According to Dolce, artists in Venice were slow to come to terms with the picture, and indeed no one produced an altarpiece in a similar idiom for many years. This would seem to corroborate the statement of the Venetian art historian Ridolfi, who wrote more than a century later that the monks of the Frari were at first reluctant to accept the picture. When they gave Titian the commission they can certainly have had no conception of what he would produce.

This does not mean that Titian's masterpiece bears no relation to the work of his contemporaries. Here, as so often before, he seems to have drawn his inspiration primarily from the art of central Italy. It has often been observed that the closest parallel to his picture is to be found in a series of drawings of the same subject produced by Fra Bartolommeo around 1516 (Plate 18). These drawings, which cannot be directly associated with any known commission, resemble the Frari altarpiece not only in the general composition, but also in the unprecedented way in which the Virgin is shown as an active participant, psychologically involved in the miracle. In the work of both artists, too, the Virgin is in double contrapposto, a type of pose in which the different parts of the body are disposed along contrasting axes to create a complex, highly artificial and graceful equilibrium. This motif is one of the principal ingredients of later sixteenth-century art throughout Europe and came to be regarded as an indispensable element in a sophisticated painting; but its first appearance in Venice was in Titian's Assumption. Like Titian, Fra Bartolommeo was at the court of Ferrara early in 1516, and it is quite possible that their visits overlapped. Unless we suppose that these two artists, living in different cities, had devised very similar compositions quite independently of one another, the obvious implication is that Titian saw these drawings or others like them while he was in Ferrara. Indeed, it seems likely that Fra Bartolommeo actually collaborated in the evolution of Titian's design, at least in the initial stages, for the idea of showing the Apostles crowded together close to the picture plane, a feature which does not appear in the drawings and which seems to be derived from a celebrated fresco by Mantegna in Padua, near Venice, is repeated in

23 The Assumption of the Virgin Fra Bartolommeo Munich, Staatliche Graphische Sammlung. α . 1516. Black Chalk on red-tinted paper 21.7 x 17 cm.

a fresco of the same subject painted by Rosso Fiorentino in Florence in 1517. It is hard to see who could have been the intermediary between Titian and Rosso if not Fra Bartolommeo, who himself can hardly have been very familiar with Mantegna's composition.

Although Titian's Assumption has marked central Italian features, in certain respects it remains distinctively Venetian, since it reflects a working procedure unknown in Florence or Rome. As a result it makes the next great altarpiece produced in Italy, Raphael's Transfiguration of 1518–20 in the Vatican, seem laboured by comparison. In Titian's picture the figures are less isolated than in Raphael's, their poses less elaborate and studied, and there is a much greater emphasis on the picture plane, in which the forms are arranged in a pattern of strong areas of colour. In this respect The Assumption has been likened, with some justification, to the characteristically Venetian art of mosaic. The pre-eminence of surface pattern and the subordination of individual elements to the overall design are a consequence of Titian's method of developing his compositions in colour directly on the panel rather than in a series of preliminary drawings, as Raphael would have done.

His approach is perfectly illustrated in an uncompleted version of an altarpiece which he seems to have begun shortly after finishing *The Assumption*. The commission once again came from the monks of the Frari and was for the high altar of the Oratory of San Nicolò ai Frari, which was part of their monastery. The finished version (Plate 59), now in the Vatican and discussed in chapter three, dates entirely from the 1530s, but beneath the final composition there is an earlier and completely different design which was revealed when the back of the paint film was temporarily exposed in the course of a recent restoration.² In looking at this design, the lower half of which is illustrated here (Plate 24), it is important to remember that the pigment which appears uppermost was actually applied first. Thus the landscape at the right was painted before the figure visible above the trees. This landscape almost certainly belongs to a still earlier picture, known as 'Il Bagno', a bathing scene, a commission from Alfonso d'Este which was cancelled in March 1518: the outline of a seated figure just visible against the white robe of St Nicholas at the lower left formed part of the same picture. When Titian received the commission for the altarpiece he simply extended the panel and painted over the unfinished bagno. His new composition followed the standard Venetian formula for such sacre conversazioni, a scheme which he had already used in St Mark Enthroned (Plate 15). The first design for the San Nicolò altarpiece, however, is much more ambitious than the earlier work: there are many more figures and they are no longer arranged on only two levels, but in several layers to form a

24 MADONNA AND CHILD IN GLORY WITH SIX SAINTS (Plate 59), detail of the paint film seen from the back. Vatican City, Pinacoteca Vaticana. 1518-19. Oil on panel, transferred to canvas. Dimensions of this detail are 212 x 264 cm, This detail of the lower half of the picture's paint film shows the unfinished bagno and part off the first version of the altarpiece. The image is here reversed to correspond to the original appearance of Titian's composition.

pyramid. In developing his composition Titian merely sketched in very rough outlines of the individual figures and then began to fill in the major areas of colour without fully elaborating the poses. When he began painting he did not even known how the figures were to be arranged. For example, it seems that St Sebastian was initially placed at the lower right, where his head is sketched just above the landscape of the *bagno*. But Titian later moved the standing Franciscan slightly to the left to occupy this space and put St Sebastian in the upper part of the picture, next to the Madonna.

In April 1519 he received a second commission from his old patron Jacopo Pesaro, this time for an altarpiece for the Pesaro family chapel in the nave of the Frari (Plate 25). The attraction of the site rather than the low fee of about 100 ducats, the same amount that the artist

demanded in 1523 from Isabella d'Este, the Marchioness of Mantua, for a picture with a single figure, was probably the main reason why he then stopped work on the San Nicolò altarpiece, whose basic composition, with several of the same saints posed in a similar way, was modified for the new painting. But whereas the earlier work was a conventional sacra conversazione, with an essentially symmetrical design and a strong central axis, in the Pesaro altarpiece the throne is set at an angle to the picture plane and the compositional balance is achieved by a much more complex disposition of figures. It has been suggested that Titian modified the traditional arrangement in this way to create a satisfactory visual effect not only for a spectator directly in front of the altar but also for someone seeing the picture from an oblique angle as he moved up the centre of the nave towards *The Assumption*. The argument, however, is unconvincing since from most parts of the nave the Pesaro altarpiece is partially or wholly obscured by piers supporting the roof of the church and by projecting columns framing the picture itself, a feature about which Titian would presumably have been consulted. The unusual character of his composition can be explained more simply by the fact that this is not a sacra conversazione as such, but a votive picture like Pesaro's earlier commission now in Antwerp (Plate 12). In works of this type Venetian artists had to contend with an obvious difficulty, since by convention the donor was shown in profile while the enthroned figure who was the object of his devotion, usually a Madonna, was normally shown frontally, so that the two could not readily face one another directly. By adopting a diagonal arrangement Titian overcame this problem. Jacopo Pesaro is thus seen kneeling before a loosely grouped sacra conversazione. It is his picture, an expression of his piety, so his privileged status is entirely appropriate, as is the inclusion of the Turk and the negro at the left, who are led towards the Madonna by a warrior saint, probably St Maurice, since they owe their salvation to Pesaro's victory in 1502. The other members of the Pesaro family, grouped at the lower right, do not participate directly in the action of the picture. Instead, they demonstrate their faith through prayer, and the youngest, by his glance, invites us in the church to join with them, while St Francis intercedes for them and us with the infant Christ. The structure of the altarpiece therefore reflects its dual function as a commemoration of private faith and a focus of public devotion.³

Titian worked on the Pesaro altarpiece intermittently over a period of seven years. As X-rays have revealed, he modified the architectural setting several times; in particular the two enormous columns were not part of his original design, and at one time it was even suggested that these were painted in the following century, since they do not logically relate to the wall at

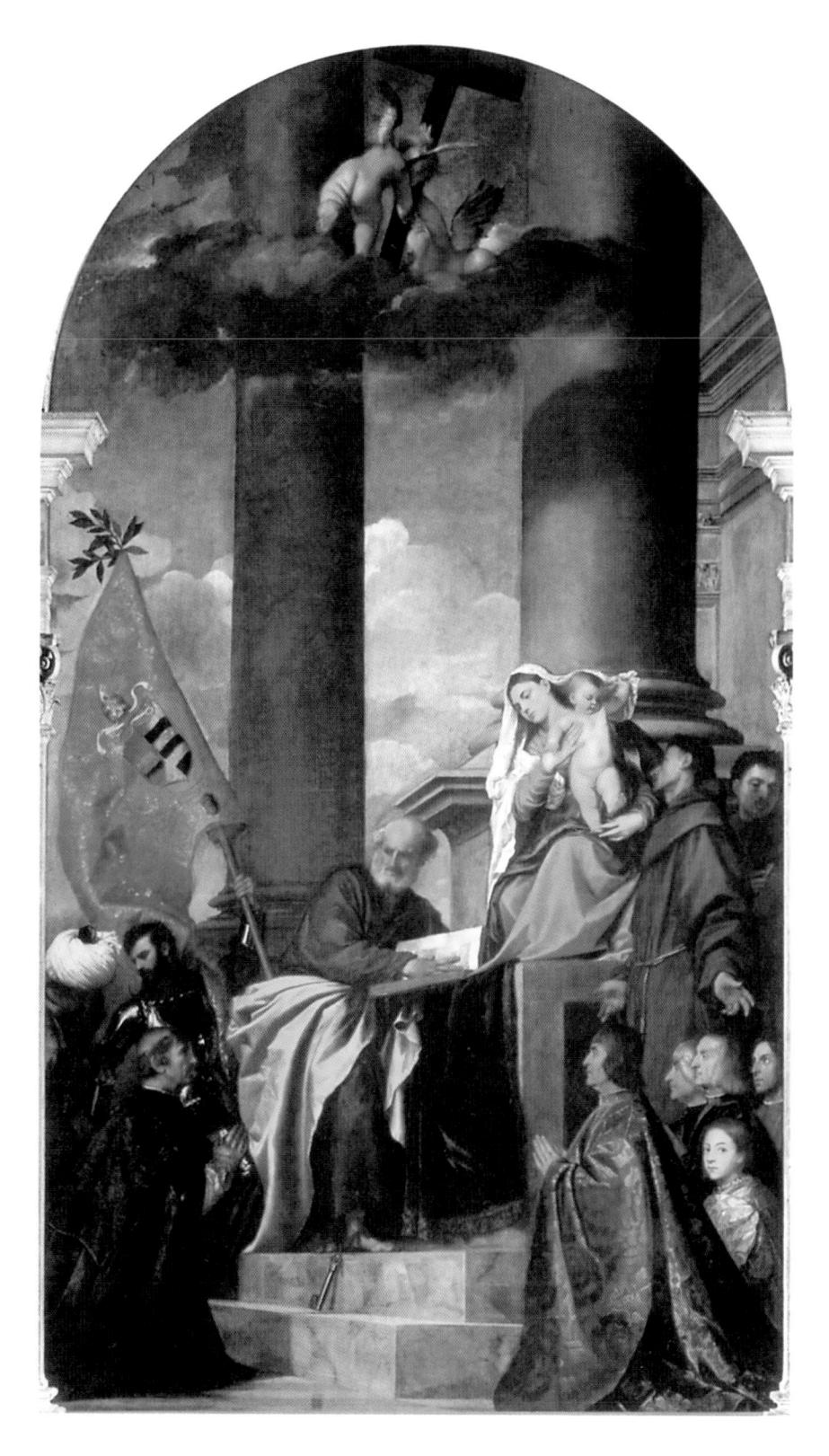

25 THE PESARO MADONNA (MADONNA WITH ST MAURICE (?), ST PETER, ST FRANCIS AND ST ANTHONY OF PADUA, WITH MEMBERS OF THE PESARO FAMILY AND TURKISH CAPTIVES), before restoration Venice, Church of Santa Maria Gloriosa dei Frari. 1519–26. Oil on canvas 478 x 268 cm.

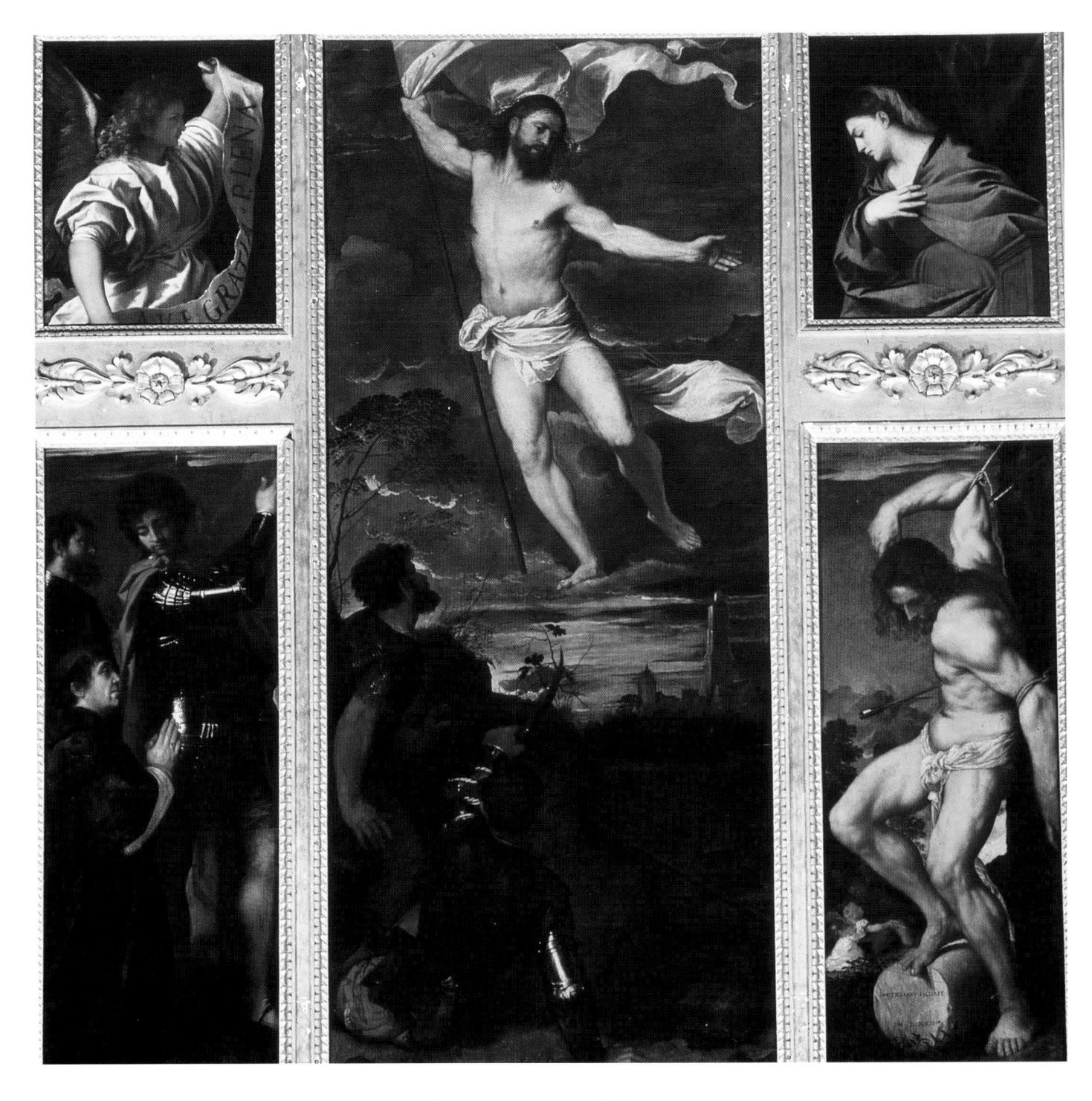

26 THE AVEROLDI ALTARPIECE (THE RESURRECTION; THE ANNUNCIATION; ST NAZARIUS AND ST CELSUS WITH ALTOBELLO AVEROLDI; ST SEBASTIAN)
Brescia, Church of Santi Nazzaro e Celso. 1519–22. Oil on panel; central panel 278 x 122 cm.; upper side panels 79 x 65 cm.; lower side panels 170 x 65 cm. *Inscribed: TICIANVS. FACIEBAT M.D.XXII*

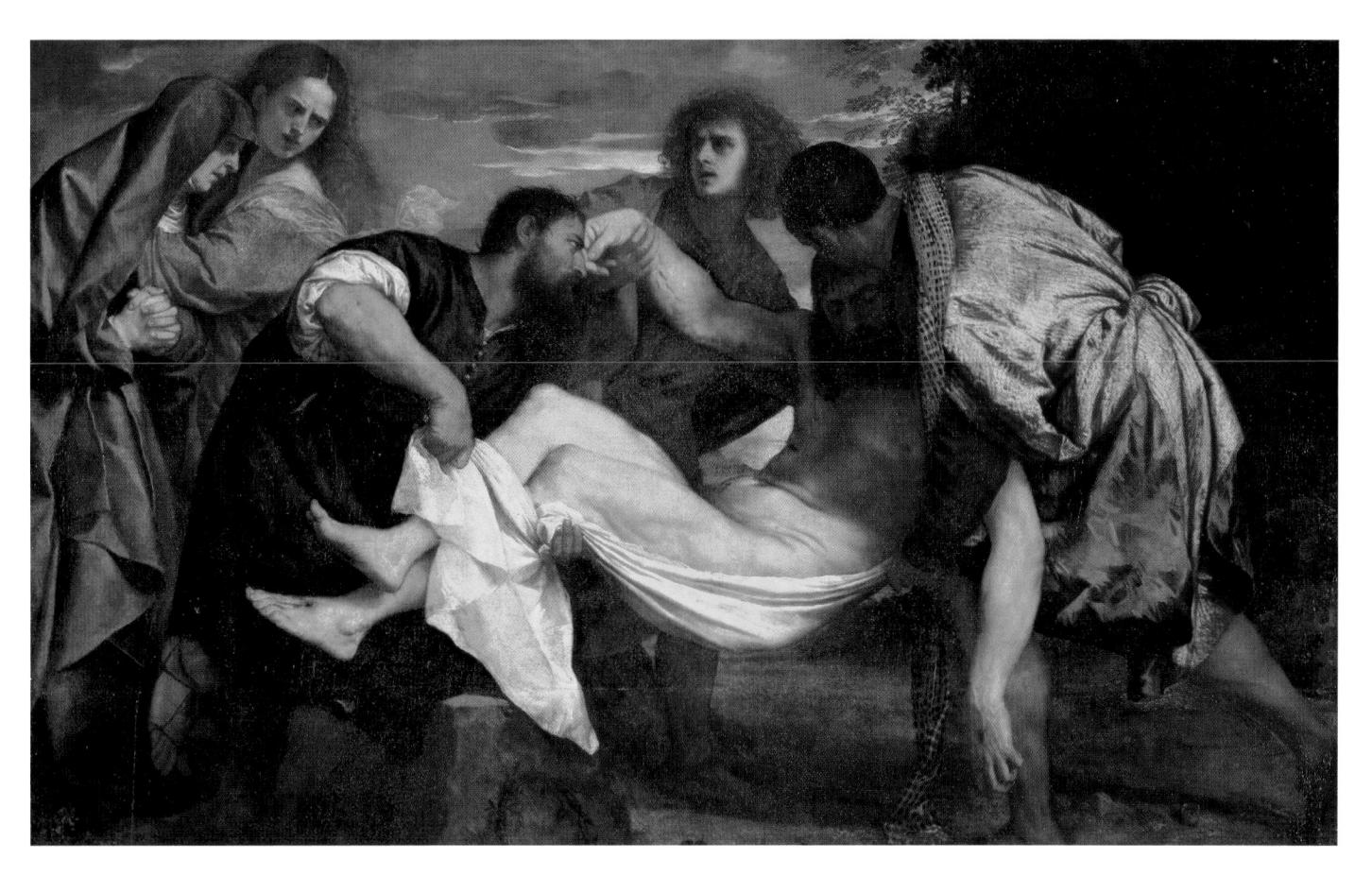

27 THE ENTOMBMENT OF CHRIST Paris, Musée du Louvre. c. 1516. Oil on Canvas 148 x 215 cm.

the right. But the spatial ambiguities which so troubled some art historians are unlikely to have worried Titian himself unduly. As we have seen, he developed his compositions as he painted, conceiving them to a large extent as two-dimensional patterns, and with such a procedure inconsistencies of the kind present in *The Pesaro Madonna* were bound to occur. His purpose in including the columns, to give the composition an added grandeur and to create an impression of depth behind the figures, is easy enough to understand, and the validity of his decision is confirmed by the fact that this feature became one of his most widely admired inventions, imitated not only in countless Venetian altarpieces from the late 1520s until well into the eighteenth century, but also in other types of picture, such as Van Dyck's portraits.

While he was engaged on the altarpieces for the monastery of the Frari Titian also painted several other major religious pictures, the earliest of which is probably the marvellous *Entombment of Christ* (Plate 27). This was once in the Gonzaga collection and is therefore usually thought to have been painted for Isabella d'Este or for her son Federico II Gonzaga,

Marquis, and from 1530, Duke, of Mantua, who first employed Titian in 1523. But there is no reference to such a commission in the well-preserved Gonzaga archives, and it is much more likely that the picture entered the collection from another source. The glowing colours, the atmospheric quality, still reminiscent of Giorgione, and the slightly clumsy vigour of the figures supporting the body of Christ all suggest a dating around 1516, close to *Sacred and Profane Love* and *The Assumption*. But the patron, who was presumably a Venetian, cannot be identified.

In the case of an altarpiece for a church in Ancona (Plate 28), completed in 1520, we do at least know the name of the patron, Alvise Gozzi, but almost nothing else about him beyond the fact that he was a merchant from Dubrovnik. He appears in the painting with St Louis, known to Venetians as St Alvise, and St Francis, before the Madonna and Child in glory. The composition is derived from Raphael's celebrated *Madonna di Foligno* (Vatican City, Pinacoteca Vaticana), which Titian can only have known at second hand, probably through the Ferrarese artist Dosso Dossi, who used a similar design. Characteristically, Titian's picture, with its unforgettable view of Venice seen across the lagoon, is more spacious and luminous than its prototype. Equally remarkable is the way in which the artist made the spatial relationship between the Madonna group and the three figures below seem entirely plausible, even though it cannot be analyzed in rational terms.

Titian's other great religious picture of this period is *The Averoldi Altarpiece* (Plate 26) in the Church of Santi Nazzaro e Celso in Brescia, ordered by the papal legate Altobello Averoldi in October 1519 and completed in 1522. One reason why the commission may have come at this moment was Averoldi's intense rivalry with the Canon of Treviso Cathedral, Broccardo Malchiostro, who had even come to blows with him in church on one famous occasion. It is likely that Averoldi approached Titian shortly after his adversary commissioned *The Annunciation*, now in Treviso Cathedral, a relatively minor work which may not be entirely autograph; the legate's picture is more imposing, but his conservatism, shown by the choice of an old-fashioned polyptych format, seems to have made him an unsympathetic patron, so much so that Titian even proposed to defraud him by secretly selling the panel showing St Sebastian to Alfonso d'Este and replacing it with a replica. This discreditable episode is indicative both of Titian's often unscrupulous and mercenary behaviour and of the high regard in which his paintings were already held.

The idea was suggested late in 1520 by the Ferrarese ambassador Jacopo Tebaldi, who reported to Alfonso that 'many people in this town speak of the *St Sebastian* as a most beautiful

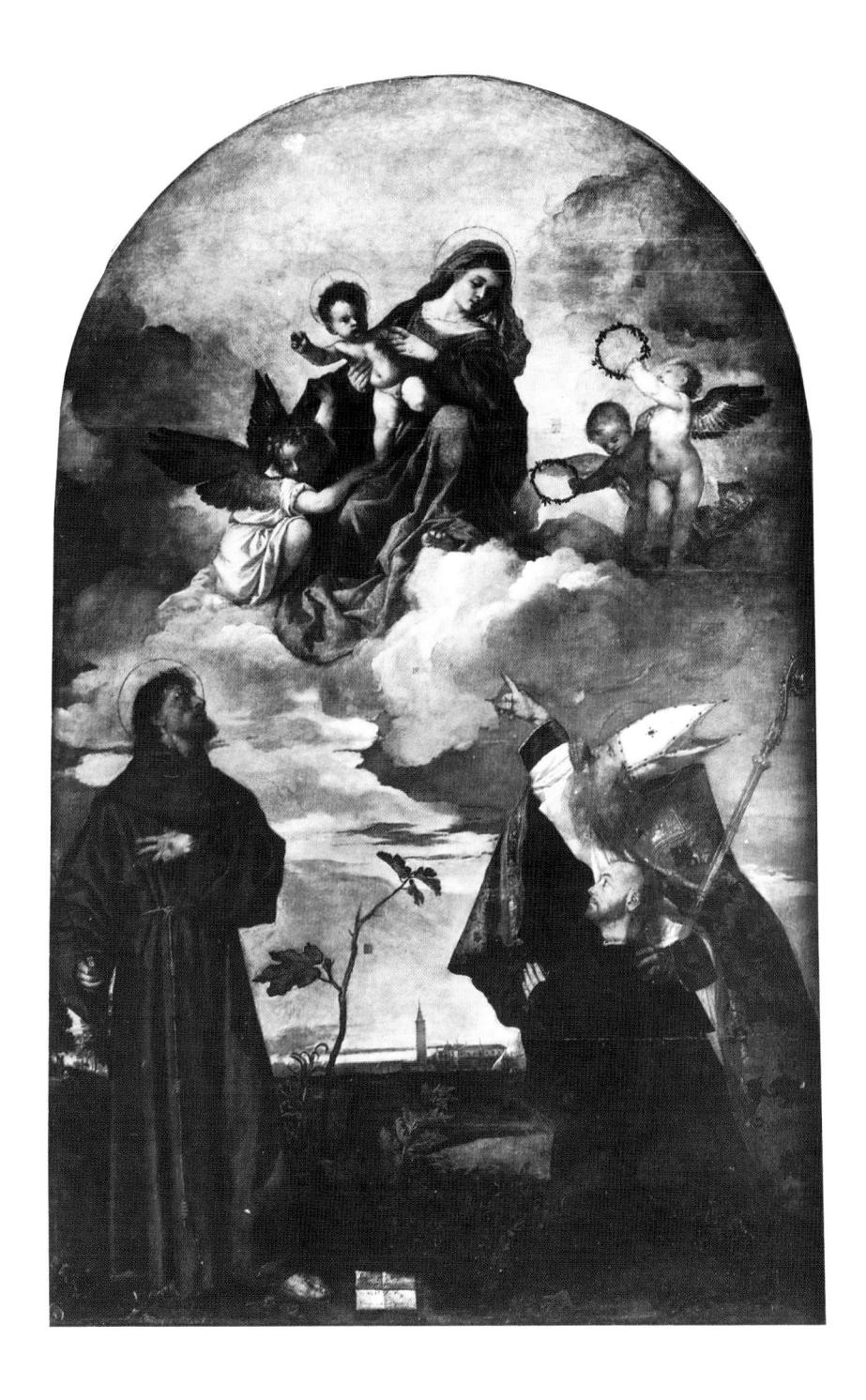

28 Madonna and Child in Glory with St Francis, St Louis of Toulouse and Alvise Gozzi Ancona, Museo Civico. 1520. Oil on panel 320 x 206 cm.

Inscribed, but apparently not by Titian himself: Aloyxius gotius Ragusinus Fecit fieri MDXX Titianus cadorinus pinsit.

picture', adding that Titian himself considered it the finest work that he had ever produced. At first the artist responded cautiously to Tebaldi's proposal, saying that he was to be paid 200 ducats for the entire altarpiece even though the *St Sebastian* panel alone was worth as much, at the same time declaring, as the ambassador reported, that 'neither for priests nor friars would he leave the service of the duke.' But it was only after Tebaldi had continued negotiations in terms of studied vagueness for several weeks that he was able to write triumphantly to Alfonso on 20 December 1520 that 'I then raised the subject of the *St Sebastian* and managed to induce him to make the following explicit statement: "The Duke may demand my poor life of me, and although I would not carry out this trick that I have promised to do against the legate for any man in the world, I would do so gladly for His Excellency if he were to pay me 60 ducats for the *St Sebastian*." But in the end Alfonso himself decided against the scheme since he thought it politically dangerous to risk offending Averoldi.

The *St Sebastian* is certainly the finest part of the altarpiece and the admiration which it aroused is easy enough to understand. The figure has a pathos and an anatomical perfection unprecedented in Venetian art. The pose is reminiscent of Michelangelo's sculpture of two *Slaves* now in the Louvre, which Titian must have known through drawings. An even more obvious borrowing can be seen in the figure of Christ, which is based on the most famous of all classical statues, the *Laocoon*. Rather than being regarded as plagiarism such quotations would merely have established Titian's modernity and sophistication. In the eyes of his contemporaries one of his outstanding gifts must have been his ability to incorporate these admired models in a composition which was no less remarkable for its landscape and its luscious paint surface.

Titian's interest in large-scale compositions in the years around 1520, so evident in the religious commissions which have just been discussed, was probably unequalled during any other period in his career. Even so, it did not prompt him to fulfill his commitments in the Doge's Palace. This may have been in part due to the fact that he failed to obtain the *senseria* left vacant at Bellini's death in 1516, as he had been promised. In the following year, however, he did paint one picture for the state, showing *St George, St Michael and St Theodore*, which was sent as an official gift to Lautrec, the French governor of Milan.⁵ It is usually assumed that a painting of *St George* in the Cini collection in Venice is a fragment of this work; but as the style is quite unlike that of Titian's undisputed pictures of this period the attribution is extremely questionable. At about the same time Titian also seems to have agreed to complete a picture

begun by Bellini for the Hall of the Great Council, *The Submission of Frederick Barbarossa before Alexander III*. But it was not until 1522, after threats that he would be deprived of his prospect of a *senseria* as well as having to repay a substantial sum to the government, that he began working seriously on the picture. It was completed in the following summer, at about the same time as a portrait of Doge Antonio Grimani, also for the Hall of the Great Council. Like most of Titian's later works in the Doge's Palace both these paintings were destroyed by fire in the 1570s, and no visual record of them has been preserved even though they were highly praised by contemporaries.

After completing *The Submission of Frederick Barbarossa* Titian at last obtained his coveted *senseria*, but predictably this did not encourage him to turn his attention once more to *The Battle of Spoleto*, the picture which he had begun ten years before. Instead, at the request of the new doge, Andrea Gritti, he at once embarked on a series of frescoes for a chapel in the palace. These decorations too have been destroyed, but there are still two small frescoes in another part of the palace, a *St Christopher* and *The Madonna and Child with Angels*, which are likely to date from this same period. Titian accepted a second commission from Gritti, probably in 1529, for a votive composition showing the doge presented to the Virgin by St Mark;6 completed in 1531, its appearance is known from a woodcut. There is little reason to suppose that the artist found these commissions particularly congenial, but they were useful to him, for it was presumably largely thanks to Gritti, whose favour towards Titian is specifically mentioned by Vasari, that the artist was able to prevaricate over *The Battle of Spoleto* until 1537, even though during this period the government continued to contribute towards the upkeep of his studio.

The paintings discussed so far in this chapter were almost all executed for public buildings. In this period the only patron who seems to have consistently acquired works by Titian for his own private collection was Alfonso d'Este. The first of these was *The Tribute Money* (Plate 29), now in Dresden, which was almost certainly painted during the artist's visit to Ferrara early in 1516. The theme of the composition, 'Render unto Caesar the things which are Caesar's; and unto God the things that are God's', had an immediate relevance to Alfonso's own situation, since he owed allegiance to both the pope and the emperor. But the subject does not seem to have been chosen only for its political significance. More relevant, perhaps, was the fact that the picture was painted for the door of a cupboard containing a collection of medals. *The Tribute Money* is primarily a display of prodigious technical skill, so evident in the high degree of finish, and as such is less immediately appealing than many of Titian's other works of this period. But

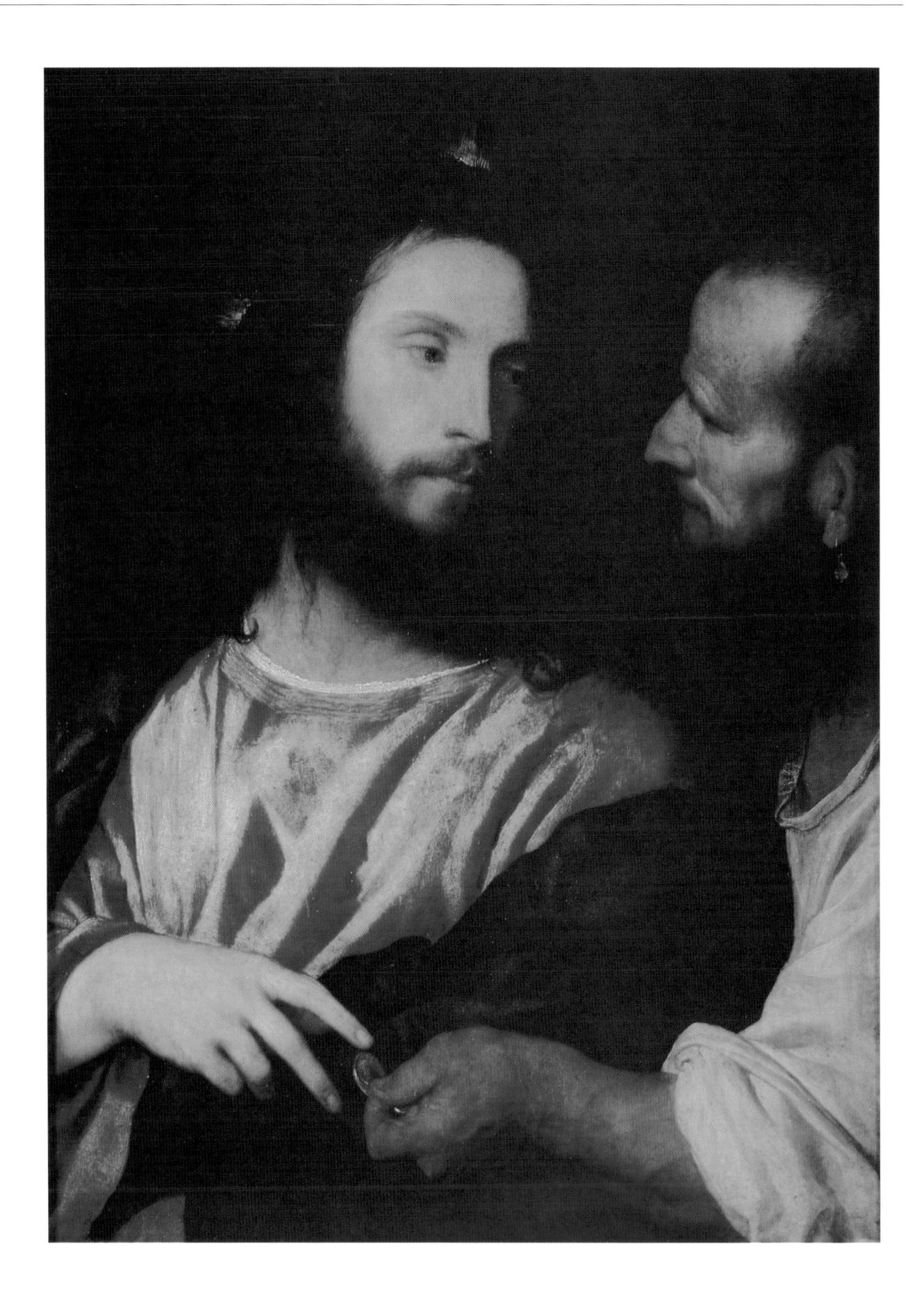

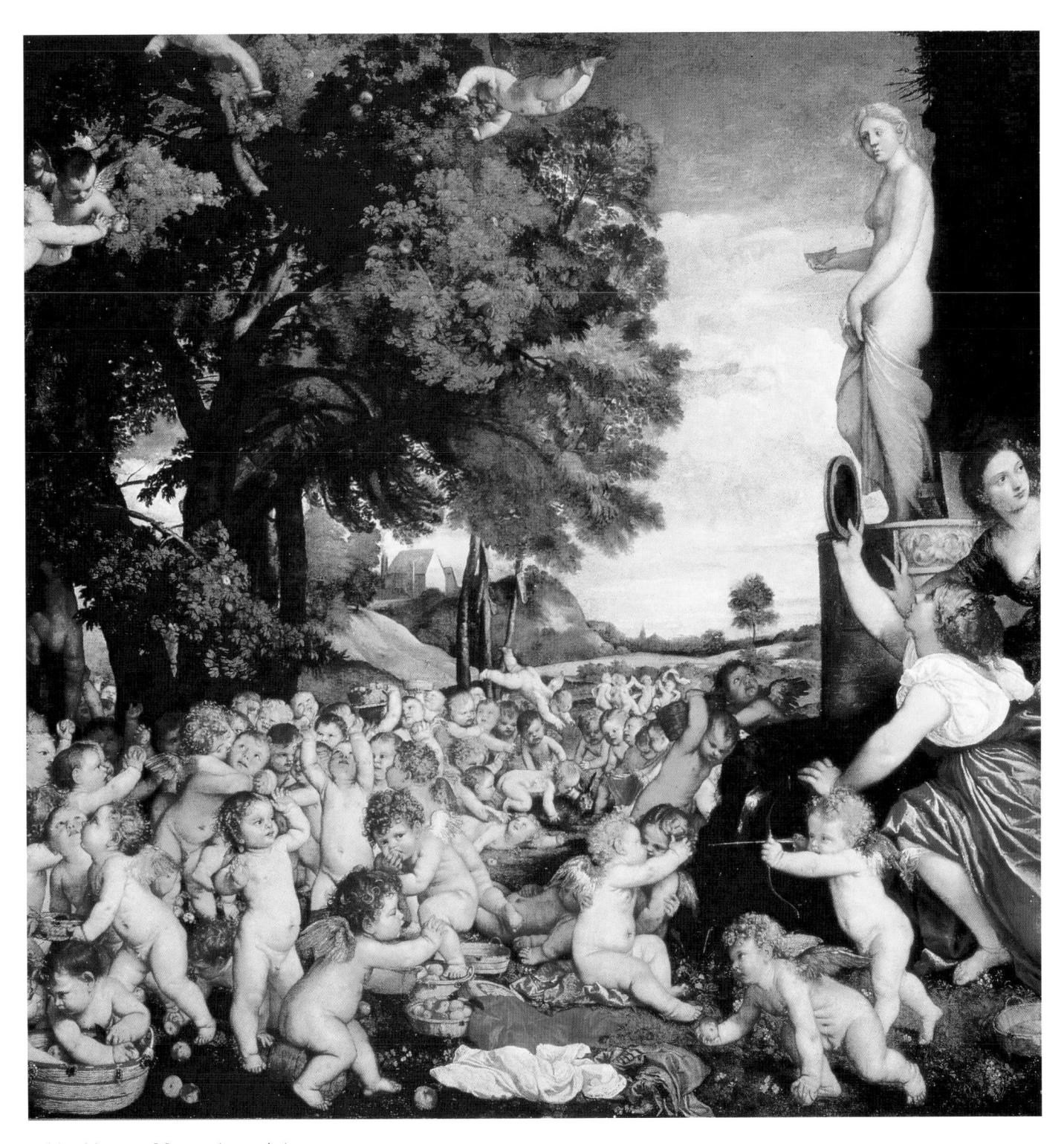

29 THE TRIBUTE MONEY (opposite) Dresden, Staatliche Gemäldegalerie. Probably 1516. Oil on panel 75 x 56 cm. Inscribed: TICLANVS.F

30 The Worship of Venus (above) Madrid, Museo del Prado. 1518-19. Oil on canvas 172 x 175 cm. Inscribed: $N.\ 102.\ Di\ Ticianus\ F\ [originally:\ Ticianus\ F]$

it was just this kind of virtuosity that was particularly prized by sophisticated collectors, and this may explain why Titian, with his interest in mastering a monumental figure style, seems to have found such commissions relatively unattractive in the decade around 1520.

After his first visit to Ferrara Titian began to work for Alfonso on a regular basis, as well as acting as his adviser in such matters as the purchase of bronzes and vases in Venice. His second commission from the duke was for a landscape composition of about the same size as *Sacred and Profane Love*, referred to as 'Il Bagno'. As we have seen, it apparently survives in an uncompleted form (Plate 24) beneath the St Nicholas altarpiece, now in the Vatican. Alfonso cancelled the commission in March 1518 because he wanted to employ Titian on a much more important work, *The Worship of Venus* (Plate 30), now in the Prado. This was intended as part of a cycle of five large mythological compositions for his new study, the so-called Camerino d'Alabastro, one of a series of rooms built or remodelled in 1518. The cycle, eventually completed in a form very different from Alfonso's original intentions, proved to be one of the outstanding decorative ensembles of the Renaissance, and it was largely Titian's creation.8 His various contributions to the project, which are among his greatest and most influential works, were to occupy him for about ten years.

The nucleus of the cycle was Giovanni Bellini's Feast of the Gods (Plate 31), which was completed in 1514. Originally this painting was probably intended to hang alone, rather than to belong to a larger scheme. X-ray photographs show that the picture was substantially altered after Bellini had worked on it: the landscape at the left was repainted not once but twice, while the figures were given attributes of the Olympian gods and the drapery on several of the women was lowered. The successive changes to the background can be explained by the need to make the landscape consistent with those of the adjacent pictures in Alfonso's study, but this would not account for the alterations to the figure group. Fortunately this problem has now been solved in a remarkable study by Philipp Fehl.9 The subject of the picture is the legend recounted in Ovid's Fasti about Priapus, who tried to make love to the sleeping nymph Lotis after a banquet of the gods; as he was approaching her the ass of Silenus suddenly brayed, awakening Lotis, who fled from her unwelcome admirer and was subsequently transformed into a lotus. Priapus and Lotis are shown at the right, and Silenus with his ass towards the left. But Bellini's original composition was not based on the Fasti at all. Instead he relied on an Italian paraphrase of Ovid's Metamorphoses, which gives an entirely different version of the legend in which all the characters are citizens of Thebes rather than gods and nymphs. Bellini's mistake

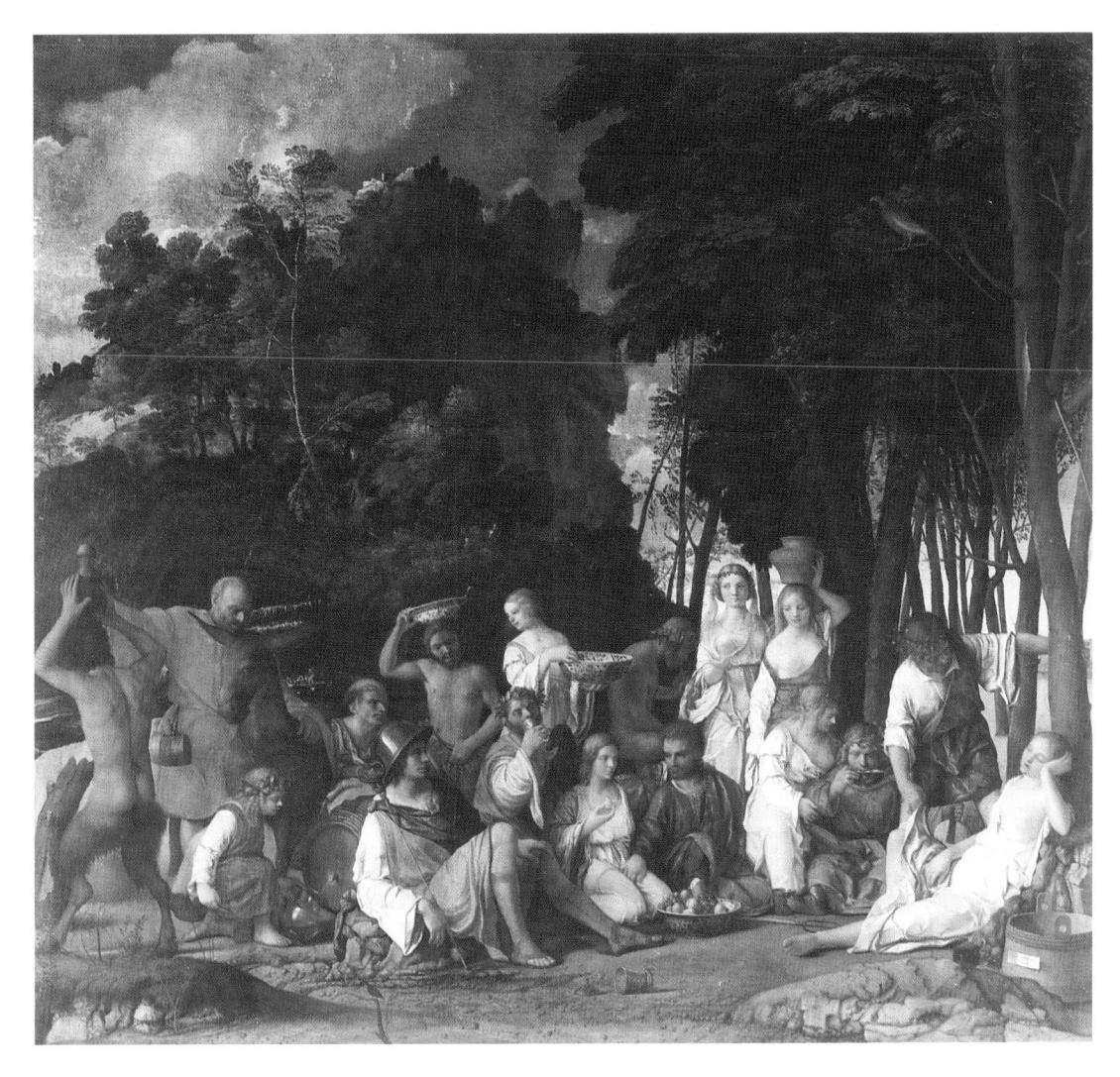

31 THE FEAST OF THE GODS Giovanni Bellini and Titian Washington, National Gallery of Art (Widener collection). Dated 1515. Oil on canvas $170 \times 188 \text{ cm}$. Inscribed: ioannes bellinus uenetus p. MDX111

was evidently not recognized until the picture was finished, and it was then decided to give the figures their Olympian attributes; but whether these modifications were made by Bellini himself, or by Alfonso's court artist Dosso Dossi, is not known.

In 1517 Alfonso decided to commission a series of mythological compositions to accompany *The Feast of the Gods*. Like his sister Isabella, who had already commissioned a similar cycle for her study in Mantua, he seems to have wanted representative works by the best artists in Italy. On the main wall of his room there were to be three paintings by the foremost masters of Rome, Venice and Florence: at the left Raphael's *Triumph of Bacchus*, in the centre *The Feast of the Gods*, at the right *The Worship of Venus* by Fra Bartolommeo. Like Bellini before him,

Raphael does not seem to have been given detailed instructions about his composition, presumably because he was thought too eminent to accept them or else because Alfonso was confident of his ability to produce a mythological picture in a convincingly Antique idiom. But Fra Bartolommeo was given a specific text to illustrate, a description by Philostratus of a classical painting. Such descriptions, or ekphrases, were a familiar literary genre and provided an obvious source for a patron like Alfonso who wanted a picture that would be authentically classical in subject-matter as well as appearance, something that Bellini had failed to achieve. This does not mean that Alfonso had any particular antiquarian bias. For any educated man of the Renaissance, the notion of high art of a non-religious kind, in painting as in literature, inevitably involved imitation of classical models.

In March 1518, several months after the death of Fra Bartolommeo, the commission for *The* Worship of Venus was transferred to Titian. His composition follows Philostratus's text very closely, and it also seems to show some knowledge of a preparatory sketch by Fra Bartolommeo. But Titian added one feature of his own invention, the two girls at the right bringing offerings to the shrine of Venus. By including these figures he was obviously seeking to link his design with the adjacent picture on the wall at the right, a 'Bacchanal of Men' by Alfonso's court artist Dosso Dossi; this was accomplished by means of the glance of one of the girls. At the same time these two figures enabled him to give an added significance to his subject. For the girls belong to the world of mortals, and are therefore oblivious of the putti playing beside them. Thus Titian was able to suggest that even though we are not aware of them, the gods and their followers are still alive all around us. The actual depiction of the putti, too, is astonishingly inventive; one has no sense of an artist merely illustrating a very detailed programme. Rather than inhibiting his invention, in fact, Philostratus inspired Titian to paint the most sympathetic and sensual recreation of the pagan world that had so far been produced in Venice. He certainly made use of the few Antique statues available to him, notably two reliefs, both now in the Museo Archeologico in Venice, in which one finds much the same kind of putti; but because he had no direct experience of the overwhelming visual remains in Rome he had to rely very largely on his own imagination. If anything this proved to his advantage, for he was able to enter freely into the spirit of the ancient world without resorting to a merely pedantic restatement of the norms of classical art.

After repeated invitations from Alfonso, Titian finally took *The Worship of Venus* to Ferrara in October 1519, completing it after his arrival. He was never a fast worker, and the nineteen

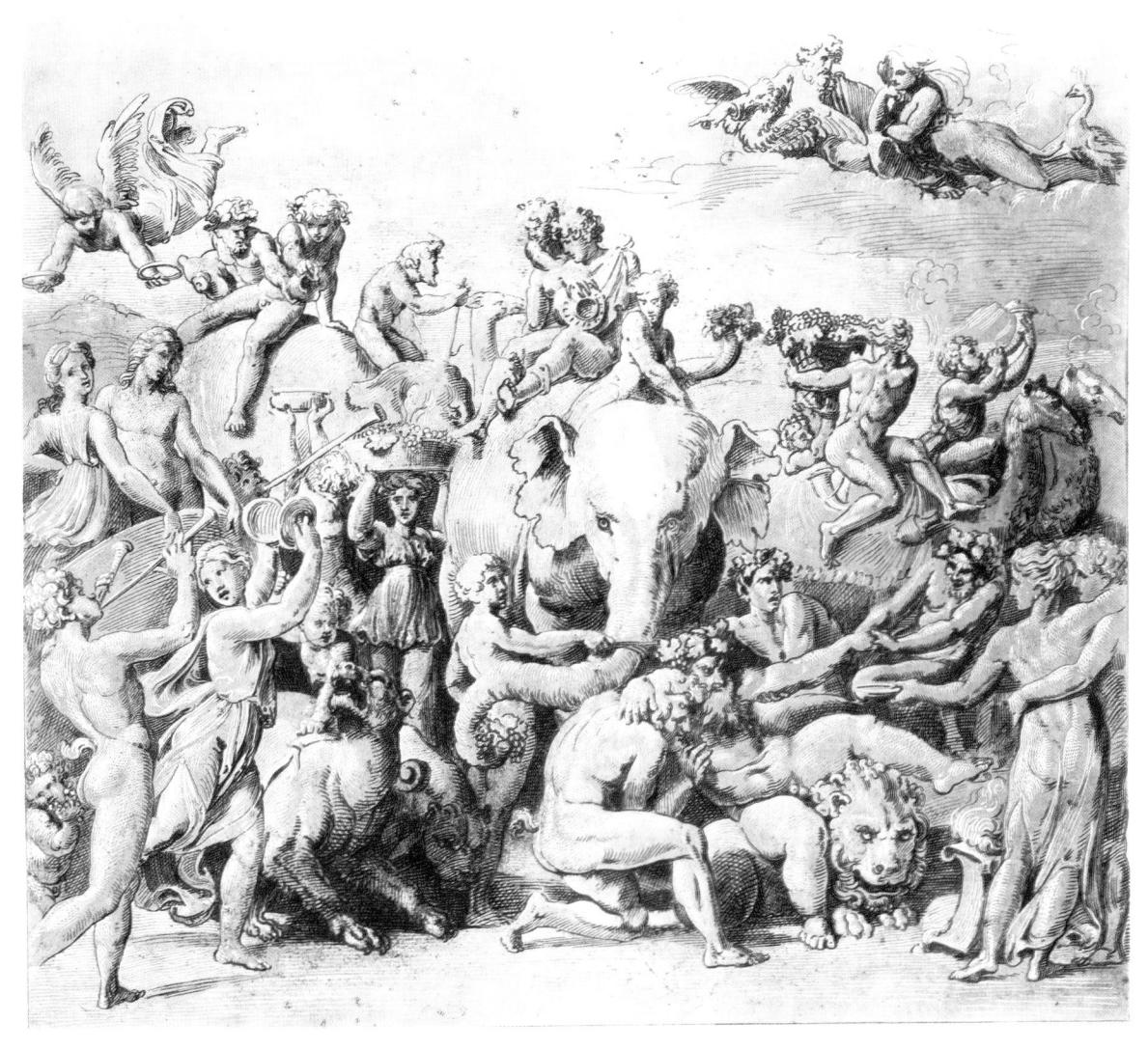

32 THE TRIUMPH OF BACCHUS
C.M. Metz, after Raphael
Engraving 35.25 x 38.5 cm.
This is a facsimile engraving, published in 1789, of a lost drawing probably executed by Gian Francesco Penni on Raphael's design in 1517. The image is here reversed to correspond to Raphael's original design.

months which he spent on the picture were for him an unusually short period, but as he had promised to finish it in less than half that time Alfonso had some grounds for impatience. Nonetheless, in his dealings with Titian the duke was more fortunate than he was with Raphael. Instead of producing a painting of *The Triumph of Bacchus*, Raphael merely sent a drawing of his composition (Plate 32) to Ferrara, where it was painted by another artist, Pellegrino da San Daniele. This picture is now lost. Raphael then asked for another subject, but he seems to have made no progress on it before his death in April 1520. At this point Alfonso once more turned to Titian, from whom he commissioned *Bacchus and Ariadne* (Plate 33).

This picture again took more time than anticipated, despite continuous pressure from the duke. At the end of 1521, as a means of inducing Titian to visit Ferrara, Tebaldi even suggested that he should be invited to accompany Alfonso on a projected trip to Rome. At first the artist showed some enthusiasm for the idea, but then claimed that he was ill. The ambassador, however, was unconvinced, and told the duke: 'I have been to see Titian, who has no fever at all: he looks well, if somewhat exhausted; and I suspect that the girls whom he often paints in different poses arouse his desires, which he then satisfies more than his limited strength permits; but he denies it . . .' One of these girls, incidentally, may perhaps have been a certain Cornelia, the daughter of a barber from a village near Pieve di Cadore; in 1524 and 1525 she had two sons by Titian, who were given the surprisingly classical names of Pomponio and Orazio. Later in 1525 he married her while she was seriously ill, but she survived for another five years and bore Titian another child, a daughter named Lavinia.

The idea of the trip to Rome having proved as futile as all Tebaldi's other efforts, in March 1522, after once more visiting the artist's studio, he wrote to Alfonso suggesting a new approach.

Today I spoke to Titian again, and he told me that he wants to put aside some other pictures and finish Your Excellency's. But, my lord, I doubt very much that he will do so; for he is a poor fellow, and spends freely, so that he needs money every day and works for anyone who will provide it, so far as I can see. Thus when some months ago Your Excellency sent him those 25 scudi, he began the picture, on which he had previously done nothing, and he worked on it for many days, making good progress; then he left it as it is now. In my opinion, therefore, I would suggest that Your Excellency should again send him some scudi, so that he has some spending money and can satisfy your wish to have the said picture.¹⁰

If this proposal was adopted it was not very effective, for Titian did not take *Bacchus and Ariadne* to Ferrara until January 1523. Somewhat ironically, the cooperation of the legate whom Alfonso had contemplated defrauding over the *St Sebastian* panel was needed to persuade him to do so; for by this point Titian claimed that he was afraid of having tried the duke's patience too far, so much so that he even demanded a safe-conduct. Of course, such protestations need not be taken very seriously. Titian worked no more slowly for Alfonso than for anyone else, and his behaviour in general was no more unreasonable than that of many other famous artists, for example Raphael and Michelangelo. Despite occasional tensions, for the most part he and his

patron remained on the friendliest terms, and Alfonso's impatience merely reflected his wholly understandable eagerness to possess another of Titian's masterpieces.

As a result of his success with *The Worship of Venus* Titian seems to have been allowed more initiative when he painted *Bacchus and Ariadne*. The principal literary source was again an ekphrastic text, this time taken from Catullus's *Carmina*, but some elements were also borrowed from other classical sources, notably Ovid's *Ars Amatoria*. Since Titian did not understand Latin, these passages must have been brought to his attention and translated by an adviser. It is likely that the detailed content of the picture was settled in Venice and that Alfonso was not fully informed about it in advance, since in 1522 Tebaldi took the trouble to send him a description of the composition, specifying the number of figures. On one feature, however, agreement must have been reached in Ferrara: the pair of cheetahs are almost certainly portraits of animals in the duke's menagerie.¹¹

As far as the visual sources are concerned, Titian's principal debt was to Raphael and particularly to the design he had sent Alfonso some years before. This included a very similar representation of Bacchus and his retinue. Similarly, the beautiful figure of Ariadne, whose confused emotions are so memorably expressed through her pose, is intensely Raphaelesque. Titian also took certain motifs from classical sculpture: the figure of Silenus, for example, recalls a motif in a famous and often-copied sarcophagus then in the Church of Santa Maria Maggiore in Rome. But to identify such borrowings ultimately does very little to explain his achievement. It is a misconception to see *Bacchus and Ariadne* as an eclectic or derivative work. Its greatest qualities, the irresistible joyfulness and vitality of the figures, the expansiveness of the landscape, the brilliantly realistic lighting and the marvellously sensitive painting of such details as the vase and the flowers in the foreground, are due to Titian alone.

His third picture for Alfonso's study was the *The Andrians*, now in the Prado (Plate 34). It replaced Pellegrino da San Daniele's version of *The Triumph of Bacchus*, which must have looked decidedly second-rate in such company. The commission dates from early in 1523 and the picture was taken to Ferrara, after the usual prevarication on Titian's part, at the beginning of 1525. Like *The Worship of Venus*, *The Andrians* is based on an ekphrastic passage in Philostratus, this time describing a painting of Andros, the island sacred to Bacchus where the rivers flowed with wine. Once more Titian took considerable liberties with his text, again introducing the convention of the parallel worlds of the gods and the mortals. The two girls reclining in the

centre, who had previously appeared in *The Worship of Venus*, are shown singing a canon to the words 'Qui boyt et ne reboyt il ne scet que boyr soit' ('He who drinks and does not drink again does not know what drinking is'). The theme of the picture, in fact, could hardly be simpler: through the effects of wine one can enter the realm the gods.

The reclining man in the centre of the composition is an obvious quotation from Michaelangelo's cartoon of *The Battle of Cascina* (Plate 4). This figure may have been included as an act of homage to Titian's great contemporary, but it is also possible that he took a certain malicious pleasure in showing a Florentine warrior among a crowd of drunken revellers. Most of the other figures, on the other hand, owe nothing to Michelangelo, particularly the glorious nude girl in the foreground (Plate 34) sleeping off the effects of wine. Her pose recalls the celebrated classical statue in the Vatican, now called *Ariadne*, but then known as 'Cleopatra', and here a cultivated spectator would surely not have failed to notice the contrast between the marble original and the marvellous rendering of living flesh in the painted version. By putting her in this corner of the composition Titian was also inviting a comparison with the sleeping figure of Lotis occupying exactly the same place in *The Feast of the Gods*, which was hung immediately to the right of *The Andrians*. The difference between his art and that of his teacher Bellini could not have been demonstrated more explicitly.

Titian's last contribution to Alfonso's scheme was to repaint the left side of the landscape in *The Feast of the Gods*, a task which he probably carried out during an extended visit to Ferrara in the first half of 1529. Bellini's original background had already been repainted once, presumably by Dosso Dossi, in order to make it consistent with the landscape in the adjacent *Triumph of Bacchus*. In the final arrangement, with Raphael's composition replaced by *The Andrians*, Bellini's picture was flanked by two works by Titian, so Dossi's landscape would have struck a discordant note. By a series of accidents Alfonso's original plan of having examples of the different schools of Italian painting was therefore replaced by a scheme dominated by the work of a single artist, Titian. The only picture in which he had no share was the so-called 'Bacchanal of Men' by Dossi, possibly a work now in the National Gallery, London, which was isolated on an end wall of the Camerino d'Alabastro.

The choice of literary sources, the freedom with which they were interpreted and the actual appearance of the pictures themselves show that in the decoration of his study Alfonso did not share his sister Isabella's taste for abstruse moralizing allegories. Instead, he seems simply to have wanted to recreate an ancient picture gallery such as Philostratus had described, and if this

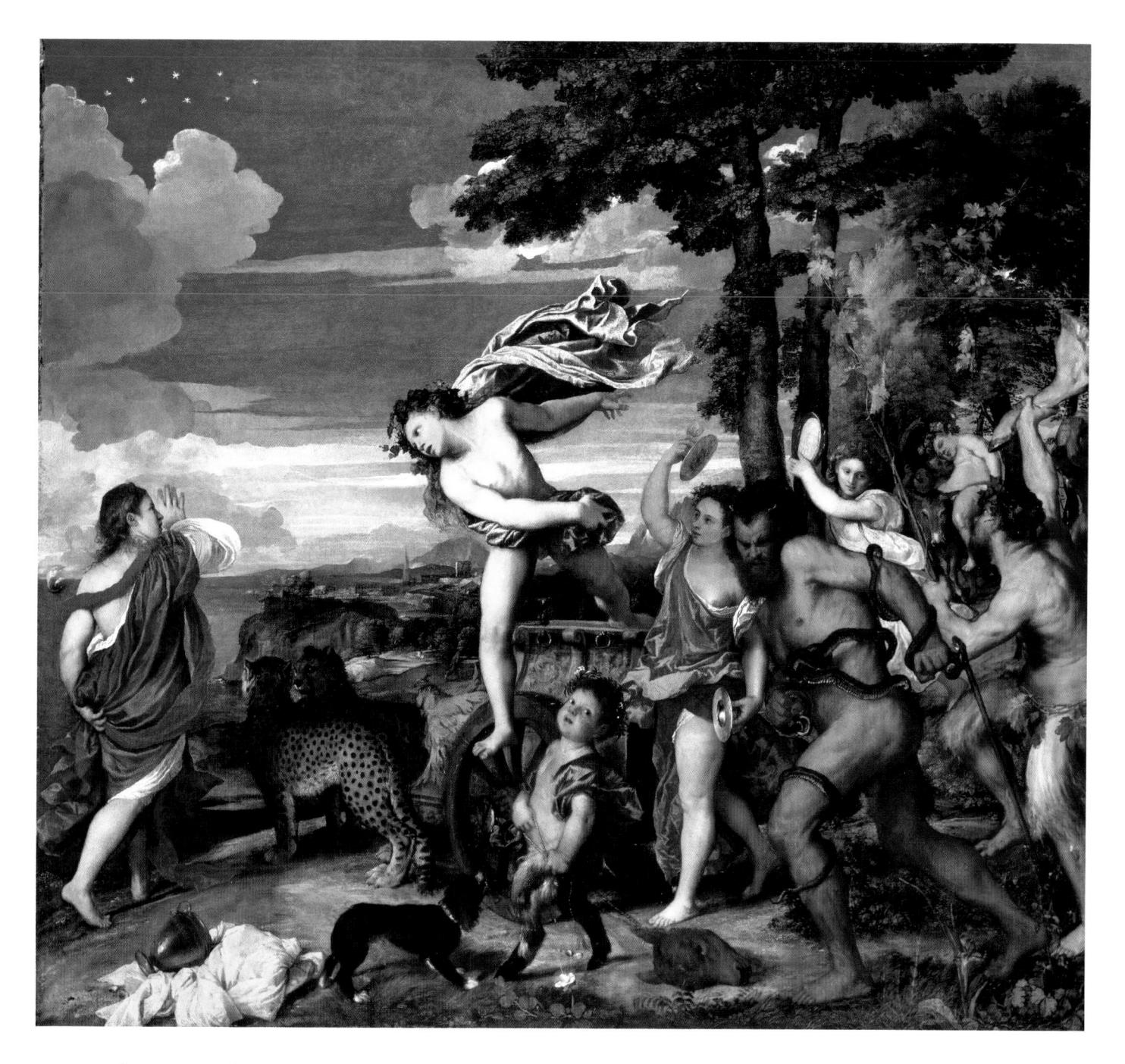

33 BACCHUS AND ARIADNE London, National Gallery. 1520–23. Oil on canvas 175 x 190 cm. Inscribed: TICLANVSF.

was his model it would be inappropriate to seek either for complex hidden meanings in the individual paintings or for any strong thematic links between them. At the same time the nature of the project, rather than any special predilection on Titian's part at this period, accounts for the overtly classical figure style of his paintings. What is most surprising, perhaps, considering

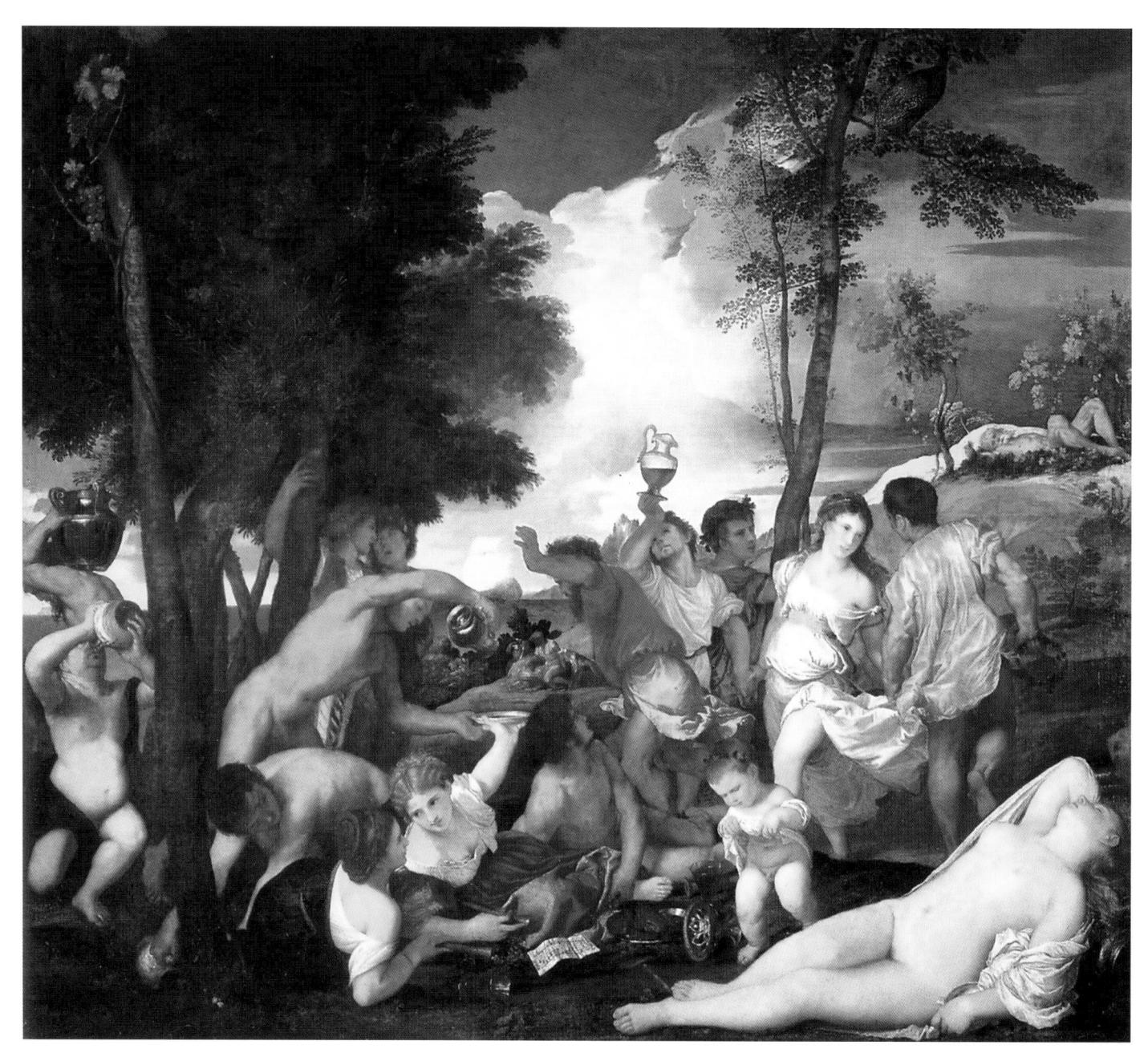

34 THE ANDRIANS
Madrid, Museo del Prado. 1523–25. Oil on canvas 175 x 193 cm. Inscribed: Ticianus F N. 201
[originally: Ticianus F]; and on the sheet of music: Qui boyt et ne reboyt II ne scet que boyr soit.
1516-1530 71

the outstanding quality of his contributions, is that he undertook a similar project only once in his career, in his mythologies of the 1550s for Philip II of Spain. For Venetian clients he painted virtually no mythological pictures based in this way on ekphrastic texts, and none at all of comparable scale or importance. The genre, in fact, long remained a predominantly courtly taste, the immediate successors to Titian's paintings for Alfonso being a series of *Loves of Jupiter* which Federico Gonzaga commissioned from Correggio around 1530; these were later owned by the Emperor Charles V.

This does not mean that Venetian collectors had no interest in erotic subjects as such. But they seem to have thought it frivolous to commission works of this type on the scale of Alfonso's pictures and they were relatively indifferent to classical precedent. It is true that in Venice paintings of naked women were sometimes given a mythological guise, for example Giorgione's *Venus*. But there was also a distinctive and more pervasive local tradition of pictures in portrait format of anonymous pretty girls, either clothed or partially nude, which were no more than elaborate pin-ups. One of Titian's earliest works of this kind, an usually sophisticated example of the genre, is *Flora* (Plate 35), which may conceivably be identical with a 'painting of a woman' mentioned by Tebaldi in a letter of December 1522. The identity of the girl as Flora is established both by the flowers in her hand and by her costume, which is of the type worn by nymphs in contemporary stage productions. These features give a clue to the significance of the picture, for in classical literature Flora was famous not only as a nymph but also a courtesan. The erotic implications of the painting, though treated with extreme sensitivity and discretion, are therefore central to its meaning.

Considered as a portrait, *Flora* is very different from the works of this type produced by Titian around 1510. The parapet has been eliminated and the figure now moves easily in the picture space, and by pose alone establishes the stability of the design. So natural and economical is the composition that it is easy to overlook the extraordinary intellectual achievement which it represents. For the syntax of portraiture, which we now take for granted, had to be invented, and much of the credit must go to Titian. The long process by which he acquired real mastery of the genre can be seen in a series of portraits of aristocratic sitters painted in the 1520s. It was in this decade that his reputation as a portraitist, which was to be the cornerstone of his European fame, was first established outside the confines of Venice through the commissions of his north Italian princely patrons.

The Portrait of Tommaso Mosti (Plate 37) has an inscription on the back of the canvas,

probably added in the seventeenth century, giving the name of the sitter and his age, twentyfive, as well as the name of the artist and the date of the picture, 1526. But this date cannot be correct, both because Mosti, a member of a family closely associated with Alfonso d'Este, from whom he received a benefice in 1524, is dressed as a layman, and because in 1526, so far as we know, Titian did not visit Ferrara.¹² As it happens, there is documentary evidence of Alfonso having commissioned a portrait of an unspecified sitter from Titian in 1520, a date which seems appropriate for this picture on the basis of style.¹³ The composition recalls *The Man with a Blue* Sleeve (Plate 17), but it is much more assured and sophisticated. Rather than forming a twodimensional triangle parallel to the picture plane, this figure is arranged in a true pyramid, thus creating a powerful sense of depth. The costume is no less elaborate than that in the London picture, but it no longer dominates the composition; it contributes to the visual interest but does not distract attention from the most important feature, the head. Wealth of surface incident, sureness of design and sympathy of characterization complement one another and create an outstandingly forceful and fluent image. Although it might be thought that Titian could have achieved this result quite independently, there is nothing in his portraiture of the second decade of the century which directly anticipates the Mosti portrait. But during a visit to Mantua late in 1519, in the course of a stay in Ferrara, he could easily have seen Raphael's celebrated Portrait of Baldassare Castiglione (Plate 36), which provides the most obvious prototype for this picture. In the general tonality, the type of costume and the emphasis on differences in texture, as well as in the three-dimensional pose, Raphael's masterpiece seems to have been the catalyst for a sudden enrichment of Titian's pictorial language.

It was probably as a result of working for Alfonso d'Este that Titian first came to the notice of his nephew Federico II Gonzaga. The artist spent a few days in Mantua at Federico's urgent invitation early in 1523, when he began a portrait which he completed in Venice a few months later. It is usually assumed that the sitter was Federico himself, but this is most unlikely; there was no immediate reason why he should have been so insistent to have Titian paint him at this precise moment, and he is in any case known to have commissioned two portraits of himself from the artist towards the end of the decade. To have acquired three such pictures in eight years seems excessive. A more likely candidate for the 1523 portrait would be Federico's younger brother Ferrante, then aged sixteen, who was about to leave home to spend several years in Spain. His imminent departure would have provided an obvious occasion for such a commission. If Titian did indeed paint Ferrante in 1523 the picture in question could be the

1516-1530 73

35 FLORA Florence, Galleria degli Uffizi. ϵ .1520. Oil on canvas 79 x 63 cm.

celebrated *Man with a Glove* (Plate 38), which may well have come from Mantua and which is always thought to be of about this date. The sitter, who has the first traces of a beard, would certainly be of approximately the right age, but since the only secure likenesses of Ferrante show him middle-aged, bearded and balding, the identification must remain somewhat speculative.

The Man with a Glove differs from the Portrait of Tommaso Mosti in several important respects. The residual parapet was eliminated, and, as in Flora, an effect of monumentality and balance achieved by means of the

pose alone. This pose, incidentally, is surprisingly close to that in Raphael's *Portrait of Angelo Doni* (Florence, Palazzo Pitti) of about 1506; it had already been used in Venice in a more timid form by Palma Vecchio in a portrait now in the National Gallery in London. At the same time, the costume in the Louvre picture is much less ostentatious than that in the *Portrait of Tommaso Mosti*, as if Titian, working now in a more adventurous format, had been content to tackle only one problem at a time. But its very simplicity contributes to the potency of the image, and quite deservedly *The Man with a Glove* has become one of the best known of all Renaissance portraits. As a statement of an aristocratic ideal, regardless of what the historical reality may have been, it is unsurpassed in its sympathy and economy.

One person who must have admired the portrait commissioned by Federico Gonzaga in 1523 was Pietro Aretino, who spent several months in Mantua before moving to Venice in March 1527. He immediately became acquainted with Titian and until his death in 1556 was to remain the artist's closest friend, his most articulate admirer and his most effective publicist. Born in Arezzo in 1492, Aretino was a prolific and versatile writer, immensely self-confident, arrogant, hedonistic and a determined enemy of pedantry in all its forms: at this period he was one of the few men with intellectual pretensions to pride himself on his ignorance of Latin. From about 1516 to 1525 he lived mostly in Rome, where he had known Michelangelo and Raphael, but he had been forced to leave the papal city after publishing a series of obscene sonnets illustrated with unusually explicit engravings by Giulio Romano. These earned him a certain notoriety, as did the *Ragionamenti*, a brilliantly vivid and unusually entertaining pornographic dialogue published in two parts in 1534 and 1536. His chief claim to fame,

1516-1530 75

36 PORTRAIT OF BALDASSAE CASTIGLIONE (opposite) Raphael Paris, Musee du Louvre. c.1514-15. Oil on canvas 82 x 66cm.

37 PORTRAIT OF TOMMASO MOSTI (above) Florence, Palazzo Pitti. *c.*1520–21. Oil on canvas 85 x 66 cm.

38 The Man with a Glove Paris, Musée du Louvre. a1523. Oil on canvas $100 \ge 89$ cm. Inscribed: TICLANVS

1516-1530 77

however, was a collection of his own letters published in six volumes from 1538 onwards. Many of these letters were written to his friends, notably Titian and the architect Jacopo Sansovino, who also arrived in Venice in 1527; others were addressed to prominent political figures in Italy and abroad. They are filled with gossip, poisonous abuse and shameless flattery, and they include some of the most perceptive comments on art published in the sixteenth century. Aretino's personal knowledge of recent developments in the major Italian artistic centres, his impatience with the literary stereotypes of contemporary criticism and his skill as a writer gave his opinions a unique authority and an immensely wide circulation. As contemporaries recognized, he played a crucial rôle in spreading Titian's name throughout Europe and in establishing his reputation as the foremost painter of his day.

One of Aretino's first actions in Venice was to commission his portrait from Titian. This picture was then sent to Federico Gonzaga together with a portrait of Girolamo Adorno, an imperial envoy who had died in Venice four years before. The portrait of Aretino is known only through an engraving, but that of Adorno, which is almost exactly contemporary with the one that Titian had painted for Federico in 1523, may be a picture now in the Louvre very close in style to *The Man with a Glove*. Of these two pictures in Paris, the supposed Adorno portrait is the more ambitious, being Titian's first known attempt at a three-quarter-length pose; it is, however, a less satisfactory composition since the sitter's body is placed rather arbitrarily on the canvas, the inflated scale of the image adding nothing to its authority.

Titian's second attempt at the three-quarter format, a portrait of Alfonso d'Este almost certainly painted in the winter of 1527–28 and now known only through a copy (Plate 39), is much more assured and effective. The pose now has a certain naturalness, and the mass of the body, instead of merely functioning as a space-filler, itself contributes to the impression of forcefulness and dignity. The costume, too, is more elaborate, and in the original, which was greatly admired by Michelangelo, must have created a marvellous effect through the rich variety of different materials. This development in Titian's portrait style once again seems to reflect his responsiveness to external influences, since the pose is very close to that of Sebastiano del Piombo's now ruined portrait of Pietro Aretino (Arezzo, Palazzo Communale), a picture whose greatest glory, according to Vasari, also lay in the variety of texture in the costume.

Once he had mastered the new format Titian proceeded to exploit it with unparalleled inventiveness. The three-quarter-length figure now became his standard portrait type for

39 PORTRAIT OF ALFONSO D'ESTE
Peter Paul Rubens(?), after Titian
New York, Metropolitan Museum of Art
(Munsey fund). Oil on canvas 127 x 98 cm.
The original portrait was probably painted in 1527-28.

important sitters, but in his hands it never degenerated into a stereotyped formula. In the few cases in which portraits with identical compositions are ascribed to him, it is probably safe to assume that only one of them is authentic. Among his finest portraits of this period is that of Federico Gonzaga (Plate 41), which almost certainly dates from the summer of 1529.15 It is clearly based on the Portrait of Alfonso d'Este, but includes a much more colourful costume. The most daring feature, however, is the little dog, a motif which might have tempted a lesser artist into sentimentality, but which instead merely makes the picture seem more intimate without detracting from the requirements of decorum. It was this portrait that finally seems to have convinced Federico of Titian's ability, and he was to employ the artist continuously until 1540, the year of the duke's death. It also seems to have given Federico the idea of taking Titian to Parma in October 1529 to meet and paint the Emperor Charles V. Unfortunately Charles, then on his first visit to Italy and

still unfamiliar with Titian's work, showed no interest in such a project and dismissed the artist with a meagre present of one ducat.¹⁶

This setback, for which Titian was generously compensated with 149 ducats by Federico, was followed only a few months later by one of his greatest triumphs, the completion early in 1530 of *The Death of St Peter Martyr*. During his own lifetime and indeed until its tragic destruction by fire in 1867, this painting was Titian's most celebrated work. It was commissioned, probably in 1526, by the members of the lay confraternity of St Peter Martyr for their chapel in the nave of the Church of Santi Giovanni e Paolo, which, with the Frari, is one of the largest and most important in Venice. The obvious candidate for the commission was Palma Vecchio, himself a member of the confraternity, but the patrons decided to hold a competition in which he and Titian both submitted designs. According to Ridolfi, another artist, Pordenone, also participated in the competition, but this is questionable since there is no other evidence to suggest that he worked in Venice before 1528.¹⁷ The idea for the contest may well have come from Titian, who agreed to carry out the commission for the unusually low fee of 100 ducats, or more if the patrons saw fit. As with *The Pesaro Madonna* (Plate 25), which he had recently completed for a comparable sum, he seems to have been attracted to the task by the prominence of the picture's location.

1516-1530 79

The Death of St Peter Martyr was the most frequently copied of all Titian's pictures, and its appearance is also recorded in an engraving by Martino Rota (Plate 40). Among the artist's surviving works the one that probably comes closest to it in its general character is St John the Baptist (Plate 42), which, on the basis of the spelling of the signature ('TICIANVS' rather than 'TITIANVS') is likely to date no later than 1535. The almost oppressive physical presence of the figure, the strong chiaroscuro and the beautifully observed, highly atmospheric landscape can all be paralleled in copies of the destroyed altarpiece. Moreover, in common with other works by Titian of the early 1530s, notably The Assumption of the Virgin of 1530–32 in Verona Cathedral, St John the Baptist has a markedly narrower range of colour than his pictures of the decade around 1520. The same was probably also true of The Death of St Peter Martyr, not only because of its tragic subject, but also because only on this basis can one envisage the dramatic effects of light which so impressed everyone who saw the altarpiece before its destruction.

In his dialogue L'Aretino, written more than a quarter of a century after this painting's completion, Lodovico Dolce singled out The Death of St Peter Martyr as Titian's greatest single work. At the beginning of Dolce's text, one of the two speakers, Pietro Aretino, says of the picture that 'the beauties of the invenzione, the disegno and the colorito ... are known ... to everyone.' In the language of sixteenth-century art criticism there could be no higher or more comprehensive praise. 'Invenzione' consists of something more than merely the composition; it is the whole manner in which the subject is conceived and presented. In this instance Titian's invenzione involved the use of an overtly rhetorical style even more extreme than that of the Frari Assumption of the Virgin (Plate 22). The complex rhythm of the main group of figures reproduced in Rota's engraving, especially the highly artificial contrapposto of the fleeing man at the left, shows that Titian was addressing himself primarily to sophisticated connoisseurs rather than to the pious Venetian public at large; while in the extreme virtuosity of the draughtsmanship and especially in the brilliant display of foreshortening, that is to say in his 'disegno', he was challenging and even surpassing the great artists of central Italy on their own ground. It might be argued that the excellence of the invenzione and the disegno and, in particular, the strongly three-dimensional character of the composition, owe something to the fact that on this occasion Titian was compelled by the circumstances of the competition to submit a preliminary drawing and thus work out his design in advance. But in the 'colorito', not just the colouring but also the handling of pigment and the treatment of light, he was apparently setting new standards in this specifically Venetian sphere of excellence.

40 THE DEATH OF ST PETER MARTYR
Martino Rota, after Titian. Engraving 37 x 27 cm.

This engraving, dating from the second half of the sixteenth century, is after the altarpiece which was formerly in the Church of Santi Giovanni e Paolo in Venice, but which was destroyed in 1867.

The altarpiece, of c.1526–30, was executed in oil on panel, transferred to canvas; its dimensions were 508 x 302 cm.

Analyzed in this way there is a danger that The Death of St Peter Martyr will be seen as little more than a prodigious and selfconscious display of skill. But this does less than justice to its extraordinary impact, which depended above all on its intense emotional and dramatic power. The best evocation of the contemporary response to the picture appears in a letter written by Aretino to the sculptor Tribolo. It is an elaborate ekphrasis, a passage of great literary artifice based on a type of rhetoric which is clearly intended to evoke the style of the painting itself, for example in the use of *contrapposti*, or antitheses, ¹⁹ and for this very reason it is all the more indicative of the strength and character of Aretino's appreciation:

If you were to direct the eyes of your sight and the light of your intellect towards this work you would comprehend all the living terrors of death and all the true agonies of life in the face and the

flesh of the man on the ground, and you would marvel at the chill and the flush which appear in the tip of his nose and in the extremity of his body; and being unable to restrain your voice you would let yourself exclaim, when you contemplated the companion in flight, that you could perceive in his appearance the pallor of vileness and the whiteness of fear. Truly you would give a just verdict on the merits of the great panel if you told me that there was nothing more beautiful in Italy. What a marvellous group of children there is in the sky, flying away from the trees which scatter the air with their leaves and branches; what a landscape, shown in all its natural simplicity; what grassy pebbles are bathed by the stream which springs from the brush of the divine Titian!

41 PORTRAIT OF FEDERICO GONZAGA (opposite) Madrid, Museo del Prado. 1529. Oil on panel 125 x 99 cm. *Inscribed: TICLANVS F* 1516-1530 81

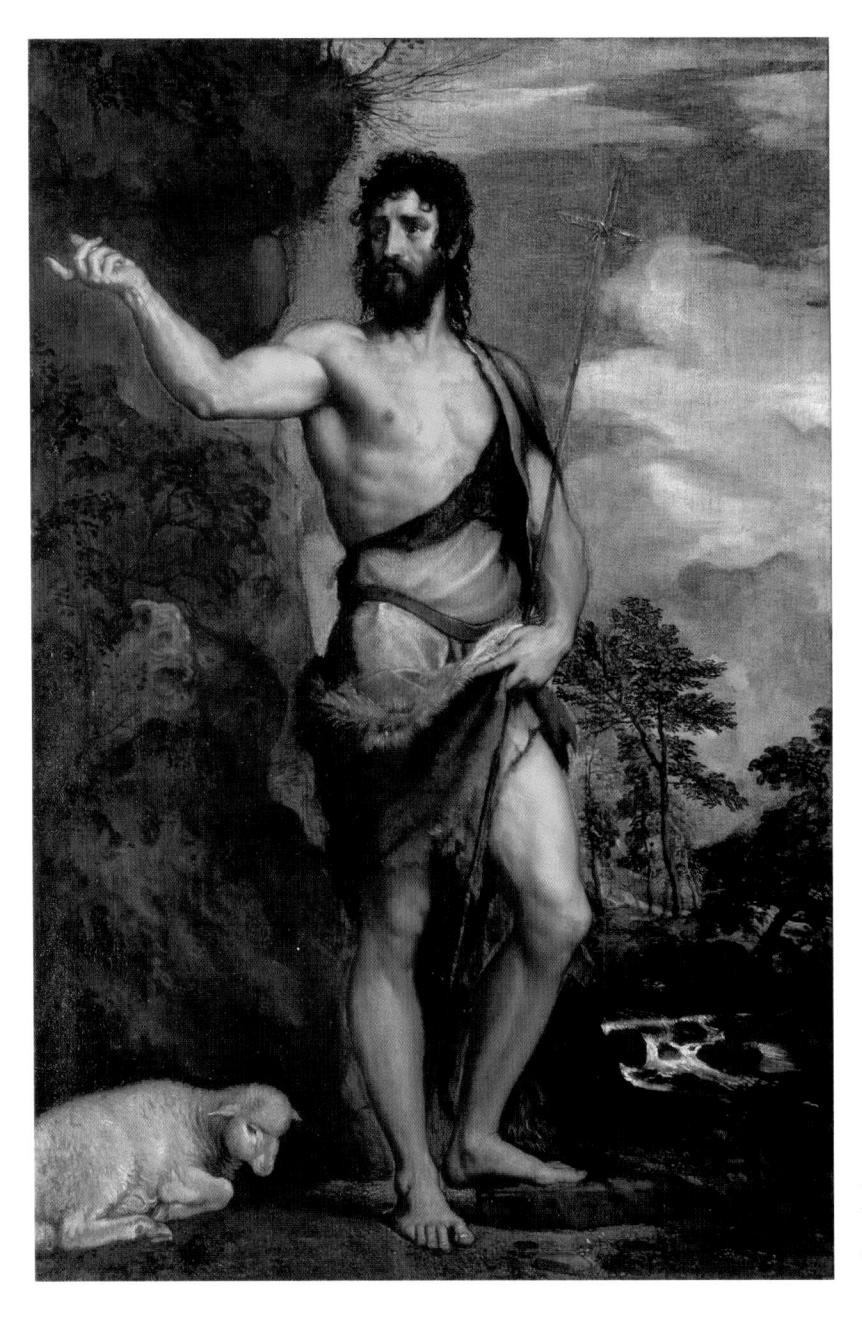

42 ST JOHN THE BAPTIST Venice, Gallerie dell' Accademia. a.1531. Oil on canvas 201 x 134 cm. *Inscribed: TICIANVS*

FOOTNOTES

- 1 On Fra Bartolommeo's visit to Ferrara, see Charles Hope, "The "Camerini d'Alabastro" of Alfonso d'Este', *The Burlington Magazine*, CXIII, 1971, p. 712, n. 2. In his letter to Alfonso d'Este of 14 June 1517, cited in this note, Fra Bartolommeo alludes to a recent stay in Ferrara.
- 2 For a full account see William Hood and Charles Hope, 'Titian's Vatican Altarpiece and the Pictures Underneath', *Art Bulletin*, LIX, 1977, pp. 534–552.
- 3 For the best discussion of the picture see Philipp Fehl, 'Saints, Donors and Columns in Titian's *Pesaro Madonna*', *Renaissance Papers 1974*, Durham (North Carolina), 1975, pp. 75–85.
- 4 On Malchiostro's rivalry with Averoldi and his commission to Titian, see Giuseppe Liberali, 'Lotto, Pordenone e Tiziano a Treviso', *Memorie dell'Instituto Veneto di scienze, lettere, ed arti*, XXXIII, 1963, fasc. III, pp. 54ff.

1516-1530 83

- 5 The common theory that Titian's picture for Lautrec was painted before 1517 is disproved by Sanuto, *Diarii*, XXIV, 67.
- 6 That in 1529 Titian was working specifically for Gritti, rather than for the state, is implied by a letter of 16 June 1529 from Alfonso d'Este to the doge (Giuseppe Campori, 'Tiziano e gli Estensi', *Nuova antologia di scienze, lettere ed arti*, XXVII, 1874, p. 599).
- 7 Hood and Hope. 1977, p. 547, n. 62.
- 8 The following discussion of Alfonso's mythologies and their early history is based on Hope, 1971, pp. 641–650, 712–721, and on Hood and Hope, 1977, p. 547, n. 57; for a different account, see Dana Goodgal, 'The camerino of Alfonso I d'Este', *Art History*, I, 1978, pp. 162–90.
- 9 Philipp Fehl, 'The worship of Bacchus and Venus in Bellini's and Titian's Bacchanals for Alfonso d'Este', *Studies in the History of Art* (Washington, National Gallery of Art), 6, 1974, pp. 37ff.
- 10 Charles Hope, 'Documents concerning Titian', The Burlington Magazine, CXV, 1973, p. 810. The value of the scudo and the ducat varied in different places and at different times, but the two units may be taken as having been roughly equivalent.
- 11 Frequent references to 'pardi' appear in documents of this period in the Archivio Estense (Archivio di Stato, Modena).
- 12 For a full discussion see the exhibition catalogue *Tiziano nelle Gallerie fiorentine*, Florence, 1978, pp. 209–16. Suggestions that the portrait actually shows Vincenzo or Agostino Mosti, Tommaso's brothers, and that the inscription is otherwise accurate are unpersuasive, since neither was twenty-five in 1526: Vincenzo took part in the Battle of Ravenna in 1512 (Wethey, *Titian*, II, p. 120) and Agostino was born in 1505 (A. Solerti, 'La vita ferrarese nella prima metà del secolo decimosesto descritta da Agostino Mosti', *Atti e Memorie della R. Deputazione di Sloria Patria per il Romagna*, ser. 3, X, 1892, p. 203).
- 13 See Alfonso d'Este to Jacopo Tebaldi, Ferrara, 23 December 1520 (Campori, 1874, p. 592).
- 14 In the winter of 1527–28 Titian executed 'tre cose' for Alfonso in Ferrara, each worth 100 ducats (Campori, 1874, p. 599). It seems reasonable to suppose that these pictures, painted in Ferrara rather than Venice, included the portrait of Alfonso himself and that of his mistress Laura dei Dianti, neither of which is otherwise documented.
- 15 Titian painted a portrait of Federico during the summer of 1529 (see Federico Gonzaga to Alfonso d'Este, Mantua, 16 April 1529, in Mantua, Archivio di Stato, Archivio Gonzaga, busta 2932, libro 298, p. 68). This portrait was apparently completed during 1529, so it cannot be identified with a portrait of Federico in armour on which Titian was working in 1530.
- 16 For Titian's early portraits of Charles V, see Hood and Hope, 1977, pp. 551f.
- 17 Two documents concerning Pordenone's work at the Church of San Rocco in Venice, published by Gustav Ludwig ('Archivalische Beiträge zur Geschichte der venezianischen Malerei', *Jahrbuch der königlich preuszischen Kunstsammlungen*, XXVI, 1905, Beiheft, pp. 124f.) with the date 1527, are actually of 1528 and 1529 respectively.
- 18 Hood and Hope, 1977, pp. 535-38.
- 19 For an important study of the relationship between rhetoric and sixteenth-century art see David Summers, 'Contrapposto: Style and Meaning in Renaissance Art', *Art Bulletin*, LIX, 1977, pp. 336–61.

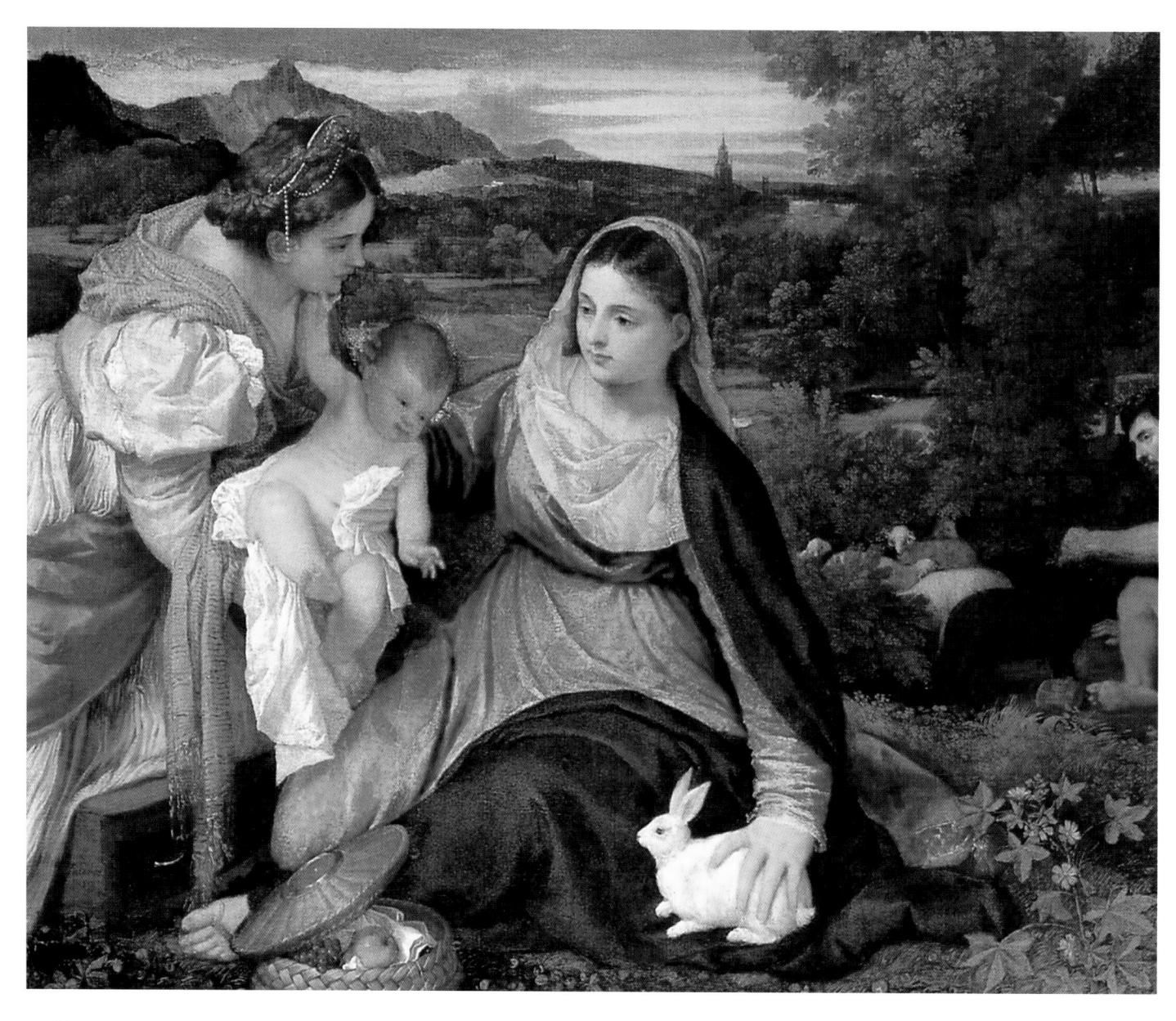

43 MADONNA WITH A RABBIT (MADONNA AND CHILD WITH ST CATHERINE OF ALEXANDRIA AND A SHEPHERD) DETAIL.

Paris, Musée du Louvre. 1529–30. Oil on canvas 84 x 70 cm. *Inscribed: Ticianus F.*

1530-1547

In the fourteen years which separated the commission for *The Assumption of the Virgin* in 1516 and the completion in 1530 of The Death of St Peter Martyr Titian devoted most of his energies to large-scale compositions. In these pictures, and especially in the three great altarpieces for the Frari and Santi Giovanni e Paolo, he was seeking to establish a reputation as a specifically modern artist, to be judged not only by the standards of Venice but also by those of Florence and Rome. After finishing The Death of St Peter Martyr the focus of his interest shifted towards smaller works, mostly portraits, many of which were commissioned by aristocratic patrons living in other parts of Italy and even in Spain. The proportion of Titian's output devoted to such pictures is not generally appreciated, since so many are lost. For example, of more than thirty paintings which he is known to have sent to Federico Gonzaga between 1527 and 1540 only three can now be identified with any confidence and eleven others are known only through copies. Similarly, of some fifteen pictures acquired by the Habsburg family, their courtiers and ministers between 1532 and 1542 no more than two seem to have survived. The extent of the loss is tragic, but it probably does not seriously affect our understanding of Titian's development, since his extant works appear to provide a fair sample of his output: they are evenly distributed chronologically and they include several that were particularly admired by his contemporaries.

One can only speculate about the reasons why Titian changed the direction of his career in this way. By 1530 he was almost certainly already in his mid-forties and may well have felt that his status as a painter of monumental compositions was now secure. It is possible, therefore, that he welcomed the challenge of working in a smaller format. But from what we know of his personality it is likely that financial considerations also played their part. In 1548 a minor Venetian painter, Paolo Pino, commenting on the lack of patronage in his native city, complained that even Titian could not command a fair price for his pictures there. The rewards available elsewhere were certainly more substantial. Thus the sum which he received for *The Pesaro Madonna* or for *The Death of St Peter Martyr* was no more than his fee for an important portrait, and in the case of the second of these altarpieces he had the added inconvenience of lengthy litigation before he was paid. Later in the 1530s, as we shall see, Titian was to demand

much more for an altarpiece in Venice, but on this occasion the patrons cancelled the commission. In working for princely patrons such problems seem to have been less frequent, since the artist often agreed to supply a series of pictures in return for a regular income. An additional advantage of such clients was that to some extent they left him free from day-to-day interference. This could have been important to a painter such as Titian, who liked to work slowly, turning his attention from one picture to another according to his mood.

His most important patron in the 1530s was Federico Gonzaga. Born in 1500, Federico was several years younger than Titian, which may have led him to behave rather more deferentially towards the artist than his uncle Alfonso d'Este had done. As a result, Titian himself was somewhat more obliging in completing pictures on time. Federico's decision to employ Titian on a regular basis was marked in the autumn of 1529 by a commission for no less than three paintings and by an offer of help over the purchase of some land near Treviso from the Venetian Monastery of San Giorgio Maggiore. The negotiations over the land ultimately came to nothing, but in the following year the duke more than compensated Titian with the gift of the benefice of Medole, near Mantua, for his seven-year-old son Pomponio. Thereafter the artist worked for him continuously for the next ten years.

The three pictures ordered by Federico in 1529, all of which were finished within a year, were a second portrait of himself, this time in armour, a composition showing women bathing and a small religious work. Only the last of these, the Madonna with a Rabbit (Plate 43), still survives. In its format and design it recalls Titian's very early Giorgionesque paintings, but the warm tonality, the rendering of evening light and landscape are the work of a mature master. At the same time the contrast with The Death of St Peter Martyr, completed at virtually the same moment, shows the futility of attempting to analyze Titian's development purely in terms of the figure style. In this respect the two pictures could hardly be more different: in the altarpiece the dramatic, rhetorical treatment is in keeping with the subject and the public setting; in the Madonna, intended for a sophisticated private collector, Titian adopted a lower key, displaying his skill by calculated understatement. One curious feature of the picture is the resemblance between the shepherd and Federico himself. This can hardly be accidental since Titian was working on a portrait of the duke at exactly the same time. It would probably be wrong to see Federico's inclusion here as indicative of a slightly misplaced vanity. On the contrary, Titian's composition more probably reflects his desire to avoid the incongruities associated with the old-fashioned convention of the donor portrait.

1530-1547

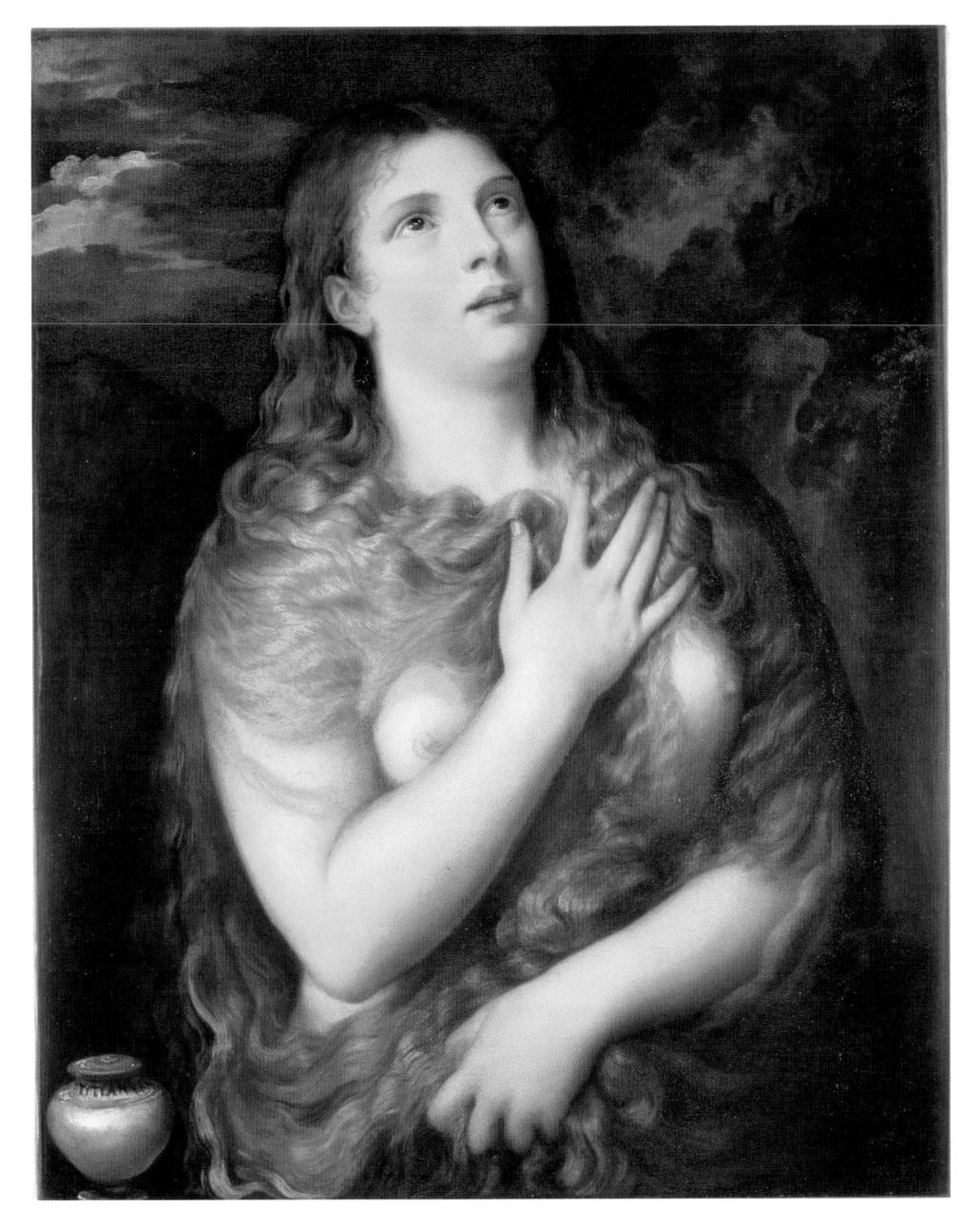

44 ST MARY MAGDALEN Florence, Palazzo Pitti. c.1535. Oil on panel 84 x 69 cm. *Inscribed: TITLANVS*

In the *St Mary Magdalen* in the Pitti (Plate 44), by contrast, the religious content is a decidedly minor element in the picture's appeal. The composition was one of Titian's most popular, and he repeated it on numerous occasions; but in most cases the figure was shown clothed. Dolce said of these *Magdalens* that they aroused feelings of compassion rather than lasciviousness, a comment that seems singularly inappropriate in connection with the Pitti version. Indeed, it is hard to imagine a more overtly sensual treatment of the subject. The

earliest reference to a picture of this type dates from 1531, when Federico Gonzaga asked Titian to paint a *Magdalen* as a gift for the Marchese del Vasto, Alfonso d'Avalos, a general in the service of Charles V.² As it happened, the artist was already working on such a painting for another client, but rather than sending this version to the duke he began a second one which he said would be somewhat different and, he hoped, more beautiful. It is tempting to suppose that the earlier composition showed the figure draped, and that Titian's modification involved the removal of the Magdalen's clothing; one could well envisage him thinking that in this form it would have a stronger appeal to d'Avalos. Unfortunately, this theory about the origin of the Pitti type cannot be proved, since neither of the 1531 versions of the subject can be identified. But the enduring popularity of Titian's *Magdalens*, both lightly clothed and naked, was surely not based on their religious content alone.

In 1532 Federico once more presented Titian to Charles V, this time with more productive results. Early in November 1532 the emperor stopped in Mantua on his way to meet Pope Clement VII in Bologna, and on the day after his arrival the artist was summoned from Venice to paint his portrait. According to Vasari, he was invited at the suggestion of Cardinal Ippolito de' Medici, who had himself just arrived in Mantua after a visit to Hungary. There may well be some truth in this story, since Ippolito had good reason to be aware of Titian's skill as a portraitist. He had recently spent two weeks in Venice, where he had enjoyed the company of a famous courtesan named Angela Zaffetta, a close friend of Pietro Aretino, and had commissioned a portrait of himself from Titian.³ This picture, showing the cardinal in Hungarian costume, is now in the Pitti (Plate 45). It is a typical example of the ease with which Titian now handled the three-quarter-length format, unusual only in the relative lack of detail, which was presumably due to the limited time at his disposal.

As one would expect, the portrait of Charles V, completed in Bologna early in 1533, was in a similar format, but it was very much more elaborate. Even though Titian seems to have painted no less than five versions of this picture for different patrons, the composition is preserved only in a copy by Rubens. As in Titian's second portrait of Federico Gonzaga, a work which Charles certainly admired, the costume consisted of a suit of armour, evidently painted with stunning virtuosity. But still more remarkable was Titian's skill in producing a highly flattering and sympathetic likeness, no easy task considering that Charles possessed typically unprepossessing Habsburg features. Not surprisingly the portrait was received with great enthusiasm. Before leaving Bologna Charles gave the artist no less than 500 scudi and

1530-1547

immediately after he returned to Spain granted him the rank of Count Palatine and Knight of the Golden Spur. In his patent of nobility the emperor described Titian as the 'Apelles of this century' and included a specific reference to the famous story about Alexander the Great, who had allowed himself to be painted only by the original Apelles. Although he was unable to follow Alexander's example, Charles retained his admiration for Titian until his death and it was principally through Titian's portraits that his appearance was known to contemporaries and to posterity.

One of the most famous of these portraits, *Charles V with a Dog*, in the Prado (Plate 46), is always associated with Titian's

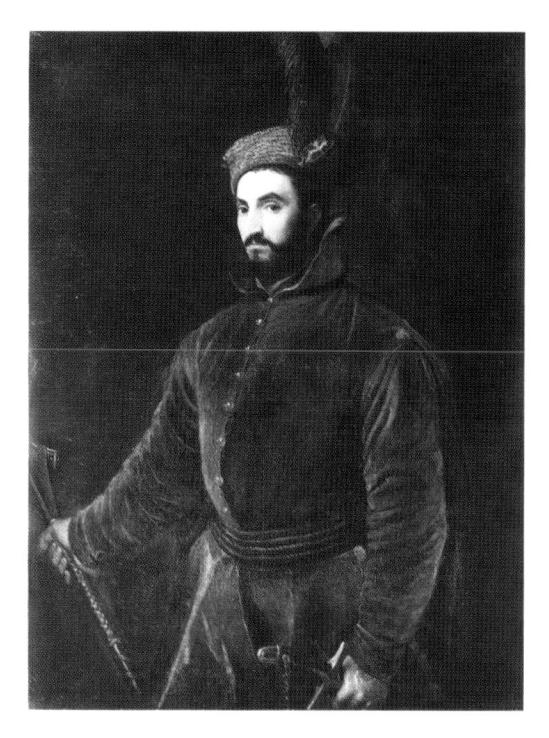

45 PORTRAIT OF CARDINAL IPPOLITO DE' MEDICI IN HUNGARIAN COSTUME Florence, Palazzo Pitti. 1532. Oil on canvas 139 x107 cm.

visit to Bologna in 1532–33. It is a copy of a picture by the Austrian artist Jacob Seisenegger, which certainly dates from this period, but Titian's version was apparently based not on the original, but on a drawing after it. This is indicated by the fact that the two pictures are identical in general composition, but differ markedly in such minor details as the embroidery and the dog's collar. It is precisely features of this kind which would have been recorded correctly in a copy made from the actual painting, but omitted from a sketch. That Titian should have taken the trouble to make such a drawing is not in the least surprising. He was keenly interested in the work of other portraitists, and the full-length format used by Seisenegger was an outstanding example of a type still very rare in Italy. The implication, of course, is that the picture in the Prado was itself presumably not painted in Bologna, but in Venice; this would account for a certain lack of animation in the face. There is some reason to believe that Titian presented it to the emperor or to a member of his court when they met again at Asti in the summer of 1536.⁴

Charles had little interest in painting as such and at first he was only attracted by Titian's work as a portraitist. He even invited him to Spain to paint his wife, the Empress Isabella, and their

son Philip.⁵ The artist initially agreed, but soon began to prevaricate in his usual way, so much so that the Spanish ambassador in Venice reported pessimistically early in 1535: 'As to his departure, I remain very doubtful about it, since I see him so attached to this Venice of his, which he loves and whose praises he is always singing to me . . .'6 In the end Titian remained in Venice, where he had more than enough work to keep him fully occupied. Not only had his visit to Bologna brought him several new clients among Charles V's courtiers, but he was still employed by Federico Gonzaga, and, from 1532, also by Federico's brother-in-law Francesco Maria della Rovere, Duke of Urbino.

As one might expect, portraiture played a conspicuous part in Titian's work for Francesco Maria. In 1536, just before he set out to meet the emperor at Asti, Titian began the celebrated portrait of the duke now in the Uffizi (Plate 47). There is some indication that this picture was planned at first as a full-length composition like *Charles V with a Dog*, which seems to have been finished at about this time; but in the form in which it was painted it was very similar, instead, to the portrait of the emperor in armour. The *Portrait of Francesco Maria della Rovere* shows very clearly why Titian was so much in demand as a portraitist, for it perfectly illustrates his ability to convey an impression of aristocratic poise and magnanimity. But as an actual likeness it is probably not very faithful; at any rate, the duke's features are scarcely different from those of several of Titian's other princely sitters. In the sixteenth century accuracy in this respect does not seem to have been considered of much importance. On more than one occasion Titian painted individuals whom he had never seen, and his pictures were nonetheless thought to be entirely satisfactory. His portraits were admired primarily because they showed his sitters as embodiments of the ideals of their social class, and as a result they continued to provide the models for aristocratic portraiture throughout Europe until the end of the eighteenth century.

Titian's portrait of the Duchess of Urbino, Eleonora Gonzaga della Rovere, was probably begun in the autumn of 1537, when she paid an extended visit to Venice. This picture, also in the Uffizi (Plate 48), was completed in the following spring. Since it is the same size as the portrait of her husband, the duke, one might have expected Titian to have adopted a similar format, but instead he showed Eleonora seated, basing his design on Raphael's famous *Portrait of Joanna of Aragon* (Paris, Musée du Louvre), the cartoon of which he would have seen in Ferrara in 1519. The portrait of the duchess, however, differs from its prototype in several important ways. Joanna was one of the most celebrated beauties of her day, and she was shown like a fashion model, sumptuously dressed, set in a pose of frozen elegance against an unreal

1530-1547 91

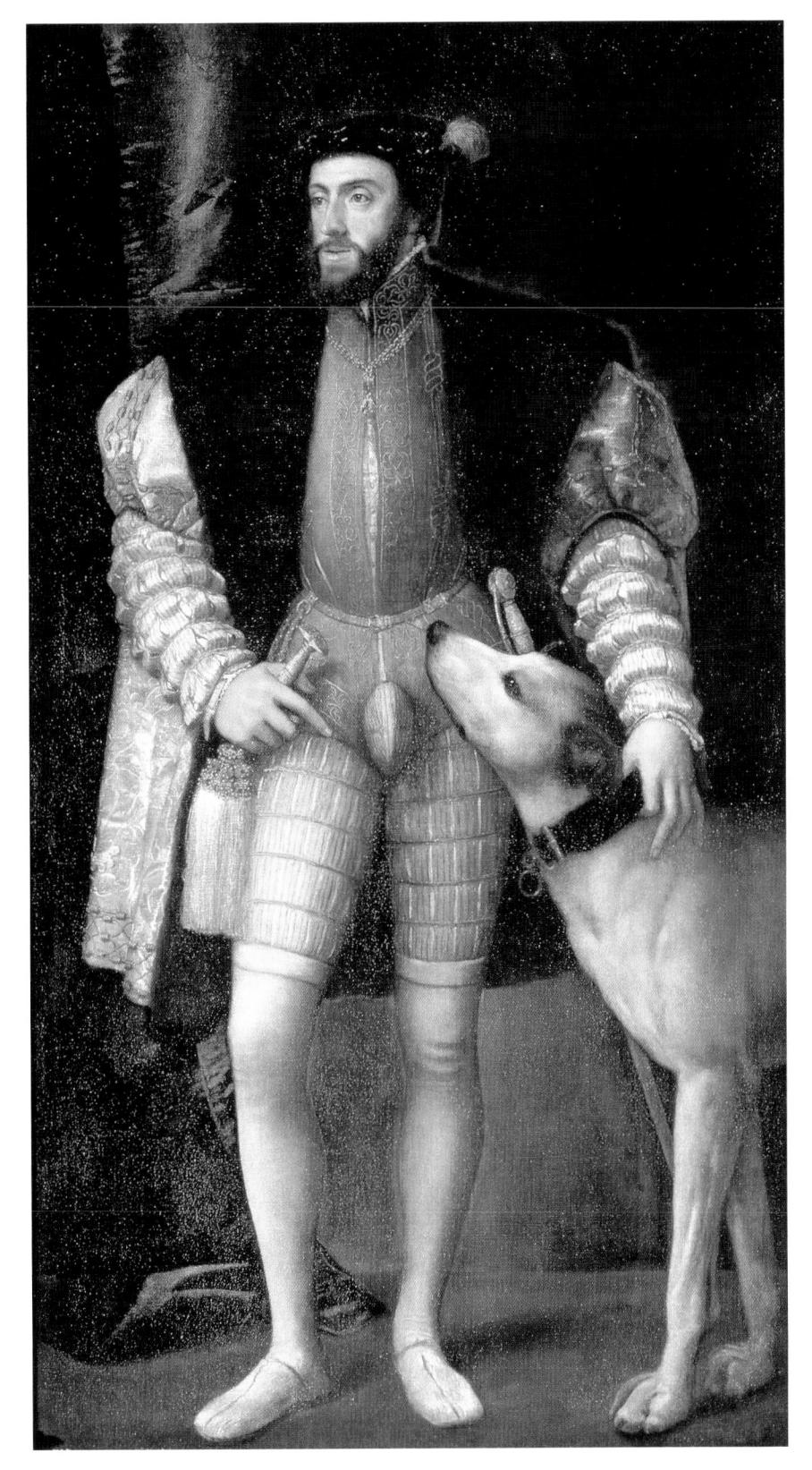

46 Portrait of Charles V with a Dog Madrid, Museo del Prado. 1536? Oil on canvas 192 x 111 cm.

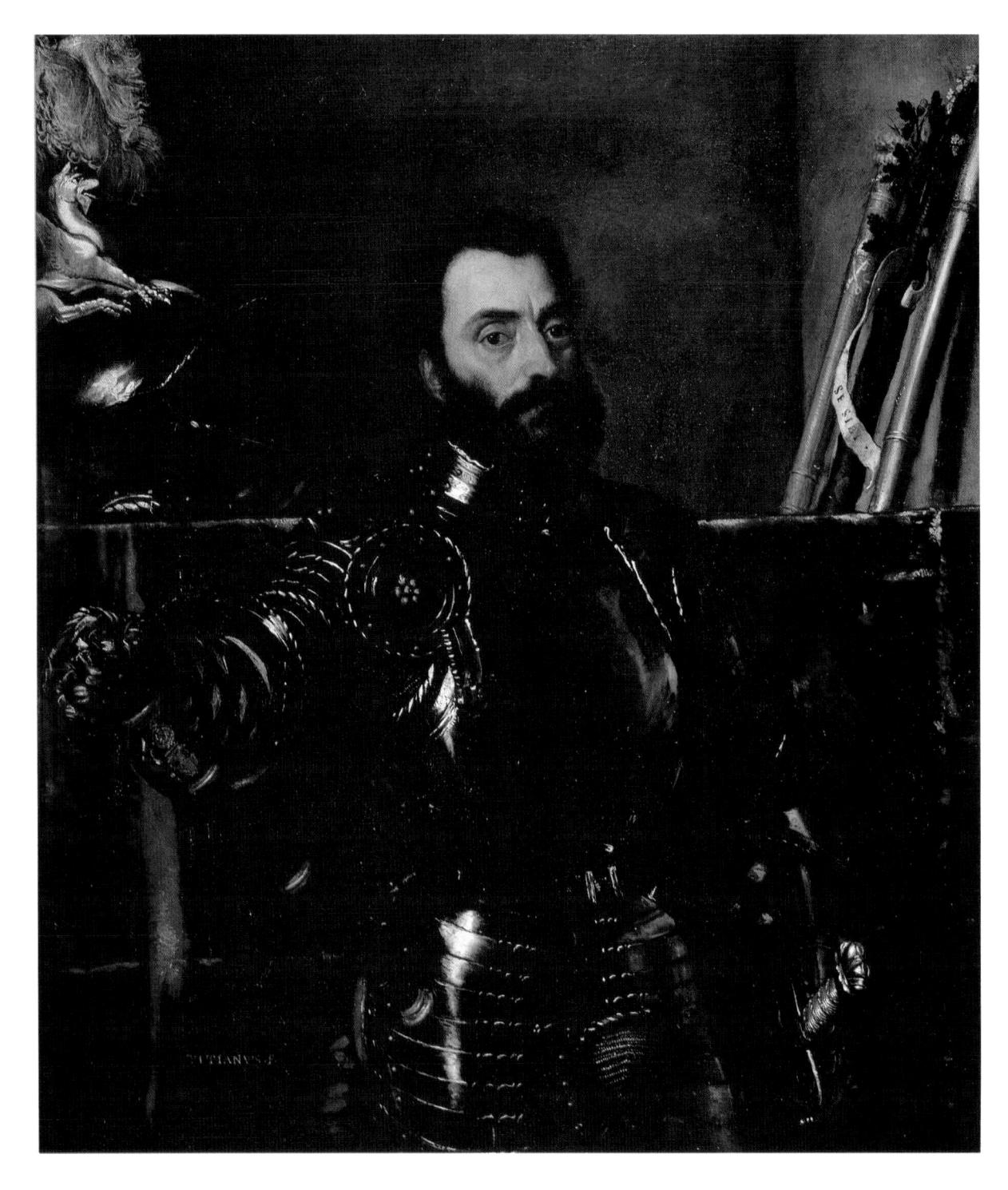

47 PORTRAIT OF FRANCESCO MARIA DELLA ROVERE Florence, Galleria degli Uffizi, 1536–38. Oil on canvas 114 x 103 cm. *Inscribed: TITLANVS. F.*

48 Portrait of Eleonora Gonzaga della Rovere (opposite) Florence, Galleria degli Uffizi. ε.1537–38. Oil on canvas 114 x 103 cm. 1530-1547 93

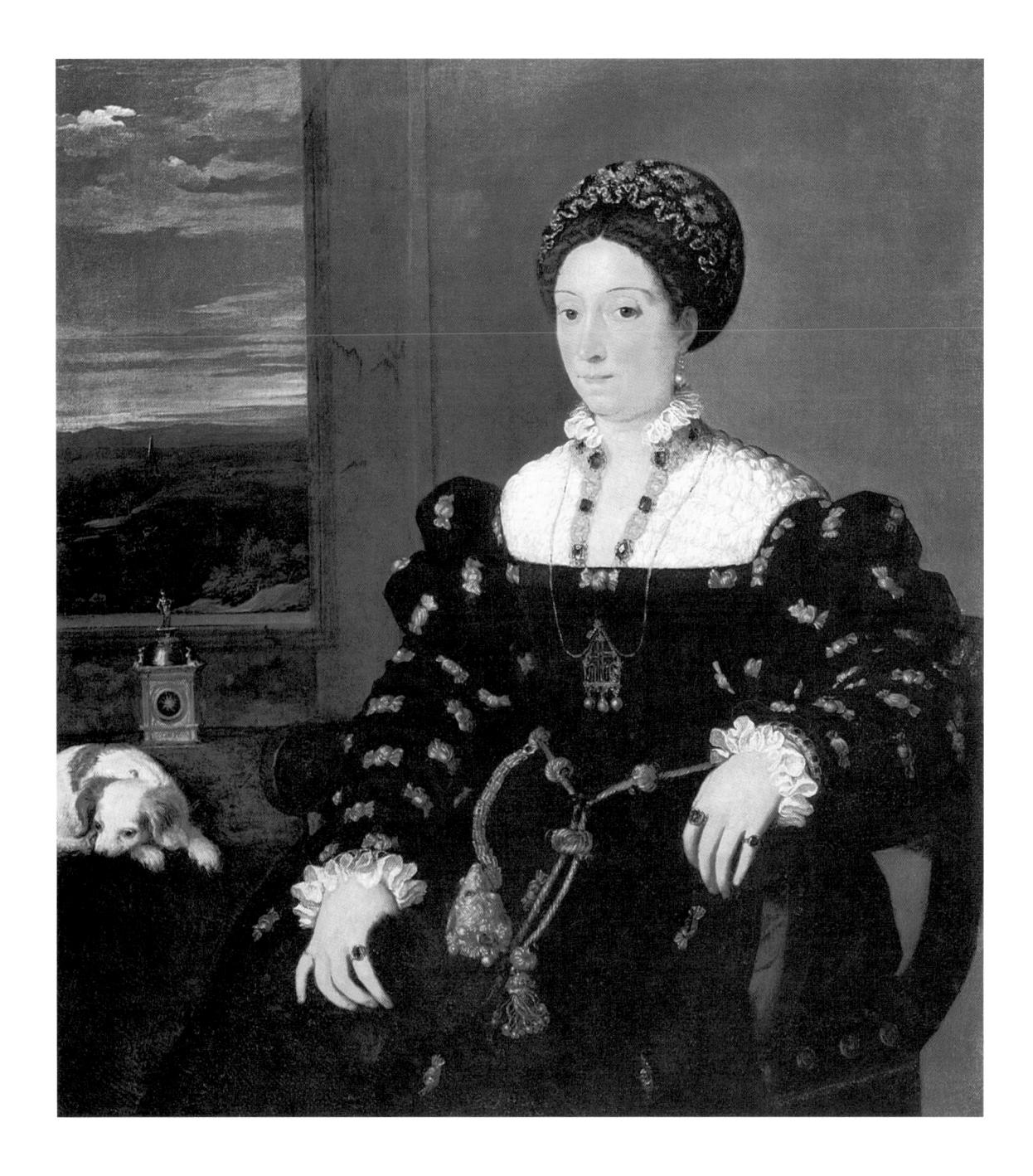

background. Titian retained only the basic structure of the pose, deliberately playing down the splendour of the setting; even the costume, though opulent, is discreet. As a result, through an art of calculated understatement, the natural warmth and sympathy of Eleonora's personality emerge all the more clearly.

So far as we know, Titian had used a similar pose only once before, in a portrait of Isabella d'Este completed in 1536 and now in Vienna. But whereas Eleonora, as we know from her letters, was singularly free of personal vanity, Isabella was a notoriously vain woman, and her

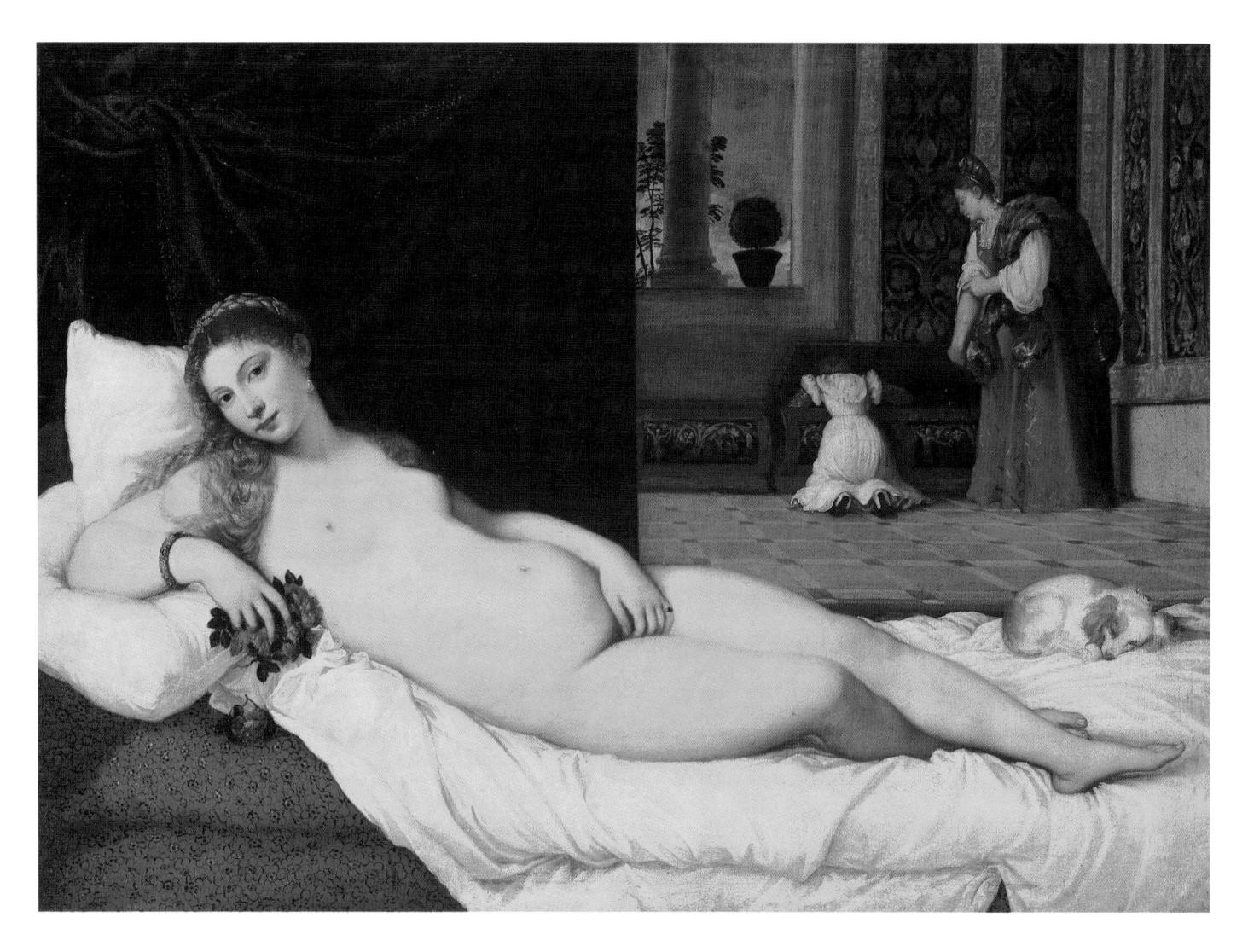

49 The Venus of Urbino (Girl on a Bed) Florence, Gallcria degli Uffizi. Completed 1538. Oil on canvas 119 x 165 cm.

portrait, despite its beauty, is both less memorable and less strongly characterized. At first sight it seems surprising that he should have waited for fifteen years before making use of Raphael's invention. The reason was that in general the seated pose was reserved for certain specific categories of sitter, such as distinguished old men, especially popes, and women of high social rank; it evidently had particular connotations of status and respectability, which Titian further emphasized in the portrait of Eleonora by the inclusion of a small clock, itself a familiar status-symbol. It was therefore only appropriate that this picture should have been praised by contemporaries specifically for the fact that it so successfully conveyed the virtuous character of the duchess.

1530-1547 95

Such comments might now seem unnecessary but as we have seen, female portraits produced in Venice at this period, for example Titian's *Flora* (Plate 35), often showed women who were far from virtuous. Francesco Maria della Rovere himself acquired an outstanding example of this type from Titian in 1536, the *Portrait of a Girl in a Blue Dress* in the Pitti (Plate 50). Here the sitter was just a pretty girl, presumably meant to be anonymous, who also appears in a very similar composition by Titian in the Kunsthistorisches Museum, Vienna, wearing only a fur wrap, and yet again, equally revealingly dressed, in still another version in the Hermitage Museum, St Petersburg, which is of lower quality. The portrait in the Pitti, in fact, was almost certainly not commissioned by the duke, but was merely a particularly fine example of a standard type of mildly erotic painting available in Titian's studio.

Two years later Francesco Maria's son Guidobaldo acquired another picture from Titian showing the same model, the famous Venus of Urbino (Plate 49). The present title is doubly misleading, for the painting was never in Urbino, but in Pesaro, nor is it a representation of the goddess. Although Titian used the pose of Giorgione's Venus he retained nothing from this picture in either the setting or the subsidiary figures to indicate the identity of the woman. Instead, he simply showed a mortal female lying on a bed and gazing at us with a startlingly direct and unambiguous sexual invitation. In its imagery The Venus of Urbino, which Guidobaldo referred to merely as 'the naked woman', belongs essentially to the same category as the Girl in a Blue Dress. This is something that many art historians have been reluctant to accept, since the idea that an artist in Venice at this period could have painted an elaborate erotic genre scene of this kind violates some widely held preconceptions about the iconography of Renaissance pictures. It has even been suggested, with an astonishing disregard of the clear visual evidence, that The Venus of Urbino celebrates not the joys of love in general, but specifically of love in marriage. This theory presupposes that the picture is associated with a particular marriage; but it is not. It can hardly commemorate the marriage of Francesco Maria, because it was purchased by his son during his lifetime, nor that of Guidobaldo, since at one moment he was worried that Titian would sell it to another client, an unlikely eventuality had it had any strong personal significance for him. All the available evidence therefore indicates that the subject is as straight-forward as it appears. Of course, the simplicity of the iconography makes Titian's picture all the more remarkable. No one before had ever treated a realistic theme with the same seriousness and monumentality as an allegory or mythology, and no one was to do so again in the sixteenth century. The closest parallel to *The Venus of Urbino*, in subject and composition, is Manet's Olympia, (Paris, Museé d' Orsay).

1530-1547 97

At this period Titian was engaged on his largest single undertaking for Federico Gonzaga, a series of eleven portraits of Roman emperors painted between 1536 and 1540. The originals were later destroyed by fire in Spain, but their appearance is preserved in various copies. The pictures were all designed for a single room in the Palazzo Ducale, and it is perhaps indicative of the change in direction in Titian's career that this major decorative project should have involved portraiture rather than anything more elaborate. Although it is difficult to imagine that the result was as exciting as the cycle of mythologies in Ferrara, the *Emperors* were always regarded as one of his supreme achievements. Some idea of the impact of these pictures can be gained from another work by Titian of exactly this period, the *Portrait of Pietro Aretino* in the Frick Collection (Plate 51), which must have been completed by 1538 when the composition was used as the basis of a woodcut.⁸ But even this picture, impressive as it is, cannot do justice to the effect that a whole series of portraits by Titian must have had. The features of the individual figures were taken from classical coins and busts, and the easy vigour and

50 PORTRAIT OF A GIRL IN A BLUE DRESS (LA BELLA) (opposite) Florence, Palazzo Pitti. 1536. Oil on canvas 100 x 76 cm.

51 PORTRAIT OF PIETRO ARETINO New York, Frick Collection, a1538. Oil on canyas 102 x 86 cm.

Aegidius Sadelier, after Titian
Engraving 30 x 20 cm.
This engraving, probably dating from c.1594, is after the picture which was originally in the Palazzo Ducale in Mantua, but which was destroyed by fire in Spain in 1734. Probably dated 1540, it was executed in oil on canvas; its dimensions were approximately 132 x: 106 cm.

forcefulness of the poses, as recorded in the copies, suggest an instinctive sympathy on Titian's part with the conventions of Roman imperial portraiture. As he proceeded with the series he grew more adventurous in his compositions, just as Michelangelo had done with the *ignudi* on the Sistine Chapel ceiling; the limitations imposed by the format and subject merely stimulated his invention. In the early pictures the designs were constructed on a framework of horizontal and vertical axes, with relatively elaborate backgrounds, as in the *Portrait of Francesco Maria della Rovere*, but in the later ones, such as the *Portrait of Julius Caesar* (Plate 52), the settings were simpler and the poses less rigid, with a greater use of *contrapposto*. As one might expect, the lesson which Titian learned from this series, that economy of means can lead to an increase in expressive power, was one that he was often to apply in his portraits of the following decade.

Titian's interest in classical portraiture, which must have been stimulated by his experience with the *Emperors*, is reflected in another work of this period, *The Allocution of Alfonso d'Avalos, Marchese del Vasto* (Plate 53), commissioned in the winter of 1539–40. The picture shows a famous incident in d'Avalos's career, when he persuaded

some mutinous troops to obey him. But it is in no sense an anecdotal work. Instead, it is closely based on a well-known theme of Roman sculpture and coins, the *adlocutio*, the representation of a general or emperor addressing his soldiers. As such it demonstrates once again the breadth of Titian's visual culture, one of the characteristics which made him virtually unique among Italian portraitists of his day. Unfortunately the picture itself is now very damaged, so the qualities for which it was admired, particularly the splendour and variety of the highlights, can only be imagined.

The commission from d'Avalos, who was then Governor of Milan, underlines the fact that by 1540 Titian had become the most sought-after portraitist in Italy. His success was due partly to the contacts which he acquired through his work for the minor rulers of north Italy, partly to the tireless publicizing of Aretino and not least to his own skill in making himself agreeable to aristocratic patrons. As was said of him in 1542, 'Quite apart from his ability, he is a reasonable person, pleasant and obliging – something to be taken into account in such

1530-1547 99

53 THE ALLOCUTION OF ALFONSO D'AVALOS, MARCHESE DEL VASTO Madrid, Museo del Prado. a.1540-46? Oil on canvas 223 x 165 cm.

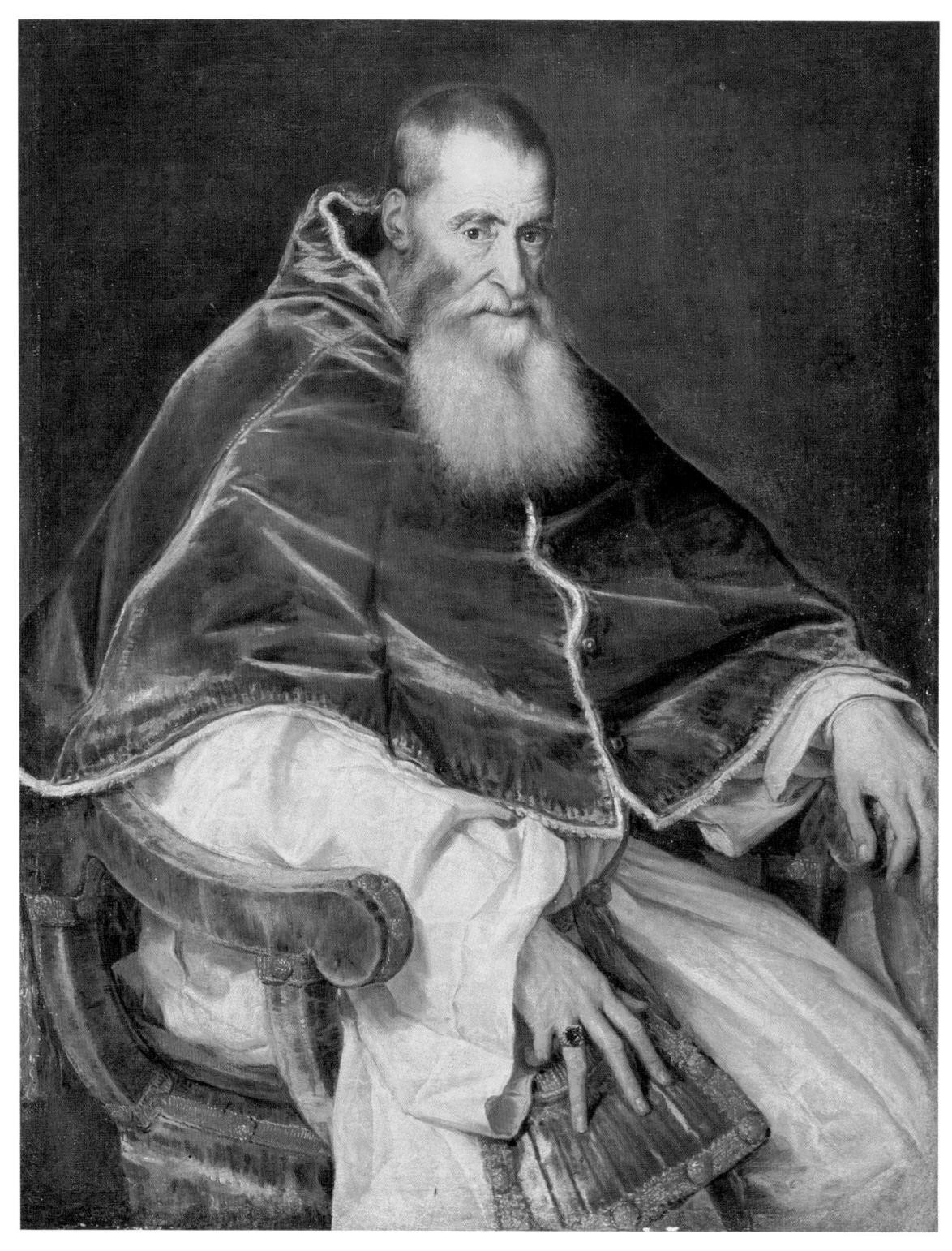

54 Portrait of Pope Paul III Naples, Musco di Capodimonte. 1543. Oil on canvas 106 x 82 cm.

1530-1547

outstanding men.' This passage comes in a letter written to Cardinal Alessandro Farnese, the grandson of Pope Paul III, so an implicit comparison was presumably intended with the notoriously temperamental Michelangelo, who was then in the papal service. But the most striking demonstration of Titian's unique status occurred in the following year, when he was summoned to Bologna to paint a portrait of Paul III. During his visit he once again met Charles V and received a new commission from him: thus Titian found himself patronized simultaneously by two of the most powerful men in Christendom.

The *Portrait of Pope Paul III* (Plate 54) is one of the artist's most memorable works, both for the astonishingly vivid characterization and for the brilliance of the technique. The handling is noticeably looser than in the earlier portraits, the paint surface consisting of a constantly shifting range of tones applied with apparent spontaneity, but nonetheless describing form and texture with complete precision. It was by colour alone, rather than line, that Titian defined the modelling of the pope's right hand, for example, and created the almost palpable differences between it, the purse and the white robe beneath. To a central Italian patron, accustomed to the ideals of high finish and *disegno*, this demonstration of Venetian *colore* must have seemed nothing less than magical.

Charles V's commission in 1543 was for a portrait of his dead wife Isabella, based on an earlier picture which he described as 'by a trivial hand'. Titian's portrait, for which he predictably used a seated pose, was finished by October 1544; its appearance is known only through copies. But a second, very similar picture of Isabella, apparently painted in the following year, is in the Prado (Plate 55). It was one of Charles's most treasured possessions and he took it with him in 1556 when he retired to the Monastery of Yuste after his abdication. His enthusiasm is easy enough to understand, for the picture shares the marvellous technique of the *Portrait of Pope Paul III*, which it resembles in pose. But the modelling and characterization is less forceful, and as a result the figure, perhaps intentionally, has an almost ghostly quality.

It is unlikely that the same could have been said of a *Venus*, now lost, which Titian painted on his own initiative for the emperor in 1545. Over the next twenty years or so the artist and his assistants produced at least six compositions showing a naked woman reclining on a bed, all of which were clearly based on a common prototype. The earliest of these is *Venus and Cupid* in the Uffizi (Plate 56), and it seems safe to assume that it is a copy of Charles's picture: it

55 PORTRAIT OF THE EMPRESS ISABELLA Madrid, Musco del Prado. Probably 1544.

1530-1547

56 VENUS AND CUPID Florence, Galleria degli Uffizi, a1546–47. Oil on canvas 139 x 195 cm.

cannot be the original, since this was described at the time as Titian's finest work to date whereas the Uffizi picture is notably inferior in execution to the paintings that have just been discussed. The composition is related to *The Venus of Urbino*, but now the woman is even more obviously the centre of attention, as if deliberately displayed for the delectation of the spectator. The design appears less calculated and the colours are relatively muted, directing the eye more forcefully towards the brightest and most strongly modelled feature, the body itself. The other difference is in the subject-matter: in Charles's picture, but not, as we shall see, in the later derivatives, the woman is unambiguously identified as Venus, shown here quietly conversing with Cupid. Titian himself was presumably responsible for this change, since the *Venus* was not a commissioned work. He may have felt that Charles would have found a mythological subject more decorous than a mere genre scene. Even so, it is doubtful whether the picture was entirely to the emperor's taste: he never acquired other erotic paintings from Titian, and he seems to have given the *Venus* away before his retirement to Yuste, for it was not among the pictures he took to Spain.

Some idea of the quality of Charles's lost picture can be gained from another female nude

57 DANAE Naples, Museo di Capodimonte, *c*.1544–45. Oil on canvas 120 x 172 cm.

of 1544–45, *Danae* (Plate 57), painted for Cardinal Alessandro Farnese. In its format and overtly erotic content it too belongs to the same category as *The Venus of Urbino*; but, as the papal legate Giovanni della Casa reported to the cardinal in 1544, 'the nude which Your Reverence saw in Pesaro in the apartment of the Duke of Urbino looks like a nun beside this one.' In this case the choice of a mythological subject may have been the patron's and in this respect conforms to the conventions of central Italian taste, but at the same time it gave Titian a pretext for showing the act rather than the promise of love. As in the emperor's *Venus* the composition is looser than in *The Venus of Urbino*, creating a heightened sense of realism, and this is enhanced by the slightly more open, atmospheric brushwork, which makes the texture of the girl's skin and the weight of her body almost tangible. Neither Titian himself nor any other artist in north Italy had ever produced a picture of such obsessive sensuality. It was of this work that Michelangelo rather ungenerously remarked, when he saw it in Rome, that 'it was a pity that in Venice painters did not learn how to draw,' a comment that was perhaps provoked more by prudery than anything else.

Titian himself took the *Danae* to Rome in October 1545. The idea of his making such a journey had been proposed by the Farnese family several years before, but with his well-known reluctance to leave Venice it was only the prospect of a benefice for his son Pomponio that finally induced him to set out. The fact that Pomponio, a constant source of disappointment to his father and by all accounts an irresponsible idler, was totally unsuited to the priesthood does

1530-1547

not seem to have been considered of significance either by Titian himself or by Cardinal Farnese. Before he left Venice the artist had promised to paint every member of the Farnese family 'including the cats', 13 but the only one of these portraits that can certainly be dated to his stay in Rome is the famous picture in Naples (Plate 58) showing Pope Paul III with two of his nephews, Ottavio Farnese, later Duke of Parma, and Cardinal Alessandro Farnese. The pope and Ottavio, in particular, both look decidedly shifty in Titian's painting, and as a result it has often been regarded as a masterly indictment of their personal behaviour and ambitions, some critics even suggesting that it was left unfinished because the patrons considered it too revealing. This is certainly a misreading. Not only is it anachronistic to interpret sixteenth-century portraits in this way, but Titian himself was also the last person to indulge in such criticism of his sitters, least of all when he was trying to obtain a favour from them. Had he completed the picture, there is no reason to suppose that it would have been any less flattering than his other

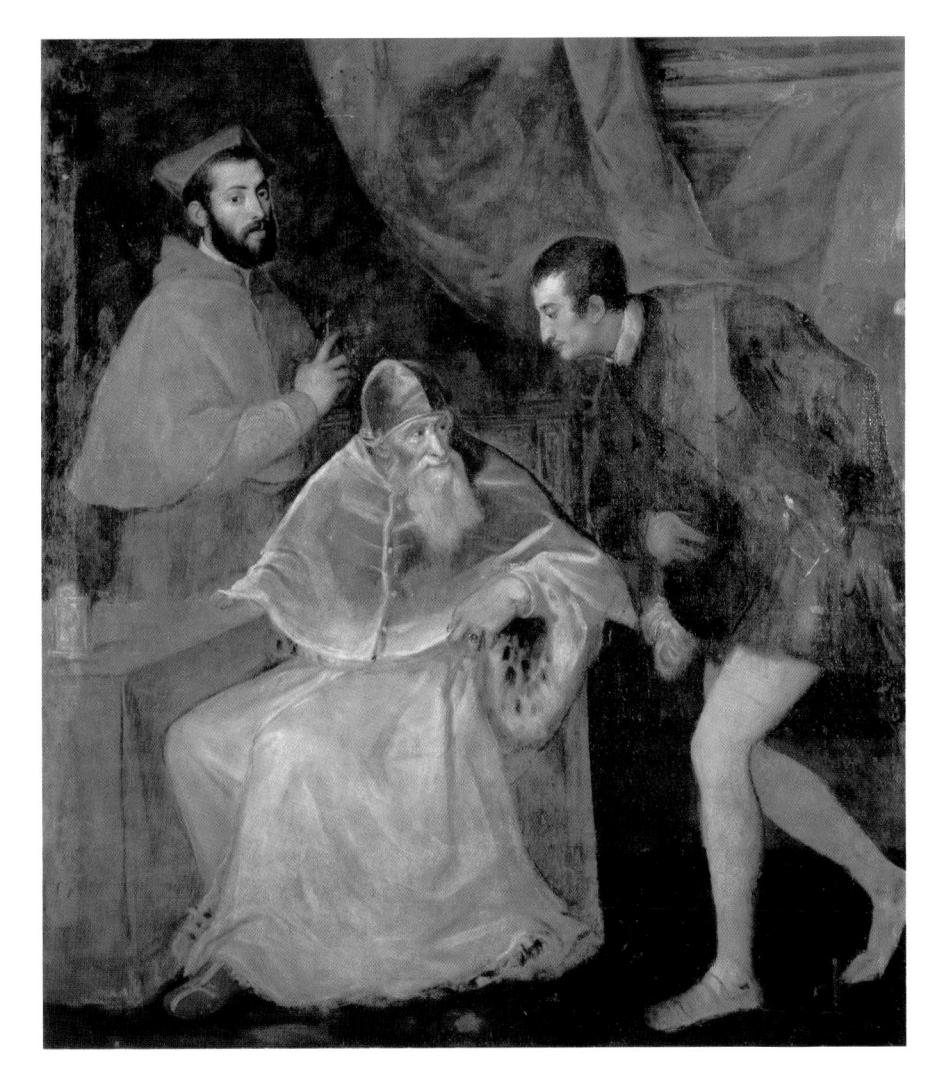

58 PORTRAIT OF POPE PAUL III WITH HIS NEPHEWS CARDINAL ALESSANDRO AND OTTAVIO FARNESE Naples, Capodimonte. 1545–46. Oil on canyas 200 x 173 cm.

portraits. Nor is there any evidence that he was instructed to leave it unfinished. When he left Rome in May or June 1546 he was certainly planning to return, ¹⁴ for he had still not obtained Pomponio's benefice, so the most reasonable hypothesis is that he chose not to bring the picture to completion at this time as an inducement to the Farnese family to ask him back. Indeed, in order to retain the favour of Alessandro he even suggested, rather unrealistically, that he would be willing to accept a permanent post at the papal court, and he continued to work for the cardinal in Venice until the end of 1547.

As was the case with several other Venetian painters of the Renaissance, the experience of visiting Rome seems to have had singularly little impact on Titian's work. This is not altogether surprising: the great masterpieces of ancient and modern art in the city were well known in Venice through prints and drawings, and, as we have seen, they had already been assimilated by Titian many years before. Moreover during the 1540s he was primarily concerned with pictorial technique, *colore* or *colorito*, a typically Venetian preoccupation, rather than with *disegno*, the major interest of central Italian artists. To some extent the way in which Titian's style changed in these years can be seen in such works as the *Portrait of Pope Paul III* and *Danae*, but it is even more evident in the sequence of larger compositions which he produced from 1530 onwards, mainly for Venetian patrons. In these paintings, however, we are confronted for the first time with the problem of distinguishing between his autograph work and the contribution of his pupils. This distinction is crucial to an understanding of Titian's personal development throughout the later part of his career.

His first major Venetian altarpiece after *The Death of St Peter Martyr* was the *Madonna and Child in Glory with Six Saints* for the Oratory of San Nicolò ai Frari, now in the Vatican (Plate 59). This was completed in 1535.¹⁵ It will be recalled that the commission, from the monks of the Frari, apparently dated from 1518 and that Titian abandoned his original composition, a relatively conventional *sacra conversazione*, when he began *The Pesaro Madonna* (Plate 25) in the following year. The final design, executed on the same panel, is very different: the Madonna and Child are placed on a cloud, physically and psychologically distinct from the figures below, and before the panel was cut down in the late eighteenth century the dove of the Holy Spirit was shown above them, providing the source of the radiance which illuminates the entire composition. Titian's changes were not prompted by formal considerations, but were the result of a change in the iconography. The key to the subject-matter is the radiance emanating from the dove, for the Madonna and Child do not belong to the same plane of reality as the saints, but are present in

59 MADONNA AND CHILD IN GLORY WITH SIX SAINTS (MADONNA AND CHILD IN GLORY WITH ST CATHERINE OF ALEXANDRIA, ST NICHOLAS, ST PETER, ST ANTHONY OF PADUA, ST FRANCIS AND ST SEBASTIAN)
Vatican City, Pinacoteca Vaticana (formerly in Venice, Oratory of San Nicolò ai Frari).

a.1533—35. Oil on panel, transferred to canvas 384 x 264 cm. (originally a.470 x 264 cm.). Inscribed: TITLAN VS FACIEBAT.

their minds as a vision, through the power of the Holy Spirit. The clearest precedent in subject and to some extent even in composition for such a representation of a mystical experience is provided by Raphael's *St Cecilia* altarpiece, now in the Pinacoteca Nazionale, Bologna, which Titian would have seen in the winter of 1532–33 and which must have been his immediate source; it can hardly have been a coincidence that the theologians who were responsible for the programme of Raphael's picture, the leading members of the Catholic reform movement associated with the Oratory of Divine Love, moved to Venice in 1527 and for the next few years made it the centre of their activities.

It is likely that the changes in the iconography of the Vatican altarpiece were made at the request of the patrons and do not reflect any special interest on Titian's part in the ideas of the Catholic reformers. His lack of involvement is suggested above all by the fact that this is the first major work in which Titian is known to have made extensive use of an assistant. Thus there is a

clear difference in the technique employed for the Madonna group and the three saints at the right, on the one hand, and that used for the three saints at the left, on the other. In the latter group the brushwork is beautifully fluent, with a marked use of impasto, and it creates the modelling by following the contours of flesh and costume, whereas the other figures are less strongly modelled by means of rather imprecise gradations of tone, applied for the most part in parallel strokes. This less sophisticated technique must be the work of Titian's brother Francesco, since the angels flanking the Madonna can be almost exactly paralleled in his own paintings of about the same date. Francesco seems to have been allowed a considerable measure of initiative even in the design of his section, even though Titian must have been responsible for the basic composition. The upper zone is merely a paraphrase of a fresco in the Doge's Palace painted by Titian in the early 1520s, and one would hardly expect him to have repeated himself so obviously had he taken a close interest in this part of the picture. The figure of St Sebastian, too, is less idealized than his own male nudes.

Virtually the same technique as in Titian's section of the Vatican altarpiece appears in *The Presentation of the Virgin* in Venice (Plate 60), painted between 1534 and 1538. It was commissioned by the Scuola Grande della Carità, one of the great charitable organizations of the city, and it is still in its original location in their *albergo*, or committee room, now part of the Accademia. Large narrative scenes of this kind were the normal form of pictorial decoration

60 THE PRESENTATION OF THE VIRGIN Venice, Gallerie dell'Accademia. 1534–38. Oil on canvas 335 x 775 cm.

in Venetian scuole and there are notable examples by most of the major local artists, but The Presentation is the only such commission which Titian accepted, which may explain why he devoted such care to the picture. It has even been suggested that the composition incorporates a number of sophisticated references to theological texts about the Virgin, involving, for example, the mountains and the pyramid, but there is no evidence that such a complicated reading of the painting was ever intended. Many of the more curious features, such as the old eggseller and the pyramid, were in any case standard elements in representations of this subject, especially in Venice, so Titian may have included them without being aware that they had any special theological significance. Moreover, he was certainly prepared to disregard textual details when they conflicted with visual considerations: thus there are only thirteen steps up to the Temple instead of the canonical fifteen. Again, it has been argued that the building in the background is meant to evoke the Doge's Palace, recalling its traditional identification as a seat of justice with the Palace of Solomon, since it has a similar pattern of marble revetment. But if Titian had wanted his contemporaries to make this connection, it is difficult to see why he did not use an identical pattern. Perhaps he simply admired this type of architectural decoration.16

Rather than searching for esoteric meanings one should perhaps see *The Presentation* primarily in the context of other Venetian paintings of the same general type. In the clarity of the composition, the informal, easy groupings of the figures and the astounding realism of the lighting it set entirely new standards. But the naturalism of the picture, its apparent artlessness, is deceptive, as Titian himself indicated. Three of the spectators at the foot of the staircase were taken virtually unchanged from Raphael's celebrated tapestry design of *Paul Preaching at Athens*, and the inclusion of this quotation suggests that he wished his work to be judged beside the most admired examples of central Italian narrative painting. This does not mean that Titian was actually imitating Raphael's style. The subject of his picture and its destination, in a Venetian *scuola* rather than the Sistine Chapel, called for a more homely idiom.

Contemporary with *The Presentation of the Virgin* are two other major pictures now known only through copies, an altarpiece of *The Annunciation* and *The Battle of Spoleto* (Plate 61) for the Doge's Palace. The altarpiece was begun for a convent on the island of Murano, but the patrons decided that they could not afford the price demanded, apparently 500 ducats, so they transferred the commission to Pordenone, a less talented but more obliging painter who was then attempting to establish himself as Titian's main rival in Venice in large-scale compositions.

61 THE BATTLE OF SPOLETO
Giulio Fontana, after Titian
Engraving 39 x 53 cm.
This sixteenth-century engraving is after the picture once in the Doge's Palace in Venice, but Fontana may have extended the composition at the right (cf. Plate 46). Titian's picture, executed between 1513 and 1538, and destroyed by fire in 1577, was painted in oil on canvas; its height was c.580 cm.

It is unlikely that Titian himself was unduly disturbed by this rebuff. He simply sent the completed picture, in 1537 or soon afterwards, to the Empress Isabella, and was rewarded by Charles V with a pension payable in Milan worth 100 scudi a year.

Pordenone was again involved in connection with *The Battle of Spoleto*.¹⁷ This was the painting for the Hall of the Great Council which Titian had undertaken in 1513; but it was only in 1537, after threats that he would be deprived of his *senseria* and that the commission would be given to Pordenone, that he set about finishing the canvas. It was finally installed in the following summer. *The Battle of Spoleto* was among Titian's works most admired by contemporaries, and it is one of his very few pictures for which there exist preparatory drawings, in particular the elaborate compositional study in the Louvre (Plate 62). This is certainly authentic, both because of its exceptional quality and because it differs from the painting in various ways which one would not expect in the work of a copyist. As we have seen, such drawings do not seem to have

62 THE BATTLE OF SPOLETO
Paris, Musée du Louvre, Cabinet des Dessins. Between 1528 and 1538. Black chalk with white heightening on blue paper 38.5 x 44.5 cm.

63 ST MARTIN AND ST CHRISTOPHER Giovanni Antonio Pordenone Venice, Church of San Rocco. *a*1528. Oil on canvas. Dimensions not known.

formed a normal part of Titian's working procedure. Unless one supposes that he changed his approach on this occasion, a hypothesis for which there seems no very obvious justification, the implication is that the Louvre drawing and another more detailed study in Oxford for the horse and rider in the left foreground were made primarily for the guidance of an assistant. That Titian should have used an assistant in the execution of the *The Battle of Spoleto* is in fact very likely: the other artists who had contributed to the same cycle had certainly done so, the commission was evidently one which did not greatly interest him and the picture itself, placed relatively high between two large windows, was badly lit and therefore difficult to see. It must have depended for its effect not so much on the actual quality of the brushwork as on the composition, which was among the most elaborate of Titian's career.

This composition, which was to exert a decisive influence on later battle paintings, particularly those by Rubens, owed its basic arrangement to Leonardo da Vinci's unfinished mural of *The Battle of Anghiari* in the Hall of the Great Council in Florence. But the final design cannot have been established until long after the original commission in 1513, since the riderless horse at the right, which is already present in the drawing, is a quotation from Raphael's tapestry of *The Conversion of St Paul*, which, like its cartoon, arrived in Venice only in the 1520s. There was one major change which postdates even the drawing: the horse and rider at the left were later more drastically foreshortened, so that they seemed to fall out of the canvas, and the actual pose of the man was made more complex, with a greater emphasis on

the musculature. In these respects this group became closer in style to the work of Pordenone (Plate 63) and it is possible that Titian modified his original design in part because of a proposal that his rival should provide another picture immediately adjacent to his own. He thus had a perfect opportunity to display his skill in precisely the kind of violent, strongly foreshortened motif that was Pordenone's speciality.

According to the terms of his senseria, after completing The Battle of Spoleto Titian ought to have begun another history painting for the same series. But he did not do so. Instead he produced a portrait of Doge Gritti, destroyed by fire in 1577, which was hung with other such portraits above the history cycle. Both Vasari and Francesco Sansovino, the son of his great friend the architect Jacopo Sansovino, stated later in Titian's career that he held a special appointment from the Venetian government, involving only the obligation of painting each reigning doge in return for his senseria. From these statements it has been widely assumed that Titian held a long-established, honorific post of official painter to the Venetian republic. The truth of the matter is rather more complicated. Like several other painters Titian had been granted a senseria simply as a form of payment for his work on the history cycle. But after he finished The Battle of Spoleto he seems to have persuaded the authorities that his obligations would be fulfilled merely by providing ducal portraits, for which, incidentally, he also received a fee. Such was his prestige and so influential were his friends and patrons that he was able to retain his senseria on these terms until his death, in spite of attempts to deprive him of it in the 1540s and 1550s. After 1555 he ceased even to paint ducal portraits. Thus it could be said that in effect Titian, with a characteristic combination of effrontery and sheer determination, eventually acquired the status of an official painter even though the institution as such did not exist.

Following *The Battle of Spoleto* his next large-scale painting was *The Crowning with Thorns* in the Louvre (Plate 64), begun in 1540 for a chapel in the Church of Santa Maria delle Grazie in Milan and completed by 1542. Like the battle picture it shows a violent, highly dramatic subject, and here too the figures are strongly foreshortened, with gross and exaggerated musculature. It is one of Titian's least appealing works, but in this case the treatment probably reflects the wishes of his patrons, the members of a confraternity which owned a thorn believed to have come from the Crown of Thorns.

Some twenty years before this confraternity had commissioned an even more grotesque fresco of the same subject from Bernardino Luini, normally the most anodyne of painters. Titian must have seen this fresco during a visit to Milan at the beginning of 1540, and its

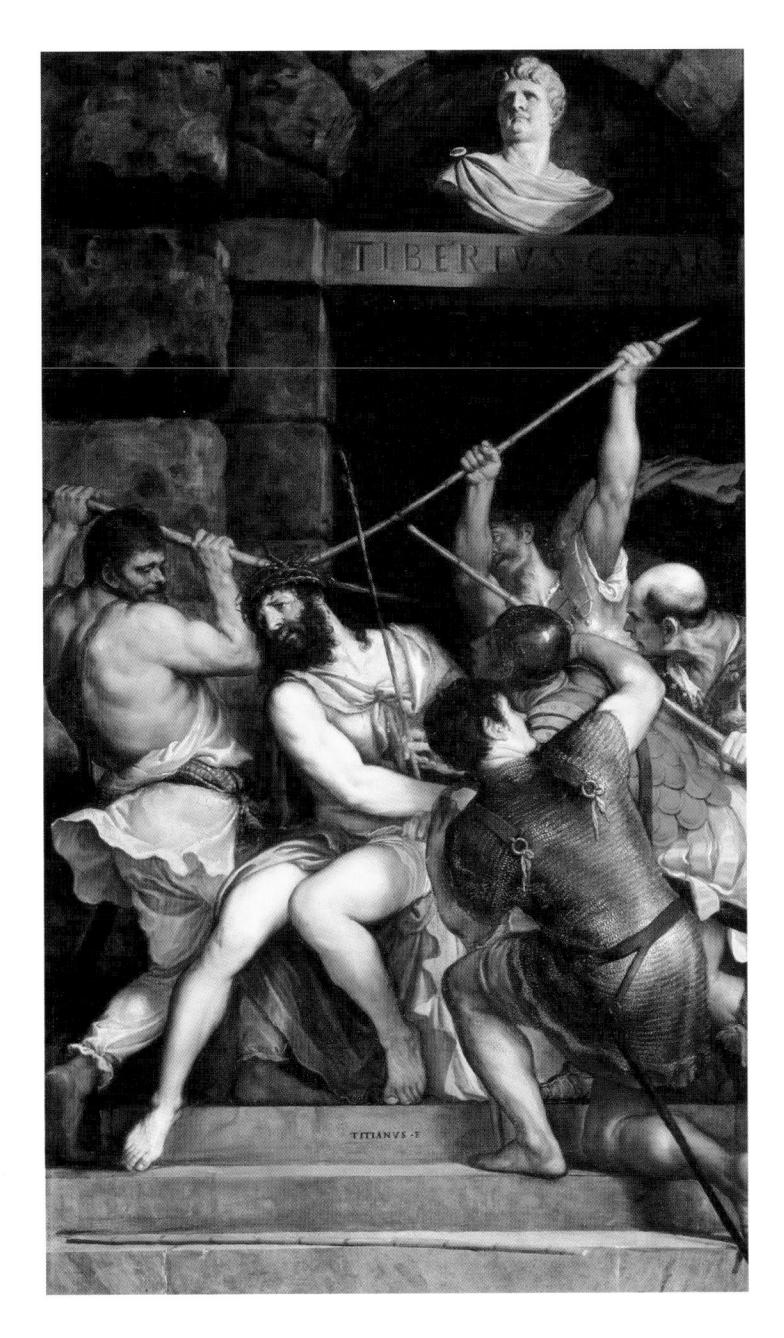

64 THE CROWNING WITH THORNS Paris, Musée du Louvre. 1540–42. Oil on panel 303 x 180 cm.

Inscribed: TITLANVS. F.

composition seems to be reflected in his own picture. But although this may help to explain why *The Crowning with Thorns* looks as it does, there remains the problem of why he accepted the commission at all, since this was his only major altarpiece of the period for a church outside Venice. It is probably no coincidence that he undertook the picture at exactly the time his son was given a benefice in Milan by Charles V. The implication is that he wished to commemorate the event by providing a conspicuous example of his work in the same city, indeed, in the very monastery in which Leonardo da Vinci had painted *The Last Supper*. In the

same way Titian was later to supply an altarpiece for Pomponio's other benefice of Medole, but of lower quality.

While he was working on *The Cromning with Thorns* Titian also completed another altarpiece, *The Descent of the Holy Spirit*, for the high altar of Santo Spirito in Isola, the monastery for which he had painted *St Mark Enthroned* so many years before. The commission dates from as early as 1529, and, according to one of the monks, at that period Titian 'sketched in the altarpiece in one way and then changed his mind; after two or three years he sketched it in a different way." He then lost interest, and did not resume work on *The Descent of the Holy Spirit* until 1541, after repeated complaints from his patrons. Only two months later the altarpiece was installed in the church, where Titian continued to work on it intermittently. Unfortunately the canvas was inadequately protected against damp, so within eighteen months the paint began to blister and flake off. After the artist had inspected the damage and had been seen on a ladder, swearing as he prised off lumps of pigment with a knife, the picture was taken back to the studio. There followed a bitter and involved legal dispute with the monks, who were reluctant to pay not only

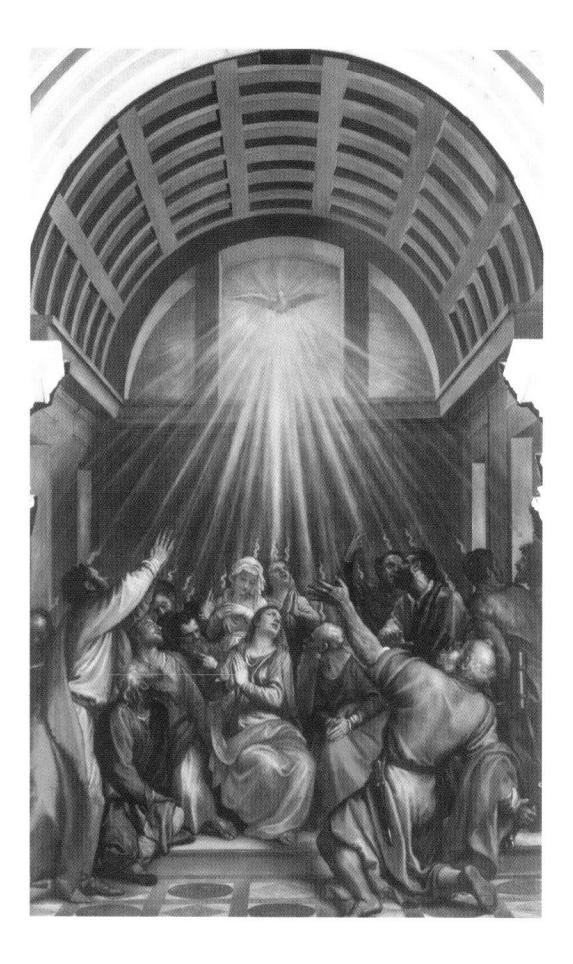

65 THE DESCENT OF THE HOLY SPIRIT Venice, Church of Santa Maria della Salute (formerly in Venice, Monastery of Santo Spirito in Isola). a.1543–45. Oil on canvas 431 x 264 cm.

DETAIL OF THE DESCENT OF THE HOLY SPIRIT (above right)

66 THE SACRIFICE OF ISAAC Paris, Ecole des Beaux-Arts. *c*.1542. Black chalk with white heightening on grey paper 23.2 x 25.8 cm.

67 THE SACRIFICE OF ISAAC Venice, Church of Santa Maria della Salute (formerly in Venice, Monastery of Santo Spirito in Isola). 1542–*c*.1543. Oil on canvas *c*.320 x *c*.280 cm.

100 ducats more than the minimum fee of 400 ducats originally agreed but also the cost of the restoration. The outcome of this dispute is not known, but the present altarpiece (Plate 65), transferred from Santo Spirito in 1656 and now in the Church of Santa Maria della Salute, probably dates in its entirety from the 1540s, although the composition almost certainly repeats the earlier version with only minimal changes. It seems to have been executed largely by assistants, since the actual paint surface does not show the liveliness of touch of Titian's autograph works for important clients and does not justify the enthusiastic comments of those who saw the altarpiece when it was first installed.

While the original version of *The Descent of the Holy Spirit* was still in the church, Titian received another commission from the monks at Santo Spirito, this time for three ceiling paintings of Old Testament subjects, *Cain and Abel, The Sacrifice of Isaac* (Plate 67) and *David and Goliath*. This commission had originally been given to Vasari, who had spent some months in Venice in 1542; it is possible that after Vasari's return to Tuscany Titian agreed to undertake the job in order to compensate his patrons for the delays which they had endured over the

altarpiece. Whether, as the documents seem to suggest, the three pictures were all completed within the unusually short span of only seven months,²⁰ or whether the execution dragged on while Titian and his patrons were involved in litigation, the likelihood remains that they are not entirely autograph. This is also implied by the fact that there exists a detailed preliminary sketch (Plate 66) for *The Sacrifice of Isaac* (Plate 67), which is very similar to the drawings for *The Battle of Spoleto*, as well as by the actual quality of the paintings themselves. The colours are muddy and lacking in brilliance, the face of Isaac, for example, curiously inexpressive, and the angel merely clumsy. That Titian should have used an assistant here is understandable enough. In their original settings the pictures could only have been seen from a distance, so the quality of the compositions, with their daring and accomplished use of foreshortening, was more important than that of the execution. Moreover, the circumstances of the commission suggest that the fee may not have been very large.

The ceiling paintings for Santo Spirito, The Crowning with Thorns and The Battle of Spoleto are often seen as symptomatic of a crisis that supposedly occurred in Titian's development in the years around 1540. It has been suggested that the violence of the subject-matter, the overt rhetoric of the style, the massive forms and the unprecedented emphasis on foreshortening reflect an attempt to come to terms with the fashionable Mannerist style of central Italy, which Titian subsequently rejected. But this argument does not stand up to serious scrutiny. In certain respects, for example in the use of foreshortening and contrapposto, these paintings certainly do show the influence of contemporary works in Florence and Rome such as Michelangelo's Last *Judgement* in the Sistine Chapel. But Titian had consistently taken a keen interest in central Italian art, so it would have been surprising and uncharacteristic if he had ceased to do so at this period. His borrowings, however, were always highly selective. Committed Mannerists like Vasari and Francesco Salviati, both of whoin visited Venice around 1540, invariably adopted a highly embellished rhetorical style for their pictures, and this indeed is one of the hallmarks of Mannerism.21 But Titian, by contrast, throughout his career was careful to observe the principle reiterated by virtually every sixteenth-century writer on art, that of decorum, choosing a style appropriate to the subject and to the character of the person represented.²² In his work there is never a dichotomy between form and content. Thus The Death of St Peter Martyr (Plate 40) shared many of the stylistic characteristics of the supposedly Mannerist pictures produced about a decade later, since it illustrated an equally dramatic event, whereas The Presentation of the Virgin, even though much closer to them in date, is more restrained than any

of these works. In the same way, when in about 1550 Titian was required to paint four mythological heroes condemned to infernal punishment, *Tityus* (Plate 78), *Sisyphus, Tantalus* and *Ixion*, he once again used an appropriately heroic, Michelangelesque idiom. Nor is there any reason to suppose that around 1540 he was suddenly attracted by violent subjects. *The Battle of Spoleto* had been commissioned in 1513 and was only completed in the late 1530s as a result of pressure from the Venetian government; the particular treatment of *The Crowning with Thorns* apparently reflected the wishes of the patrons; and the Santo Spirito ceiling paintings seem to have been a commission in which Titian himself was not especially interested.

One reason why it is so often suggested that a crisis occurred in his work at this period is that few of the extant paintings completed around 1540 are of outstanding quality. This is partly the result of a historical accident, the loss of *The Annunciation*, the *Emperors*, the first version of *The Descent of the Holy Spirit* and *The Battle of Spoleto*, and partly a consequence of Titian's increasing use of assistants in his larger pictures. From this time onwards only a few particularly favoured clients could normally hope to obtain works entirely by Titian's own hand, and since the outstanding attraction of his paintings lay above all in quality of the brushwork the effects of leaving the actual execution to pupils were more evident than they would have been with central Italian artists, who were more concerned with *disegno*. The extent of studio participation, however, varied according to circumstances: when Titian provided detailed designs and himself participated in the execution, as he seems to have done in the Santo Spirito ceiling paintings and probably also in *The Battle of Spoleto*, the results could be very impressive; but sometimes, as in an altarpiece for the provincial town of Serravalle, now Vittorio Veneto, even this degree of involvement was missing and the consequences were all too apparent.

Although the theory concerning Titian's 'Mannerist crisis' seems to be misconceived, this does not mean that his personal style remained unchanged in the decade after the mid-1530s. The series of *Emperors* and the female nudes reveal an increasing fluency in his treatment of figures, but, as we have seen in the case of his portraiture, the most conspicuous development occurred in his brushwork, a change in his attitude to *colore* rather than *disegno*. The same process can be seen very clearly from a comparison of two of his larger pictures with very similar themes from the same period, the Louvre *Crowning with Thorns* and *Ecce Homo* (Plate 68), painted for a Flemish merchant resident in Venice, Giovanni d'Anna, and dated 1543. This second painting recalls the altarpiece strongly in only one detail, the crouching soldier in the foreground, which Titian doubtless included in accordance with the dictum later repeated by

68 ECCE HOMO Vienna, Kunsthistorisches Museum. Completed 1543. Oil on canvas 242 x 361 cm. Inscribed: TITIANVS EQVES CES F 1543

the painter Paolo Pino, that in any picture there should be at least one foreshortened figure to demonstrate the painter's skill in this most difficult area of his art. But the total effect of the composition is entirely different, because of the much looser handling of the pigment, which creates a highly atmospheric and mobile surface, vibrant with light and colour. It is variety of touch and gradations of tone, too, rather than drawing that establish the sense of depth.

Titian was by no means the only artist in Venice to adopt a more open type of brushwork at this period and it is not even certain that he was the first to do so, despite the common belief that throughout his career he was the major innovator in Venetian painting. During the 1540s at least two painters of the next generation, Jacopo Tintoretto and Andrea Schiavone, seem to have carried the process even further, so much so that in 1548 both were criticized by Aretino for the rapidity of their technique and the lack of finish in their pictures.²³ In the case of Tintoretto, Aretino's comments concerned *The Miracle of the Slave* (Plate 69), whereas the

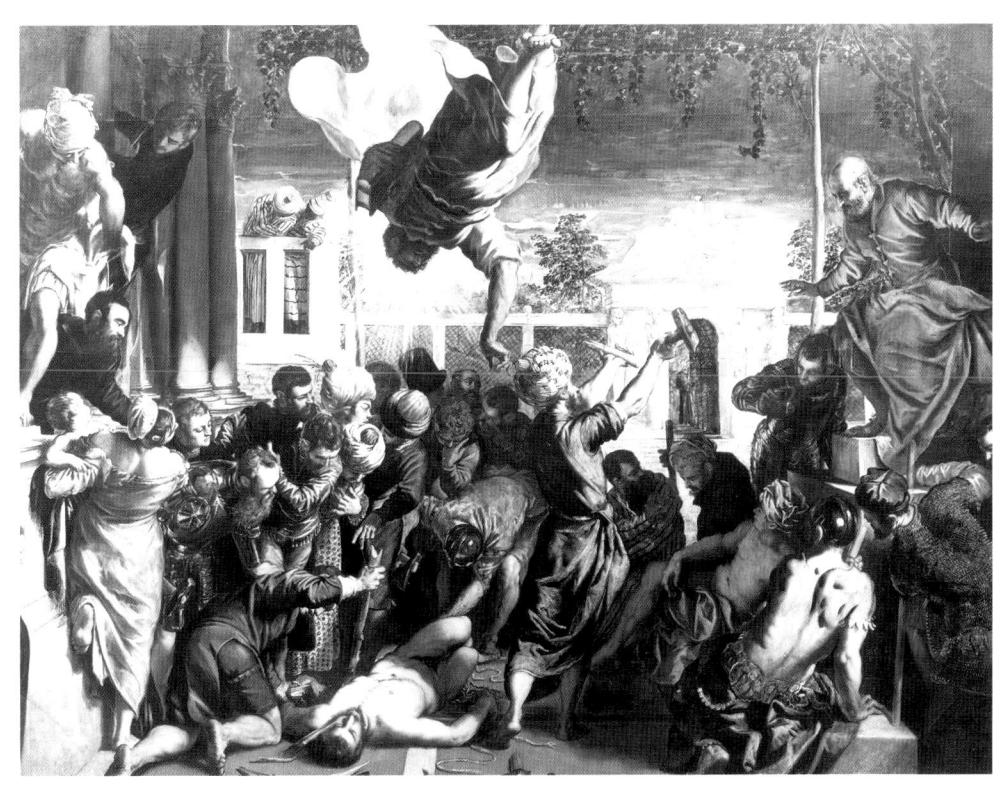

69 The Miracle of the Slave Jacopo Tintoretto Venice, Gallerie dell'Accademia. 1548. Oil on canvas 415 x 541 cm.

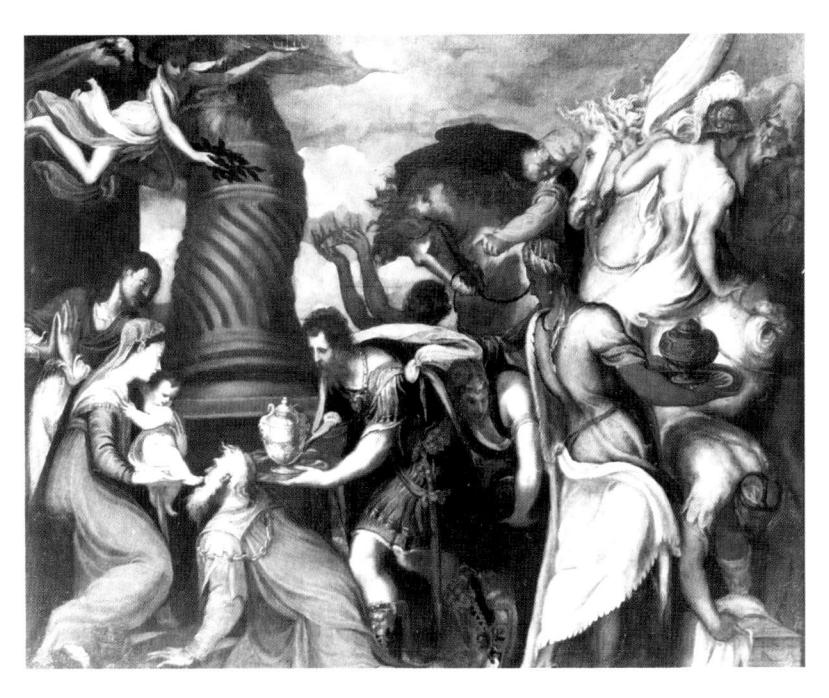

70 The Adoration of the Magi Andrea Schiavone Milan, Pinacoteca Ambrosiana. ϵ 1548. Oil on canvas 185 x 222 cm.

painting in question by Schiavone can no longer be identified, although the marvellous Adoration of the Magi in the Ambrosiana, Milan (Plate 70), probably provides a fair example of what Aretino had in mind. Three years earlier he had criticized Titian's superb portrait of him (Plate 71), now in the Pitti, on much the same grounds, describing it as 'sketched rather than finished'. This seems a singularly insensitive comment about a masterpiece which depends so much for its effect on its apparent spontaneity, and at first sight Aretino's remarks suggest that he disliked freedom of handling as such without making any real distinction between the work of Titian on the one hand and that of Tintoretto and Schiavone on the other. However, this was the only occasion on which he criticized his friend in these terms and the context of his statement, a letter to the artist, implies that he may not have been entirely serious. In these circumstances it is reasonable to suppose that his later comments on the two younger artists do indeed imply that there was some basic difference between their approach and that of Titian. In order to understand the latter's intentions at this time it is important to appreciate what this difference actually involved.

The most notable example of Titian's work for Venetian patrons in the late 1540s is the Portrait of the Vendramin Family (Plate 72), which almost certainly dates from about 1543-47. It is his largest known group portrait, an astonishingly skilful composition that conveys the status of his sitters while preserving a certain informality, providing at the same time a striking illustration of male pre-eminence in Venetian society. In certain passages, such as the candles and the reliquary, once miraculously saved by a member of the family, the pigment is applied quite as freely as in any painting by Schiavone, with single strokes of a loaded brush. Similarly, the highlights on the costumes are not very different from those in pictures by Tintoretto. But in Titian's picture these characteristics are less prominent than they are in the work of the two younger artists: here every stroke serves a precise descriptive purpose, whereas with Tintoretto and Schiavone a rapid and fluent touch, sheer virtuosity in the application of paint, became an end in itself. They were concerned above all to provide a conspicuous display of skill, and in this respect their ideals were similar to those of central Italian Mannerists, the only difference being that their skill was manifested primarily in terms of colore rather than disegno. Titian, by contrast, achieved an art that conceals art, a quality to which Dolce, with great critical insight, was to apply the term 'sprezzatura'. This was the word used by Castiglione in Il Cortegiano to describe the essential characteristic of the perfect courtier, the man whose every action, however difficult, is carried out with grace and casual facility. Although Titian modified his

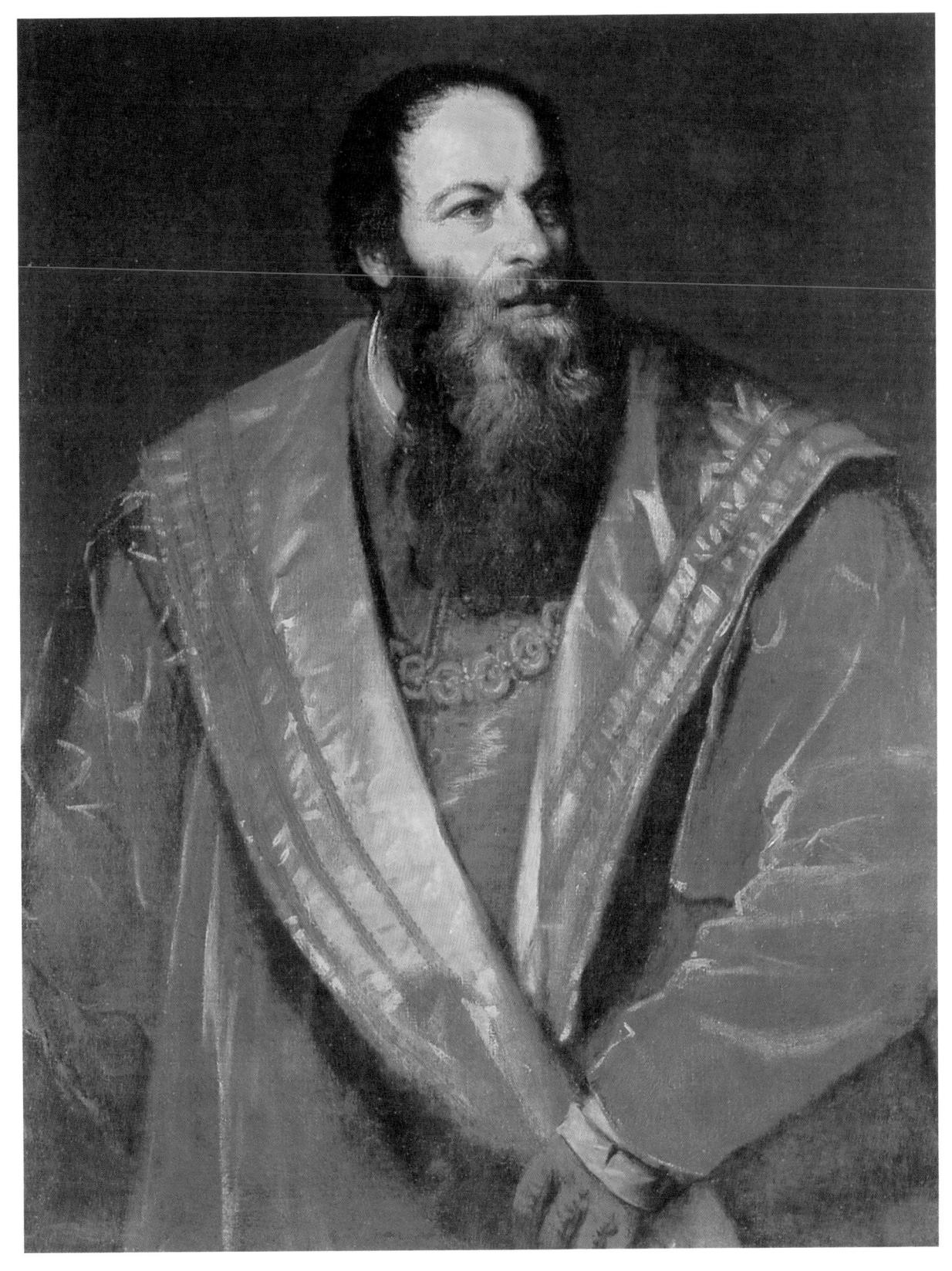

71 Portrait of Pietro Aretino Florence, Palazzo Pitti. 1545. Oil on canvas 97 x 78 cm.

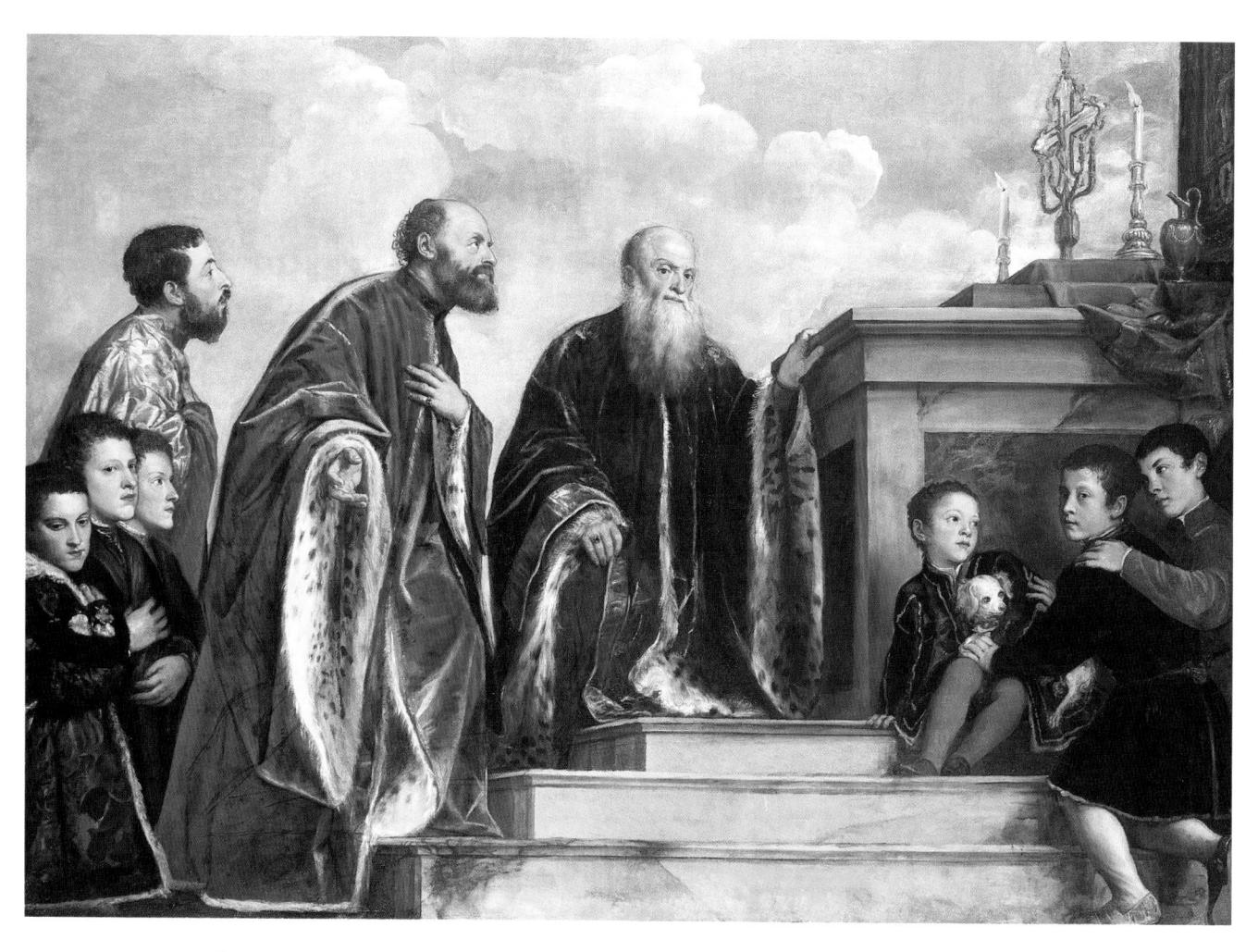

72 PORTRAIT OF THE VENDRAMIN FAMILY London, National Gallery. *c*.1543–47. Oil on canvas 206 x 301 cm.

technique during the 1540s in much the same way as did the younger artists, his ideals remained fundamentally different and in their eyes must have appeared more conservative.

FOOTNOTES

- 1 This total includes several pictures mentioned only in unpublished documents in the Archivio Gonzaga in Mantua.
- 2 The picture was actually for d'Avalos's mother Vittoria Colonna, but Titian was not informed of this.
- 3 For Ippolito's visit to Venice, see Sanuto, *Diarii*, LVII, 108, 111, 112, 173. Titian had already painted his portrait before 19 December 1532 (Francesco Berni, *Poesie e prose*, ed. Ezio Chiòrboli, Geneva and Florence, 1934, p. 152).
- 4 Titian sent a portrait of the emperor to Federico just before setting out for Asti with the duke (Crowe and Cavalcaselle, 1877, I, p. 458). It is unlikely to be the one which he had begun for Federico three years before (*ibid.*, p. 457), since he received and carried out other commissions on behalf of the duke in the intervening period.
- 5 Hans von Voltelini, 'Urkunden and Regesten aus dem k. und k. Haus-, Hof- und Staats-Archiv in Wien',

- Jahrbuch der Kunsthistorischen Sammlungen des Allerhöchsten Kaiserhauses, XI, 2, 1890, p. XVIII, no. 6313.
- 6 Luigi Ferrarino, Tiziano e la Corte di Spagna, Madrid, 1975, p. 12, no. 7.
- 7 For the commission, see Benedetto Agnello to Federico Gonzaga, Venice, 2 May 1536 (Mantua, Archivio Gonzaga, busta 1470, fol. 126v.).
- 8 The frontispiece to the second edition of *De le lettere di M. Pietro Aretino*, published by Marcolini in September 1538, is manifestly based on the Frick portrait (see *Lettere sull' arte di Pietro Aretino*, ed. F. Pertile and E. Camesasca, Milan, 1957–60, III, plate 29, facing p. 328), whereas the more famous frontispiece to Marcolini's edition of January 1538 is derived from a different prototype (*ibid.*, plate 27, facing p. 312). The Frick portrait is usually dated no earlier than 1548 because Aretino ceased to dye his beard in that year, but this argument is inconclusive, since it is not known when he began to do so.
- 9 Augustus was certainly the earliest of Titian's Emperors, but the sequence in which he painted the others is not specified in the documents. I assume that it corresponded approximately with the order in which they were hung, ending with Julius Caesar.
- 10 The portrait of Isabella sent to Charles V in October 1545 was damaged in transit and repaired by Titian at Augsburg in 1548. The picture in question was presumably the one in the Prado, which was the only such portrait by Titian known to have been at Augsburg, where it served as a prototype for a portrait by Seisenegger.
- 11 For a more extended discussion of these pictures and their iconography, see below, pp. 157–58; see also my contribution to the forthcoming publication of the proceedings of the 1976 conference on 'Tiziano e Venezia'.
- 12 Lorenzo Campana, 'Monsignor Giovanni della Casa e i suoi tempi', Studi Storici, XVII, 1908, pp. 382f.
- 13 Ibid.
- 14 See Georg Gronau, Documenti artistici urbinati, Florence, 1936, p. 97, nos. XLVIII, XLIX.
- 15 For a fuller discussion of the Vatican altarpiece, see Hood and Hope, 1977, pp. 534-43.
- 16 For an extended discussion of the iconography, see David Rosand, 'Titian's *Presentation of the Virgin in the Temple* and the Scuola della Carità', *Art Bulletin*, LVIII, 1976, pp. 55ff. I am very conscious that I have not been able to do justice to the cogency and interest of Rosand's analysis, but our disagreement concerns the appropriateness of his method of interpretation, rather than specific points of detail. In this context it should be emphasized that the patrons' discussion about a further painting for the same room reveals a singularly unsophisticated attitude to religious iconography (see Ludwig, 1905, p. 146, document of 6 March 1539).
- 17 It is often argued that the correct title is *The Battle of Cadore*, but this is certainly a mistake. The Battle of Spoleto was a crucial episode in the narrative cycle in the Hall of the Great Council, a cycle that was completed only in the 1560s; but a representation of the Battle of Cadore (1508) can have had no place in a scheme devoted to events of the twelfth century. The assertion of Panofsky (1969, p. 181) that in Titian's picture the imperial banner was held by a member of the defeated army seems to be false; the banner is apparently held by a horseman participating in the successful sortie across the bridge.
- 18 For the payments see Herbert Siebenhüner, 'Tizians "Dornenkrönung Christi" für S Maria delle Grazie in Mailand', *Arte Veneta*, XXXII, 1978, pp. 123–26.
- 19 Most of the information about *The Descent of the Holy Spirit* given in this paragraph is derived from a typescript in the library of the National Gallery in London, made by the late Mr E. W. Paul from a document dated 22 March 1543 in the Archivio della Curia Patriarcale in Venice. I have not been able to trace the original document, which is a verbatim transcript of statements made by monks of Santo Spirito in the course of legal proceedings, but I have found other unpublished documents concerning this matter in this archive, so there seems no reason to doubt the authenticity of the evidence in the typescript.
- 20 On 22 March 1543 (see note 19) two monks stated that Titian had painted 'several works' for the church; one would imagine that this phrase referred not only to *St Mark Enthroned* and *The Descent of the Holy Spirit*, but also to the ceiling paintings, all of which were presumably installed at the same time.
- 21 See Summers, 1977, passim.
- 22 See especially David Summers, 'Maniera and Movement: the figura serpentinata', Art Quarterly, XXXV, 1972, p. 294.
- 23 I owe my appreciation of the rôle of Schiavone in Venice to Francis Richardson, who read a paper on the subject at a conference on 'Titian, Sansovino and Aretino' at King's College, Cambridge, in 1973.

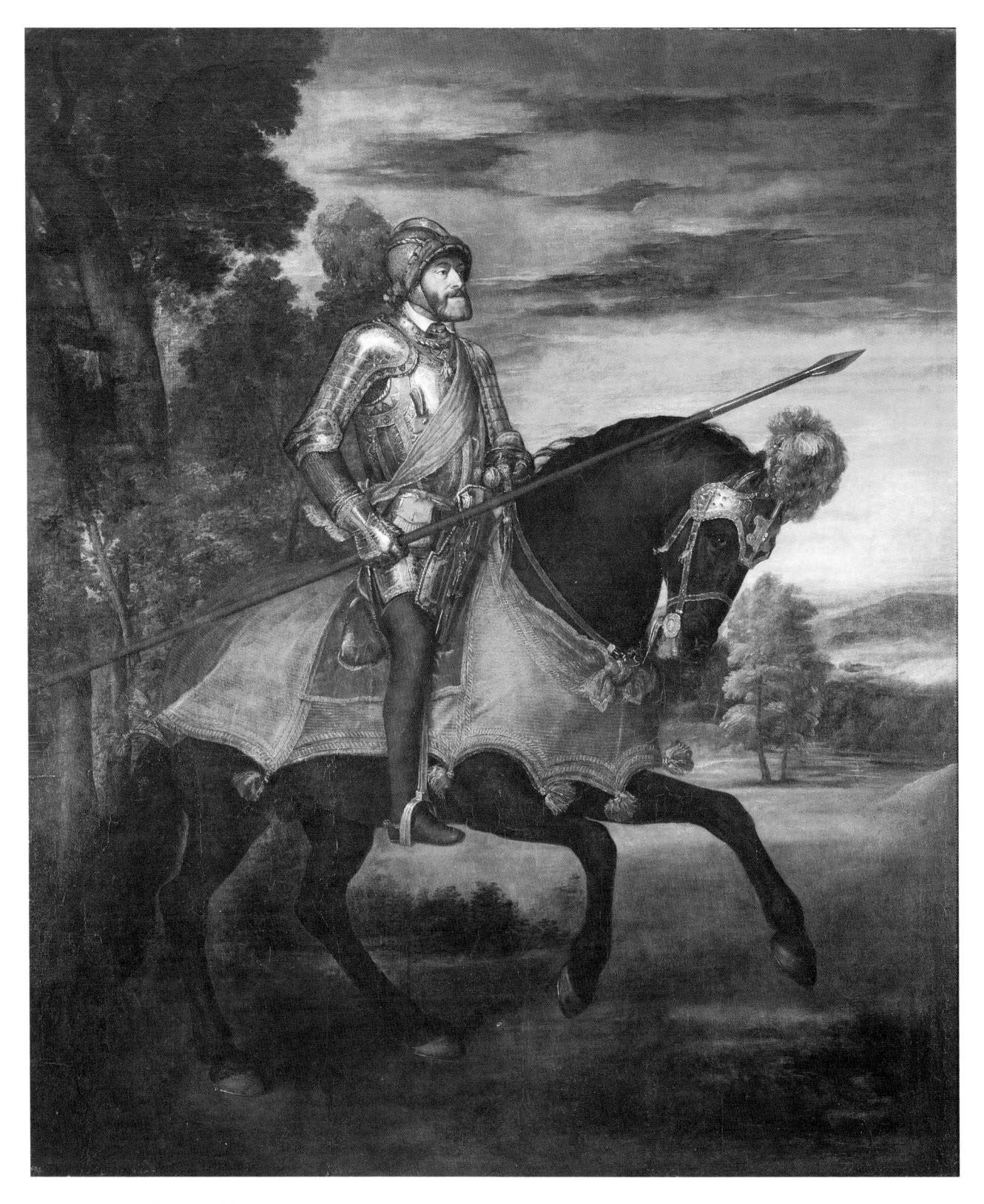

73 PORTRAIT OF CHARLES V ON HORSEBACK Madrid, Musco del Prado. 1548. Oil on canvas 332 x 279 cm.

EARLY IN JANUARY 1548, after waiting more than two months for the weather to improve, Titian set out from Venice for the imperial Diet at Augsburg, where he remained for about eight months. He had been invited by Charles V, but during his stay he also worked for Charles's younger brother Ferdinand, King of the Romans, for his sister Mary of Hungary, and for several of his ministers and close advisers. From this moment until his death in 1576 Titian's paintings for members of the Habsburg family and their circle were to account for by far the most significant share of his output. He became in practice if not in name their court painter. During the next seven years he supplied them with no less than seventy pictures, some of which were large and important, but well over half of which are lost without trace. This loss is less serious than it seems at first sight, since a high proportion of these pictures must have been in part the work of assistants. Thus if one considers that in 1531, working at full speed, Titian had taken a month to paint a Magdalen for Federico Gonzaga, it is evident that the seventeen or more paintings, most of them portraits, which he is known to have produced at Augsburg in 1548 cannot have been entirely in his own hand. On this occasion his assistants included his first cousin once removed, Cesare Vecellio, and almost certainly his own son Orazio, who had accompanied him to Rome and who had himself already acquired a certain reputation as a portraitist.

Titian brought with him from Venice two pictures for Charles V. One of these, *Venus and Cupid* (see Plate 56), has already been discussed. The other was an *Ecce Homo* (Plate 74), painted on slate, a work particularly well suited to the emperor's tastes. In its simplicity and pathos the imagery seems calculatedly Spanish in character; but in fact the picture, a replica of which Titian had given to Aretino in 1547, is almost certainly a variant of one that he had painted for Paul III in Rome. If this is so, Vasari's rather unenthusiastic attitude to the pope's version is easy to understand. For in *Ecce Homo* Titian's virtuosity is deliberately understated: it is one of the earliest and most perfect examples of Counter-Reformation religious art, a work specifically designed first and foremost to promote feelings of piety. As such it is a remarkable imaginative achievement, and although we have almost no evidence about Titian's own religious convictions this painting at least suggests that by this period he felt an instinctive sympathy with the aims of the Catholic reformers.

While he was in Augsburg, besides repairing some damage which the *Portrait of the Empress Isabella* (Plate 55) had suffered in transit in 1545, Titian painted three new pictures for Charles V, all of them portraits. The first of these, strongly reminiscent of the picture which he had produced at Bologna in 1532–33, showed the emperor three-quarter-length in armour; the second showed him seated at a table with Isabella; the third, the only one that still survives, is the great *Portrait of Charles V on Horseback* in the Prado (Plate 73). This is not only the artist's largest portrait, but also one of his supreme achievements, a masterpiece which transcends the normal limitations of the genre to become the most compelling and sympathetic interpretation of Charles's imperial ideology. In its insight it clearly reflects the genuine personal friendship that existed at Augsburg between Titian and his patron, a friendship whose intimacy was a source of surprise and even slightly scandalized comment among their contemporaries. For example, on the artist's return to Venice, Giovanni della Casa reported to Alessandro Farnese as follows:

Messer Titian has spent a long time with His Imperial Majesty painting his portrait, and seems to have had plenty of opportunities to talk with him, while he was painting and so on. In short, he reports that His Majesty is in good health, but exceptionally anxious and melancholy, and that when the court left for Flanders Monsignor d'Arras told him, on behalf of His Majesty, that he ought to go too; but after he had excused himself on the grounds that he had spent too long away from home, and had asked permission to return to Venice, Monsignor d'Arras said that he could go, because in any case His Majesty would see him again next summer in Italy, and this would be equally satisfactory. Since Your Reverence knows the gentlemen of this court you will be able to judge whether it is customary to tell people like Messer Titian what His Majesty does or does not intend to do.²

In the field of portraiture an equestrian pose had specific imperial associations that went back as far as the famous statue of Marcus Aurelius on the Capitol in Rome. But Titian's picture of Charles V was the first modern portrait of this type on such a scale, and it initiated an entire genre in European painting. An additional allusion to classical precedent was provided by the spear, which was not the short weapon such as Charles normally carried, but a long one of the type used by the Roman emperors of Antiquity. At the same time the imagery could be seen as a reflection of a very different iconographical tradition, that of the Christian

1548-1562 127

74 ECCE HOMO Madrid, Museo del Prado. c.1547. Oil on slate 69 x 56 cm. *Inscribed: TITLANVS*

warrior, as he appeared for example in Dürer's famous engraving of The Knight, Death and the Devil, and it was perhaps no accident that the emperor was shown in the armour which he had worn on the occasion of his great victory over the German Protestant princes at Mühlberg in 1547. Because of its wealth of allusions, in fact, the picture in the Prado is the only work by Titian that can justly be termed a 'state portrait'. In his earlier portraits of rulers he had used a format similar to that of his paintings of private individuals, but here the composition was designed above all as a statement of Charles's political ideals. Only a supreme artist could have achieved

this with such economy of means, while also creating a totally credible representation of a man courageously bearing the weight of his responsibilities to his God and his subjects.

While the canvas was drying in the sun on a terrace in Augsburg it was blown over and gashed on a stake, but the damage, providentially limited to the body of the horse, was so skillfully repaired by the German artist Christoph Amberger that it is now scarcely visible. In every other respect the paint surface appears to be entirely in Titian's own hand, and it is among the most remarkable examples of his skill. Presumably in deference to Charles's personal taste he adopted a less flamboyant technique than in the slightly earlier *Portrait of the Vendramin Family*, another example of the fallacy of seeing his development as a steady process, but, as can be seen in the marvellous detail of the emperor's head and shoulders, this restraint in no way limited Titian's ability to indicate differences in tone and texture. The real glory of the picture, however, is in the depiction of evening light, the glow of sunset that fills the entire composition. In the eyes of his contemporaries Titian's skill in reproducing natural effects of

this kind was perhaps his greatest gift. Indeed, there exists a wonderfully eloquent evocation of just this aspect of his work in a famous letter written to him by Pietro Aretino, in which the writer described the view from his window over the Grand Canal in terms which could almost as well be applied to this very picture:

... and so I turn my eyes to the sky, which was never embellished by so beautiful a painting of lights and shades since God created it. Thus the air was such as those who envy you because they are not like you would wish to depict it. As I describe it, see first the houses which, although of living stone, appear to be of some artificial substance. Then consider the air as I perceived it, in some places clear and vivid, in others cloudy and dull. Observe also my amazement at the clouds made of condensed humidity; in front of me some were almost at the roofs of the houses, and others almost at the horizon, while at the right there was a threatening mass in shades of grey and black. I was truly astonished at the variety of tones which they displayed: the nearest ones burned with the flames of the sun's fire, the more distant glowed less brilliantly in tones of red lead. Oh, with what beautiful strokes did Nature's brush push back the air, making it recede from the palaces just as Titian does when he paints a landscape! In some parts there appeared a greeny blue and in others a bluish green truly combined by the whims of Nature, teacher of the masters. With her dark and light tones she pushed into the background and brought to the fore the very things she wished to emphasize or to set back, so that I who know that your brush is the essence of her soul exclaimed three or four times, 'Oh Titian, where are you now?'

Unlike the other pictures which Titian painted for him at Augsburg Charles did not take the equestrian portrait to Yuste after his abdication. Instead it passed into the collection of Mary of Hungary, who herself acquired no less than nineteen other portraits from the artist between 1548 and 1554, in addition to several pictures of religious and mythological subjects. In terms of the number of his works that she owned, Mary was among Titian's most important patrons, but her rôle in his career has been to a large extent overlooked, both because of the lack of documentary evidence and because virtually her entire collection is lost. Almost all of the portraits, for example, were burnt at the Palace of EI Pardo near Madrid in 1604. Fortunately for us, it is likely that most of them were not of the highest quality. Many were replicas of portraits produced by Titian for other members of the Habsburg family, notably Ferdinand,

while others date from periods when pressure of work must have forced him to rely extensively on assistants. This is true of one of the very few extant portraits from Mary's collection, Johann Friedrich of Saxony in the Kunsthistorisches Museum, Vienna, which almost certainly dates from the artist's second visit to Augsburg in the winter of 1550-51. If we take the Portrait of Charles V on Horseback as being representative of his autograph work at this period, it is evident that the picture in Vienna was largely executed by another hand, with a tighter, more pedantic technique. But it is impossible to say who this assistant was, since Titian seems to have employed several: the portrait of Charles V's minister Antoine Perrenot de Granvelle, Bishop of Arras, for example, painted at Augsburg in 1548 (Plate 75), is somewhat different in technique and superior in quality to the Vienna picture, but it too does not match the best of the autograph paintings. This is as one would expect, since Titian's first priority at Augsburg was presumably the commissions which he received from the Habsburgs.

75 PORTRAIT OF ANTOINE PERRENOT DE GRANVELLE Kansas City, Nelson-Atkins Gallery (Nelson fund). 1548. Oil on canvas 112 x 88 cm

Although some of the portraits owned by Mary of Hungary, such as that of her niece, Christina of Denmark, painted at Augsburg in 1548, were of relatives, others showed people with whom she was not personally associated, for example Johann Friedrich of Saxony, who was the defeated leader of the Protestant princes. This suggests that the collection as a whole was planned primarily as a historical record of the Habsburg family. As such it is unlikely to have been assembled entirely on Mary's own initiative, but was probably a project initiated jointly with her brother Charles. Similar dynastic considerations, as distinct from any special interest in Titian's work as such, also seem to have characterized the commissions which the artist was given by the third of his Habsburg patrons of this generation, Charles's brother

Ferdinand, who ordered no less than nine portraits of his immediate family in 1548–49. Like the various replicas which Titian painted for Mary and others, these have all vanished; only two are recorded even in copies. The first three, of Ferdinand himself and two of his elder children, were painted at Augsburg; five more, showing seven of his daughters, that is to say four single-figure compositions and one group portrait of the three youngest girls, were begun at Innsbruck on Titian's journey back to Venice; and the last, of the young Archduke Ferdinand, was painted in Venice the following year.

Among these works there was a painting of the Archduchess Catherine, then aged fifteen, which involved Titian in one of his few notable failures as a portraitist. It had been arranged that a replica of Titian's portrait should be sent to Mantua, since the girl was soon to marry the duke, Francesco Gonzaga, but no one seemed to know who was supposed to pay for it. As a result, when the picture was finished Titian found himself empty handed, and he complained bitterly to the Mantuan ambassador 'that he could not believe that His Excellency did not intend to send him a present appropriate to his greatness and to the merits of the work itself; and if nothing was forthcoming he would be forced to say even worse things than Aretino.²³ It would probably not have come to this point had the portrait itself been a success. But the Archduchess was evidently not very prepossessing, and Titian, forced to choose between flattery and honesty, seems uncharacteristically to have made the wrong choice. There were signs of trouble even in Innsbruck, for one of Ferdinand's courtiers had felt obliged to write to Mantua: 'although the archpainter signor Titian has portrayed her in as natural as a way as possible in one respect alone the likeness is slightly less than perfect, that is to say in the picture the face is somewhat more severe than in life; this is not the fault of the painter, for it seems that when Her Serenity had to sit for a long and tedious period she became pensive, and as a result her face appears less cheerful, gentle and sweet than it really is; but otherwise it is so natural that it lacks nothing except the living spirit.⁴ It seems that the portrait did not create a good impression in Mantua either, for when the Mantuan ambassador met the girl on her arrival in Italy, he at once wrote to the duke's mother as follows: 'I found her most cheerful and very satisfied with the Illustrious Duke her husband; and His Excellency for his part is bound to be very happy with her, because in my opinion he has as rare and gentle a wife as any that I have ever seen or known, besides which she is beautiful, and Titian can go hang himself, for the portrait that he has painted resembles Her Serenity as much as a wolf does an ass.²⁵ How much Titian actually received for his trouble, however, we do not know.

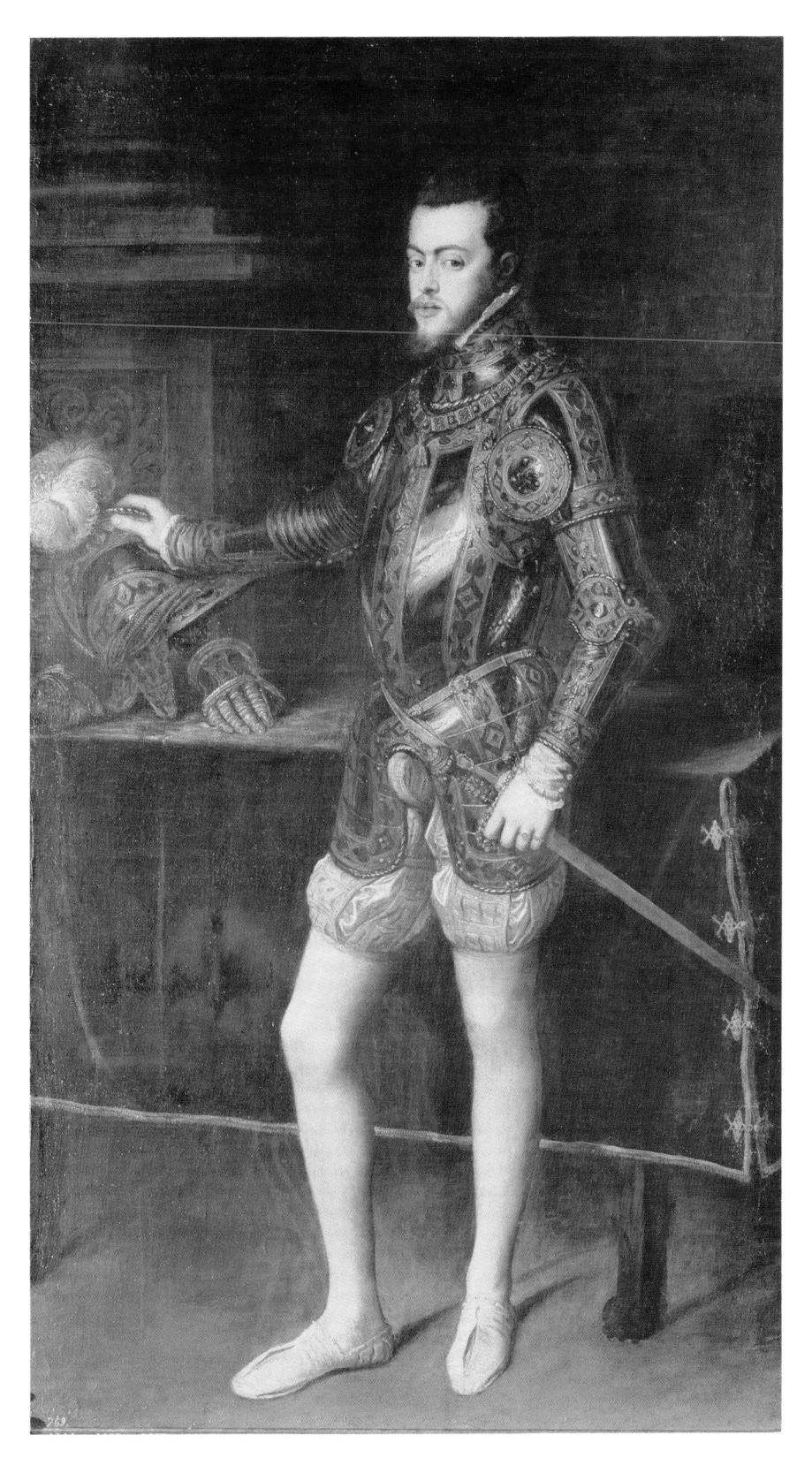

76 PORTRAIT OF PRINCE PHILIP OF SPAIN, LATER PHILIP II Madrid, Museo del Prado. 1549. Oil on canvas 193 x 111 cm.

As if the commissions from Charles, Mary and Ferdinand were not enough, at the end of 1548, almost immediately after his return from Germany, the artist set out for Milan to paint Charles's son Philip, later to become Philip II of Spain, who was then on his way from Spain to Flanders. His first portrait of the prince (Plate 76), showing him full length and in armour, is now in the Prado. The quality of brushwork is comparable to that of the *Portrait of Charles V on Horseback*, but the characterization, in keeping with Philip's personality, is unusually aloof and distant. Nonetheless the picture evidently delighted this new patron, for it was Philip rather than his father who was primarily responsible for inviting Titian to visit Augsburg again towards the end of 1550. From this moment until Titian's death, Philip was to remain his most loyal patron, the one member of the Habsburg family who showed a real appreciation of every aspect of his work and a genuine feeling for painting as such.

Even before setting out for Augsburg, Titian almost certainly sent the prince a picture of major importance, *Danae* (Plate 77). Since this was a variant of the work (Plate 57) he had taken to Alessandro Farnese in Rome, a painting about which Philip would presumably not have known, it was probably undertaken by the artist on his own initiative, just as Charles V's *Venus* had been. But, except in its general format, Philip's picture could hardly have been more different from his father's, and no doubt the differences were intentional. It is the most frankly erotic of all Titian's nudes, both in the design, even the residual drapery of the earlier *Danae* being omitted, and in the mood of the figure, who complacently accepts the embrace of her divine lover. Thus the spectator is now cast in the rôle of a voyeur, in a way that had not been the case with the *Venus*. Here too the attractions of the girl's naked body were enhanced, as they had not been in the Farnese *Danae*, by the contrast provided by the old woman, an example of the principle of *contrapposto* calculated to delight any sixteenth-century connoisseur.

In its technique Philip's *Danae* is equally novel. The handling is looser than in any of Titian's earlier paintings, the contours less defined, so that every feature appears to tremble in a haze of light and colour (Plates 77). It was his most ambitious and accomplished interpretation so far of contemporary Venetian *colore*. But this does not necessarily mean that it embodies his most personal ideals. As we have seen, at this period he was prepared to vary his style to suit the tastes of his patrons, and *Danae*, in both subject and treatment, was evidently intended as a young man's picture. Rather than trying to find some consistent inner logic in Titian's development at every stage in his career we should be prepared to recognize the importance of this kind of flexibility of approach, to admit even the possible relevance of such ephemeral factors as a

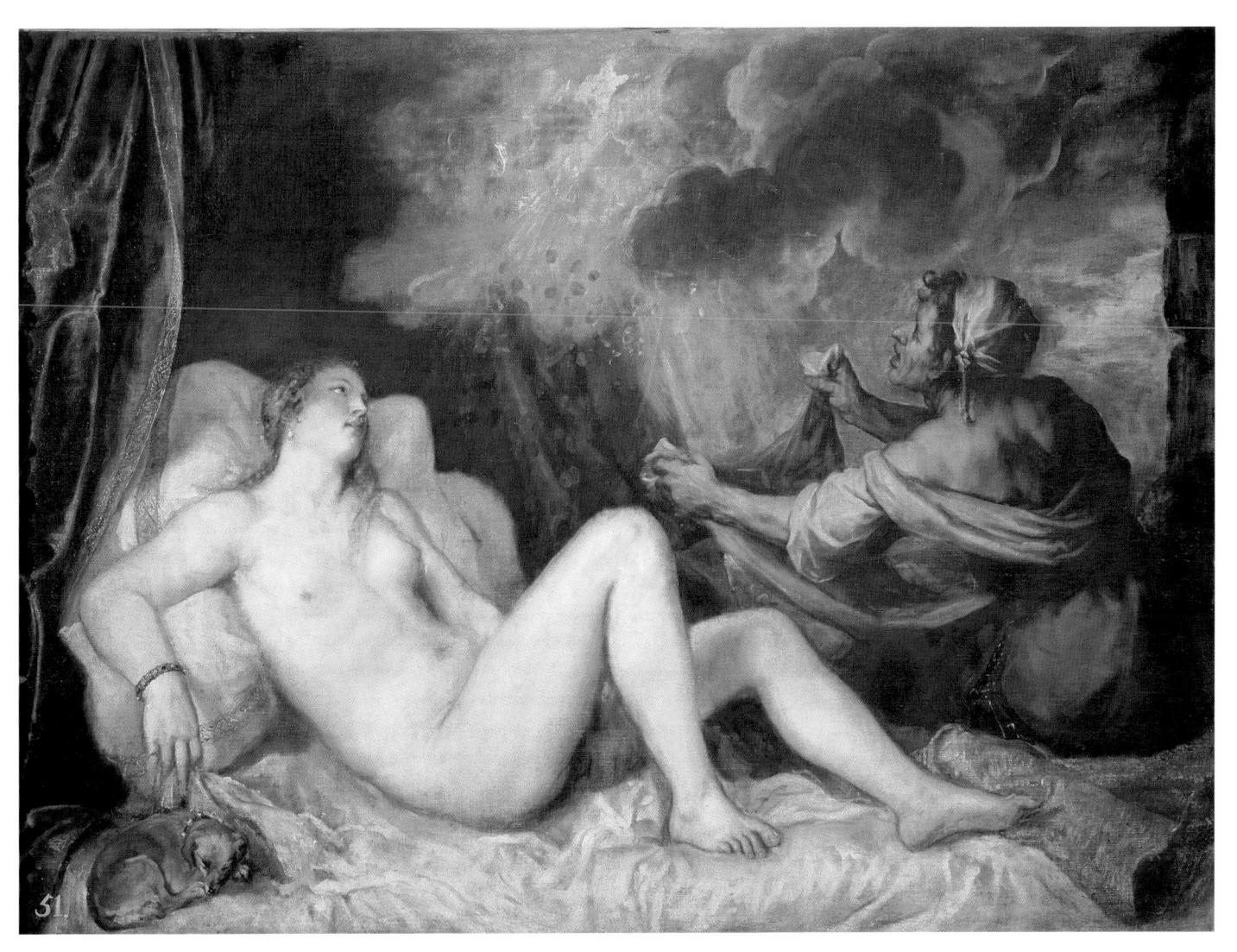

77 DANAE Madrid, Museo del Prado. a1549–50. Oil on canvas 129 x 217 cm.

desire for novelty. Indeed in this context Titian himself, perhaps not entirely in jest, confessed as much when he was asked, apparently in about 1552, why he painted with such bold strokes rather than in the more delicate manner of the other great masters of his time. He is said to have replied:

Sir, I am not confident of achieving the delicacy and beauty of the brushwork of Michelangelo, Raphael, Correggio and Parmigianino; and if I did, I would be judged with them, or else considered to be an imitator. But ambition, which is as natural in my art as in any other, urges me to choose a new path to make myself famous, much as the others acquired their own fame from the way which they followed.⁷

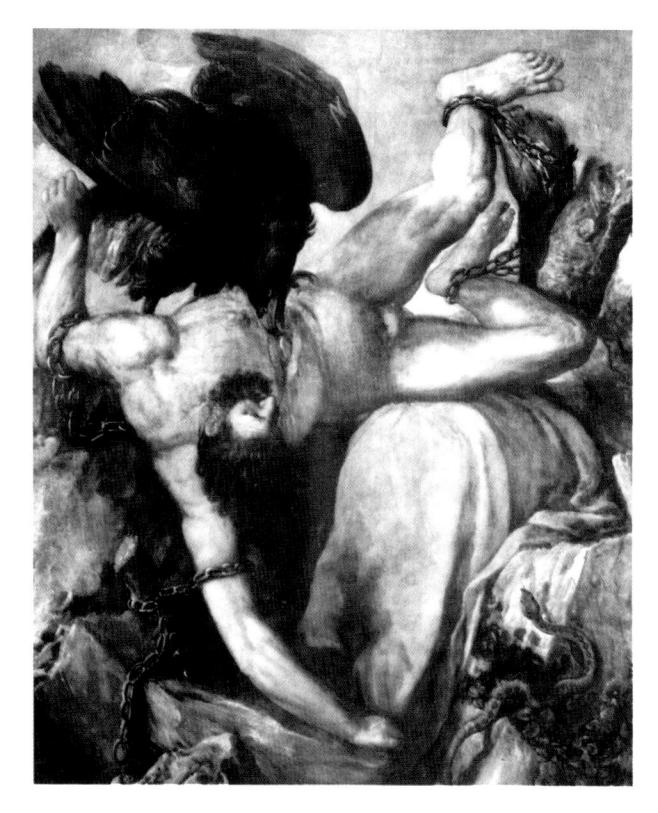

78 TITYUS Madrid, Museo del Prado. 1548–49. Oil on canvas 253 x 217 cm.

Danae belonged to a genre already familiar in Titian's oeuvre, but at the same period he was also working on a project of a very different kind for Mary of Hungary, one that had no precedent in his career. This involved four large paintings of Tityus (Plate 78), Sisyphus, Tantalus and Ixion for her palace at Binche in Flanders, and it seems to have been the first commission not involving portraiture that he had ever received from any member of the Hapsburg family. Tityus and Sisyphus, both of which are now in the Prado, were completed and delivered by June 1549, but the other two, neither of which survives, were only finished about five years later. Although the subjects were taken from Ovid they do not belong to that familiar repertoire of erotic themes usually illustrated by Italian artists. There is a certain precedent in representations of The Fall of the Giants in several north Italian villas and palaces, a tradition going back to a famous fresco by Giulio Romano in the

Palazzo del Tè in Mantua, which Mary must have known by report. At the same time, her commission anticipates in a surprising way the Flemish taste for the gigantic foreshortened male nudes in the style of Michelangelo which, in the eyes of northern artists, were soon to embody all that seemed best in Italian painting. But whatever her reasons for the choice of subjects, the project appears to have been singularly ill-suited to Titian's temperament and abilities, and the paintings themselves, though undeniably impressive, betray a notable and uncharacteristic lack of emotional involvement.

In November 1550 Titian returned to Augsburg. During this second visit, lasting about six months, he was again busy with portrait commissions, particularly from Philip, whom he painted once more in a full-length pose. He also completed a replica of his earlier portrait of the prince for Mary of Hungary. When this was sent to Flanders Philip himself remarked that 'as to my armour, you can easily see the haste with which he painted it, and if there had been more time I would have made him work on it again', a comment which suggests that at this period Philip still shared his father's preference for a relatively high finish.⁸ The implication, of

course, is that Danae had not been entirely to his liking, and this is corroborated by the fact that the paintings which Titian sent him over the next few years were all more restrained in their handling. But despite his reservations Philip's appetite for Titian's work was undiminished, so much so that he commissioned a whole series of new pictures at Augsburg. The exact terms of the agreement are not known, but it seems that the artist undertook to paint about ten large compositions for him during the next decade, some religious and some mythological, as well as several smaller works. In return Titian was granted a pension from the Spanish treasury of 200 scudi a year. His pension in Milan had already been doubled by Charles V in 1548, so this was now worth the same amount, and in 1536 he had also received a valuable concession for the export of corn from the kingdom of

Naples. In theory he could thus expect an annual

income from the Habsburgs of at least 500 ducats,

a very substantial sum considering that a skilled workman in the Arsenal in Venice earned about

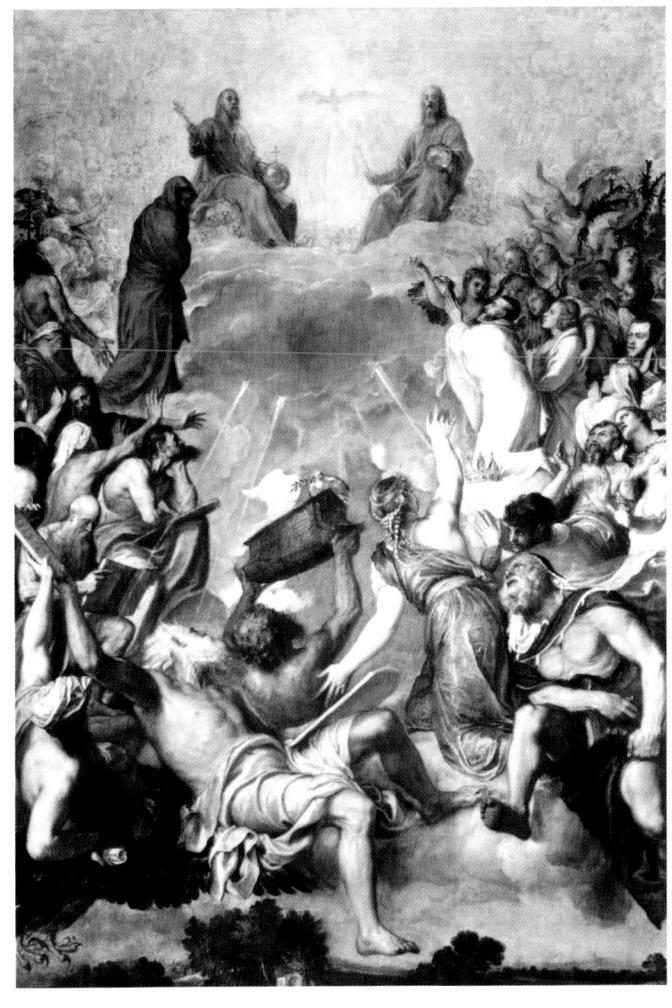

79 THE TRINITY
Madrid, Musco del Prado. 1551–54. Oil on canvas 346 x 240 cm. *Inscribed: Titianus P.*

fifty ducats a year. In practice Titan had considerable difficulty in extracting his money from Spanish and Italian bureaucrats, so his income was often several years in arrears. But the situation improved as he grew older, and by the end of his life he had obtained virtually all that he was owed.

During the early 1550s Philip had less claim on Titian's time than Charles and Mary, both of whom gave the artist important commissions at Augsburg. The most notable came from the emperor, who ordered a large painting of *The Trinity* (Plate 79), the first work other than a portrait that he had ever asked for. It evidently had a special personal significance for him. From the first it was intended for the Monastery of Yuste, the chosen place of his retirement; and in his final illness Charles had the picture brought before him so that he could

contemplate it immediately before withdrawing to his deathbed. The iconography is extremely unusual and must reflect the emperor's personal instructions, at least in the inclusion of himself and his immediate family, dressed in their shrouds and already in Heaven, adoring the Trinity. The picture is thus a profession of his faith and of his hope of salvation, a profession, incidentally, in which Titian also joined, since he too is present at the extreme right of the composition just below Philip. But it is probably wrong to suggest, as some writers have done, that a specific theological point was intended by the prominence given to figures from the Old

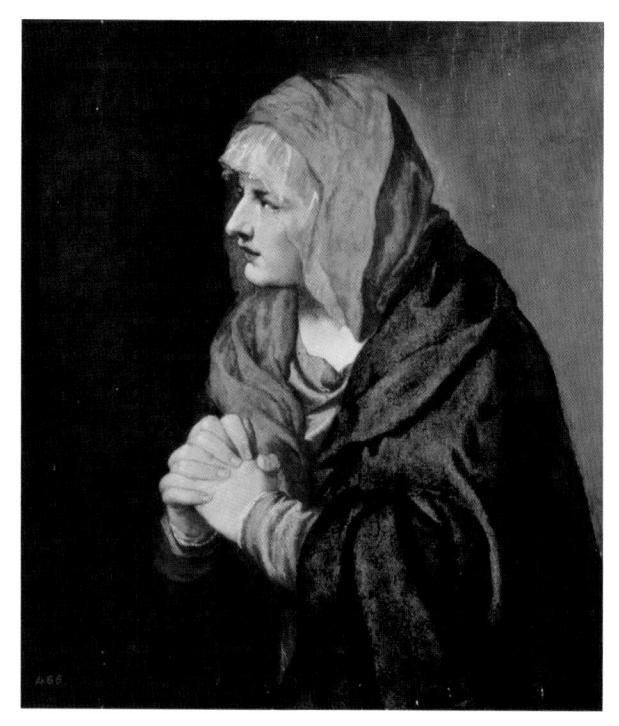

80 MATER DOLOROSA Madrid, Musco del Prado. 1554. Oil on panel 68 x 61 cm.

Testament. Not only was Charles himself inaccurate in his references to the subject of the picture, which in his will he called *The Last Judgement*, but also the inclusion of St John the Baptist as well as of a martyr holding a palm, at the extreme left near the Virgin, suggests that there was no deliberate intention of excluding New Testament figures. Their relative insignificance in the design can be adequately explained by its general structure, which was based on an altarpiece by Lorenzo Lotto in the Church of Santa Maria del Carmine in Venice. Since the Trinity was shown in the upper part of the picture it was only appropriate that Old Testament figures should appear below, where they do not see Christ directly but merely apprehend his presence by means of the light of the Holy Spirit that illuminates them through the clouds.

The Trinity was completed in the autumn of 1554. At the same time Titian sent the emperor another devotional picture now in the Prado, a *Mater Dolorosa* on panel (Plate 80). This was planned as a pendant to the *Ecce Homo* (Plate 74) and shares its direct appeal to religious sentiment; only in the beautiful colouring did Titian permit himself a certain indulgence. Unfortunately the panel turned out to be the wrong size, so in the following year he was asked to produce a second version of the subject (Plate 81) which is also in the Prado but is

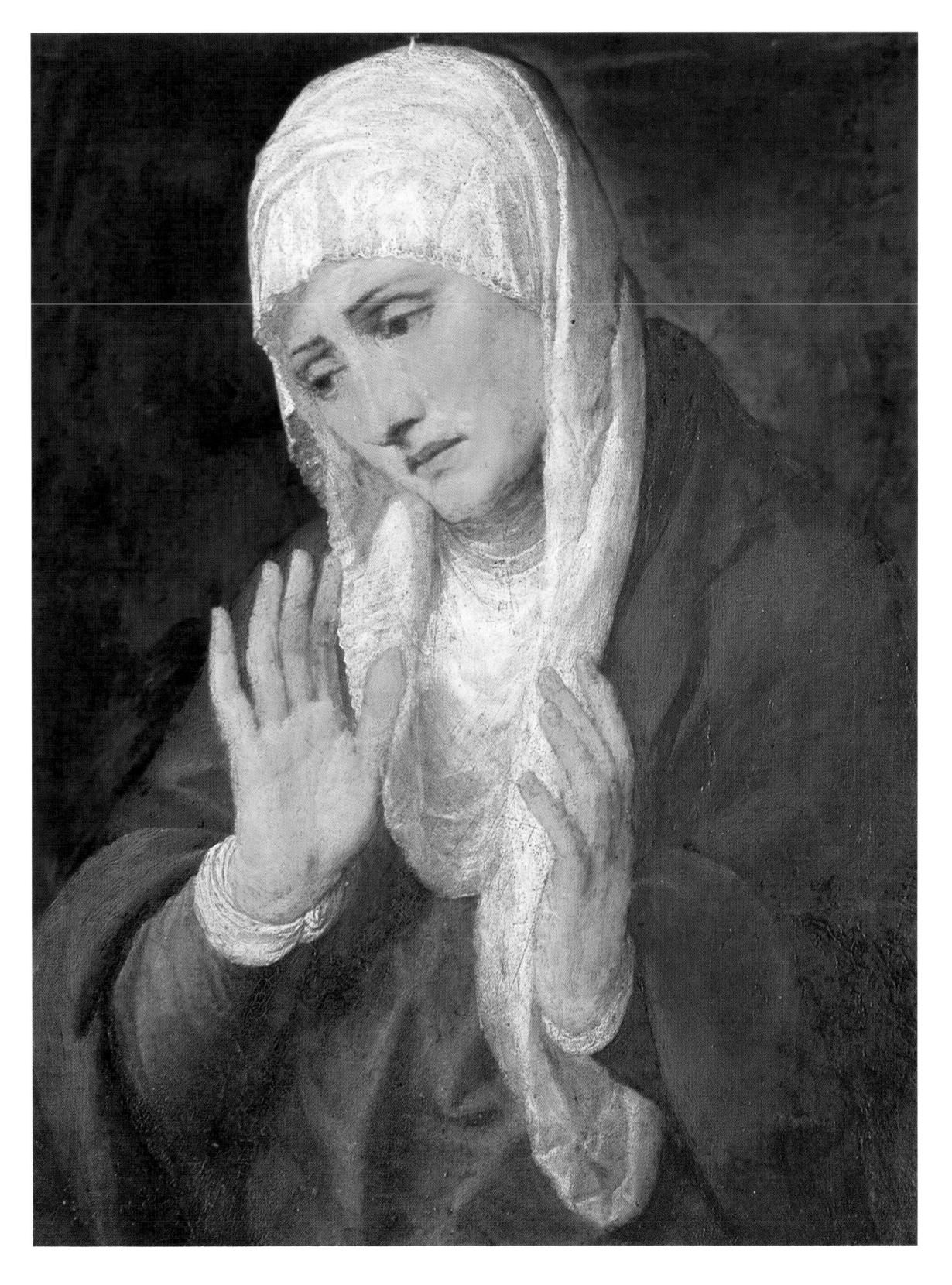

81 MATER DOLOROSA Madrid, Museo del Prado. 1555–56? Oil on marble 68 x 53 cm. Inscribed: TITI . . . S

painted on marble. On this occasion he was required to use a drawing sent by Charles from Flanders, apparently after a work by Van der Weyden or one of his followers. There is no comparable instance of a great sixteenth-century Italian painter being asked to copy a northern prototype in this way. Indeed, it would be hard to imagine a model less suited to Titian's particular gifts or preoccupations; the angular forms and undiluted emotionalism, manifested in a detail such as the Madonna's tears, have nothing in common with the idealism and classical restraint which were the legacy of the High Renaissance and which had previously marked Titian's treatment of similar themes. But there is no evidence that Charles himself was in the least aware of this contradiction. His request, in fact, perfectly illustrates the basic limitations of his patronage: the Flemish original presumably aroused his piety, so he saw nothing incongruous in asking his favourite painter to reproduce it. He regarded Titian essentially as a supreme craftsman, rather than as a creative artist with his own distinctive vision.

Mary seems to have been a more perceptive patron, with much more of the attitude of a conventional collector. The fact that her interests extended beyond portraiture had already been demonstrated in 1548, and at Augsburg in 1551, in addition to commissioning more portraits, she also asked for two other pictures, Psyche Presented to Venus and Noli Me Tangere. Apart from a small fragment of the latter (Madrid, Museo del Prado), neither of these has survived, but a later work for the queen, St Margaret (Plate 82), is now in the Prado. Although the date of the commission is unknown, it is likely that Titian was already at work on the picture by the end of 1554, and he presumably completed it before Mary's death in 1558. 10 The composition, which was later extended at the top by another artist, is based on a picture in the Escorial sent by Titian to Philip in 1552, and this in turn was derived from a work by Raphael (Vienna, Kunsthistorisches Museum) then in a Venetian collection. But Mary's version far surpasses either of these prototypes in its stunning evocation of nocturnal illumination, especially in the burning city in the background, a reminder of the dragon's depredations. As a display of pictorial pyrotechnics St Margaret demands primarily an aesthetic rather than a religious response. It thus perfectly illustrates the essential difference between Mary's taste and that of her brother Charles.

Although the emperor and his sister both commissioned outstanding pictures from Titian in the 1550s, even before their deaths in 1558 Philip had emerged as his foremost patron. The first works which Philip received from the artist after their meeting at Augsburg were the Escorial version of *St Margaret* and *The Pardo Venus* (Plate 83), so named because it was once in the Palace

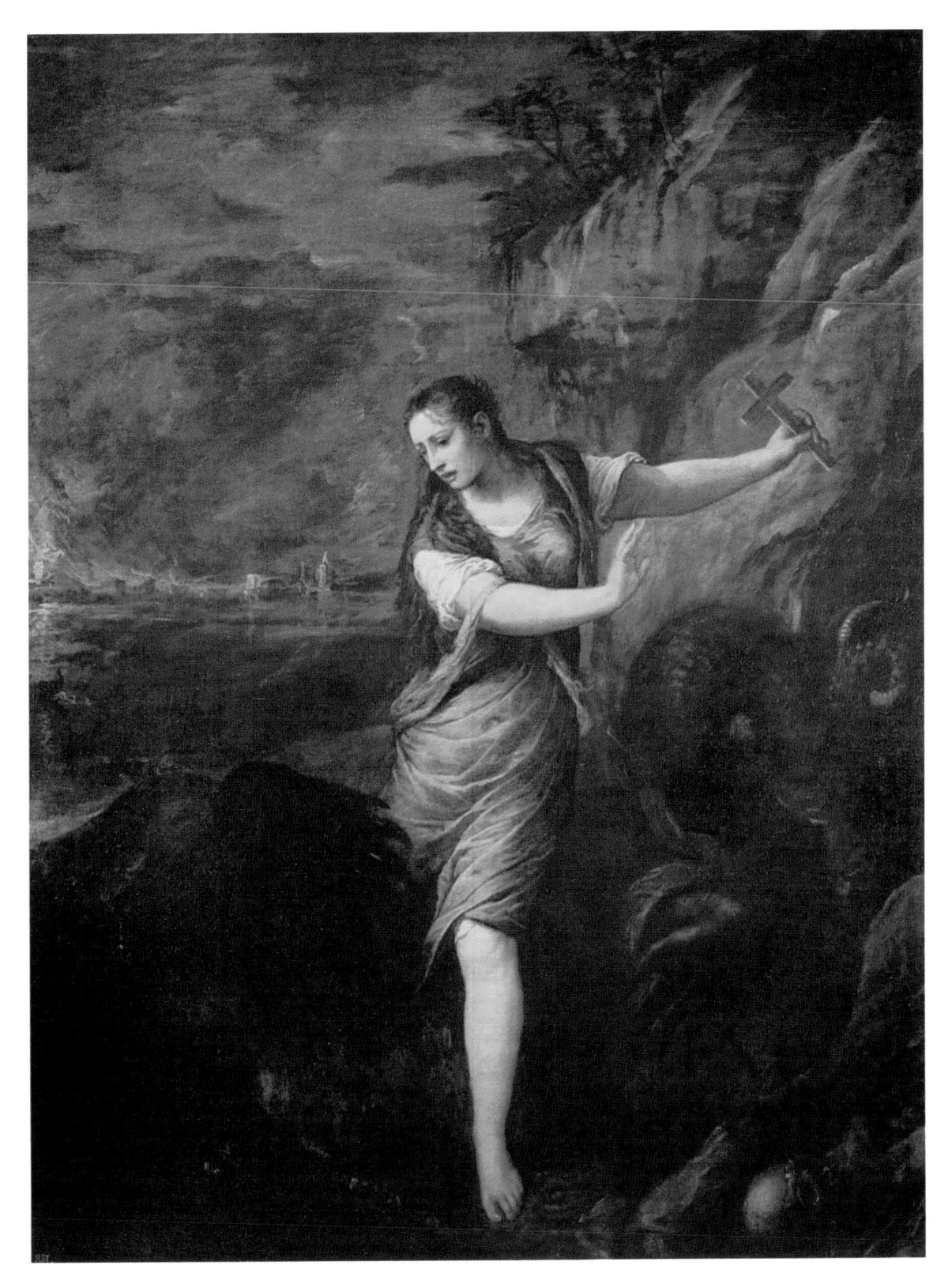

82 ST MARGARET Madrid, Museo del Prado c.1554–58. Oil on canvas 242 x 182 cm., (the upper section of c.33 cm. is a later addition). *Inscribed: TITLANVS. [originally: TITLANVS. F.]*

of El Pardo. The *St Margaret* is a ruin, so its original quality cannot be assessed. There seems no reason why Philip should have commissioned a picture of this subject, and, given the fact that it was sent to him less than a year after Titian's return to Venice, the implication is that the painting may have been begun for another client at an earlier date. This is surely true also of *The Pardo Venus*, which, even excluding a strip added at the left apparently by another hand, is still the largest mythological composition that the artist ever produced. It is also a work whose technique looks far more characteristic of the previous decade, even though, as we have seen, one cannot be dogmatic about such stylistic judgements. But if, as seems likely, it was painted in the 1540s it could well have been undertaken for Alessandro Farnese, for whom Titian is known to have been working on an unspecified commission in 1547, just before his first visit to Augsburg.

Various attempts have been made to explain the subject-matter of The Pardo Venus, none of them convincing. In 1552 Titian himself referred to it simply as 'the landscape' and in a later document he described it as 'the nude woman with the landscape and the satyr'. In the same document he listed various other mythological pictures, in every case indicating the subject with very specific titles, for example 'Europa carried off by the bull'. The omission of any such precise mythological reference in the case of The Pardo Venus suggests that it was a different kind of painting, not an illustration of a familiar legend but merely an Arcadian landscape with figures of mortals, nymphs and satyrs. Historians are usually reluctant to believe that pictures with such unspecific content were produced in the sixteenth century, but Dolce mentioned another work by Titian, 'the land of lasciviousness', again with nymphs and satyrs, which seems to have been of the same general type. 12 Moreover, there are even more obvious precedents in Titian's own oeuvre for paintings without anecdotal or allegorical subjects, namely The Worship of Venus (Plate 30) and The Andrians (Plate 34) for Alfonso d'Este. These were not illustrations of particular stories, but recreations of ancient pictures described by Philostratus showing gods and mortals in landscape settings. Although The Pardo Venus does not correspond to any known classical ekphrasis, educated patrons of the sixteenth century would certainly have known from Philostratus and other writers that paintings of just this kind had existed in antiquity; and one could envisage that one of these patrons, Alessandro Farnese being in this respect a more plausible candidate than Philip, confident of Titian's instinctive sympathy with the conventions of classical art, might have asked him to try his hand at reviving the genre, unconstrained by a written programme. It is true that the experiment does not seem to have been attempted again

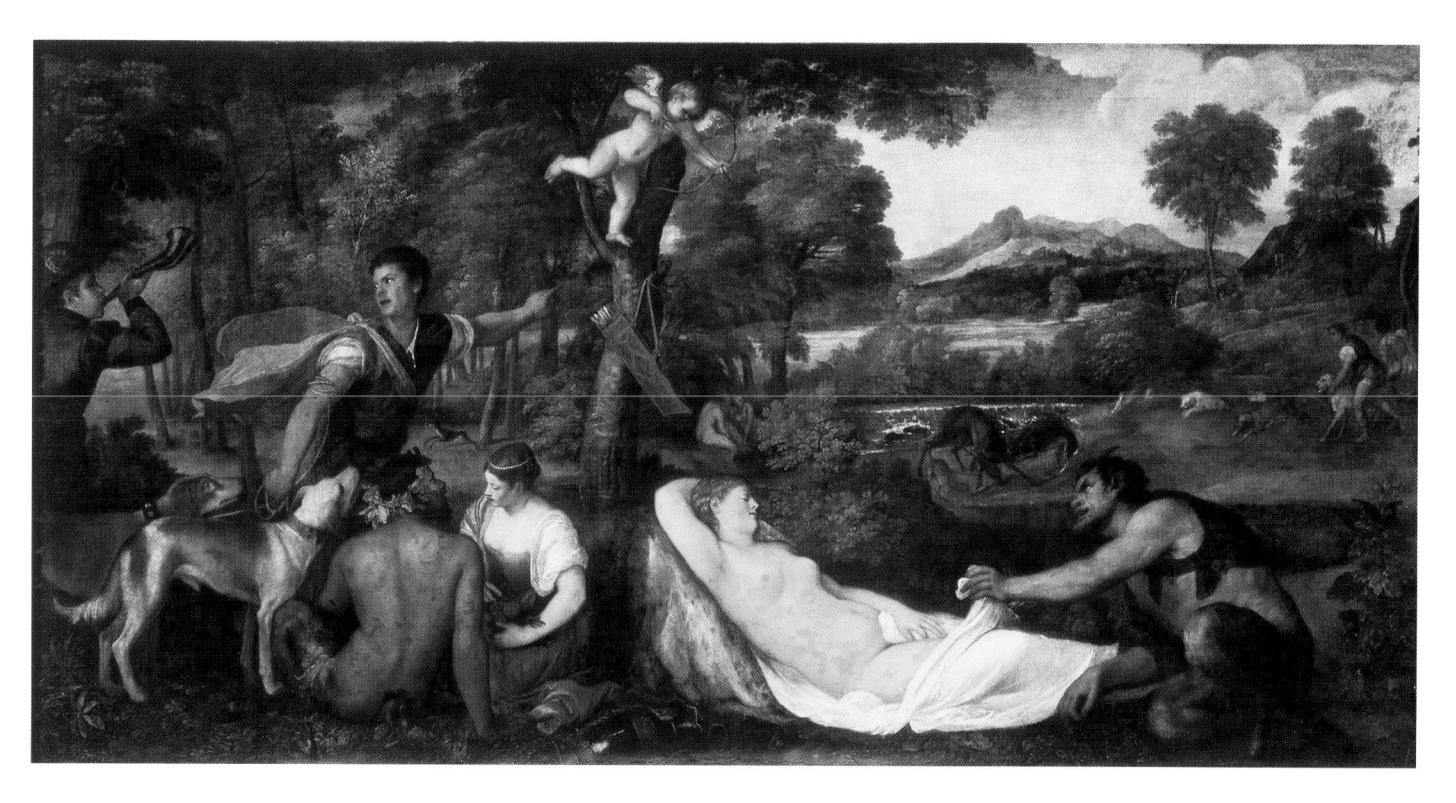

83 THE PARDO VENUS (FIGURES IN A LANDSCAPE)
Paris, Musée du Louvre. £1546–52. Oil on canvas 196 x 385 cm.

in the Renaissance, at least on this scale, but seen in these terms it is at least explicable within the cultural conventions of the period. Unfortunately the picture itself is not well preserved and once splendid features like the sleeping nude in the foreground are no more than shadows of Titian's original creations. But one can still admire the landscape, of a grandeur unparalleled in his career, and the altogether less frivolous mood of the figures as compared with those in the paintings for Alfonso. To use the kind of analogy often found in sixteenth-century texts, in the earlier works Titian had painted like Ovid, whereas here his approach was Virgilian.

For more than two years after the dispatch of *The Pardo Venus* and *St Margaret*, other commitments prevented Titian from completing any of the other major works that he had promised Philip at Augsburg. In the meantime, as an indication that he still remembered his undertaking, he sent the prince two small pictures of a kind that involved relatively little effort. He was often to placate Philip in this way in later years. The first of these pictures, a *Queen of Persia*, was completed in 1552. It can no longer be identified, but it was presumably one of those paintings of pretty girls in elaborate costume already so familiar in his *oenvre*. The second, also lost, was more unusual. It was a self-portrait showing the artist holding a small picture of Philip,

a striking demonstration of his devotion to his patron that was unparalleled in his career.

In September 1554 Titian finally completed a much more substantial work for Philip, who was then in London following his marriage to Mary I, Queen of England. This was *Venus and Adonis* (Plate 84). A letter written at this time by the artist to his patron, who had by now become King of Naples, contained the following passage:

Because the figure of Danae, which I have already sent to Your Majesty, is seen entirely from the front, I have chosen in this other *poesia* to vary the appearance and show the opposite side, so that the room in which they are to hang will seem more agreeable. Shortly I hope to send you the *poesia* of *Perseus* and *Andromeda*, which will have a viewpoint different from these two; and likewise *Medea* and *Jason*.

At this period, then, Titian was planning to send Philip a whole series of mythological paintings, or 'poesie' as he called them, which he envisaged as forming a single ensemble. This series, which was to occupy him for the next eight years, is arguably his greatest achievement.

Titian's use of the term 'poesia' indicated the genre to which the pictures belonged and the way in which they were meant to be interpreted. Just as a picture with a historical subject was often called an 'istoria' and one with a religious subject a 'devozione', so a poesia was a work based on the repertoire of legends used by poets such as Ovid. All Titian's poesie, in fact, illustrate myths recounted in the Metamorphoses. But in Venus and Adonis, in particular, he did not follow Ovid's account at all closely. In the poem Venus leaves her lover at dawn, and only later does Adonis break his promise by setting out on the hunt; in the painting he rejects her pleas even before her departure. In 1584 Titian was criticized for his lack of fidelity to the Ovidian text by the Florentine theorist Raffaello Borghini. But at the time when Venus and Adonis was painted it is doubtful whether anyone would have objected to his composition on these grounds. According to the tenets of contemporary criticism, fidelity to a written text was a prerequisite for a successful istoria or devozione, but when an artist painted a poesia he was permitted the same freedom of invention as poets. In this context Titian's version of the myth, for which, incidentally, there exist precedents in classical sculpture, could be seen as a truly poetic invention since it expressed the essential tragic content in beautifully economical and pictorial terms. At the same time it gave Titian a pretext for showing the female figure from the back,
1548-1562 143

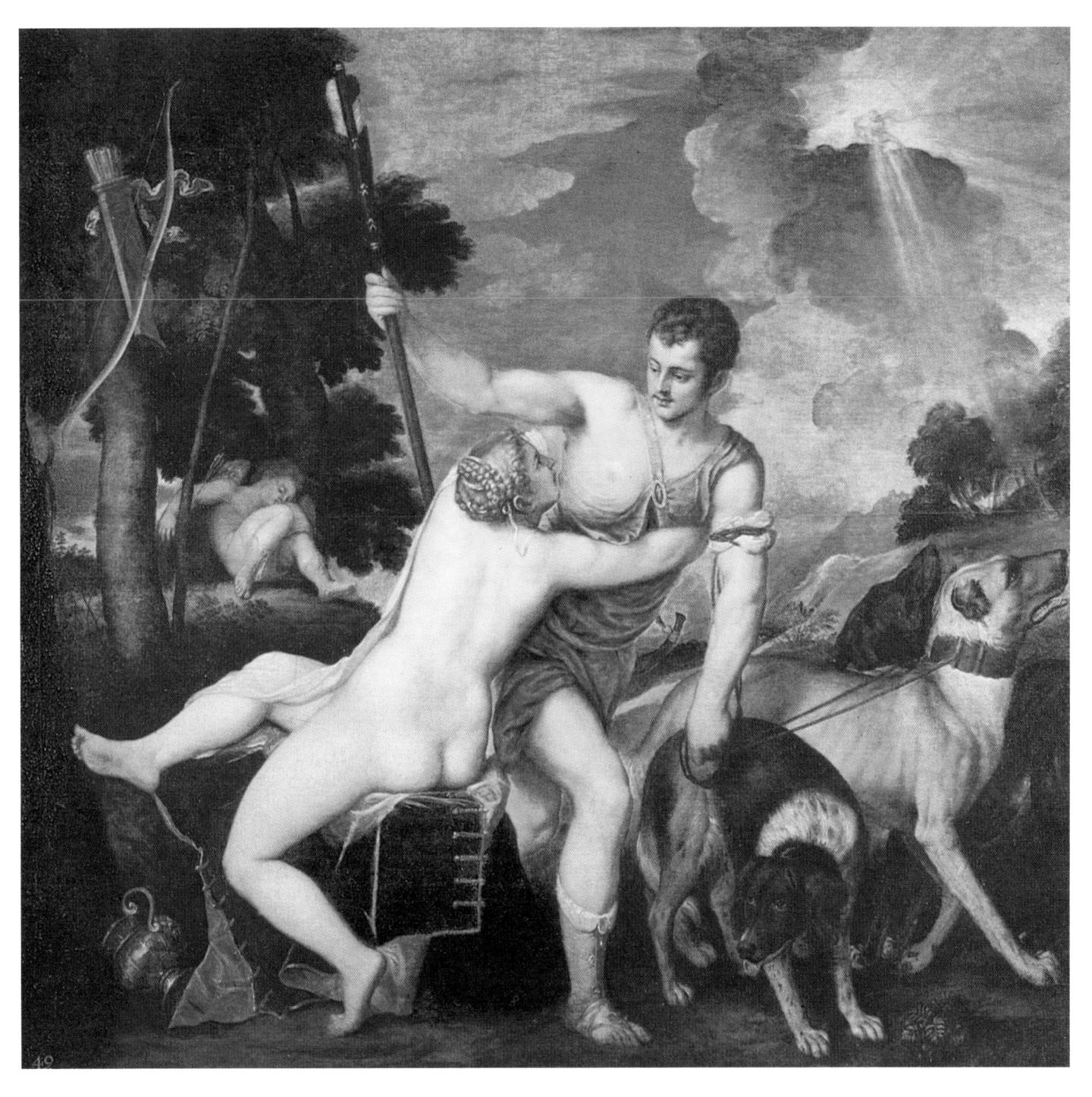

84 VENUS AND ADONIS Madrid, Museo del Prado. 1551–54. Oil on canvas 186 x 207 cm.

thus providing, as he himself indicated, a counterpart to the figure of Danae. The two compositions when viewed together, in effect, created a *contrapposto*, an example of the highly prized quality of variety that Titian planned to elaborate in further pictures.¹³ Indeed, in the letter quoted above he even used the term 'variare', making his intentions absolutely explicit. The *poesie* were therefore not just sophisticated erotica, but a highly self-conscious, calculated demonstration of what the art of painting could achieve.

It was in basically these terms that *Venus and Adonis* was discussed by Dolce in a long and enthusiastic description of the picture, which is the most elaborate surviving passage of contemporary criticism about any of Titian's works. Inevitably he began by praising the picture for the perfection of the *disegno* and the *colore*. He then went on to examine the figure of Adonis, 'in the appearance of whose face this unique master has sought to express a certain graceful beauty, which has something feminine in it without detracting from its masculinity: in other words, there should be a certain quality of the man in a woman, and of the beautiful woman in a man, a most difficult combination to achieve, desirable, and if we are to trust Pliny greatly prized by Apelles.' Again echoing Pliny, Dolce then turned his attention to Venus, who

is shown from the back, not for lack of art . . . but to demonstrate double art; because in turning her face towards Adonis, seeking with both arms to restrain him and half seated on a heavy purple cloth, she shows in every part certain sweet and lively feelings, such as one cannot see except in her. And in this figure the wonderful skill of that divine spirit is displayed by the fact that one can even see the slight compression of her flesh caused by the weight of her body as she sits. What more can I say, except that every stroke of the brush is such a stroke as nature herself is accustomed to apply?

Though such comments may appear to us as forced and even irrelevant, they nonetheless provide the context in which a work like *Venus and Adonis* was discussed and admired. The appeal of the picture lay not only in its sensuality, although this was certainly remarked on by contemporaries, not least by Dolce, or in its technical excellence, but above all in its understated artifice.

The *poesie* were evidently designed to form a single ensemble, but thematically they are linked only in rather tenuous ways. To give the series a certain coherence Titian seems to have

adopted the principle of designing the pictures as loosely related pairs. Thus *Venus and Adonis* was associated with *Danae* (Plate 77), one showing a female figure from the back, the other from the front. At the same time their subjects create a similar type of symmetrical contrast. In one case a woman accepts the love of a god, in the other a man rejects the pleas of a goddess. The second pair of pictures promised in 1554, *Perseus and Andromeda* and *Medea and Jason*, were to have been related in much the same way. Unlike the earlier pair both involved only mortals, and it may be no coincidence that these very myths had previously been chosen by Pietro Bembo, in his famous book *Gli Asolani*, as examples of the different effects of love, which on the one hand brought Andromeda happiness in the midst of misery, and on the other reduced Medea from contentment to a state of wretchedness.

In the event Titian did not keep to his initial plan. *Perseus and Andromeda* (Plate 85) was sent to the king as promised in 1556, but *Medea and Jason* was never painted. The reason is not known, but it may have been connected with a decision Titian seems to have made to exclude *Danae* from the series. This picture, originally conceived as an independent work, is substantially smaller than the other *poesie* and would therefore have looked out of place beside them. Significantly, when in 1568 Titian offered a series of replicas of Philip's mythologies to the Emperor Maximilian II, and probably also to Albrecht V, Duke of Bavaria, *Danae* alone was not among the subjects that he mentioned, even though the popularity of the composition is

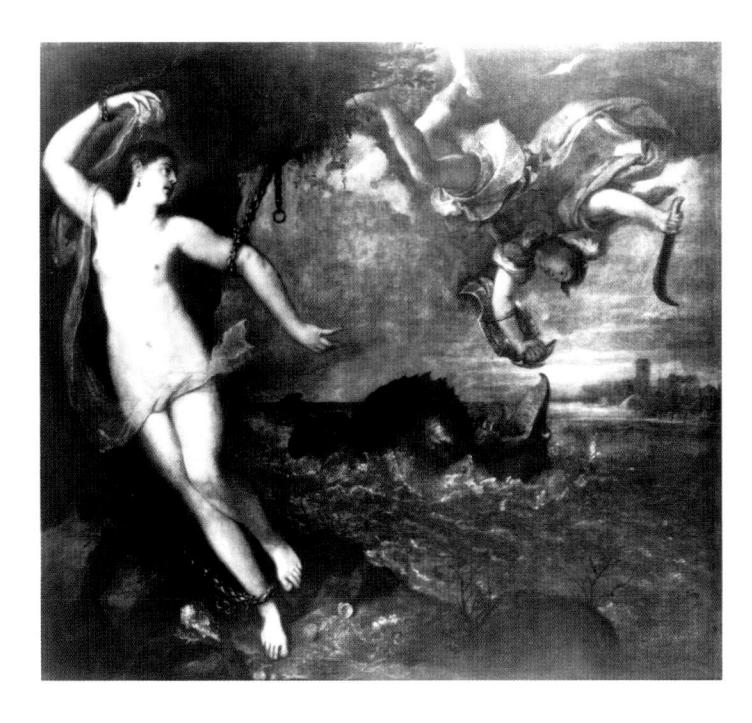

85 PERSEUS AND ANDROMEDA London, Wallace Collection. 1554–56. Oil on canvas 183 x 199 cm.

attested by the existence of numerous copies and derivatives. As for *Perseus and Andromeda*, it is the least well preserved of all the *poesie*, but some idea of its original quality can be gained from another large picture which Titian almost certainly sent to Philip at the same time, *The Crucifixion* now in the Escorial. If, as seems likely, this was the 'most devout work' which the artist mentioned in a letter of 1554, when it had already been in his studio for ten years, it must have been begun for another client. Its general appearance, however, suggests that it was produced in the mid-1550s, at about the same time as the *St Margaret* for Mary of Hungary.

Titian's next major picture for Philip, completed in 1557, was again a religious subject, an Entombment of Christ. Unfortunately it was lost in transit somewhere between Venice and Flanders so two years later he sent a second version (Plate 88), together with two more poesie, Diana and Actaeon (Plate 89) and Diana and Callisto (Plate 86). These three pictures mark a new departure in Titian's career. The most obvious innovation is to be seen in the sumptuous colour, a play of brilliant reds, greens, golds and blues such as had scarcely been seen in his work for thirty years. This change in Titian's palette is so sudden and unexpected that one is bound to seek some explanation. The closest parallel in terms of colour is to be found in the work of Paolo Veronese, an artist whose first mature masterpiece in Venice, the ceiling paintings in the Church of San Sebastiano (Plate 87), had been completed in 1556, that is to say at just at the moment when Titian was starting work on the Edinburgh poesie. In the

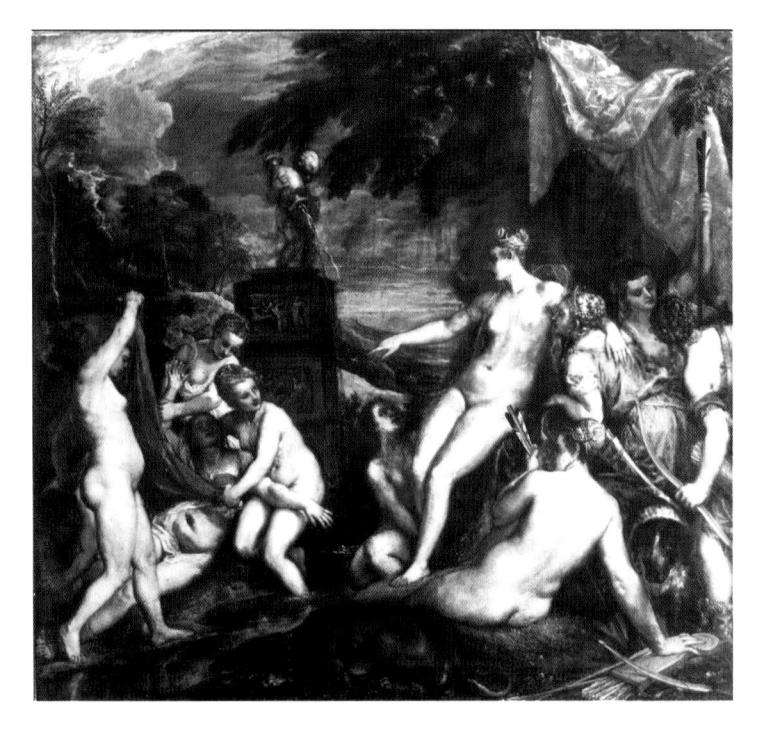

86 DIANA AND CALLISTO Edinburgh, collection of the Duke of Sutherland, on loan to the National Gallery of Scotland, 1556–59. Oil on canvas 188 x 206 cm. *Inscribed: TITLANUS, F.*

same year seven of the foremost young painters in the city, apparently selected by Titian, were asked to provide ceiling paintings for the new Library designed by Sansovino, and Veronese's contribution was judged to be the finest. The implication, of course, is that Titian shared in the general enthusiasm for his work. Thus once again, even in his old age, he showed himself to be by no means an isolated figure, but keenly responsive to artistic developments in Venice.

It is not difficult to see why Titian should have been drawn to Veronese's work. As we have seen in his paintings for Venetian patrons in the 1540s he had participated in the general trend towards a looser type of brushwork, but had rejected the extreme virtuosity of handling and rapidity of execution adopted by Tintoretto and Schiavone in their more flamboyant exploitation of Venetian *colore*. In the 1550s the one major artist of the younger generation who was conspicuously uninfluenced by their innovations was Veronese, probably because his style was already virtually fully formed before he arrived in Venice. This does not mean that in the pictures sent to Philip in 1559 Titian adopted a technique comparable to Veronese's, merely that he might have been predisposed to study his work sympathetically.

In fact the pictures completed in 1559 are noticeably freer in their handling than anything he had painted for the king since Danae. But the technique was significantly different from that of the earlier picture. In Danae the colours are predominantly monochrome, the pigment was treated as a fluid, transparent and insubstantial substance, and the lusciously thick impasto favoured by Schiavone and Tintoretto, and to some extent by Titian himself in a work like The Portrait of the Vendramin Family (Plate 72), was replaced by a more uniform, restrained kind of brushwork, as if he was trying to paint not physical objects but the veil of light that played over every surface). Thus there is scarcely any perceptible difference in texture between, for example, the fur of the dog and sheet on which it lies. In a picture like Diana and Actaeon, by contrast, Titian took a real delight in such distinctions as those between skin and hair, water and stone, and he consistently modified the strength of modelling according to the distance of the object represented from the picture plane. The actual way in which he built up his paint surface defies analysis, but it was evidently an immensely laborious and elaborate procedure, even though the result appears miraculously fresh and spontaneous. A detail such as the figure of Diana shows a fullness of modelling, a richness of surface and above all a sense of life never before seen in European painting; and it makes even the finest passages in Titian's early work, for example the naked goddess in Sacred and Profane Love (Plate 20) seem pedantic in comparison.

Modern art historians, who have consistently tended to emphasize the innovative character of Titian's work, have had much less to say about the basically conservative aspects of

87 VASHTI BANISHED Paolo Veronese Venice, Church of San Sebastiano. 1556. Oil on canvas 500 x 370 cm.

paintings like *The Entombment* (Plate 88) and the Edinburgh *poesie* as compared with those of some of his younger contemporaries. But Vasari, who is often accused of insensitivity in his assessment of Venetian painting and who certainly criticized Tintoretto for the rapidity of his technique, was well aware of this aspect of Titian's achievement, as he showed in his account of these very pictures, written after his meeting with the artist in 1566:

... they are owned by the Catholic king, and are greatly valued by him on account of the vivacity which Titian has given to the figures with his colours, making them natural and almost alive. But it is true that his method of painting in these late works is very different from the technique he had used as a young man. For the early works are executed with a certain finesse and an incredible diligence, so that they can be seen from close to as well as from a distance; while these last pictures are executed with

broad and bold strokes and smudges, so that from nearby nothing can be seen whereas from a distance they seem perfect. This method of painting has caused many artists, who have wished to imitate him and thus display their skill, to produce clumsy pictures. For although many people have thought that they are painted without effort this is not the case, and they deceive themselves, because it is known that these works are much revised and that he went over them so many times with his colours that one can appreciate how much labour is involved. And this method of working, used in this way, is judicious, beautiful and stupendous, because it makes the pictures appear alive and painted with great art, concealing the labour.

Although Vasari characteristically emphasized the element of virtuosity in Titian's late style, just as he stressed the complexity of the foreshortened figures in Michelangelo's *Last Judgement*, he recognized that this was not an end in itself but contributed to the impression of abundant energy and movement that infused every part of his pictures. Vasari was right too in realizing that the appearance of spontaneity achieved by Titian was the result of prodigious effort.

X-ray photographs of *Diana and Actaeon* reveal that the artist made countless modifications to his original design, altering the placing and structure of the building, the poses of the figures and the fall of light and even adding at a relatively late stage the brilliant red hanging at the left which isolates Actaeon and causes the nymphs to recede from the picture plane. There could be no better illustration of the consistency of Titian's approach to composition throughout his career, the lack of distinction between conception and execution that was already apparent even in his early works. In a way unmatched in the *oeuvre* of any other artist, his paintings, and especially those of his later years, reveal the very workings of his creative process; they have a quality of immediacy, of apparent improvisation, that his great contemporaries in central Italy display only in their drawings.

Titian's working procedure also had two other important consequences. First, it meant that he avoided the two major problems inherent in the practice of establishing a composition in

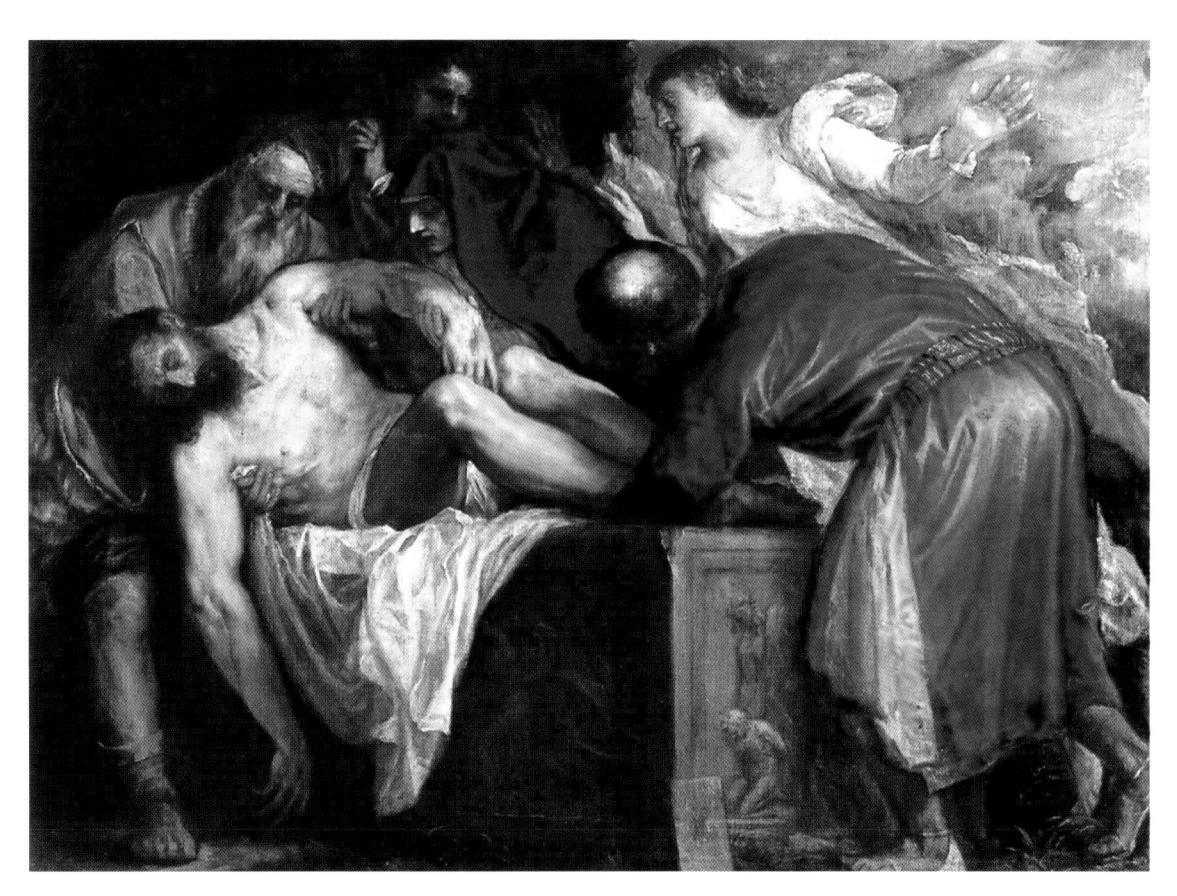

88 THE ENTOMBMENT OF CHRIST Madrid, Museo del Prado. 1559. Oil on canvas 137 x 175 cm. *Inscribed: TITLAN: VECELLIVS AEQVES CAES*.

detail in the form of a drawing, namely the effects of a change in scale and of the introduction of colour. Secondly, it led him away from the type of architectonic design prevalent in central Italy. *Diana and Actaeon*, in fact, has been called one of the earliest baroque designs in modern painting, and it breaks with the dominant conventions of Renaissance art in several important ways: recession is no longer established primarily by a system of orthogonals, there are no strong horizontal or vertical axes and every figure is shown in movement. Yet the composition itself is completely coherent and the narrative is expressed with absolute clarity. In one respect, however, Titian did make a concession to the ideals of *disegno*, namely in the treatment of the figures: *Diana and Actaeon* and *Diana and Callisto* include a repertoire of poses for the female nude which perhaps intentionally provide a counterpart to Michelangelo's definitive exploration of the theme of the male nude in *The Battle of Cascina* and the frescoes of the Sistine Chapel.

The most interesting of the changes in *Diana and Actaeon* involve the figure of Diana herself. In its final form we see an unrealistically large proportion of the body: the breast is shown in full profile but at the same time virtually the whole of the back is also visible, as if the torso was wedge-shaped. This cannot have been just a mistake on Titian's part, since the figure was initially painted quite correctly. The only plausible explanation for the change is that he deliberately chose to show Diana from two distinct viewpoints simultaneously, with the intention of emphasizing her sudden turning movement. There is no close parallel to the use of such a device in the art of this period, but it is in a sense analogous to the practice adopted by many contemporary Mannerist painters of showing figures with a degree of *contrapposto* that was anatomically impossible.¹⁷ It must be admitted that Titian's experiment is not wholly convincing, but it is none the less indicative of his ambition to extend the potentialities of his art to their very limit in this picture. In other ways, too, *Diana and Actaeon* is a manifesto for the art of painting, notably in such details as the mirror, the glass flask and the reflections of the carvings in the water, all of which could have been understood by contemporaries as allusions to the continuing discussion of the *paragone* of painting and sculpture.

When Titian sent *Diana and Actaeon, Diana and Callisto* and *The Entombment* to Spain he was extremely apprehensive about Philip's reaction to them, so much so that he refused to undertake anything further to the king until he had heard that these three pictures were to his satisfaction. This was the only time in his dealings with Philip that Titian acted in this way, but considering his patron's earlier preference for high finish his fears are easy enough to

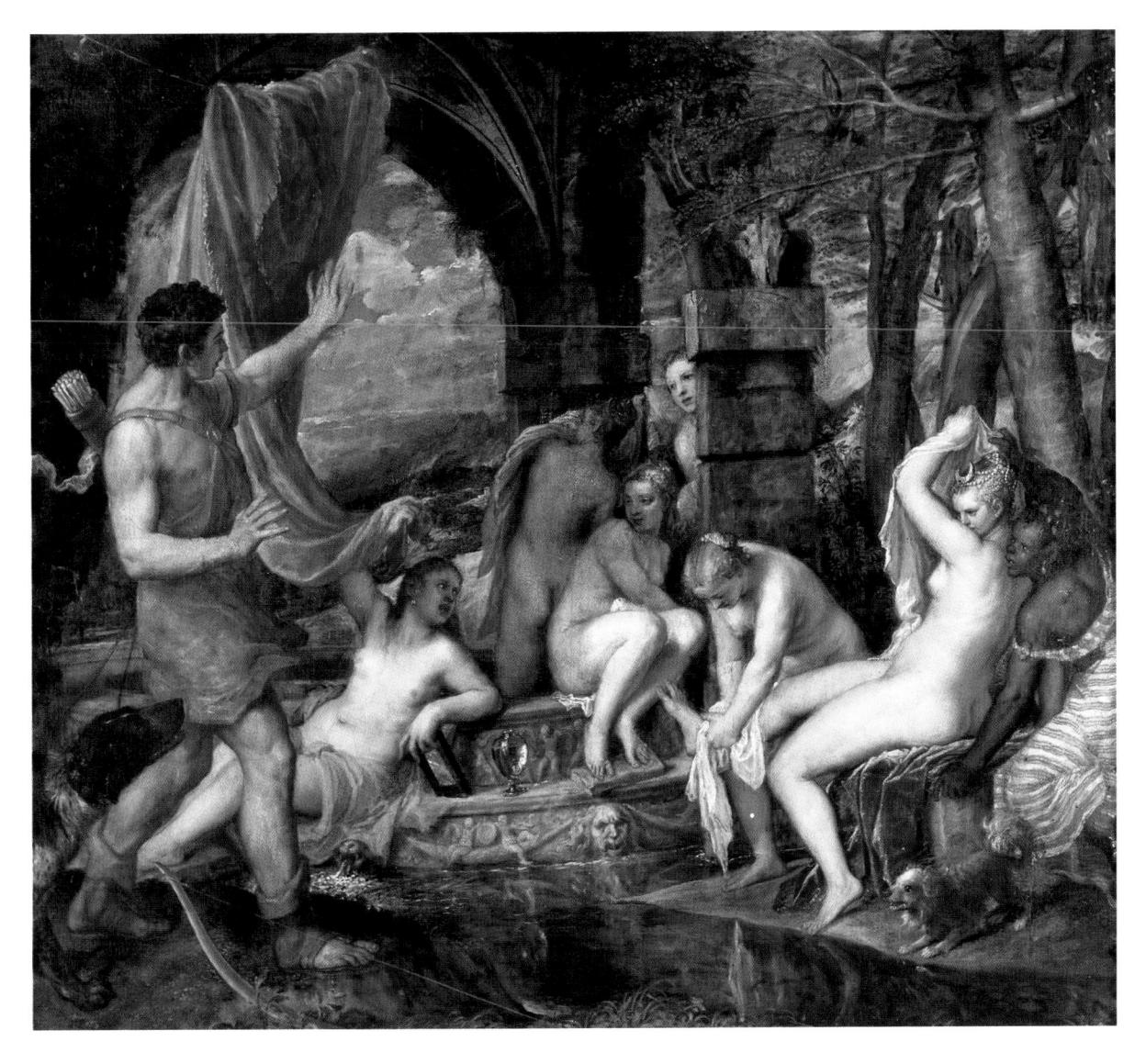

89 DIANA AND ACTAEON
Edinburgh, collection of the Duke of Sutherland, on loan to the National Gallery of Scotland. 1556–59. Oil on canvas 188 x 203 cm. Formerly inscribed, but reputedly not by Titian: TITLANVS F

understand. By now, however, the king had become more sophisticated and his verdict was entirely favourable. This episode is important, for it demonstrates that in his work for Philip after the mid-1550s Titian no longer modified his style to suit his patron's tastes. From this time onwards the pictures for Philip provide the clearest indication of his artistic ideals; they are the touchstone of his autograph work. Significantly, one of the paintings of this period that is closest in style to those for the king is the figure of *Wisdom* (Plate 90) painted in or soon after 1560 for the ceiling of the vestibule of Sansovino's new Library. On this occasion one would expect Titian to have taken particular care, since the work in question was to hang in close

90 WISDOM Venice, Biblioteca Nazionale Marciana. ε.1560. Oil on canvas 177 x 177 cm.

proximity to those submitted by the younger artists of Venice three years before, when the prize, a gold chain, had been awarded to Veronese.

In June 1559, shortly before he finished Diana and Actaeon and Diana and Callisto, Titian told Philip that he had already begun two more pictures for the same series, The Death of Actaeon (Plate 92) and The Rape of Europa (Plate 91). The Death of Actaeon presents something of a problem. It was never sent to Spain, indeed never mentioned again by the artist in his correspondence with the king. In its present form it looks nothing like the pair of poesie completed in 1559 since it is much less colourful, and one can hardly envisage that Titian could have begun work on it in that year with the intention that it should be hung with these two pictures. For quite apart from its very different appearance, its subject is one that he would surely not have chosen at this moment. Since the painting in London involved Actaeon it would inevitably have been associated with Diana and Actaeon, which shows the preceding episode of the story, but these two works are in no sense pendants and could never have been planned as such. The placing of the two main protagonists, in fact, is virtually identical in both pictures, as are their poses, and there are further parallels in the landscapes, notably in the streams and the groups of trees at the right. The most reasonable hypothesis is that The Death of Actaeon was begun about 1555, before the two poesie in Edinburgh, a circumstance which would help to account for the relatively narrow range of colour. In terms of its subject, at least, it might have

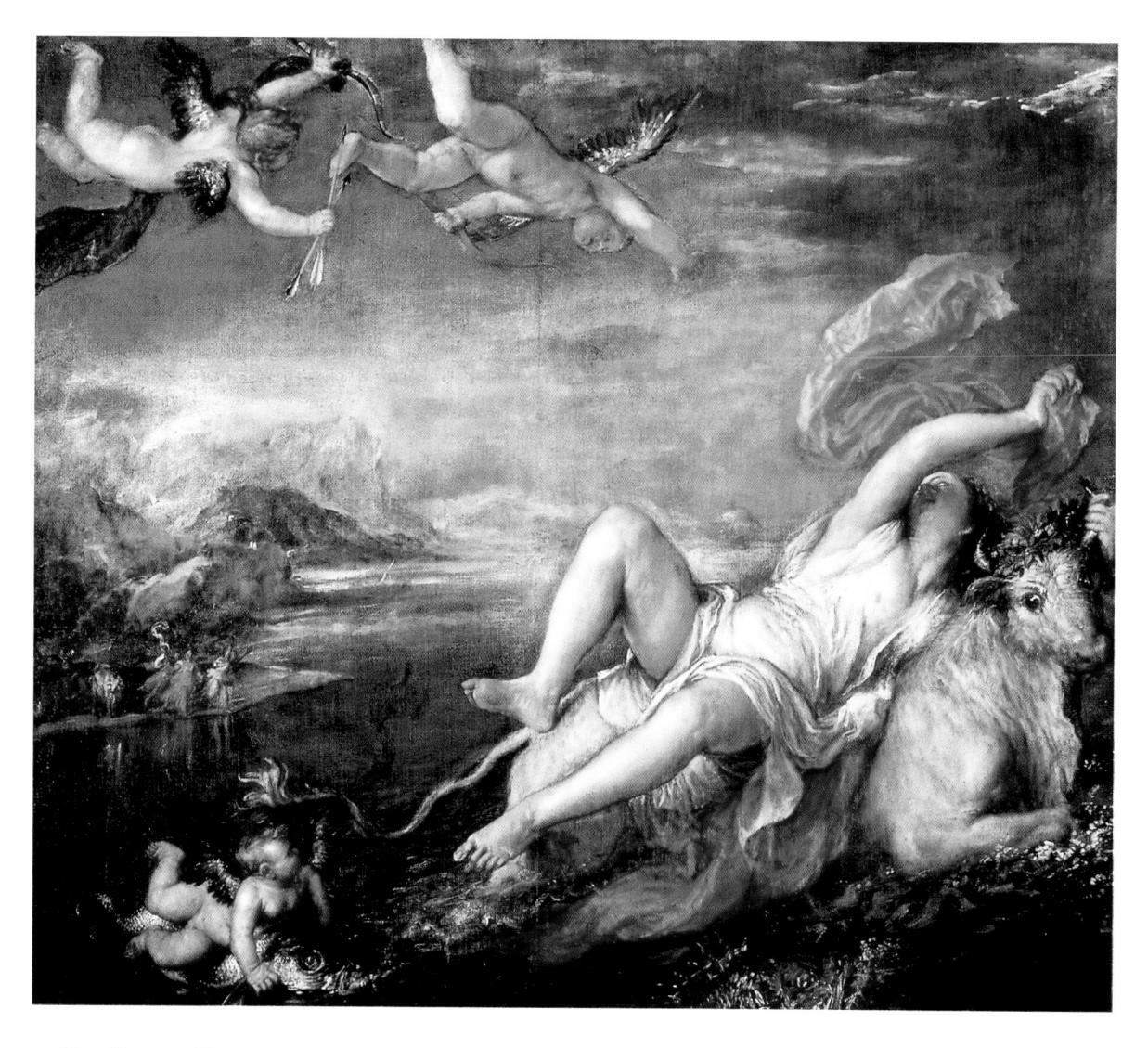

91 THE RAPE OF EUROPA Boston, Isabella Stewart Gardner Museum. 1559–62. Oil on canvas 178 x 205 cm. *Inscribed: TITLANVS. P.*

been planned as a pendant to *Venus and Adonis*, following the exclusion of *Danae*: it too involved hunting and concerned a goddess and a mortal, in this case the goddess of chastity rather than love. But then Titian changed his mind and began *Diana and Actaeon* and *Diana and Callisto*. In 1559 he seems to have thought again briefly about incorporating it in the series, but then realised that this was impracticable. At a later date, as we shall see, he may have returned to the picture with a view to selling it to another client. As it stands, therefore, *The Death of Actaeon* cannot be taken as in any sense representative of Titian's work around 1559.

The early history of *The Rape of Europa* is fortunately in no way problematical. Completed in 1562, it was designed as a pendant to *Perseus and Andromeda* and it is entirely consistent in colour and handling with the pictures in Edinburgh. As well as being the last of the *poesie* it is also the

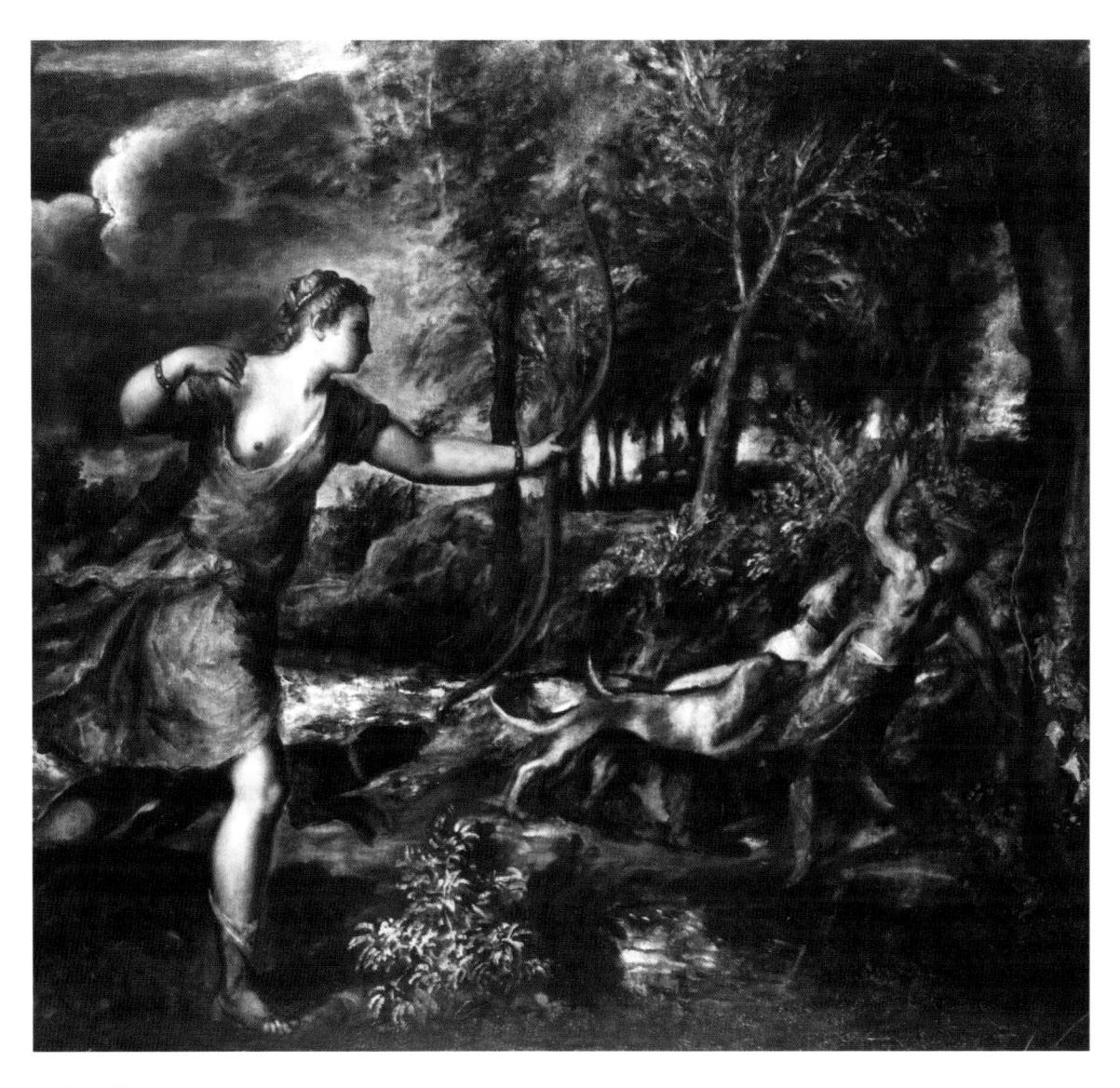

92 THE DEATH OF ACTAEON London, National Gallery. *c.*1555–76. Oil on canvas 179 x 198 cm.

best preserved of the series, the one work which most perfectly illustrates the vitality and colouristic splendour of Titian's late style. Some writers have claimed that the composition is based on a description of a painting in a late Antique prose romance, *Leucippe and Clitophon* by Achilles Tatius, a translation of which was available in Venice, but Titian's picture does not correspond particularly closely to the text. Moreover, even if Titian did use Achilles Tatius he did not trouble to mention the fact to Philip, as one would have expected if he had intended *The Rape of Europa* as an explict recreation of a classical work of art, in the way that *The Worship of Venus* (Plate 30) for Alfonso d'Este had been. For all Philip's *poesie* Titian's principal literary

source was the *Metamorphoses*, which he read only in translation.¹⁸ But none of these pictures are precise illustrations of passages in Ovid; they embody the spirit of the myths rather than the letter of the text, interpreted in his own way by a painter who would have been right to regard himself, and indeed was regarded by contemporaries, as the equal of any poet.

Just as it is a mistake to try to relate the *poesie* very closely to written texts, so too it is unjustified to suppose, as several art historians have done, that a complex iconographical programme underlies either the series as a whole or any individual picture. To judge from the abundant documentation the subjects were chosen by Titian rather than his patron, and as we have seen were changed on several occasions and for a variety of reasons, implying that the artist had no rigid overall scheme in mind. Moreover, although

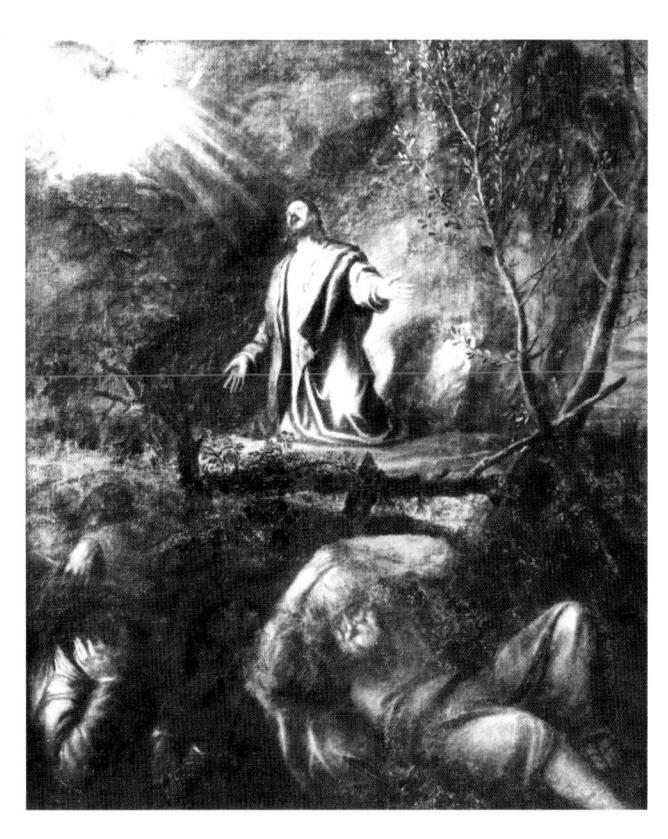

93 THE AGONY IN THE GARDEN
Escorial, Nuevos Museos. 1559–62. Oil on canvas 177 x 146 cm.

Ovid's poetry had in certain contexts frequently been subjected to the most esoteric interpretations and moralizations, it certainly was not always read in these ways; similarly, there is no evidence that Titian's pictures were supposed to have any such 'second level of meaning'. Nor is it correct to suggest that they were unusual in their imagery, that they reflect, as is sometimes said, an exceptional or even morbid erotic taste on the part of the patron. Philip II may have been neurotic in later life, and he has never been popular in English-speaking countries, but it does not follow that his patronage of Titian was either unconventional or unsophisticated. On the contrary, the *poesie* belong to an established genre and are precisely the kind of non-religious pictures which a princely patron might have hoped to acquire from a famous artist. Indeed, Philip himself must have been familiar with this genre since childhood, through the famous series of paintings of *The Loves of Jupiter* by Correggio which had been owned by his father. Apart from their superb quality, Titian's *poesie* are exceptional not in the fact that they are erotic, but because they convey the geuine passion and terror underlying the familiar and often trivialized myths recounted by Ovid. In Titian's interpretation even subjects

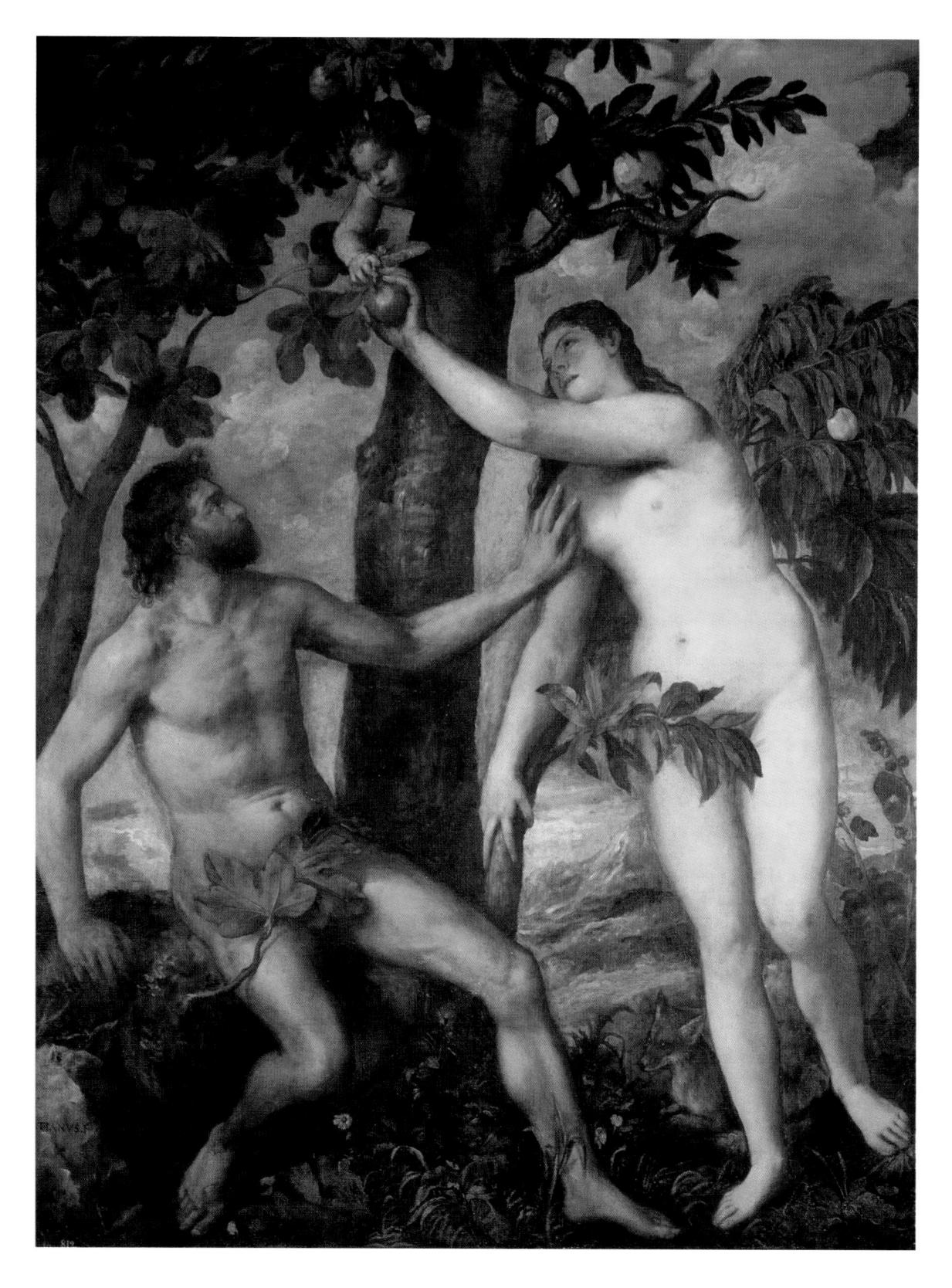

94 THE FALL OF MAN Madrid, Musco del Prado. ϵ .1560. Oil on canvas 240 x 186 cm. *Inscribed: TITLANVS. F.*

such as *The Rape of Europa*, so often treated in a lighthearted manner, acquired intimations of tragedy.

Together with this mythological painting, in 1562 Titian also sent Philip *The Agony in the Garden* now in the Escorial (Plate 93).¹⁹ In his letters to the king the artist always implied that the two works were of comparable quality and importance, but because of its ruinous state of preservation *The Agony in the Garden* has for the most part been disregarded by recent writers. Yet it is not difficult to see why Titian himself valued it so highly. It was the first night scene that he had painted for Philip, and even now the radiance that emanates from the angel and flickers over the entire composition remains a *tour de force*. While its original paint surface, executed in the technique of the later *poesie*, was still intact the effect must have been magical.

With the completion of *The Agony in the Garden* and *The Rape of Europa* Titian fulfilled the agreement which he had made with Philip at Augsburg. In all the paintings he sent to the king in the intervening period, whether the major compositions that have just been examined or relatively minor works like a *Magdalen* which he sent in 1561, he seems to have had total freedom in the choice of subject. As a result his patron received some of the artist's greatest and most personal masterpieces. At first Philip had to share his services with Charles and Mary, but after about 1556 he enjoyed a unique status among Titian's clients, so much so that even someone as important as Cardinal Ippolito d'Este, one of the most powerful members of the Curia, had to accommodate himself to the king's wishes. Thus in about 1556 the cardinal commissioned an *Adoration of the Magi* as a gift for Henri II, King of France, but three years later, admittedly after Henri's death, the Spanish ambassador saw the picture in Titian's studio and suggested that it should be sent to Philip instead; the artist agreed, and it was not until 1564 that Ippolito finally received a second version of the composition.²⁰

The original picture, now in the Escorial, is not as impressive as those undertaken expressly for Philip. By this period, in fact, other clients could only hope to acquire autograph works, including portraits, in exceptional circumstances as, for instance, in the case of *Wisdom* for the new Library in Venice. Another example is provided by *The Fall of Man* (Plate 94), which looks very like the pictures sent to Philip in the late 1550s. It was probably painted in about 1560 for the king's chief minister Gonzalo Pérez, a man well placed to help Titian obtain payment of his Spanish pension. But even though the artist needed to cultivate his favour, *The Fall of Man* still seems to have cost Pérez the enormous sum of 400 ducats.²¹ His special status therefore merely gave him the opportunity of paying for Titian's services, whereas less influential clients,

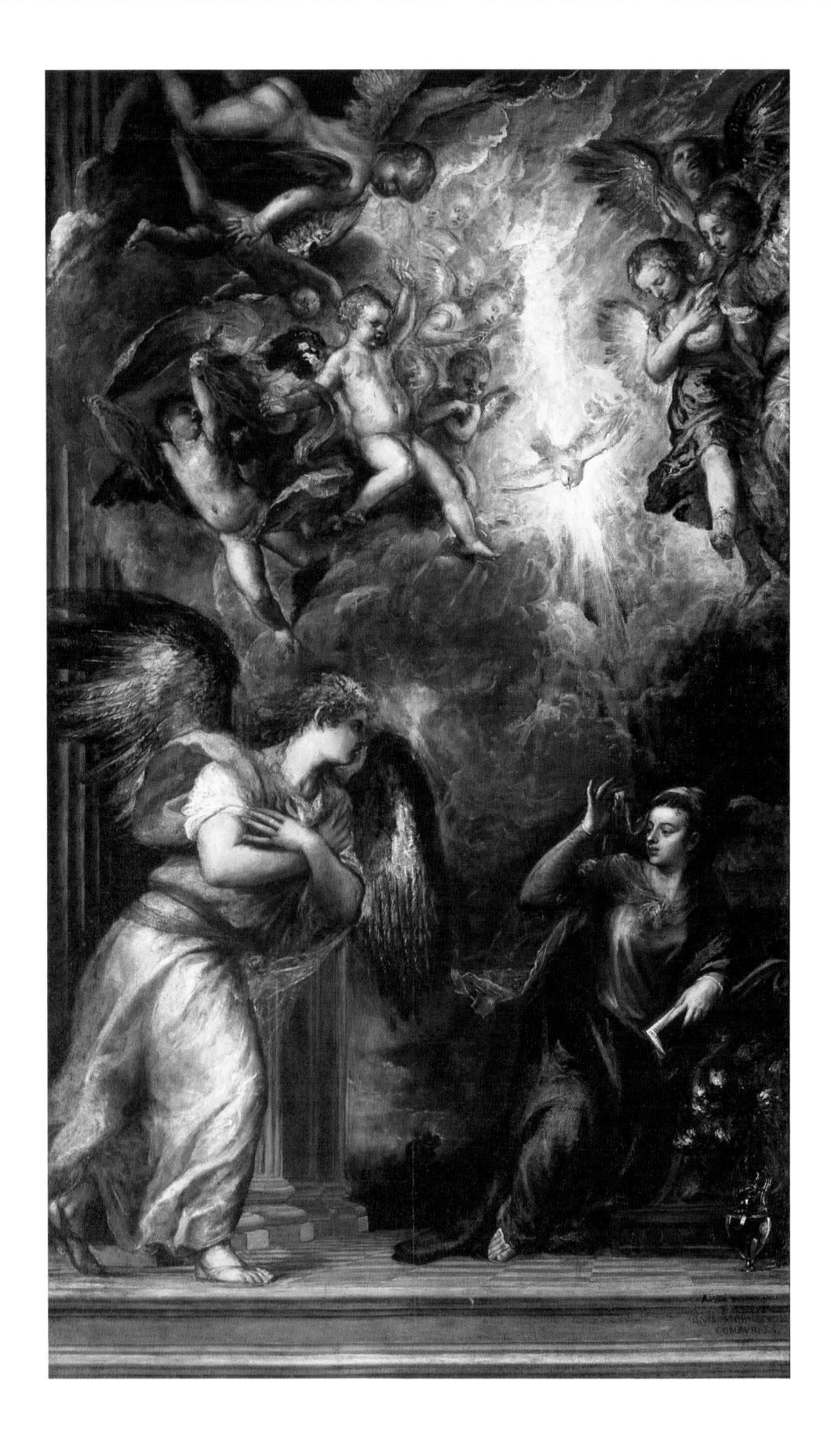

however wealthy, generally had to be content with studio works.

There is one notable exception, The Crucifixion in the Church of San Domenico in Ancona, apparently completed in 1558 for a member of the Venetian family of Cornovi della Vecchia and of superb quality. Why Titian should have taken such trouble with this picture is unknown, as is the date of the commission. But a second picture for the same family, The Annunciation (Plate 95), in the Church of San Salvatore in Venice, ordered by 1559 and completed by 1566, is very much less impressive. It is true that this altarpiece has often been admired by critics, but Vasari explicitly stated that Titian himself did not think highly of it. His reservations are easy enough to understand, for the muddy colours, the physical types, the mannered pose of the Virgin and incompetent features like the angel on his stomach at the top of the canvas or the badly drawn figure of Gabriel have no parallel in contemporary works for Philip. The use of gesture is also inept. In representations of the Annunciation it is usually the Virgin who is shown with crossed wrists, to indicate her humility; but in this case the gesture is given to Gabriel, whose general demeanour is anything but humble. In short, the picture has all the hallmarks of a studio product, as one would expect of a work painted for a chapel so dark that it can never have been seen adequately. Titian's other important Venetian altarpiece of this period, The Martyrdom of St Lawrence in the Church of the Gesuiti (Plate 96),

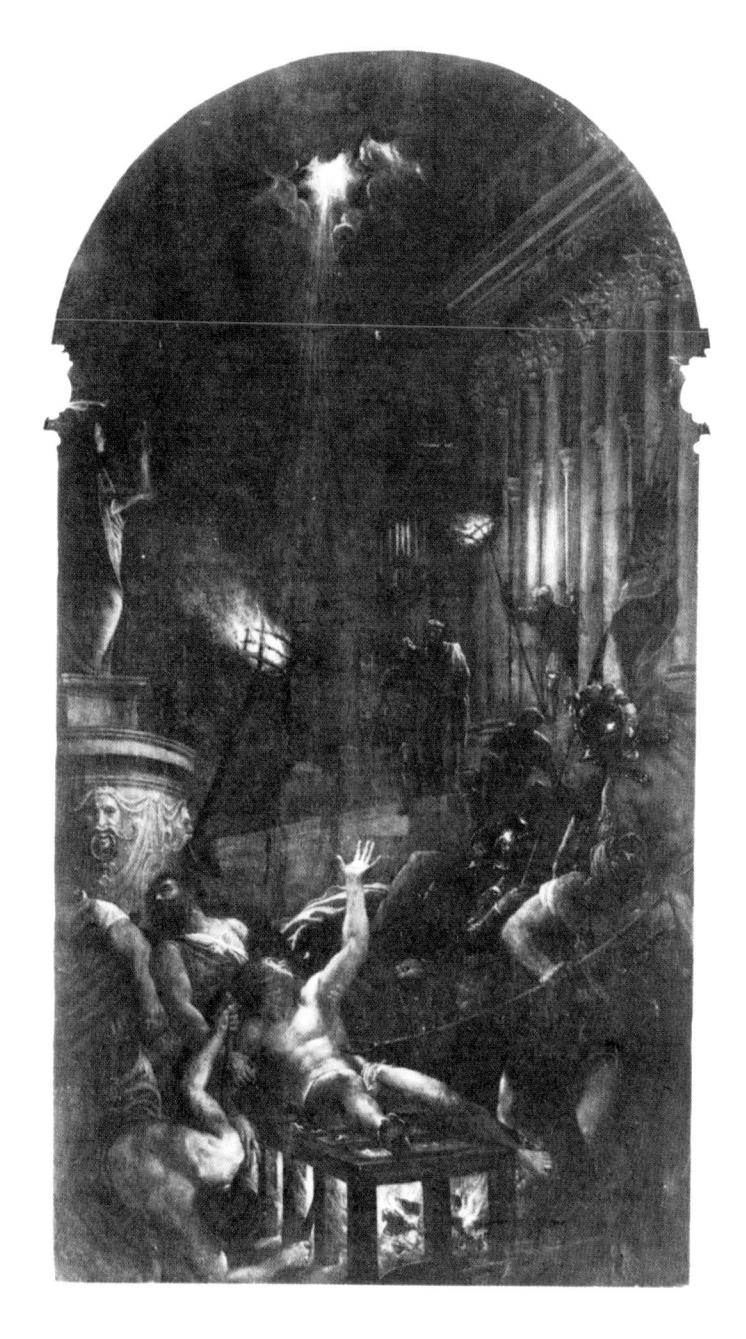

95 THE ANNUNCIATION (left)
Venice, Church of San Salvatore. Between 1559 and 1566.
Oil on canvas 403 x 235 cm. *Inscribed: TITLANVS FECIT. FECIT.*

96 THE MARTYRDOM OF ST LAWRENCE Venice, Church of the Gesuiti. £1548–57. Oil on canvas 500 x 280 cm. Inscribed: TITLANVS VECELIVS AEQUES F.

which was commissioned by a lawyer named Lorenzo Massolo by 1548 and finished about ten years later, is more impressive. But even here such passages as the portico in the background and the carvings on the plinth seem too mechanical to be by Titian's own hand. It is significant too that the owners tried to sell the picture to Philip II for as little as 200 scudi in 1564, a price that would have been astonishingly low for an autograph work.

Of course it was through pictures like *The Annunciation* and *The Martyrdom of St Lawrence* that Titian's later work was chiefly known in Italy, so one can see why Vasari should have said that 'it would have been a good idea if in these last years of his he had worked only as a pastime, so as not to spoil with inferior paintings the reputation that he had acquired in better times before his powers, in the natural course of events, had begun to decline.' In effect, by the 1550s he had all but withdrawn from the Venetian stage. From this time onwards only Philip II was in a position to know that he was still capable of producing masterpieces equal to anything ever painted in Europe.

FOOTNOTES

- 1 The documents relating to Titian's work for the Hapsburgs are scattered in many different publications, and they raise complicated problems of interpretation which cannot be examined here. In this chapter I merely try to indicate as briefly as possible my reasons for redating pictures that I actually illustrate and discuss.
- 2 Campana, 1908, p. 387.
- 3 Alessandro Luzio, 'Altre spigolature tizianesche', Archivio Storico dell'Arte, III, 1890, p. 210.
- 4 Hieronymus von Sprinzenstein to Sabino Calandra, Innsbruck, 28 October 1548 (Mantua, Archivio Gonzaga, busta 545).
- 5 Benedetto Agnello to Margherita Paleologo, Bussolengo, 20 October 1549 (Mantua, Archivio Gonzaga, busta 1481).
- 6 Danae is first mentioned in a letter from Titian to Philip published by Lodovico Dolce (Lettere di diversi eccellentiss. huomini . . ., Venice, 1554, pp. 229f.). Although undated, this letter is datable on internal evidence to the summer of 1553, by which time the picture was already in Philip's possession. Since Danae is not cited in the very complete and consistent correspondence about Titian's transactions with Philip between this period and June 1552, the implication is that it was sent at an even earlier date. Unless Titian painted and dispatched the picture very soon after his return from Augsburg in the previous summer, which seems most unlikely, it follows that Danae predates his second journey to Augsburg in October 1550.
- 7 Antonio Pérez, Segundas cartas, Paris, 1603, pp. 120v,-121r.
- 8 The widespread assumption that Philip's remark applies to the picture in the Prado (Plate 76) and that this picture dates from 1551, is unwarranted. Since Mary is known to have acquired a portrait by Titian of Philip in a blue coat, showing him as he looked in 1550–51, it seems more reasonable to suppose that her portrait of him in armour was the copy of Titian's earlier picture of the prince which had been promised to her, but so far as is known never dispatched from Venice. Titian could well have wished to complete this copy at Augsburg, where Philip's armour was presumably available to him.

- 9 On 10 September 1554 Titian reported to Charles V that he had finished a *Mater Dolorosa*, painted on an unspecified support, and *The Trinity* (Ferrarino, 1975, p. 40, no. 55). In an undated letter to the emperor he also reported that he had completed a *Mater Dolorosa* on stone (Carlo Ridolfi, *Le maraviglie dell'arte*, ed. Detlev Freiherr von Hadeln, Berlin, 1914–24, I, p. 185). This second letter, conventionally dated to late 1554, cannot be earlier than March 1555, when Titian obtained a suitable block of stone (Ferrarino, 1975, p. 43, nos. 60, 61). The first letter must therefore refer to the *Mater Dolorosa* on panel (Plate 80).
- 10 That the *St Margaret* was painted for Mary of Hungary is indicated by an inscription on a print after it by Luca Bertelli (see Wethey, *Titian*, I, p. 142). Even though the picture is not recorded in her inventory this does not seem an adequate reason for discounting Bertelli's statement, especially as the work is first recorded in the Monastery of San Jerónimo in Madrid, an institution much patronized by the Habsburg family. I believe that Titian's reference, in a letter to Juan de Benavides of 10 September 1554, to 'una divotione della Maestà dell Regina, la quale tosto se le manderà' concerns this picture rather than one for Mary Tudor, as is usually supposed, since there is nothing about such a painting in his letter to Philip, apparently of the same date (Dolce, 1554, pp. 230–32, with the letter to Benavides misdated 1552).
- 11 The 'landscape' sent in 1552 was described as a large picture (Ferrarino, 1975, p. 32, no. 42). None of Titian's other works for Philip fits this description, and there are no documents of other dates which could plausibly refer to the dispatch of *The Pardo Venus*.
- 12 Lodovico Dolce, Dialogo . . . de i colori, Venice, 1565, p. 51v.
- 13 David Summers, 'Figure come fratelli: a Transformation of Symmetry in Renaissance Painting', Art Quarterly, new series, I, 1977, p. 68.
- 14 The list of copies of the *poesie* offered to Maximilian in 1568 is well known. The existence of an identical, but undated, list in Munich (Bayer. Hauptstaatsarchiv, Libri Antiquitatum, III, fol. 31) implies that similar pictures were also offered to Albrecht V.
- 15 For a general discussion see Thomas Puttfarken, Masstabsfragen, Ph.D. diss., Hamburg, 1971.
- 16 E. K. Waterhouse, Titian's 'Diana and Actaeon', London, 1952, p. 16.
- 17 Lars Skarsgård, Research and Reasoning, Göteborg, 1968, pp. 73ff.
- 18 For a discussion of the literary sources, see Philipp Fehl and Paul Watson, 'Ovidian Delight and Problems in Iconography: Two Essays on Titian's *Rape of Europa'*, *Storia dell' Arte*, 26, 1976, pp. 23ff., and 28, 1976, pp. 249ff. For Titian's reliance on Italian versions of the *Metamorphoses*, see also Carlo Ginzburg, 'Tiziano, Ovidio e i codici della figurazione crotica del Cinquecento', *Paragone*, 339, 1978, pp. 3–24.
- 19 Wethey, *Titian*, I, pp. 68f., argues that Philip's *Agony in the Garden* is a picture now in the Prado, rather than the one in the Escorial. All Titian's religious pictures were sent by Philip to the Escorial, and in the 1574 Escorial inventory only one version of the subject is ascribed to Titian. Wethey associates this reference with the Prado picture, but the actual description ('Otro lienzo de pintura de la Oración del Huerto, *con los Apóstoles durmiendo* . . . de mano de Tiziano' [my italics]) is readily applicable only to the version still in the Escorial.
- 20 Cardinal d'Este visited Venice in 1556. The theory of Wethey (*Titian*, I, pp. 64f.) that the cardinal's picture, apparently finished only in 1564, was the prototype of the picture sent to Philip in 1560 is unpersuasive, especially as Vasari explicitly stated that it was derived from an earlier version. If, as I suggest, Titian began the Escorial picture for Ippolito and replaced it after 1560 with the one now in Milan, it follows that the other two versions in Cleveland and Madrid, both of which are exact copies of Philip's picture, must have been painted in Spain by another hand.
- 21 In 1585 *The Fall of Man* belonged to Antonio Pérez, who is not known to have acquired any works directly from Titian. But his father Gonzalo certainly did, for example in 1564 (Ridolfi-Hadeln, I, p. 190). Gonzalo owed Titian 400 ducats in April 1563 (Angel González Palencia, *Gonzalo Pérez secretario de Felipe Segundo*, Madrid, 1946, II, p. 593); assuming that his debt had been incurred in acquiring a picture, *The Fall of Man*, which looks to be of about 1560, would be the obvious candidate.

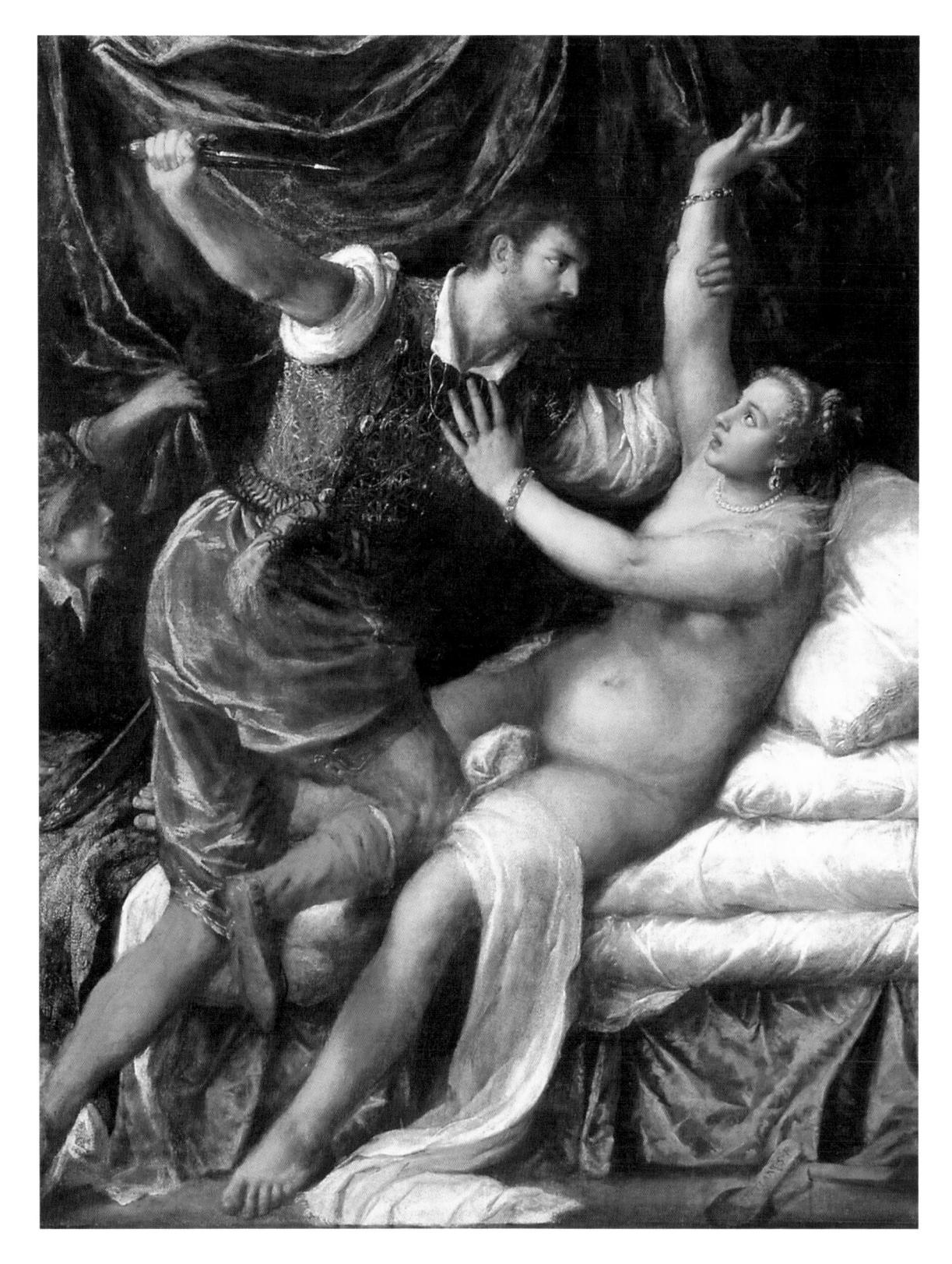

97 TARQUIN AND LUCRETIA Cambridge, Fitzwilliam Museum. 1568–71. Oil on canvas 189 x 145 cm. *Inscribed: TITLANVS. F*

WITH THE COMPLETION of *The Agony in the Garden* and *The Rape of Europa* in April 1562 Titian might well have felt that his life's work was virtually at an end. He must already have been in his mid-seventies, if not older, and he had outlived almost all the major artists of his generation. His brother Francesco had already died, as had his closest friend Pietro Aretino. On account of his great age he had even been excused from his obligation of producing ducal portraits for the Hall of the Great Council. His business affairs, including the administration of the studio, were largely in the hands of his son Orazio, who was by now in his late thirties. In the eyes of contemporaries, in fact, Titian can hardly have been regarded any longer as a working painter, but as a celebrity, Venice's most famous subject, her one supreme genius.

It was perhaps because he wished to mark the conclusion of his active career that he now painted a self-portrait, not a commissioned work, but one produced for his own satisfaction and preserved in his house. The picture in question is probably the one in the Prado (*frontispiece*), which seems to be the latest of several self-portraits preserved in the form of originals and copies. As in the earlier self-portraits, the emphasis is characteristically on the artist's social status, which is indicated by the discreetly opulent costume and the gold chain, and to judge from a contemporary painting of Titian by another hand it is a distinctively flattering likeness. In these respects the picture in the Prado thus conforms to the pattern of Titian's portraiture in general. In his own life and work Titian always presented a public façade. In one respect the Prado picture is different from his other self-portraits: instead of showing himself in an animated mood, even actively engaged in his work, he is now portrayed as a mere observer, as if pausing to contemplate a picture that he has already completed.

If this self-portrait was really intended as a kind of epilogue to his career it proved premature, for Titian lived another fourteen years and continued to paint until his death. Throughout this period, as in the previous decade, most of his energies were devoted to work for Philip II, as he had promised in a letter addressed to the king in 1562, when he announced that he had finished *The Rape of Europa* and *The Agony in the Garden*: 'Although nothing more remains for me to do in fulfilling the order which Your Majesty gave me, and although I had decided on account of my old age to rest during the years which God may still grant me;

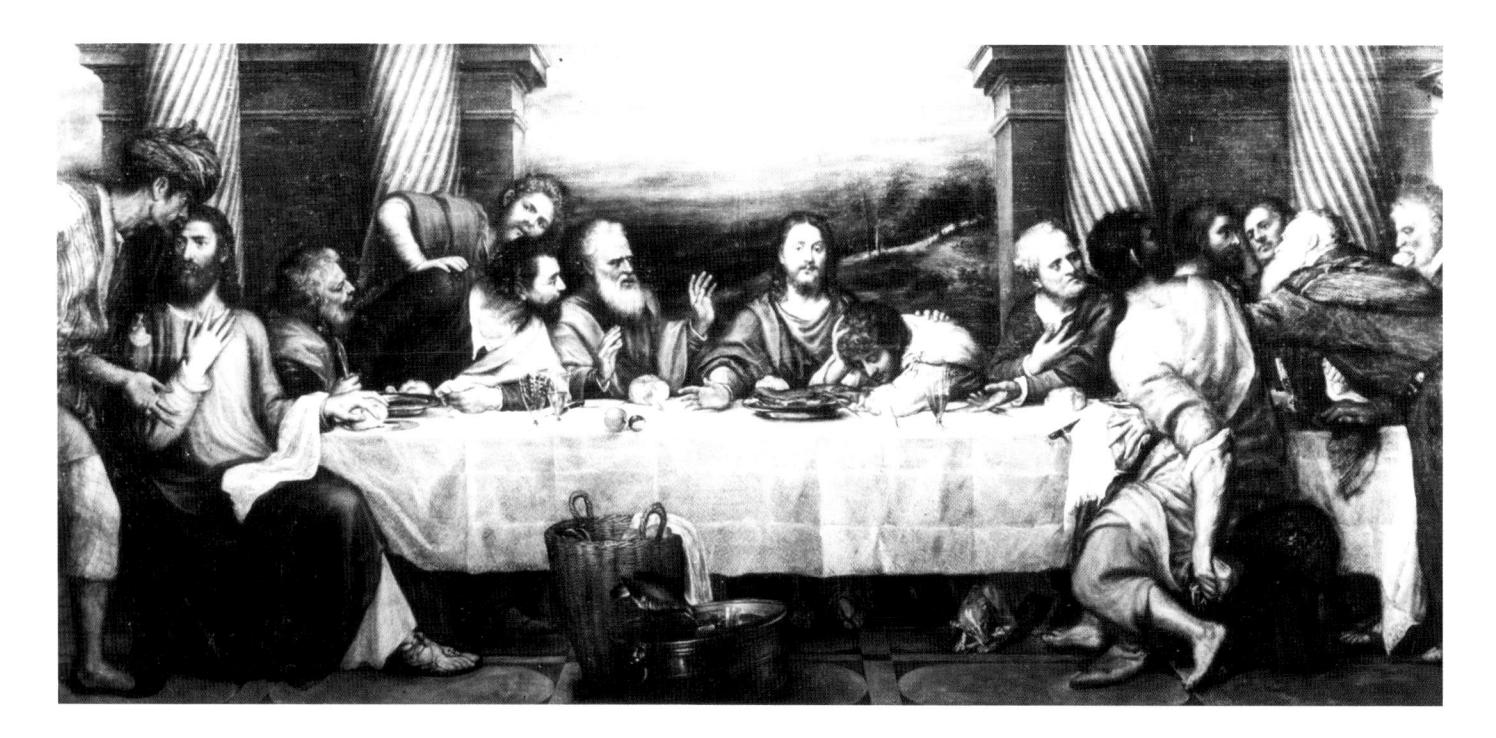

98 THE LAST SUPPER Escorial, Nuevos Museos. 1557–64. Oil on canvas 209 x 467 cm. *Inscribed: TITLAN V.S. F.*

nonetheless, having dedicated such skill as I have to the service of Your Majesty, when I hear, as I hope to do, that these labours of mine are pleasing to your most excellent judgement, in the same way I shall spend the rest of my life making very frequent homage to Your Catholic Majesty with some new picture of mine, striving that my brush will bring you the satisfaction which I desire and which the greatness of so mighty a king deserves.'

The first of the later pictures which Titian sent to Philip was *The Last Supper* (Plate 98), completed in 1564. Its original appearance is difficult to imagine, since it was cut down on all sides soon after its arrival in Spain and was subsequently extensively repainted. As a result, it is now among the least impressive of all his works for the king, only the group of Apostles at the right showing something of the artist's characteristic touch. It must once have looked very different, for when it was finished the Spanish ambassador reported that 'it is a marvellous thing, and among Titian's finest paintings in the opinion of the masters of the art and many other people who have seen it'. But despite these favourable comments it is unlikely that *The Last Supper* was entirely autograph, since it was apparently not started expressly for Philip. In a letter of 1564 Titian himself stated that he had begun the picture seven years before, that is to say while he was engaged on *The Entombment* and the Edinburgh *poesie*, but it was not mentioned

1562-1576 165

in the correspondence with Spain until 1563. In all probability the original clients were the monks of the Church of Santi Giovanni e Paolo in Venice; they are known to have acquired another painting of this subject produced by Titian and his pupils, which was destroyed by fire in 1571. The obvious implication is that this version was substituted for the Escorial picture, which Titian had decided to send to Spain.

Shortly before *The Last Supper* was finished Philip asked Titian for an altarpiece of *The Martyrdom of St Lawrence*. So far as is known, this was the first time he had requested a painting of a specific subject since his meeting with the artist at Augsburg. He had a special reason for doing so, since the picture was intended for the high altar of the new church in the Monastery of the Escorial, which was dedicated to St Lawrence. But Philip did not know whether Titian was still capable of carrying out such a commission, so he indicated that he would be prepared to accept a work by pupils. As it happened, when the king's request was first known in Venice Titian was away in Brescia, and taking advantage of his absence, Girolamo Dente, who had been his assistant for some thirty years, offered to supply a copy of the earlier altarpiece in the Gesuiti (Plate 96). But on his return Titian himself rejected the proposal, preferring instead to produce an entirely new picture, which he completed in 1567. Unfortunately it proved to be the wrong size for its intended location, so it was placed in the old church of the Escorial, where it still remains.

The Martyrdom of St Lawrence (Plate 100), which is seldom seen by visitors to the Escorial, has not received the same degree of recognition as the other major pictures for Philip, but it is arguably the supreme masterpiece of Titian's last years and the most exciting night scene of his entire career. Although the basic design was taken from the earlier version, Titian made a number of substantial changes which enhanced the drama and horror of the subject. The most important was the elimination of the figures and architecture in the background, thus effectively focusing attention on the principal group, which is also considerably enlarged. The two angels above, copied from those in The Death of St Peter Martyr (Plate 40), serve a similar function, keeping the action firmly confined to the foreground. Within the main group too there are significant changes: the figures themselves are less harmoniously arranged, deliberately inclegant in their poses and agitated in their movements, and there is an almost obsessive emphasis on the weapons and instruments of torture. In the Escorial picture the range of colour is also much wider than in the Venetian version, as in Titian's other late autograph paintings, and the brushwork is livelier and more consistent in quality; one need only

compare, for example, such details in the two works as the carving on the plinth or the flames in the braziers. But the chief glory of Philip's altarpiece lies in the virtuoso treatment of light, sometimes barely illuminating the figures, sometimes bringing them into powerful focus. The head of the horse at the right, in particular, the most forcefully modelled feature of the entire painting, has all the vigour and strength of form of the finest passages in the *poesie*.

Simply in terms of the labour involved *The Martyrdom of St Lawrence* was an astonishing achievement for a man of Titian's age, but when it was finished he suggested an even more ambitious project to the king, namely a series of up to ten large canvases illustrating the entire life of St Lawrence. Titian undertook to execute these with the help of Orazio and of another 'very talented young pupil of mine', probably Emanuel Amberger, whose father had repaired the *Portrait of Charles V on Horseback* (Plate 73) at Augsburg. At his age it was obviously unrealistic to suppose that he would be able to see the project through to its completion, but it is possible that Titian was hoping to ensure that Philip would continue to employ his son after his own death. At this period Titian was also trying to persuade the Venetian government to transfer his *senseria* to Orazio, although without success, and he was attempting to interest the Emperor Maximilian II, and apparently Albrecht V of Bavaria as well, in a series of replicas of the *poesie*. Such efforts to preserve the studio as a functioning enterprise were by no means unusual among Venetian artists: Jacopo Bellini, the father of Gentile and Giovanni did much the same thing, as later did Tintoretto, Veronese and Jacopo Bassano. In Venice painting was often a family business, like any other commercial undertaking.

Together with *The Martyrdom of St Lawrence* Titian sent Philip 'a naked Venus', painted during 1567. This has not survived, but its appearance is known from written descriptions, a copy by Rubens (Madrid, Thyssen Museum) and several other versions differing in minor details, the finest of which is *Venus with a Mirror* (Plate 99). Most of these are wholly or in part by pupils, but, as we shall see, there is every reason to believe that Philip's picture was substantially autograph. The choice of subject indicates that Titian, at least, did not suppose that the king's taste in paintings had changed in any significant respect, despite his increasing preoccupation with religion.

In keeping with his consistent practice of sending Philip works in different genres and of varying size, Titian's next picture for the king, completed in 1568, was *The Tribute Money* (Plate 101). Perhaps partly on account of its subject, this painting has not received much critical attention, but it illustrates very well the highly coloured appearance and elaborately worked

1562-1576 167

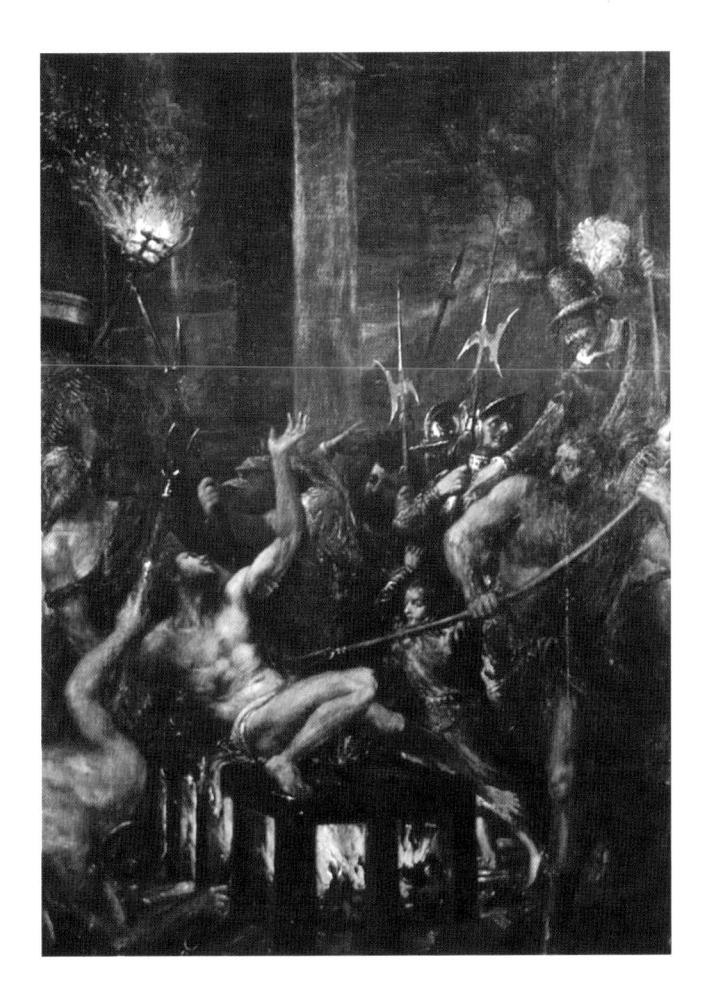

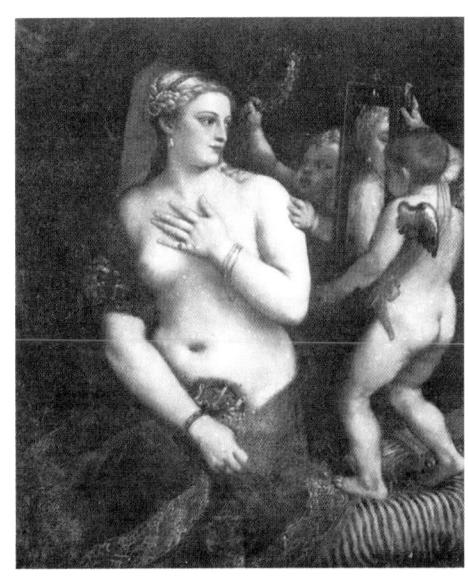

99 VENUS WITH A MIRROR
(THE MELLON VENUS) (above)
Washington, National Gallery of Art, Mellon
Collection. a.1567.
Oil on canvas 124 x 105 cm.

100 THE MARTYRDOM OF ST LAWRENCE (left)
Escorial, Iglesia Vieja. 1564–67. Oil on canvas
415 x 299 cm. *Inscribed: TITLANVS. F.*

surface characteristic of Titian's late style. These qualities are equally apparent in *Tarquin and Lucretia* (Plate 97) which was begun in 1568 and sent to Spain three years later. Titian himself described it as 'an invention involving greater labour and artifice than anything, perhaps, that I have produced for many years', and it certainly was more ambitious than the *Venus* or *The Tribute Money. Tarquin and Lucretia* is also one of his most dramatic and brutal works, with the violence of the subject underlined by strident colouring, especially the brilliant red, black and gold of Tarquin's costume.

The Tribute Money and Tarquin and Lucretia both demonstrate the consistency of Titian's artistic preoccupations after the change in his style in the mid-1550s. But in neither picture does he quite achieve the sure touch or confident draughtsmanship of the later poesie. Thus the relationship of Tarquin's hips to his torso and that of Lucretia's right foot to her leg are surprisingly insecure. This slight but unmistakable loss of quality is almost certainly the effect of advancing years, as Vasari suggested. The decline in Titian's powers was also noticed by the

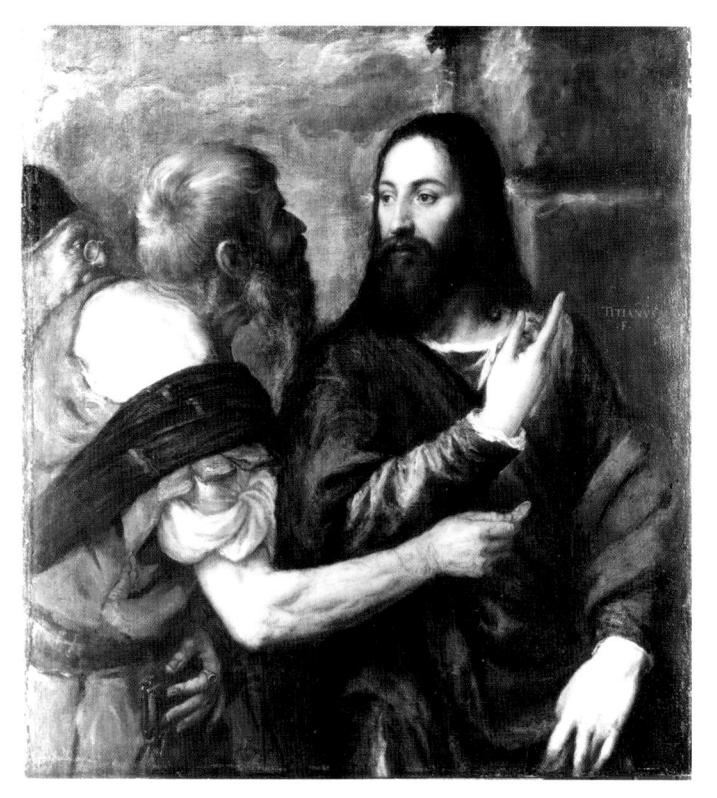

101 THE TRIBUTE MONEY LONDON, National Gallery. 1568. Oil on canvas 109 x 101 cm. *Inscribed: TITLANVS. F.*

dealer Niccolò Stoppio, who reported in 1568 that everyone says he no longer sees what he is doing, and his hand trembles so much that he cannot bring anything to completion, but leaves this to his pupils. He has a German in his house, Emanuel ..., who is excellent and does many things for him which he then finishes with two strokes of his brush and sells as his own work.

Stoppio's letter is gossipy and malicious in tone, so he is likely to have exaggerated, at least about the contribution of the pupils. But this does not mean that his remarks about Titian's trembling hand and failing eyesight were unfounded.

Even if Stoppio is suspect as a source, this is not the case with the Spanish ambassador Diego Guzmán de Silva, who negotiated with the artist on behalf of the Governor of Milan, the Marquis of Ayamonte, from 1573 onwards; he fully confirmed Stoppio's observations on Titian's physical

condition.² The consequences of this are only too apparent in the last three pictures which Philip received, all of which were sent to him late in 1575. Two of them, the *Allegory of the Battle of Lepanto* (Plate 102) and the *Allegory of Religion*, are in the Prado; the third, *St Jerome* (Plate 103), is in the Escorial. Like *The Martyrdom of St Lawrence*, the *Allegory of the Battle of Lepanto*, which commemorates the great victory of the combined Venetian and Spanish fleets over the Turks in 1571, was a subject specifically requested by the king, who even provided a sketch by another artist, Alonso Sánchez Coello. But this time Titian himself does not seem to have contributed much to the picture. It reveals a slackness in conception and execution which suggests that it was largely the work of pupils. The other two pictures, on the other hand, show precisely the weaknesses that one would expect in autograph works of this period: lack of brilliance in the colouring and absence of definition in details such as the foliage.

The paintings which Titian sent to Philip II after 1562 have received comparatively little attention from modern writers. It is now generally believed that during this period his

personal style evolved in a quite different direction and that the works which he sent to Spain were largely produced by his pupils and were therefore unrepresentative of his own ideals. But before examining the conventional view of Titian's last years it is important to ask two questions, one relatively simple and the other more complicated: first, whether there is any circumstantial evidence that Titian himself was not closely involved in the production of Philip's later pictures, and secondly, whether as a group these pictures display the characteristics of studio works. Surprisingly, neither of these questions has received detailed consideration in recent literature.

As we have seen, during the late 1550s Titian had ceased to make concessions to Philip's taste and his patron had accepted his stylistic innovations with equanimity, even enthusiasm. One might, therefore, expect that after 1562 the artist would have felt even

102 ALLEGORY OF THE BATTLE OF LEPANTO Madrid, Museo del Prado. c.1572–75.
Oil on canvas 335 x 274 cm. (originally 298 x 195 cm.).
Inscribed: Titianus Vecelius eques Caes. fecit

more at liberty to paint exactly as he liked when working for the king, for by this time he was no longer obliged to send any pictures at all. His pensions were recompense for services already rendered, and they were for life. This meant that Titian had no immediate financial inducement to continue in Philip's service. The later paintings were apparently produced primarily for his own satisfaction and it would have been an unprofitable use of his pupils' time to devote much effort to them.

There is one obvious objection to this argument, namely that as Titian depended on Philip's goodwill for the continued payment of his pension, he might have thought that the king's favour could only be maintained by a constant supply of new pictures. But in practice Philip invariably responded very willingly to the artist's requests for help over his pensions, whether any paintings were in prospect or not, and Titian was actually paid much more regularly after 1562 than before.³ Moreover, during this period not only did his patron never put pressure on him to send new works, but Titian's own response on an occasion when

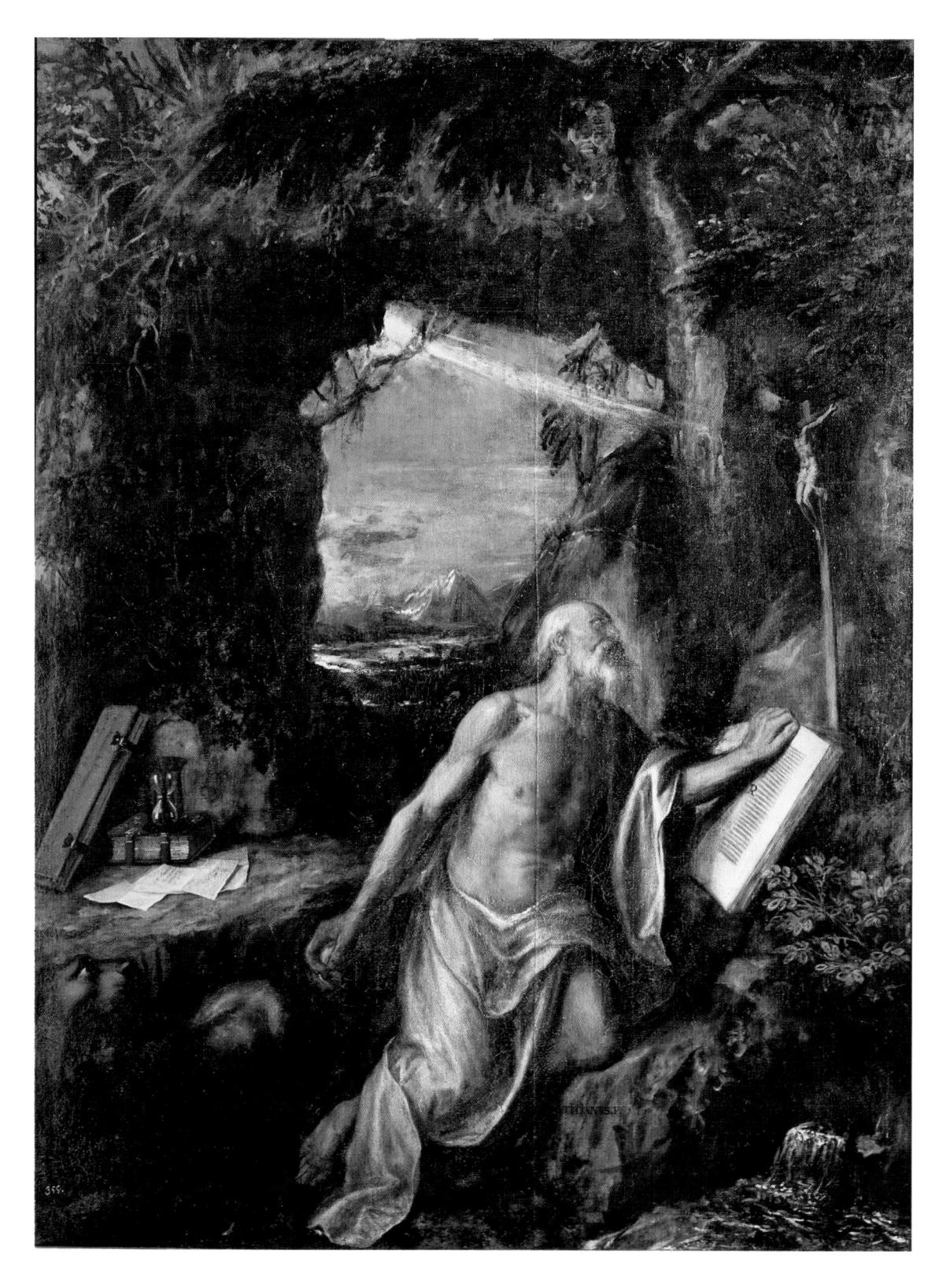

103 ST JEROME Escorial, Nuevos Muscos. Between 1571 and 1575. Oil on canvas 186 x 143 cm. Inscribed: $TITLANVS.\ F.$

his money was not forthcoming was to withhold a picture that he had completed, rather than to promise something more. Finally, it is worth remembering that, given his long association with Titian, Philip was in a unique position to know what an autograph painting looked like; therefore it would have been counter-productive to supply him with works of indifferent quality.

Circumstantially, then, it is likely that the later paintings for the king were among the best that the artist could provide at that time. It remains to see whether they are in fact significantly different from the pictures produced by his pupils. Unfortunately evidence about the organization of the studio is fragmentary, with the result that art historians often disagree about the extent of Titian's own involvement in many works of this period. Yet there exists enough information to provide at least a general answer to the problem.

One of the most specific statements about the studio was made by Vasari, who said that 'Although many people have come to study with Titian the number of those who can truly call themselves his pupils is not large; for he has not taught much, and each has learned less or more depending on what he has been able to acquire from Titian's work.' The truth of this remark is confirmed by other evidence. About thirty artists are reported to have spent some time in the studio: some of these are totally obscure; others, such as El Greco and Tintoretto, later became famous but left no mark during their association with Titian; a third group consists of a few painters who remained with him for a decade or more, namely his son Orazio, Girolamo Dente and Emanuel Amberger. It is these three who seem to have been principally responsible for the products of the studio. None of them is known to have painted a significant group of independent works. They were apparently skilled but uncreative craftsmen, trained to provide an acceptable paraphrase of the master's style.

Until 1562, as we have seen, the rôle of the studio was to produce works for less important clients and the extent of Titian's participation depended on the circumstances of the commission. In his last years Titian's personal contribution seems to have become progressively smaller. Even if Stoppio's comment quoted above is probably not to be taken literally, other evidence suggests that it contains a measure of truth. In 1573, for example, the Duke of Urbino stated that he believed that Titian himself no longer painted. Yet such was the prestige of Titian's name that the products of his studio were still greatly sought after and even very prominent patrons could seldom hope for anything better. A striking example is provided by *St Catherine* (Boston, Museum of Fine Arts) which Titian sent in 1568 to an influential member of the Curia, Cardinal Michele Bonelli. The cardinal had specifically requested this

subject and on this occasion one would have expected Titian to take special trouble with the picture, since he wanted Bonelli's help in obtaining papal permission for his son Pomponio to change one of his benefices.⁴ But the painting which was sent to Rome was nothing more than an unfinished *Annunciation* which happened to be in the studio, clumsily modified to fit the new iconography.

Despite its indifferent quality Bonelli declared himself delighted with the *St Catherine*, but other clients were sometimes less satisfied.⁵ In 1564, for instance, the town council of Brescia commissioned three large ceiling paintings for their town hall. These were completed four years later, but destroyed by fire in 1575. When the pictures were delivered Titian claimed he had painted them himself, as he had promised to do, but his patrons thought that they were entirely executed by pupils. This seems to have been the case, for although Titian claimed a higher fee than the Council thought fair and threatened to take the matter to arbitration, he eventually backed down.⁶

At this period the studio seems to have produced original compositions relatively rarely. The greater part of its output consisted of replicas and variants of earlier works. These were painted on a somewhat mechanical basis, involving little effort on the part of Titian himself. The way in which successful designs were preserved and reproduced varied according to the size of the picture. One of the most popular of all was St Mary Magdalen, of which a good example (Plate 104) was sent to Cardinal Alessandro Farnese in 1567, a master version being kept in Titian's house and simply copied, sometimes with minor changes, as the need arose. But with larger compositions this procedure was obviously impracticable, and one must assume that the design was recorded in a drawing. This would have happened, for instance, with *The Trinity* for Charles V, which was engraved in Venice in 1566, more than a decade after the actual painting had left the studio. In the same way it is likely that the replicas of Philip's poesie offered to the Emperor Maximilian II in 1568, for the significantly low price of only 100 crowns each, would have been based on drawings. When such replicas were required it seems that the basic procedure was to reproduce the main outlines of the original composition on a new canvas and then paint over them. This happened, for example, with St Jerome in the Thyssen-Bornemisza Collection, Lugano, which is derived from a picture now in the Brera, Milan. Such features of the Milan picture as are preserved in the underdrawing are reproduced almost exactly in the Lugano painting. But sometimes significant alterations might be introduced at the final stage. In the case of *Diana and Callisto* in the Kunsthistorisches Museum, Vienna, the underdrawing

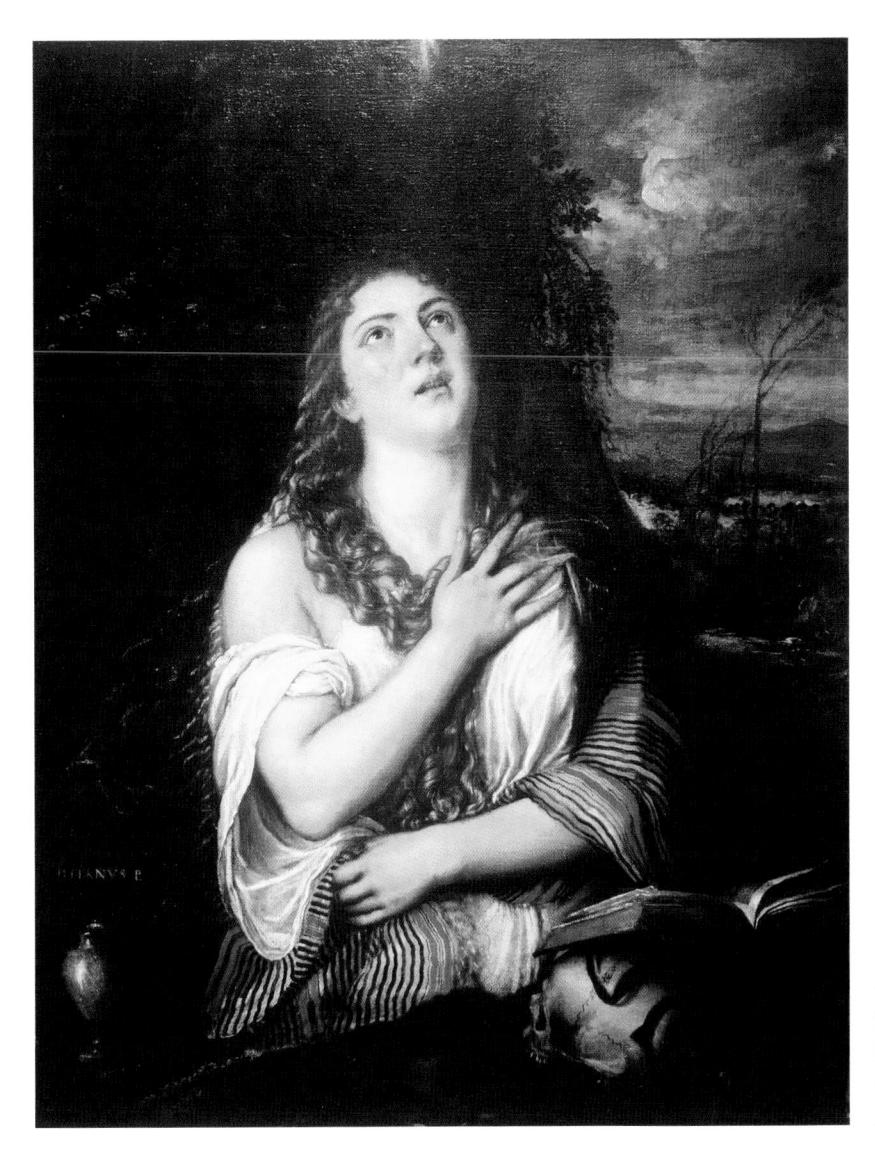

104 ST MARY MAGDALEN Naples, Museo di Capodimonte. Probably 1567. Oil on canvas 128 x 103 cm. *Inscribed: TITLANVS. P.*

corresponds exactly to Philip's version (Plate 86), but the finished picture does not.

The clearest illustration of how the studio functioned is provided by the series of six so-called *Reclining Venus* compositions. They can be divided into three types: the first is represented by the single *Venus and Cupid* in the Uffizi (Plate 56); of the second type there are three pictures, *Venus and Cupid mith an Organist* (Plate 105) in the Prado, *Venus and an Organist* also in the Prado and *Venus, Cupid and an Organist* in the Gemäldegalerie, Berlin; the third type comprises two pictures showing *Venus and Cupid mith a Lutenist*, one in Cambridge (Plate 106) and the other in the Metropolitan Museum of Art, New York. It is generally agreed that the execution of this series must have been spread over a period of many years, from about the mid-1540s to the early 1560s, but one picture of each type, and only one, shows an identical

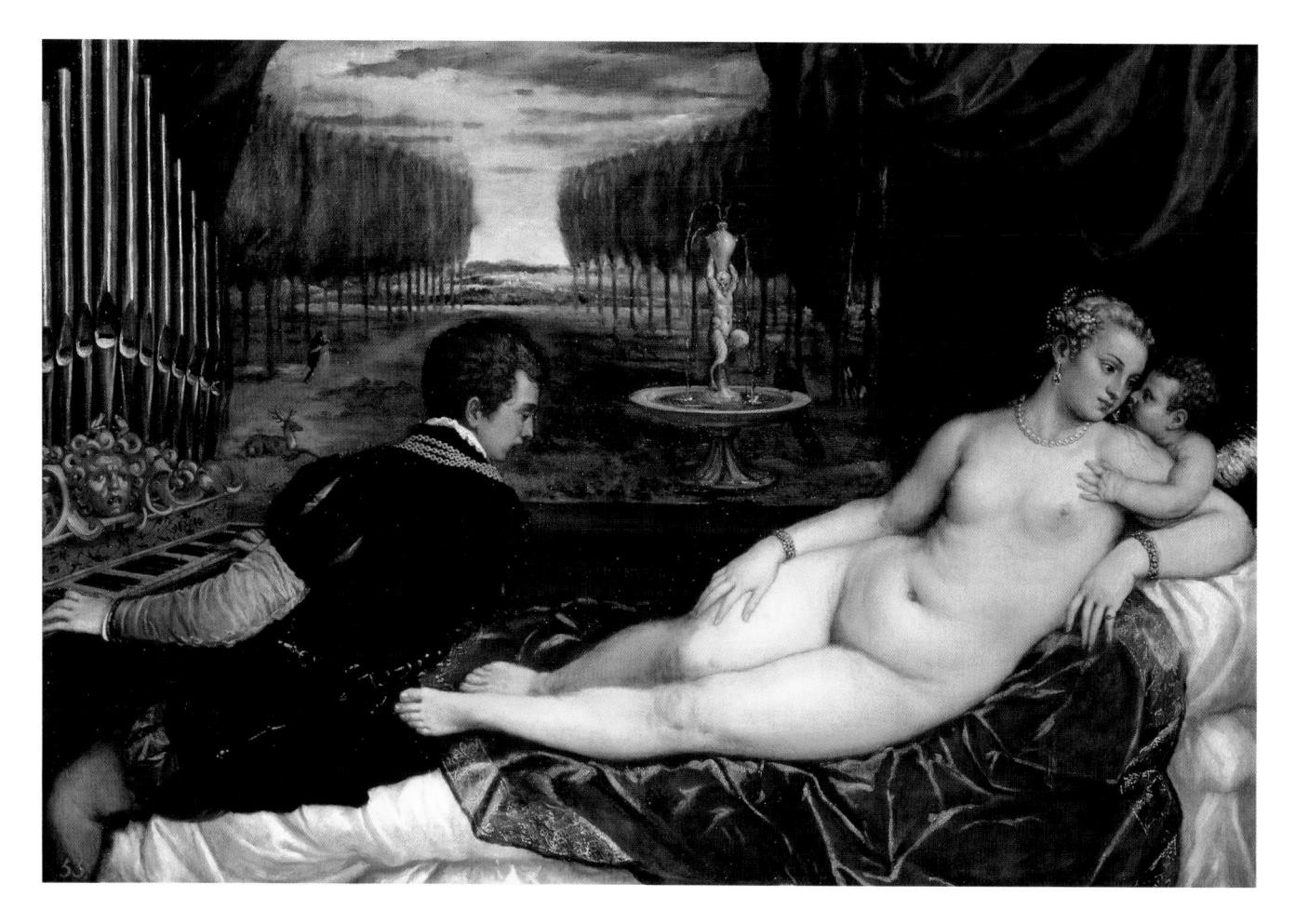

105 VENUS AND CUPID WITH AN ORGANIST (A WOMAN WITH CUPID AND AN ORGANIST) (above) Madrid, Museo del Prado. *c.*1550.
Oil on canvas 148 x 217 cm. *Inscribed: TITLANVS F.*

106 VENUS AND CUPID WITH A LUTENIST (A WOMAN WITH CUPID AND A LUTENIST) (opposite) Cambridge, Fitzwilliam Museum. ε1560–65.
Oil on canvas 150 x 197 cm.

arrangement of folds in the velvet rug on which the woman lies (Plates 56, 105 and 106). It follows that these three works must have been derived from a common prototype, which itself included such a rug. As we have seen, this prototype was almost certainly the *Venus* painted by Titian for Charles V in 1545, whose appearance must have been recorded in a drawing. The three pictures with identical rugs belong to the first generation of derivatives, but the remaining pictures, each of which includes a different rug, belong to the second generation. They were evidently not based directly on the drawing, or even on Charles's *Venus* itself, but were copied with varying degrees of fidelity from paintings of the first generation.

The process of reproducing an existing design was essentially a mechanical one which Titian could easily have left to pupils. The only point at which one would expect him to have intervened, if at all, was when the original composition was modified. This is exactly what

seems to have happened. Thus in the second-generation example in the Prado, *Venus and an Organist*, the elimination of Cupid occasioned a modification of the pose of the woman, and the technique used for this figure is significantly different from that of the rest of the picture. It is very close, in fact, to that of Philip's *Danae* (Plate 57), so this section is presumably autograph. Such a conclusion suggests that the entire picture, and consequently the other works of the same type, were produced around 1550,

at the same time as *Danae*. In the third and latest group of derivatives, those with a lutenist, the original design was even more extensively altered. As one would expect, the earliest example, in Cambridge (Plate 106), is of outstanding quality: the style is very like that of the later *poesie*. The version in New York, on the other hand, is merely an indifferent copy of the Cambridge picture and shows no trace of Titian's own hand.

The manner in which the *Reclining Venus* pictures were produced helps to explain their meaning. Predictably enough they have been the subject of the same kind of prudish and abstruse interpretations as have so many of Titian's other secular compositions. Thus it has been suggested that those incorporating a musician were concerned with the contemporary philosophical controversy about the relative merits of the senses of sight and of hearing. In the versions with an organist, for example, the man, in turning from his instrument, is supposedly revealing that he values visual beauty above the beauty of music. But considering that the prototype for all these works, the *Venus* painted for Charles V, was apparently a straightforward erotic subject, it seems most unlikely that the derivatives, painted on what amounted to a production-line basis and evidently intended for less important clients, would have been significantly more complex in their iconography. In fact, they are even more directly sexual. In the earliest surviving version, in the Uffizi (Plate 56), we see merely Venus and Cupid conversing together on a bed. But in the next picture (Plate 105), in the Prado, Cupid has moved closer to the woman and is whispering insistently into her ear, as if trying to persuade her to adopt some course of action. It is not difficult to guess his purpose. He is

107 PORTRAIT OF JACOPO STRADA Vienna, Kunsthistorisches Museum. 1567–68. Oil on canvas 125 x 95 cm. Inscribed: TITLANVS. F; and on the letter: Al Mag[®] Sig[®] il Sig[®] Titiano Vecellio suo compare Venetia.

urging her to accept the amorous advances of the man, whose intentions are made plain by the direction of his glance. Now Cupid normally acts as his mother's agent, encouraging people to fall in love; only rarely does he use his powers of persuasion on Venus herself. This suggests that the nude in the picture is not the goddess, but merely a mortal The later version woman. the composition in the corroborates this interpretation. In this case Cupid is omitted, but it seems most unlikely that the basic subject has been altered; the change merely clarifies the meaning by removing any suggestion that the gods are involved. Both pictures, in fact, simply show a man attempting to win the favours of a woman through the power of music. This is a common enough theme in other art forms of the period, notably madrigals; its relevance is underlined here by the details in the background, the pair of lovers and the

stag and doe, whose behaviour echoes that of the principal figures. But if the paintings with an organist show the prelude to love, those with a lutenist show the sequel (Plate 106). The open pages of music indicate that the couple have just been performing a duet, and appropriately the woman holds a flute, an instrument whose suggestive appearance had already been exploited by Titian in just such a context in *The Three Ages of Man* (Plate 9).

Another important group of paintings from the studio, showing *Venus with a Mirror*, seems to have been produced on a similar basis, although in this case the exact procedure was different, since at least one painted version remained in Titian's house (Plate 99) and was itself

extensively modified. Together with simpler pictures of pretty women, which were always in demand, such works must have accounted for a large part of the output of Titian's pupils. What most of his clients wanted, in fact, were mildly salacious works executed in a plausible imitation of the master's style. This is true even of the countless versions of *St Mary Magdalen*, in which piety was presented in an equally palatable form. Occasionally, of course, a patron might demand a devotional picture of a different kind, but here too it was generally a case of repeating an earlier composition. After about 1560 there are very few instances in which Titian is known to have supplied a client with a subject outside the studio's normal repertoire. When he did so, as in the case of Cardinal Bonelli's *St Catherine*, the contribution of pupils was all too evident.

As one would expect, the reduction of Titian's personal activity as a painter after the early 1560s is particularly apparent in the field of portraiture. Very few portraits from this period are even mentioned in documents, among them that of dealer Jacopo Strada (Plate 107), which was painted in 1567–68. In this case there were special reasons why Titian should have accepted the commission, as Strada's great rival Niccolò Stoppio indicated in the following letter:

Titian and he are like two gluttons at the same dish. Strada is having him paint his portrait, but Titian will take another year over it, and if in the meantime Strada does not do as he wants it will never be finished. Titian has already demanded a sable lining for a cloak, either as a gift or for cash, and in order to get it he wants to send something to the emperor. Strada encourages his hopes so that he can get the portrait out of him; but he is wasting his time. You will be amused to hear that the other day, when a gentleman who is great friend of mine as well as intimate of Titian asked him what he thought of Strada, Titian at once replied: 'Strada is one of the most pompous idiots you will ever find. He doesn't know anything beyond the fact that one needs to be lucky and to understand how to get on with people, as Strada has done in Germany, where he shoots them every line you can imagine, and they, being open by nature, don't see the duplicity of this fine fellow.' These were Titian's own words.

In fact, it was not only help over some furs that Titian wanted. A few months later, when he was trying to sell the replicas of the *poesie* to Maximilian II, he called on Strada, who had already had dealings with the emperor on his own account, to vouch for their quality.

From the preceding argument it should be evident that as a group the later paintings for Philip, like the earlier ones, have none of the typical characteristics of works by Titian's pupils.

Of the eight pictures which he sent to the king after 1562 only one, Venus with a Mirror, was related to a common studio type. It most closely resembled a composition revealed by X-rays beneath the version of the subject once in Titian's house and now in Washington, whereas the extant variants by Titian's pupils are closer to the Washington picture in its final, revised form. This suggests that Philip's picture was the prototype from which all the existing versions were indirectly derived. Two other late works for the king were certainly based on earlier compositions, namely The Martyrdom of St Lawrence and the Allegory of Religion. But in the case of The Martyrdom of St Lawrence it is known that Titian refused to allow Philip to acquire a version by a pupil, choosing instead to provide a much revised elaboration of his earlier altarpiece and spending no less than three years in the process. The Allegory of Religion repeats the composition of a picture sent to Maximillian II in 1568, but the style is very close to that of the Escorial St Jerome, which was sent to Philip at the same time, in 1575; and the latter, significantly, is notably different from previous paintings of the same subject by Titian and his studio. All the available evidence therefore indicates that all the later works for the king apart from The Last Supper and the Allegory of the Battle of Lepanto were substantially autograph, embodying the best that Titian could then provide. If his pupils contributed to these pictures at all, it was presumably only to supply the degree of finish which he was no longer physically capable of achieving. But there is no reason to believe that their intervention seriously falsified his intentions.

It is in the light of these conclusions that we must now examine the conventional view of Titian's later development. Every recent writer on the subject has argued that at the very end of his life he evolved a new way of painting, which I shall call his 'last style', characterized by a reduction in his palette and an unprecedentedly free and impressionistic type of brushwork. At this period, so it is said, he was painting primarily for posterity in a manner largely incomprehensible to his contemporaries, like Rembrandt in old age. In the works which supposedly embody this style, such as *The Crowning with Thorns* (Plate 108), the *Pietà*,(Plate 109) *The Death of Actaeon* (Plate 92) and *St Sebastian* in the Hermitage Museum, St Petersburg, 'form is dissolved in light and colour', to use the current cliché. That these paintings are very different from the late works for Philip is not in question: one need only compare, for example, a detail from *The Crowning with Thorns* (Plate 108) with one from *Tarquin and Lucretia* (Plate 97). But the explanation commonly proposed to account for these differences is highly suspect.

For one thing, although it is a common enough phenomenon for artists to evolve intensely personal late styles, Michelangelo and Beethoven being cases in point, Titian would be unique
1562-1576 179

108 THE CROWNING WITH THORNS MUNICH, Alte Pinakothek. &1570-76. Oil on canvas 280 x 182 cm.

in developing two, the first in works such as the later *poesie*, the second in pictures like *The Crowning with Thorns*. Moreover, the idea that one can only come to appreciate an artist's work through the experience of later paintings, in this case by Rembrandt and the Impressionists, may enhance one's self-esteem, but may also lead to anachronistic judgments. It is worth noting, too, that none of Titian's contemporaries spoke of a last style, or suggested that he ever painted incomprehensible pictures. On the contrary, his work remained in demand until his death. Thus in 1575 the Marquis of Ayamonte, who attributed the lack of finish in Titian's paintings entirely to his physical incapacity, told the ambassador Guzmán de Silva that '... I believe that a blotch by Titian will be better than anything by another artist."

Apart from these general difficulties, the concept of Titian's last style raises several more immediate problems. When were the pictures in question actually painted? For whom were they painted? Why do they look so different from the latest pictures for Philip? Fortunately, there is a simple way of resolving all these problems, namely by supposing that these works are simply unfinished. As it happens, this hypothesis is fully corroborated by an eye-witness account of Titian's working method in his last years recorded by the seventeenth-century writer Boschini. This passage, one of the most famous and vivid in the literature of art, reads as follows:

Titian was truly the most excellent of all painters, since his brushes always gave birth to expressions of life. I was told by Palma Giovane . . ., who was himself fortunate enough to enjoy the learned instruction of Titian, that he used to sketch in his pictures with a great mass of colours, which served, as one might say, as a bed or base for the compositions which he then had to construct; and I too have seen some of these, formed with bold strokes made with brushes laden with colours, sometimes of a pure red earth, which he used, so to speak, for a middle tone, and at other times of white lead; and with the same brush tinted with red, black and yellow he formed a highlight; and observing these principles he made the promise of an exceptional figure appear in four strokes. The most sophisticated connoisseurs found such sketches entirely satisfactory in themselves, and they were greatly in demand since they showed the way to anyone who wished to find the best route into the Ocean of Painting. Having constructed these precious foundations he used to turn his pictures to the wall and leave them there without looking at them, sometimes for several months. When he wanted to apply his brush again he would examine them with the utmost rigour, as if they were his mortal enemies, to see if he could find any faults; and if he discovered anything that did not fully conform to his intentions he would treat his picture like a good surgeon would his patient, reducing if

1562-1576

necessary some swelling or excess of flesh, straightening an arm if the bone structure was not exactly right, and if a foot had been initially misplaced correcting it without thinking of the pain it might cost him, and so on. In this way, working on the figures and revising them, he brought them to the most perfect symmetry that the beauty of art and nature can reveal; and after he had done this, while the picture was drying he would turn his hand to another and work on it in the same way. Thus he gradually covered those quintessential forms with living flesh, bringing them by many stages to a state in which they lacked only the breath of life. He never painted a figure all at once and used to say that a man who improvises cannot compose learned or well-constructed verses. But the final stage of his last retouching involved his moderating here and there the brightest highlights by rubbing them with his fingers, reducing the

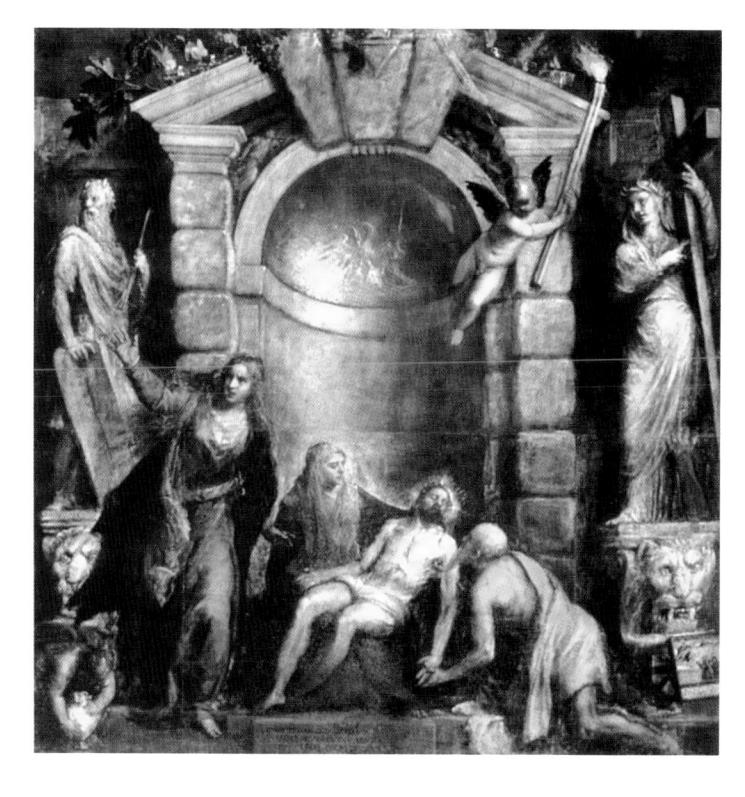

109 PIETÀ WITH ST MARY MAGDALEN AND ST JEROME
Venice, Gallerie dell'Accademia.
Probably 1575–76, completed by Palma Giovane.
Oil on canvas 353 x 348 cm.
Inscribed: QVOD TITIANVS INCHOATVM RELIQVIT PALMA REVERENTER ABSOLVIT DEOQ. DICAVIT OPVS

contrast with the middle tones and harmonizing one tone with another; at other times, using his finger he would place a dark stroke in a corner to strengthen it, or a smear of bright red, almost like a drop of blood, which would enliven some subtle refinement; and so he would proceed, bringing his living figures to a state of perfection. And as Palma himself informed me, it is true to say that in the last stages he painted more with his fingers than his brushes.

In their actual appearance the examples of Titian's supposed last style show all the signs of being works in progress. For one thing, the degree of finish varies considerably from one picture to another, from the extreme sketchiness of certain passages in *The Crowning with Thorns* to the more uniform surface of the *Nymph and Shepherd* in the Kunsthistorisches Museum, Vienna. Also they are painted almost entirely in middle tones, especially reds, browns and creams. Moreover, the ill-defined, impressionistic treatment of detail can be precisely paralleled in a self-portrait by Titian in the Gemäldegalerie, Berlin, a work which, to judge from the artist's

appearance, is of the early 1550s and which is manifestly unfinished. Most important of all, *The Crowning with Thorns*, which was acquired by Tintoretto after Titian's death, was singled out by Boschini, in a passage immediately following the one quoted above, specifically as an outstanding example of the artist's unfinished works.

Only if it could be shown that the paintings in the last style had left Titian's studio before he died could one be sure that they were completed. But there is no clear evidence that this happened. Indeed, it is certain that other besides *The Crowning with Thorns* were still there at his death. This is true of the *Pietà*, as we know from an inscription added by Palma Giovane, who later worked on the picture to bring it to an acceptable state. Similarly, the *Nymph and Shepherd* in Vienna must be unfinished, since the shepherd has three arms, two holding a flute and one around his companion's shoulders. As for *The Death of Actaeon* (Plate 92), which was apparently begun in the 1550s, its surface quality suggests that Titian worked on it again at a later date, but there is no firm indication that he ever sold it. The suggestion has even been made that he figure of the woman, particularly the inexpressive head, was repainted by another artist after Titian's death. The closest parallels to this kind of profile in shadow, however, appear in two paintings of *The Annunciation* largely executed by assistants, one in Naples and the other in Venice (Plate 95); so this feature, though presumably not by Titian's own hand, probably dates from his lifetime.

If the pictures of this type are simply unfinished the problems about their dating and destination become much less significant. For their execution could have been spread over the last decade or more of Titian's life, just as earlier pictures had often remained in the studio for comparable periods. Had they been completed one would expect that some would have been sent to Philip, but in the cases of *St Sebastian* and the *Pietà* there are other reasons why Titian might have been personally involved. It has been plausibly argued that *St Sebastian*, on account of its subject, was connected with the disastrous epidemic of plague that began in Venice in 1575, in the course of which a third of the population died. In such exceptional circumstances it is easy to understand why Titian might have accepted a commission of this kind from a Venetian patron and might also have wished to paint the picture himself.

The *Pietà with St Mary Magdalen and St Jerome* (Plate 109) presents a more complex problem. According to Ridolfi, who is often unreliable as a source, Titian planned to place this picture above his own tomb in the Frari; it was to serve as payment to the monks for the privilege of being buried there. But so far as is known, although the artist was indeed buried in the church,

1562-1576

the altarpiece never belonged to the monastery, which would seem inconsistent with Ridolfi's story. Whatever the truth of his account, it is likely that the picture was at least begun for nother client, the Marquis of Ayamonte. Early in 1575 Ayamonte asked Titian for a *Pietà*, which was to be of a characteristically Spanish type, with a standing Madonna. The artist himself had more ambitious ideas. By April Titian was planning to paint an unusually large composition for his patron and it was to include, besides Christ and his mother, at least one other figure, the Magdalen.8 The picture in Venice does not show the Madonna standing, but it does show the Magdalen. Moreover, from the way in which the canvas is constructed from several separate pieces one can be sure that Titian at first intended to produce a relatively small composition consisting only of the central group of Christ and the Madonna, but he then enlarged it on all sides, adding the other figures and the architecture. Unless he began two large pictures of the Pietà at the end of his life, in each case starting with just Christ and the Madonna and then including the Magdalen as well, it follows that the one in Venice must initially have been intended for Ayamonte, even if Titian may subsequently have decided to offer it to the monks of the Frari. At first sight it is unexpected that he should have undertaken so important a picture at this period for anyone other than Philip, but this can be explained by the fact that Ayamonte controlled the payment of his pension in Milan.

Even if Titian may therefore have sometimes accepted important commissions from other clients in his last years, the available evidence suggests that right up until his death the pictures for Philip provide the clearest indication of his own ideals. The conventional view of his last style is a myth, based on a misunderstanding of his development. At the end of his life, in fact, Titian's rôle in the artistic environment of Venice remained very much as it had been thirty years before. He was essentially a conservative painter, retaining a preference for elaborately worked surfaces and relatively high finish in the face of the more extreme interpretation of Venetian *colore* favoured by artists of the next generation, notably Tintoretto and Schiavone, and later Jacopo Bassano. This does not mean that he was wholly indifferent to their work. On the contrary, in the late 1560s his own pictures, like those of Tintoretto, Bassano and even Veronese, became noticeably darker, with a more dramatic type of lighting, and there is no reason to suppose that Titian himself initiated this development.

But although they have been misunderstood, the paintings in Titian's so called last style are not only very beautiful but also historically important. As we know from Boschini, the sketchy, impressionistic quality that we now value so highly was admired enthusiastically by younger

contemporaries, among them Tintoretto. This is not surprising, for these pictures show a spontaneity and luminosity which would have been very much to Tintoretto's taste. For much the same reason it is likely that they would also have appealed strongly to Jacopo Bassano. Indeed, it could be argued that Titian's unfinished paintings had a certain influence on both these artists in the second half of the 1570s, after the dispersal of the contents of the studio. Thus even after his death Titian still may have had one last contribution to make to the Venetian tradition.

FOOTNOTES

- 1 Many documents about Titian's business affairs, but not his activities as a painter, can be found in Venice, Archivio di Stato, Archivio Notarile, Atti, buste 8230–8240. These cover the period from 1561 to 1573, and mostly involve Orazio rather than Titian himself. From 1565 Emanuel Amberger is frequently named as a witness in these documents.
- 2 Ferrarino, 1975, p. 123, no. 166.
- 3 Evidence about payments to Titian in connection with his Spanish pension and his concession in Naples can be found in the correspondence with Philip II and his ministers (e.g. Ferrarino, 1975, p. III, no. 147; p. 119, no. 161). Payments in Milan are recorded in Milan, Archivio di Stato, Cancelleria dello Stato, Registri, series XXII, under various dates.
- 4 For the commission see Bonelli to Giannantonio Facchinetti, Rome, 22 March 1567 (*Nunziature di Venezia*, VIII, ed. Aldo Stella, Rome 1963, pp. 193f., no. 100). Contrary to the speculation of some historians, Bonelli did not provide a detailed programme, but merely indicated his preference for 'un quadro di Santa Catherina Martire'.
- 5 For Bonelli's reaction to the picture see his letter to Facchinetti, Rome, 15 May 1568 (ibid., p. 386, no. 226).
- 6 For the fullest account of the Brescia commission, with many new documents, see Carlo Pasero, 'Nuove notizie d'archivio intorno alla Loggia di Brescia', *Commentari dell' Ateneo di Brescia*, CLI, 1952, pp. 49ff.
- 7 Ferrarino, 1975, p. 125, no. 169.
- 8 For Ayamonte's commission, see Ferrarino, 1975, p. 121, no. 164; p. 126, no. 171. Although it is possible that Ayamonte was hoping for two pictures, a *Pietà* and a *Magdalen*, this reading seems much less plausible than the one proposed here.

CONCLUSION

TITIAN DIED ON 27 August 1576, perhaps of the plague, perhaps simply of old age. Because of the epidemic it was not possible to arrange an elaborate funeral like Michelangelo's in Florence twelve years before. But some kind of ceremony, involving the Canons of San Marco, certainly did take place; and, according to Ridolfi, the fact that Titian was accorded a funeral at all at this moment was in itself an exceptional mark of respect. He was buried in the nave of the Frari, close to two of his greatest masterpieces, but it was not until the nineteenth century that a grandiose monument was erected to his memory, decorated with marble reliefs illustrating a selection of his most famous pictures. By an unfortunate mistake they include one work that was not by him at all.

Orazio Vecellio survived his father by less than two months; he was certainly a victim of the plague. Soon afterwards their house in Biri Grande, at the northern edge of the city, was looted by thieves, who removed 'a large quantity of ... very valuable goods, notes of credit, papers, accounts, legal documents, records of debtors, leases and receipts, and objects of gold and silver and other furniture, as well as countless paintings of no small value." Some historians have suggested that this episode might account for the almost total lack of extant drawings by Titian. But unless one assumes that the robbers dropped their loot in a canal it is difficult to see why any drawings that they might have taken should not have subsequently come to light, and in any case the record of the theft does not specifically refer to drawings. Whether any were stolen or not, it is certain that the thieves did not take everything of value, for in 1581 the house and its contents, including four pictures ascribed to Titian himself, among them *The Venus with a Mirror* (Plate 99), were sold by Pomponio Vecellio to a Venetian nobleman named Cristoforo Barbarigo. As we have seen, some unfinished pictures found in the studio were also acquired by Tintoretto, probably at an earlier date.

During the last third of his career Titian was more respected than imitated in Venice, where the best of his recent work was not to be seen. After his death his uncompleted paintings seem to have aroused considerable enthusiasm among some of the younger local artists, confirming them on a path which they had already taken. But from the 1590s onwards Titian's influence was more important than ever before and it was felt well beyond the confines of the Veneto.

By this period it was no longer possible to regard the conventions of Mannerism as a logical or necessary development of the achievements of the early years of the century. On the contrary, artists and critics were becoming increasingly aware that the High Renaissance had been a golden age whose creative vitality had been lost, replaced by the tired repetition of a small repertoire of stereotyped conventions. Although Titian's work, just like that of Raphael or Michelangelo, had many characteristics that strongly appealed to Mannerist taste, he never indulged in the extreme forms of *disegno* or *colore* that were the hallmarks of committed Mannerists. In the second half of the sixteenth century he was recognized as the last great survivor of the High Renaissance and as one of the founding fathers of the classic period of Italian painting.

Artists were therefore predisposed to look again at his work, and by a fortunate coincidence at just this period his paintings were becoming more widely accessible than ever before. In 1598 a large proportion of the d'Este collection, including the great mythologies, was taken to Rome. From about 1600 the Gonzaga collection too was gradually being dispersed, culminating in the sale of several hundred pictures to Charles I of England in 1627. But even before this date the most influential painter of the seventeenth century, Rubens, had had ample opportunity to study Titian's work not only in Mantua, but also, like the young Velázquez, in Spain. Finally, in 1631 the collection of the della Rovere dukes of Urbino was sent to Florence. Thus within the space of little more than three decades Titian's work became part of the common visual culture of artists all over Europe.

Titian was so famous and so prolific in all the major genres of painting that no artist could disregard his achievements. The conventions of aristocratic portraiture which he established survived as long as the social structure whose ideals they so brilliantly proclaimed. Through his mythologies he created an image of the pagan world which probably had a more pervasive effect on the European imagination than the work of any other painter or sculptor, whether ancient or modern. His great religious compositions, such as *The Assumption of the Virgin* (Plate 22) and *The Death of St Peter Martyr* (Plate 40) anticipated many of the basic principles of Baroque art. His work as a whole, in fact, acquired virtually the status of classical art: for generations of painters and patrons it provided a selection of models almost above criticism. Probably the main reason why his paintings could be regarded in this way is that they do not seem to reflect a strongly idiosyncratic personal vision. This is a quality that does not readily correspond to modern taste. Today we are accustomed to see art as a form of self-expression,

CONCLUSION 187

to admire above all the uniqueness of the artist's imagination. Titian's late unfinished pictures are now esteemed precisely because they seem so personal, because they appear to reveal the painter as he really is, working for his own satisfaction rather than to fulfil the demands of patrons. In the same way recent writers have interpreted the *Portrait of Pope Paul III with his Nephens* (Plate 58) as social criticism, because in this way it conforms to twentieth-century preconceptions about the nature of great portraiture.

But so far as one can tell this kind of reading of Titian's work is entirely alien to his intentions. It can be no accident that of all the great painters since the beginning of the Renaissance his personality is among the most elusive. There is no lack of information about his day-to-day existence, about his family and friends or about his business affairs. But his attitude to religion, to literature, although Ridolfi said that he had little interest in it, and indeed to intellectual matters of any kind is largely a matter of speculation. Although he lived in a period when the comments of artists and even their eccentricities were eagerly recorded Titian is remembered for almost none. Apart from such essentially trivial aspects as his preoccupation with money and his good manners, only one facet of his character emerges with real clarity, his single-minded and total involvement in his work. This in itself probably constitutes his most important contribution to European painting.

His generation was the first to include artists who were regarded by their contemporaries not as supreme craftsmen, but as men of genius. But whereas Michelangelo, for example, was famous for his terribilità, Raphael for his social assurance and aristocratic manner of life and Leonardo for his enigmatic personality, Titian's genius was manifested in his work alone. In every other respect he was unremarkable. He, more than anyone else, was responsible for creating the idea that the very act of painting is an imaginative and intellectual activity of the highest order. This idea is implicit in everything that Aretino wrote about his pictures; it underlies Palma Giovane's description of his working procedure, as recounted by Boschini. But it also appears in a more surprising context, in a Treatise on the Human Mind by Antonio Persio, published in Venice in 1576. In a passage of great originality, which occurs rather unexpectedly in a discussion about the way in which the character of a person is affected by the circumstances of his conception, Persio likened the intense empathy which Titian felt for whatever he was painting, the complete concentration with which he approached his work, to the act of love itself:

leaving aside the children of prostitutes, who are conceived in the worst possible

circumstances, and referring to those born of women who seem honourable, or are more discreet than prostitutes, in most cases bastards are born of a man and a woman who love one another most ardently, or at least of two people one of whom loves the other in the way that I have said. And being so much in love, but able to enjoy one another only rarely and with difficulty (and assuming that both or at least one is beautiful and graceful), when they have the opportunity of taking pleasure together they do so with extreme ardour and emotion, and their souls are as strongly linked as the parts of their bodies. From such well executed labour in most cases one cannot expect anything but perfect offspring, beautiful, vigorous and distinguished in mind. I do not know a better way to demonstrate this than by the example of the great Titian, the father of colouring: as I have heard from his own lips and from those who were present when he was working, when he wanted to draw or paint some figure, and had before him a real man or woman, that person would so affect his sense of sight and his spirit would enter into what he was representing in such a way that he seemed to be conscious of nothing else, and it appeared to those who saw him that he had gone into a trance. As a result of this state of abstraction he achieved in his work little less than another Nature, so well did he represent her form and appearance.³

FOOTNOTES

- 1 Giuseppe Cadorin, Dello amore ai veneziani di Tiziano Vecellio, Venice, 1833, pp. 97f.
- 2 Ridolfi-Hadeln (I, p. 200) lists eleven pictures in the Barbarigo collection said to have been in Titian's house at his death. But Christoforo Barbarigo indicated in his will of March 1600 that he only owned four pictures by Titian, namely *Christ Carrying the Cross, St Mary Magdalen, The Madonna*, and *Venus* (Cadorin, 1833, p. 113).
- 3 Antonio Persio, Trattato dell' ingegno dell'huomo, Venice, 1576, pp. 97f.

BIBLIOGRAPHY

The standard work on Titian is the catalogue raisonné by Harold E. Wethey, The Paintings of Titian, 3 vols., London, 1969-75; this includes an extensive bibliography and the best available collection of plates. Rodolfo Pallucchini, Tiziano, 2 vols., Florence, 1969, has a more informative and perceptive text. Francesco Valcanover, L'opera completa di Tiziano, Milan, 1969, gives a brief but very useful catalogue. For a discussion of subject matter, see especially Erwin Panofsky, Problems in Titian, Mostly Iconographic, London, 1969. Of the earlier monographs much the most important is Joseph Crowe and Giovanni Battista Cavalcaselle, The Life and Times of Titian, 2 vols., London, 1877 (second edition, 1881); although many details now need to be corrected this remains the most complete account of Titian's life ever written and it includes a rich collection of original documents. Theodor Hetzer, Tizian, Geschichte seiner Farbe, Frankfurt, 1935 (second edition, 1948), provides an influential discussion of Titian's use of colour. Finally, Titian's drawings and woodcuts have been studied in four excellent recent exhibition catalogues: Tizian und sein Kreis, Holzschmitte, ed. Peter Dreyer, Berlin, 1971; Tiziano e il disegno veneziano del suo tempo, ed. W. R. Rearick, Florence, 1976; Disegni di Tiziano e della sua cerchia, ed. Konrad Oberhuber, Vicenza, 1976 Tiziano e la silografia veneziana del cinquecento, ed. Michelangelo Muraro and David Rosand, Vicenza, 1976 (also English edition, with some changes, entitled Titian and the Venetian Woodcut, Washington, 1976). The sources for most of the statements in my text can be found easily enough in the books listed above, especially in Wethey's catalogue. The footnotes at the end of each chapter are concerned primarily with material that for one reason or another is not readily traceable in the standard literature and with the discussion of various points of detail. To keep them reasonably short, I have tried to indicate the basis of my arguments in a general way, rather than justifying every statement in exhaustive detail. London, National Gallery Titian 2003, by Charles Hope and brings up to date the ever-growing Titian literature.

Bellini, Jacopo 166

Achilles Tatius Bembo, Pietro 41 Ecce Homo (Madrid, Museo del Prado) 125, 136, 74 Leucippe and Clitophon 154 Gli Asolani 145 Ecce Homo (Vienna, Munsthistorisches Museum) 117, 68 Adoration of the Magi (Cleveland, Museum of Art) 161 n. 20 Benavides, Juan de 161 n. 10 Ecce Homo (lost versions) 125 Adoration of the Magi (Escorial, Nuevos Museos) 157, 161 n. 20 Bertelli Luca Emperors, Roman (lost) 97-8, 117, 123 n. 9 Adoration of the Magi (Madrid, Museo del Prado) 161 n. 20 engraving of St Margaret 161 n. 10 engraving by Aegidius Sadeler 52 Adoration of the Magi (Milan, Pinacoteca Ambrosiana) 157, 161 Binche, Château de 134 Entombment of Christ (Madrid, Museo del Prado) 40, 146, 148, Bonelli, Michele, Cardinal 172, 184 n. 4, n. 5 n. 20 Adorno, Girolamo 77 Borghini, Raffaello 11, 142 Entombment of Christ (Paris, Musée du Louvre) 55-6, 27 Agnello, Benedetto 123 n. 7, 130-2, 160 n. 5 Boschini, Marco 180-81, 184, 187 Entombment of Christ (lost) 146 Escorial, El 161 n. 19, 165 Agony in the Garden (Escorial, Nuevos Museos) 157, 161n. 19, Brescia Palazzo della Loggia 172 Este, Alfonso d', Duke of Ferrara 50, 56, 59, 72, 77-8, 82 n. 1, Agony in the Garden (Madrid, Museo del Prado) 161 n. 19 Santi Nazzaro e Celso 56 n. 6, n. 13, 86 Este, Ippolito d', Cardinal 157, 161n. 20 Alberti, Leon Battista 10 Albrecht V, Duke of Bavaria 145, 161 n. 14, 166 Este, Isabella d', Marchioness of Mantua 51-2, 63, 68, 93 Cain and Abel (Venice, Santa Maria della Salute) 115, 123 n. 20 Este collection 186 Alexander the Great 89 Calandra, Sabino 160 n. 4 Alexander VI, Pope 25, 28 Carpaccio, Vittore 10, 29, 41-2 Allegories, for Brescia (lost) 172 Presentation of Christ in the Temple 29 Facchinetti, Giannantonio 184 n. 4, n. 5 Allegory of the Battle of Lepanto (Madrid, Museo del Prado), 168, Casa, Giovanni della 104, 126 Fall of Men (Madrid, Museo del Prado) 157-8, 161 n. 21, 94 178, 102 Farnese, Alessandro, Cardinal 101, 104-5, 126, 140, 172 Castiglione, Baldassare Allegory of Religion (Madrid, Museo del Prado) 168, 178 Il Cortegiano 120 Farnese, Ottavio 105 Allegory of Religion (lost) 178 Catherine, Archduchess 130-31 Feast of the Gods, begun by Giovanni Bellini (Washington, Allocution of the Marchese del Vasto (Madrid, Museo del Prado) 98, Catullus National Gallery of Art) 62-3, 68, 31 Carmina 67 Ferdinand, King of the Romans and later Emperor 125, 129, Amberger, Christoph 127, 166 Charles I, King of England 186 130 Amberger, Emanuel 166, 168, 171, 184 n. 1 Charles V, Emperor 71, 78, 83 n.16, 88-9, 90 98, 101, 103, 113, Ferrara Andrea Gritti presented to the Virgin (lost) 59 123 n.10,125,132,135,161 n.9, 174-175, 73 Camerino d'Alabastro 62-68 Andrians (Madrid, Museo del Prado) 67-68, 140, X, 34 Christ and the Adulteress (Glasgow, City Art Gallery and Flora (Florence, Galleria degli Uffizi) 71, 95, 35 Anna, Giovanni d' 117 Museum) 46 n. 19 Annunciation (Naples, San 'Domenico Maggiore) 164 Christ carrying the Cross (St. Petersburg, Hermitage Museum) Giorgione 10-14, 16-18, 20, 22-4, 28, 30, 32, 37-8, 43, Annunciation (Treviso, Cathedral) 56 188, n. 2 43 n.4,44 n.17, 56 Annunciation (Venice, San Salvatore) 160, 184, 95 Christ carrying the Cross (Venice, Scuola di San Rocco) 46 n. 19 frescoes on the Fondaco dei Tedeschi 11-2, 16 Annunciation (lost) 109, 117 Circumcision (New Haven, Yale University Art Gallery) 46 n. 19 engraving by Anton Maria Zanetti 1 Appelles 89, 144 Clement VII, Pope 88 Tempesta 15, 20 Arras, Bishop of: see Perrenot de Granvelle, Antoine Three Philosophers 16-7 Cleopatra: see Ariadne Aretino, Pietro 74 -77, 80, 88, 97, 98, 118,120, 123 n. 8, 125, Colonna, Vittoria 122 n. 2 see also Venus 128, 130, 163, 187 colore and colorito 79, 101, 106, 117, 120, 132, 144, 147, 183, 186 Giotto letters 77, 80, 74 Concert Champétre (Paris, Musée du Louvre) 46 n.19 frescoes in the Arena Chapel, Padua 29 Ragionamenti 74 contrapposto 42, 79, 98, 116, 132, 144, 150 Gipsy Madonna (Vienna, Kunsthistorisches Museum) 23-5, 29, Ariadne 68 Cornovi della Vecchia family 159 32, 38, 10 Assumption of the Virgin (Venice, Frari) 47-8, 50, 52, 56, 79,85, Correggio 133 Giulio Romano 74 186, 22 Loves of Jupiter 71,155, Fall of the Giants 134 Assumption of the Virgin (Verona, Cathedral) 79 Crowning with Thorns (Munich, Alte Pinakothek) 178, 181, Gonzaga, Federico, Marquis and later Duke of Mantua 55-6, Aurelio, Niccolò 34, 39-40 71-2, 74, 77-8, 83 n. 15, 85-6, 88, 90, 97, 122 n.4, 123 Avalos, Alfonso d', Marchese del Vasto 88, 98 Crowning with Thorns (Paris, Musée du Louvre) 112-3, 116-7, 64 n.7, 125 Averoldi, Altobello 56, 58, Crucifixion (Ancona, San Domenico) 159, Gonzaga, Ferrante 72 Averoldi Altarpiece (Brescia, Santi Nazzaro e Celso) 56, 58, 26 Crucifixion (Escorial, Nuevos Museos) 146 Gonzaga, Francesco, Duke of Mantua 130 Ayamonte, Marquis of 168, 180, 183, 184 n. 8 Gonzaga collection 186 David and Goliath (Venice, Santa Maria della Salute) 115, 123 n. Gonzaga della Rovere, Eleonora, Duchess of Urbino 90-1 Bacchus and Ariadne (London, National Gallery) 66-8, 33 Gozzi, Alvise 56 'Bagno, Il' (uncompleted) 50-1, 62, 24 Danae (Madrid, Museo del Prado) 106,132-5, 142, 144-45, 147, Greco, El 171 Grimani, Antorio, Doge 59 Baptism of Christ (Rome, Pinacoteca Capitolina) 18, 20, 7 153, 155, 160 n.6, 175, 77 Danae (Naples, Museo di Capodimonte) 104, 106, 132-5, 57 Gritti, Andrea, Doge 59, 83 n. 6, 112 Barbarigo, Cristoforo 185, 188 n. 2 Barbarigo collection 188 n. 2 Death of Actaeon (London, National Gallery) 134, 161, 164, 69 Guzmán de Silva, Diego 168, 180 Bartolommeo Fra 20, 48, 50, 64, 82 n. 1 Death of St Peter Martyr (lost) 78-80,85,86,116,135, drawings for The Assumption of the Virgin 48, 23 engraving by Martino Rota 40 Habsburg family, patronage of: see Charles V; Ferdinand; Mary, drawing for The Worship of Venus 64 Dente, Girolamo 165,171 Queen of Hungary; Philip II Noli Me Tangere 20, 43 n. 6 Descent of the Holy Spirit (Venice, Santa Maria della Salute) Habsburg ministers and courtiers, patronage of 85, 125 Bassano, Jacopo 166, 183 114-5, 117, 123 n. 19, n. 20 Henri II, King of France 157 'Bathing Women' (lost) 86 Diana and Actaeon (Edinburgh, National Gallery of Scotland) Holy Family with St John the Baptist (Edinburgh, National Gallery Battle of Cadore 123 n. 17 146-7, 89 of Scotland) 44 n. 19 see also Battle of Spain Diana and Callisto (Edinburgh, National Gallery of Scotland) Holy Family with a Shepherd (London, National Gallery) 44 n. 19 Battle of Spoleto (lost) 41-2, 59, 110-11, 116-7, 123 n. 17 146-7, 150-4, 172, 86 Hypnerotomachia Polifili 38 drawing for (Oxford, Ashmolean Museum) 111, 116 Diana and Callisto (Vienna, Kunsthistorisches Museum) 172 drawing for (Paris, Musée du Louvre) 111, 116, 62 disegno 79, 101, 106,, 117, 120, 144, 150, 186 Impressionists 8, 180 Dolce, Lodovico 11, 41, 43, 43 n. 3, 48, 79, 87, 120, 140, 144, engraving by Giulio Fontana 61 invenzione 79 Beethoven, Ludwig van 180 160 n. 6, n. 10, n. 12 Isabella, Empress 89, 101, 110 Bellini, Gentile 9, 12, 25, 41, 166, L'Aretino 11, 79 Ixion (lost) 117, 134 Bellini, Giovanni 9, 12, 20, 24–5, 28, 32, 41–2, 58, 62–3, 68, Donatello Miracle of the New-born Child 29 Jacopo Pesaro presented to St Peter by Pope Alexander VI (Antwerp, Madonna and Child 24 Dossi, Dosso 56, 63 Koninklijk Museum voor Schone Kunsten) 25, 29, 38, 40, 'Bacchanal of Men' 64 see also Feast of the Gods, Submission of Frederick Barbarossa 51.12 before Alexander III Dürer, Albrecht 10 Judith (Venice, Gallerie dell'Accademia) 12-4

The Knight, Death and the Devil 127

engraving by Anton Maria Zanetti 2

INDEX 191

Portrait of Federico Gonzaga (Madrid, Museo del Prado) 78, 83 n. Navagero, Andrea 41 Last Supper (Escorial, Nuevos Museos) 164-5, 178, 98 Noli Me Tangere (London, National Gallery) 18, 20, 22, 8 15 41 Portrait of Federico Gonzaga in Armour (lost) 83 n. 15, 86 Last Supper (lost) 164 Noli Me Tangere, fragment (Madrid, Museo del Prado) 138 Lautrec, Vicomte de 58 Portrait of Eleonora Gonzaga della Rovere (Florence, Galleria degli Nymph and Shepherd (Vienna, Kunsthistorisches Museum) 182 Leo X, Pope 41, 43 n. 5 Uffizi) 90, 47 Leonardo da Vinci 10, 22, 187 Portrait of Antonio Grimani (lost) 59 Oratory of Divine Love 107 Battle of Anghiari 41, 111 Portrait of Andrea Gritti (lost) 112 Ovid 134 141 Last Supper 113 Ars Amatoria 67 Portrait of the Empress Isabella (Madrid, Museo del Prado) 101, Lombardo, Antonio Fasti 62 123 n. 10, 126, 55 Miracle of the New-born Child 29 Portrait of Johann Friedrich of Saxony (Vienna, Kunsthistorisches Metamorphoses 62, 142, 155 Loredan, Leonardo, Doge 41 Museum) 129 Lotto, Lorenzo Portrait of a Man (Paris, Musée du Louvre) 77 St Nicholas of Bari in Glory with St John the Baptist and St Lucy see also Man with a Blue Sleeve, Man with a Glove Scuola di Sant' Antonio 28-9 136 Paleologo, Margherita, Duchess of Mantua 130, 160 n. 5 Portrait of Ippolio de' Medici (Florence, Palazzo Pitti) 88, 45 Luini, Bernardino Portrait of Tommaso Mosti (Florence, Palazzo Pitti) 74, 83 n. 12, Palma Giovane, Jacopo 180-1, 187 Crowning with Thorns 112 see also Pietà Portrait of Paul III (Naples, Museo di Capodimonte) 101,105, 58 Palma Vecchio, Iacopo 78 Macone 44 n. 11 Portrait of Paul III and his Grandsons (Naples, Museo di Portrait of a Man 74 Madonna and Child (Bergamo, Galleria dell' Accademia Carrara) paragone 34, 150 Capodimonte) 101 187 54 Portrait of Antoine Perrenot de Granvelle (Kansas City, Nelso-Pardo Venus (Paris, Musée du Louvre) 140-1, 161 n. 11, 82 Madonna and Child with Angels (Venice, Doge's Palace), 59, 106 Atkins Gallery) 129, 75 Parmigianino 8, 113 Portrait of Philip II in Armour (Madrid, Museo del Prado) 132, Madonna and Child in Glory with St Francis, St Louis of Toulouse and Paul III, Pope 101, 105, 125 162 n. 8 a Donor (Ancona, Museo Civico) 56, 28 Pelligrino da San Daniele Madonna and Child in Glory with Six Saints (Vatican City, replica (lost) 134, 160 n. 8 Triumph of Bacehus 65, 67-8 Portrait of Philip II (lost versions) 134, 160 n. 8 Pinacoteca) Pérez, Antonio 161 n. 21 underpainting 50-1, 24 Portrait of Francesco Maria della Rovere (Florence, Galleria degli Pérez, Gonzalo 157, 161n, 21 final version 106, 59 Uffizi) 90, 95, 98, 47 Perrenot de Granvelle, Antoine, Bishop of Arras 129 Madonna and Child with St Catherine of Alexandria, St Dominic and a Portrait of Jacopo Strada (Vienna, Kunsthistorisches Museum) Perseus and Andromeda (London, Wallace Collection) 142, 145, 177, 107 Donor (La Gaida, private collection) 37-8, 43, 19, 153 85 Madonna and Child with St Mary Magdalen (St Petersburg, Portrait of Titian: see Self-portrait Persio, Antonio Portrait of the Vendramin Family (London, National Gallery) 120, Hermitage Museum) 188 n. 2 Trattato dell' Ingegno dell'Huomo 187-8 Madonna and Child with Saints and Members of the Pesaro Family: see 127, 147, 72 Pesaro, Jacopo, Bishop of Paphos 25, 29, 44 n. 8, n. 9, 51-2 Pesaro Madonna Portrait of a Woman (London, National Gallery) 32, 34, 16 Pesaro Madonna (Venice, Frari) 52-5, 78, 85-6, 25 Madonna with a Rabbit (Paris, Musée du Louvre) 86, 43 Philip II, King of Spain 11, 71,90, 132-5, 140,142, 146, 150-2, Presentation of the Virgin (Venice, Gallerie dell'Accademia) 109, 116,60 Malchiostro, Broccardo 56, 82 n. 4 155, 157-8, 160, 160 n. 6, n. 8, n. 11, n. 19, 164-6,168-9, Man with a Blue Sleeve (London, National Gallery) 32, 34, 72, 38 Psyche presented to Venus (lost) 138 171, 178, 182, 184 n. 3 Man with a Glove (Paris, Musée du Louvre) 74, 77, 38 Philostratus 64, 67-8, 140 Manet, Edouard Pietà (Venice, Gallerie dell' Accademia) 178, 182-3, 109 Oueen of Persia (lost) 141 Olympia 95 Pino, Paolo 85, 118 Mantegna, Andrea Pliny 34, 144 Ram, Giovanni 18, 28 Assumption of the Virgin 50 poesie 142, 166, 172, 175, 177, Rape of Europa (Boston, Isabella Stewart Gardner Museum) Mantua Porcia, Jacopo di 28, 44 n. 9 134-5, 137, 163, 91 Palazzo Ducale 97 Pordenone, Giovanni Antonio da 78, 83 n. 17, 110-2 Raphael 8, 63-65, 74, 133, 187 Martyrdom of St Lawrence (Escorial, Iglesia Vieja) 165-6, 168, St Martin and St Christopher 63 Conversion of St Paul 111 178, 100, 76, 77 Portrait of Pietro Aretino (Florence, Palazzo Pitti) 120, 71 Madonna di Foligno 56 Martyrdom of St Lawrence (Venice, Gesuiti) 160, 165, 178, 96 Portrait of Pietro Aretino (New York, Frick Collection) 97, 123 n. Paul preaching at Athens 109 Mary of Hungary 125, 128-9, 134-5, 138, 161 n. 10 8,51 Portrait of Baldassare Castiglione 72, 36 Mary Tudor, Queen of England 161 n. 10 Portrait of Pietro Aretino (lost) 74 Portrait of Andrea Doni 74 Massolo, Lorenzo 160 Portrait of Archduchess Catherine (lost) 130 Portrait of Joanna of Aragon 90 Mater Dolorosa on marble (Madrid, Museo del Prado) 136-8, 161 Portrait of Charles V in Armour with a Baton (lost) 126 St Cecilia 107 n. 9, 81 Portrait of Charles V in Armour with a Sword (lost) 88-9, 90, 126 St Margaret 139 Mater Dolorosa on panel (Madrid, Museo del Prado) 136, 161 n. copy by Rubens 88 Transfiguration 50 9.80 replicas (lost) 88, 122 n. 4 Triumph of Bacchus 63-5, 67-8 Maximilian II, Emperor 145, 166, 172, 177-8 Portrait of Charles V with a Dog (Madrid, Museo del Prado) 89, copy by Pellegrino da San Daniele 65, 67-68 Medea and Jason 142, 145 90,46 engraving by C. M. Metz 32 Medici, Ippolito de', Cardinal 88, 122 n. 3 Portrait of Charles V on Horseback (Madrid, Museo del Prado) Rembrandt 178 126, 129, 132, 73 Resurrection: see Averoldi Altarbiece Santa Maria 88, 115 Portrait of Charles V with Isabella (lost) 126 Ridolfi, Carlo 48, 78, 183, 185, 187, 188 n. 2 Michelangelo 7-8, 66, 74, 77, 98, 104, 133-4, 180, 185-7 Portrait of Christina of Denmark (lost) 129 Rosso Fiorentino Battle of Cascina 14, 22, 41, 68, 150 Portrait of Laura dei Dianti (Kreuzlingen, Kisters Collection) 83 Assumption of the Virgin 50 copy of Aristotile da Sangallo 4 n. 14 Rovere, Francesco Maria della, Duke of Urbino 90, 95 ceiling of the Sistine Chapel 14, 30, 98, 150 Portrait of Alfonso d'Este (lost) 77, 83 n. 14 Rovere, Guidobaldo della, Duke of Urbino 95, 171 Last Judgement 116, 148 copy (New York, Metropolitan Museum) 39 Rovere collection 186 Staves 58 Portrait of Isabella d'Este (Vienna, Kunsthistorisches Museum) Rubens, Peter Paul 7-8, 111, 186 Michiel, Marcantonio 10, 16, 18 93 Portrait of Alfonso d'Este (attributed) 39 Portrait of Archduke Ferdinand (lost) 130 Portrait of Charles V in Armour with a Sword 88 Santa Maria delle Grazie 112 Portrait of Ferdinand, King of the Romans (lost) 130 Venus with a Mirror 149 Miracle of the Jealous Husband (Padua, Scuola di Sant' Antonio) Portraits of the Children of Ferdinand, King of the Romans (lost) 130 30, 14 Portrait of a Girl in a Blue Dress (Florence, Palazzo Pitti) 95, 50 Sacred and Profane Love (Rome, Galleria Borghese) 38-9, 43, 56, Miracle of the New-born Child (Padua, Scuola di Sant' Antonio) 2, Portrait of a Girl in a Fur Wrap (Vienna, Kunsthistorisches 147, 20, 21 29.13 Museum) 95 Sacrifice of Isaac (Venice, Santa Maria della Salute) 115-6, 123 n.

Portrait of a Girl with a Plumed Hat (Leningrad, Hermitage

Museum) 95

20,67

drawing for (Paris, Ecole des Beaux-Arts) 116, 66

Mosti, Agostino 83 n. 12

Mosti, Vincenzo 83 n. 12

Mosti, Tommaso 71-2, 83 n.12

St Catherine of Alexandria (Boston, Museum of Fine Arts) in Parma 78 in Rome 104-6, 125 171-2, 177 St Christopher (Venice, Doge's Palace) 59 'later style' 180, 181-2 pensions etc. 86, 106, 110, 135, 169 St George (Venice, Cini Collection) 58 prices 51, 58, 78, 85-6, 88, 106, 109-10, 157 St George, St Michael and St Theodore (lost) 58 St Jerome (Escorial, Nuevos Museos) 168, 178, 103 pupils and assistants 29, 95, 106, 115-6, 125, 129, 157, 160, 165, 168-9, 171-4, 182 St Jerome (Lugano, Thyssen-Bornemisza Collection) 172 transactions with the Venetian government 41-3, 58-9, St Jerome (Milan, Pinacoteca Ambrosiana) 172 St John the Battist (Venice, Gallerie dell'Accademia) 79, 42 110-1, 112, 163 St Margaret (Escorial, Nuevos Museos) 138, 141 use of drawings 8, 89, 110, 115-6, 172-5 St Margaret (Madrid, Museo del Prado) 138, 146, 161 n. 10, 82 working practice 20, 22, 50-5, 114-6, 120, 127, 131-2, 146-50, 166-8, 180-1 engraving by Luca Bertelli 161 n. 10 St Mark Enthroned with other Saints (Venice, Santa Maria della Tityus (Madrid, Museo del Prado) 117, 134, 78 Salute) 30, 32, 38, 43, 50, 114, 123 n. 20, 15 Tribolo, Niccolò 80 St Mary Magdalen (Florence, Palazzo Pitti) 87-8, 44 Tribute Money (Dresden, Gemäldegalerie) 59, 29 St Mary Magdalen (St. Petersburg, Hermitage Museum) 172, 188 Tribute Money (London, National Gallery) 166-7, 101 Trinity (Madrid, Museo del Prado) 135-6, 161 n. 9, 172, 79 n. 2 St Mary Magdalen (Naples, Museo di Capodimonte) 172, 104 Triumph of Christ 14, 16, 3 St Mary Magdalen (lost versions) 88, 125, 157, 177 St Sebastian: see Averoldi Altarpiece Van Dyck, Anthony 55 St Sebastian (St. Petersburg, Hermitage Museum) 178, 182 Van der Weyden, Rogier 138 Salome (Rome, Galleria Doria-Pamphili) 34, 37, 18 Vasari, Giorgio 7-17, 22, 32, 41, 43, 77, 88, 112, 115-6, 125, Salviati, Franceso 116 148, 160, 161 n. 20 Sánchez Coello, Alonso 168 Vasto, Marchese del: see Avalos, Alfonso d' Sansovino, Francesco 40, 112 Vecellio, Cesare, distant cousin of Titian 125 Sansovino, Jacopo 77, 112, 147 Vecellio, Cornelia, wife of Titian 66 Schiavone, Andrea 118, 120, 147, 183 Vecellio, Francesco, brother of Titian 10-1, 29, 43 n. 2, Adoration of the Magi 120, 70 44 n. 11, 108, 163 Sebastiano del Piombo 29-30, 32, 43 Vecellio, Gregorio, father of Titian 10 Portrait of Pietro Aretino 77 Vecellio, Lavinia, daughter of Titian 66 Salome 25, 34, 11 Vecellio, Lucia, mother of Titian 43 n. 2 St John Chrysostom with other Saints 29-30 Vecellio, Orazio, son of Titian 66, 125, 163, 166, 171, 184 n. 1, Self-portrait (Berlin, Gemäldegalerie) 182 Self-portrait (Madrid, Museo del Prado) 163, frontispiece Vecellio, Pomponio, son of Titian 66, 86, 104-5, 113, 172, 185 Self-portrait with an Image of Philip II (lost) 141 Vecellio, Tiziano, distant cousin of Titian 28, 43 n. 3, 44 n. 9 Seisenegger, Jacob 123 n. 10 see also Titian Portrait of Charles V with a Dog 90 Velázquez, Diego 8, 186 Seraphino da Cai 44 n. 11 Venice Sisyphus (Madrid, Museo del Prado) 117, 134 Biblioteca Marciana (Library) 147, 151, 157 Sprinzenstein, Hieronymus von, Baron 160 n. 4 Doge's Palace 41-3, 58-9, 108-9, 163 Stoppio, Niccolò 168, 177 Fondaco dei Tedeschi 12-4 Strada, Jacopo 177 Scuola Grande di Santa Maria della Carità 108-9, 123 n. 16 Submission of Frederick Barbarossa before Alexander III, begun by San Giorgio Maggiore 86 Giovanni Bellini (lost) 58-9 Santi Giovanni e Paolo 78, 165 San Nicolò ai Frari 50, 106 Tantalus (lost) 117, 134 San Salvatore 159 Tarquin and Lucretia (Cambridge, Fitzwilliam Museum) 167, 178, Santo Spirito in Isola 28, 115-6, 123 n. 19, n. 20 Venus, begun by Giorgione (Dresden, Gemäldegalerie) 17-8, 20, 24-5, 37, 71, 95, 6 Tebaldi, Jacopo 56, 58, 66-7, 71, 83 n. 13 Three Ages of Man (Edinburgh, National Gallery of Scotland) Venus, for Charles V (lost) 101-3, 125, 132, 174-5 Venus and Adonis (Madrid, Museo del Prado) 142, 144, 153, 84 18, 20, 23, 38, 176, 9 Tintoretto, Jacopo 118, 120, 147-8, 166, 171, 182-3, 185 Venus and Cupid (Florence, Galleria degli Uffizi) 173-5, 56 Venus and Cupid with a Lutenist (Cambridge, Fitzwilliam Miracle of the Slave 118, 69 Museum) 173-4, 106 Titian bassim and the art of the Renaissance in Florence and Rome 8, 14, Venus and Cupid with a Lutenist (New York, Metropolitan 20, 22, 28-9, 34, 48, 50, 58, 67-8, 74, 78-9, 85, 90, 106-7, Museum) 173-4 109-11, 116, 150 Venus and Cupid with an Organist (Berlin, Gemäldegalerie) 173-5 and classical art 32, 58, 64, 67-8, 97-8, 140-2 Venus and Cupid with an Organist (Madrid, Museo del Prado) and Mannerism 116-7, 120, 186 173-5, 105 Venus with a Mirror (Washington, National Gallery of Art) 176, birth and early years 10-2 character 7, 11,56, 66, 90, 98, 126, 187-8, 178, 185, 188 n. 2, 78 death 185 Venus with a Mirror (lost) 176 copy by Rubens 166 family: see Vecellio Venus and an Organist (Madrid, Museo del Prado) 173-5 house 185 in Asti 90 Venus of Urbino (Florence, Galleria degli Uffizi) 95, 103-4, 49 in Augsburg 125–8, 130, 134–5, 140 Veronese, Paolo 146, 152, 166, 183 ceiling paintings in the Biblioteca Marciana, Venice 146, in Bologna 88-101,107, 151 - 2in Brescia 165 ceiling paintings in San Sebastiano, Venice 146 in Ferrara 48, 59, 64, 66-8, 72, 83 n. 14 in Innsbruck 130 Vashti Banished 87 in Mantua 72, 88 Virgil 141 in Milan 112, 132 Vivarini, Alvise 9, 43

in Padua 29

Wisdom (Venice, Biblioteca Marciana) 152, 157, 90
Worship of Venus (Madrid, Museo del Prado) 62, 64, 67, 140, 154, 30
Zaffetta, Angela 88
Zaneti, Anton Maria 12
engravings after frescoes on the Fondaco dei Tedeschi 1, 2